CONTEMPORARY GERMAN CINEMA

D0808989

MANCHESTER
1824

Manchester University Press

Contemporary German cinema

Paul Cooke

Manchester University Press

Manchester and New York

distributed in the United States exclusively by Palgrave Macmillan

Published by Manchester University Press
Oxford Road, Manchester M13 9NR, UK
and Room 400, 175 Fifth Avenue, New York, NY 10010, USA
www.manchesteruniversitypress.co.uk

Distributed in the United States exclusively by
Palgrave Macmillan, 175 Fifth Avenue, New York,
NY 10010, USA

Distributed in Canada exclusively by
UBC Press, University of British Columbia, 2029 West Mall,
Vancouver, BC, Canada V6T 1Z2

British Library Cataloguing-in-Publication Data
A catalogue record for this book is available from the British Library

Library of Congress Cataloging-in-Publication Data applied for

ISBN 978 0 7190 7618 3 hardback
ISBN 978 0 7190 7619 0 paperback

First published 2012

Typeset
by Carnegie Book Production, Lancaster
Printed in Great Britain
by Bell & Bain Ltd, Glasgow

Contents

Acknowledgements *page* vii

List of illustrations ix

Introduction
 Contemporary German cinema: mapping the terrain 1

1 Financing cinema in Germany: art, entertainment or
 commerce? 22

2 Representational strategies and questions of realism 53

3 Heritage cinema, authenticity and dealing with
 Germany's past 88

4 Transnational cinema, globalisation and multicultural
 Germany 123

5 'German cinema today is female': gender and the
 legacies of the *Frauenfilm* 164

6 Visions of America across the generations 197

7 The Heimat film: reconfiguring 'Papas Kino' 230

Bibliography 268

Index 289

Acknowledgements

Without the support of the School of Modern Languages and Cultures at the University of Leeds, its research allowance and its provision of time away from teaching, this book could not have been written. I would also like to thank the *Alexander von Humboldt Stiftung* for a three-month fellowship to study at the Humboldt University in Berlin, supported by Erhard Schütz, the library staff of the *Deutsche Kinemathek*, who were incredibly helpful during my time working there, Alistair Noon, Sabine Heurs and the rest of Zorro for their wonderful hospitality, as well as the Faculty of Arts at the University of Leeds, the Worldwide Universities Network, the Arts and Humanities Research Council and the British Academy for a variety of financial support over the last few years. There are a huge number of individuals that I would like to thank for their engagement with this project, giving generously of their time and providing very useful comments on various chapters along with fascinating conversations that have helped shape the volume: Stephen Brockmann, Stephen Connor, Belinda Cooke, Ingo Cornils, Klemens Czyzydlo, Frank Finlay, Sabine Hake, Chris Homewood, Paul Mitchell, Brad Prager, Stuart Taberner and Jane Wilkinson. Special thanks go to Lúcia Nagib, Marc Silberman and Rob Stone, who read the entire manuscript, providing very detailed feedback. Both I and the book have benefited enormously from their guidance and support throughout. My gratitude also goes to Matthew Frost at Manchester University Press for the opportunity of writing this book, and his careful stewardship of its publication. Finally, I would like to thank my family: Alison Fell, for her constant intellectual input and guidance, and my children, Rosie and Aidan, who help me keep everything in perspective. Through

her engagement with this project, Alison now knows more about German cinema than she perhaps ever wanted. Equally, my children have allowed me to learn more about CBeebies than perhaps I ever wanted. It is to Alison, Rosie and Aidan that this book is dedicated.

Paul Cooke
Heptonstall, May 2011

Illustrations

1 Focusing on the state security services at Hanns-Martin Schleyer's funeral, *Deutschland im Herbst/Germany in Autumn*, Filmverlag der Autoren (1978). *page* 3

2 Herr Feierlich (Benno Fürmann) holds on to his Starbucks coffee for comfort in Tykwer's critique of globalisation *Feierlich Reist/Feierlich Travels*, Tykwer's contribution to *Deutschland 09/Germany 09*, Herbstfilm Produktion (2009). 4

3 A now middle-aged 68er (Burghart Klaußner) contemplates his Heimat, *Die fetten Jahre sind vorbei/The Edukators*, y3 film (2004). 7

4 Konrad Wolf's classic of DEFA 'anti-fascist' filmmaking, *Ich War Neunzehn/I was Nineteen* (1968): Jaecki Schwarz as the young Gregor Hecker returning to Germany with the Red Army. 8

5 Romy Schneider as the future Empress of Austria in *Sissi*, Erma-Film (1955). 11

6 Franka Potente as Tykwer's eponymous heroine in *Lola rennt/Run Lola Run*, X Filme Creative Pool (1998). 14

7 Markus (Andreas Müller) builds up the courage to commit suicide as his life unravels, *Sehnsucht/Longing*, Rommel Film (2006). 27

8 Rokko (Florian Lukas) enjoys a moment of transnational harmony in Istanbul watching the Champions League final, *One Day in Europe*, Filmanova (2005). 32

9 Gitti (Birgit Minichmayr) tries her hand at childcare, teaching her young charge (Paula Hartmann) to express her emotions honestly, *Alle Anderen/Everyone Else*, Komplizen Film (2009). 35

10 The director (Sylvester Groth) explains to Arno Runge (Markus Hering) the economic realities of the film business on a less-than-glamorous windy Rostock night, *Whisky mit Wodka/Whisky with Vodka*, Senator Film Produktion (2009). 39

11 Philip (Maxim Mehmet) negotiating life as a restaurant advertisement, *Männerherzen/Men in the City*, Wiedemann & Berg Film (2009). 41

12 Herbig and his camp crew (Christian Tramitz and Rick Kavanian) perform 'Miss Waikiki' in his sci-fi parody *(T)Raumschiff Surprise – Periode 1/Dreamship Surprise – Periode 1*, herbX film GmbH (2004). 42

13 Jürgen Vogel playing a multiple rapist overwhelmed by guilt, *Der freie Wille/The Free Will*, Colonia Media (2006). 60

14 Katrin (Gabriela Maria Schmiede) wanders through her snow-covered truckstop, *Halbe Treppe/Grill Point*, Rommel Film (2002). 68

15 17 Hippies play to the 'real' clientele of *Halbe Treppe/Grill Point*, Rommel Film (2002). 70

16 Sophie (Maren Eggert) sits in a police station next to a translator (Frederic Moriette) trying to compose herself, *Marseille*, Schramm Film Koerner & Weber (2004). 78

17 The women of the factory (here Özen Erfurt) refuse to submit completely to Ivan's (Devid Striesow) camera, *Marseille*, Schramm Film Koerner & Weber (2004). 81

18 Laura (Nina Hoss) works up a sweat, *Jerichow*, Schramm Film Koerner & Weber (2008). 84

19 Ali (Hilmi Sözer) dances on the beach in a drunken stupor to music from his Heimat, *Jerichow*, Schramm Film Koerner & Weber (2008). 85

20 A country house within a German heritage context, *NaPolA: Elite für den Führe/Before the Fall*, Max Riemelt and Michael Schenk, Olga Film (2004). 94

21a and 21b 'Real' and staged depictions of a fatally wounded
Benno Ohnesorg, *Der Baader Meinhof Komplex/The Baader
Meinhof Complex*, Martin Glade and Sara Ciabattini,
Constantin Film Produktion (2008). 100

22 Hitler (Bruno Ganz) sheds a tear as his friend Albert
Speer leaves him, *Der Untergang/Downfall*, Constantin
Film Produktion (2004). 103

23 A childish Hitler (Helge Schneider) plays with his toy
battleship in the bath, *Mein Führer – Die wirklich wahrste
Wahrheit über Adolf Hitler/My Führer – The Truly Truest
Truth About Adolf Hitler*, X Filme Creative Pool (2007). 109

24 Wiesler (Ulrich Mühe) takes up residence in his
surveillance suite, *Das Leben der Anderen/The Lives of
Others*, Wiedemann & Berg Film (2006). 113

25 Wiesler (Ulrich Mühe) mesmerised for a moment, *Das
Leben der Anderen/The Lives of Others*, Wiedemann & Berg
Film (2006). 117

26 Crossing the River Oder: for some a simple journey by
train or car, *Lichter/Distant Lights*, Claussen+Wöbke+Putz
Filmproduktion (2003). 134

27 Crossing the River Oder: for others a near-death
experience. Antoni (Zbigniew Zamachowski) tries to
lead a family (Juri Konkov and Jana Pfeffer) across by
foot, *Lichter/Distant Lights*, Claussen+Wöbke+Putz
Filmproduktion (2003). 135

28 A picture-postcard representation of Istanbul in the
film's musical tableaux, featuring Idil Üner and Selim
Sesler's ensemble, *Gegen die Wand/Head On*, Wüste Film
(2004). 143

29 'Punk is not dead': Cahit (Birol Ünel) and Sibel (Sibel
Kekilli) dance to The Sisters of Mercy, *Gegen die Wand/
Head On*, Wüste Film (2004). 145

30 Protesting women facing Nazi machine guns, *Rosenstraße*,
Studio Hamburg Letterbox, Tele München (2003). 151

31 Marlene (Hannelore Elsner) playing it (literally) by the
book as Jaeckie (Henry Hübchen) looks on in disbelief,
Alles auf Zucker/Go for Zucker!, X Filme Creative Pool
(2004). 156

32 A train arrives at Oświęcim Station, the opening shot of
 Am Ende Kommen Touristen/And Along Come Tourists, 23/5
 Filmproduktion (2007). 159

33 Pope Johanna (Johanna Wokalek) dies in a moment
 of high melodramatic excess, *Die Päpstin/Pope Joan*,
 Constantin Film Produktion (2009). 172

34 Sophie (Julia Jentsch) as serene victim, *Sophie Scholl – Die
 letzten Tage/Sophie Scholl – The Final Days*, Goldkind Film,
 Broth Film (2005). 176

35 Hanna Flanders (Hannelore Elsner) playing the diva
 in *Die Unberührbare/No Place To Go*, Distant Dreams
 Filmproduktion (2000). 180

36 Fariba (Jasmin Tabatabai) watched through a venetian
 blind, caught in the stare of the border authorities, *Fremde
 Haut/Unveiled*, MMM Film (2005). 184

37 Fariba defiantly re-appropriates Siamak's gaze, *Fremde
 Haut/Unveiled*, MMM Film (2005). 185

38 The family (Felix Eitner and Floriane Daniel) grieves
 while tourists enjoy a day at the beach, *Kirschblüten –
 Hanami/Cherry Blossoms – Hanami*, Olga Film (2008). 190

39 Rudi (Elmar Wepper) dancing as/with Trudi (Hannelore
 Elsner) at the foot of Mount Fuji, *Kirschblüten – Hanami/
 Cherry Blossoms – Hanami*, Olga Film (2008). 192

40 Alice Dwyer as a damaged teenager negotiating her
 dysfunctional life, *Torpedo*, Credofilm (2008). 193

41 The LA cityscape at dusk from the roof of the hotel, *The
 Million Dollar Hotel*, Road Movies Filmproduktion (2000). 209

42 Emmerich recalls *Holocaust* (1978), in his depiction of a
 congregation locked inside a burning church, *The Patriot*,
 Columbia Pictures Corporation (2000). 215

43 Traces of the mountain film in Petersen's depiction of the
 sea, *The Perfect Storm*, Warner Bros (2000). 216

44 The assassin's hands construct and load his rifle, *The
 International*, Columbia Pictures (2009). 220

45 Jürgen (Harald Warmbrunn) and Manfred (Karl-Fred
 Müller) contemplate their friend's life in America, *Schultze
 Gets the Blues*, Filmkombinat (2003). 223

46 Schultze's (Horst Krause) moment of epiphany, *Schultze Gets the Blues*, Filmkombinat (2003). 225

47 Anti-Heimat 'reality' inside a Heimat fantasy, Fritz Karl, *Wer früher stirbt ist länger tot/Grave Decisions*, Roxy Film (2006). 238

48 The German team ride their train into the sunset through the Heimat landscape, *Das Wunder von Bern/The Miracle of Bern*, Little Shark Entertainment (2003). 242

49 'Unser Heimat': the community (Daniel Brühl, Chulpan Khamatova, Maria Simon, Alexander Beyer, Michael Gwisdek, Christine Schorn, Jürgen Holtz, Denys Darahan and Bastian Lang) collects around the mother's bed to re-enact the GDR, *Good Bye, Lenin!*, X Filme Creative Pool (2003). 248

50 The rural landscape drained of colour, *Das weiße Band – Eine deutsche Kindergeschichte/The White Ribbon*, X Filme Creative Pool (2009). 256

51 The children move around the village 'in unwholesome intimacy', *Das weiße Band – Eine deutsche Kindergeschichte/ The White Ribbon*, X Filme Creative Pool (2009). 257

52 Franz (Josef Bierbichler) surveys the Kenyan savannah that will never be his Heimat, *Winterreise/Winter Journey*, die film GmbH (2006). 260

53 Zinos (Adam Bousdoukos) and Lucia (Anna Bederke) take in their Heimat vista, still under construction, *Soul Kitchen*, corazón international (2009). 262

Introduction
Contemporary German cinema: mapping the terrain

In August 2007, the filmmaker Tom Tykwer and the German television channel NDR (*Norddeutscher Rundfunk*) brought together a group of well-known German filmmakers to discuss an omnibus movie project that would explore the state of the nation in the first decade of the new millennium, years that have seen the industry enjoy levels of success at home and abroad that it has not experienced for decades. The result, *Deutschland 09: 13 Kurze Filme zur Lage der Nation* (Germany 09: 13 Short Films About the State of the Nation) opened at the Berlin Film Festival two years later to mixed reviews; but leaving aside the aesthetic qualities of the various contributions to the film itself for the moment, its very existence offers a useful starting point for an examination of contemporary German cinema in a number of ways.

Germany seems particularly prone to this type of 'stock-taking' treatment by filmmakers, a tradition to which the title of Tykwer's project itself alludes. *Deutschland 09* immediately recalls Roberto Rossellini's classic of post-war Italian Neorealism *Germania, anno zero* (Germany Year Zero, 1948), set amongst the rubble of Berlin, or Jean-Luc Godard's *Allemagne 90 neuf zero* (Germany Year 90 Nine Zero, 1991) which, in a pun on Rossellini's title, posited the moment of German unification as a new (neuf) year zero for the nation.[1] Nor is it the only domestic film of recent years to use an omnibus format to examine contemporary society. Harald Siebler's lesser known *GG19: Eine Reise durch Deutschland in 19 Artikeln* (GG19: a Journey Through Germany in 19 Articles, 2007), for example, presents a series of 19 shorts based around the first 19 articles of the German Constitution, which set out the 'Fundamental Rights' of each citizen. The self-declared inspiration for

Deutschland 09, however, was probably the best-known omnibus film to come from Germany in the post-war period, *Deutschland im Herbst* (Germany in Autumn, 1978), a collective response by the internationally renowned New German Cinema to the events of the so-called 'German Autumn' of 1977. This was a moment that saw an increase in violent attacks by the urban terrorist group the Red Army Faction (RAF), culminating in the deaths of its founding members Jan-Carl Raspe, Gudrun Ensslin and Andreas Baader in their high-security prison Stammheim, as well as one of the group's high-profile kidnap victims, the industrialist Hanns-Martin Schleyer. *Deutschland 09* was to be Tykwer's generation's response to the challenges of contemporary German society, its opportunity to speak for the nation, as the likes of Alexander Kluge, Rainer Werner Fassbinder and Volker Schlöndorff had done 30 years earlier, with their aesthetically challenging, acerbically critical film.

But as the pre-release press material makes clear, while all the other films mentioned above respond either to a specific event or a definable document, Tykwer's film was provoked by a broad range of stimuli:

> Over 60 years after the end of the Second World War, 40 years after the student awakening in 1968, 30 years after the 'German Autumn' in 1977, 20 years after the fall of the inner-German border in 1989 and in the midst of the social upheavals of 'Agenda 2010' as the country moves towards the globalised world of the 21st Century, a group of film directors have come together to produce a panorama from their individual perspectives of the social and political situation in today's Federal Republic. (Presseheft 2009a: 1)

For Tykwer and his colleagues, the Berlin Republic, as the present-day Federal Republic of Germany is often termed, does not find itself at a defining moment in its history, but rather in the middle of a series of processes. On the one hand, these are constituted by the nation's continuing need to negotiate its problematic past, to face the legacies of National Socialism, the Holocaust and the war. This has been further complicated, we are reminded, since the end of the Cold War and the unification of the West and East German states by the need to face the crimes of GDR state communism as well as the trauma of left-wing terrorism that gripped West

1 Focusing on the state security services at Hanns-Martin Schleyer's funeral, *Deutschland im Herbst* (1978).

Germany in the aftermath of the student movement of the late 1960s. This generation of students – generally referred to as the '68ers' after that key year of social revolt across Europe – continue to make their presence felt in a variety of ways in the Berlin Republic of today. On the other, the nation continues to feel the effects of economic globalisation and the imperative to reform its much celebrated – but expensive – *Soziale Marktwirtschaft* (Social Market Economy), and in so doing to rethink the economic certainties that once underpinned the affluence enjoyed by many in the West and that many in the East longed for. At the same time, the nation has been forced to rethink its political position in the world, increasingly being treated not as an exceptional state that must be constrained due to its history, but as a 'normal' affluent western democracy that must play its part in world affairs. To a degree, the film might best be understood as a response to the very *lack* of a defining moment to which its makers can collectively respond. In effect, it expresses a wish for the kind of distinctive collective sense of identity that *Deutschland im Herbst* appeared to articulate for the New German Cinema. As Tykwer himself puts it, almost plaintively, 'Of course this generation doesn't have as strong an emblematic identity as the New German Cinema of the 1970s had. But for a long time I have had the sense that a certain identity

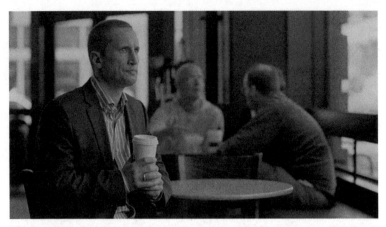

2 Herr Feierlich (Benno Fürmann) holds on to his Starbucks coffee for
comfort in Tykwer's critique of globalisation *Feierlich Reist*, Tykwer's
contribution to *Deutschland 09* (2009).

has developed, albeit a far more disparate one' (Presseheft 2009a:
2). The extent to which the 'New German Cinema' in fact had
anything like an 'emblematic identity' is questionable. The film-
makers connected with its output were also a hugely diverse group,
exploring a wide range of material, from the legacies of the Nazi
regime, to gay rights and the classics of the nation's literary canon.
They also adopted an equally broad range of aesthetic approaches
– be it Kluge's 'essay films', the operatic narrative experimentation
of Werner Schroeter or Fassbinder's reinterpretation of Holly-
wood genre cinema. Thus, for all Tykwer's somewhat nostalgic
construction of a coherent collective identity in *Deutschland im
Herbst*, with regard to the New German Cinema more broadly,
it might be more accurate to suggest that the filmmakers who
came together to make *Deutschland 09* are a *similarly* 'disparate'
collection.

Defining German national cinema in the 2000s

The core of the group that made *Deutschland 09* is constituted
by filmmakers connected to the *X Filme Creative Pool*, a company
created in 1994 that has played a key role in the renaissance
of the German industry since the late 1990s. Tykwer, *X-Filme*'s

co-founder, shot to fame in 1998 with the techno-fuelled youth film *Lola rennt* (Run Lola Run), the story of the flame-haired Lola (Franka Potente) and her attempt to beat the clock and save her boyfriend Manni (Moritz Bleibtreu) from the retribution of his underworld boss, told at breakneck speed in a style reminiscent of a music video or computer game. Tykwer's film won the World Cinema Audience Award at the Sundance Film Festival in the United States and subsequently broke into the top 20 of the US box office, something not achieved by a German film since the early 1980s. In the following decade Tykwer continued to develop his *auteurist* approach to filmmaking, seeking to combine the sensibilities of the European avant-garde with the populism of Hollywood genre cinema, looking to build his international reputation with large-budget films such as his adaptation of Patrick Süskind's bestselling novel, *Perfume: The Story of a Murderer* (2006) and the conspiracy thriller *The International* (2009), albeit with limited commercial or critical success. In *Deutschland 09*, Tykwer is joined by his fellow *X-Filme* co-founders, Wolfgang Becker and Dani Levy, both of whom also focus on audience appeal in their work. However, this they marry not with Tykwer's esoteric sensibilities, but with narratives that have a particularly German flavour, such as Becker's international hit *Good Bye, Lenin!* (2003), which explored the widespread rediscovery of consumer goods from the old communist East German state (GDR) in the second half of the 1990s, along with a broader nostalgic longing for certain aspects of pre-unification life in the East through the medium of a 'coming-of-age' comedy. Levy's biggest success to date, *Alles auf Zucker* (Go for Zucker, 2004), on the other hand, investigates the changing nature of Jewish and non-Jewish relations post-unification, reworking motifs from classics of the 'pool-hall movie' *The Hustler* (Robert Rossen, 1961) and *The Color of Money* (Martin Scorsese, 1986). This work contrasts starkly with the more experimental contributions to the film by Angela Schanelec (*Marseille*, 2004; *Nachmittag*/Afternoon, 2007) and Christoph Hochhäusler (*Milchwald*/This very Moment, 2003; *Falscher Bekenner*/I am Guilty, 2005). Both these filmmakers are connected with the so-called *Berliner Schule* (Berlin School), a group of artists that began work in the mid-1990s who are amongst a number of contemporary filmmakers currently exploring new forms of cinematic realism. Equally, the work of Levy and Becker is very different to the melodrama of Fatih Akın, who also produced

a short for *Deutschland 09*. Achieving international acclaim with *Gegen die Wand* (Head On, 2004) and *Auf der anderen Seite* (The Edge of Heaven, 2007), Akın stands at the vanguard of a group of Turkish-German filmmakers fêted in the press as a particularly important development for this 'national' cinema. Much Turkish-German filmmaking highlights what has been defined by Randall Halle as a 'transnational' turn in the industry, both with regard to the topics filmmakers are choosing to examine and in the way they are attracting funding for their projects (Halle 2008). This is a tendency that is, of course, suggested in the title of *Deutschland 09* itself, which implicitly looks beyond Germany's borders through its reference to Rossellini and Godard, even as it explores the state of the nation. Alongside this transnational tendency, however, stands the segment by Hans Steinbichler, whose films *Hierankl* (2003) and *Winterreise* (Winter Journey, 2006) are amongst the best-known examples of the contemporary Heimat film, a genre that is firmly rooted within a specifically German national context. All these pieces are then further complemented by the work of a range of experimental and more mainstream artists, from the documentary filmmaker Romuald Karmakar (*Das Himmler Projekt*/The Himmler Project, 2000) to Hans Weingartner (*Die fetten Jahre sind vorbei*/ The Edukators, 2004; *Free Rainer – Dein Fernseher lügt*/Reclaim Your Brain, 2007), filmmakers that, like some of the most famous figures connected with the New German Cinema, explore the legacies of the nation's problematic past, now updated to include the impact of this generation itself on contemporary society. *Die fetten Jahre sind vorbei*, for example, is one of a number of recent films (including *Deutschland 09* itself) to investigate the legacy of 1970s left-wing terrorism while also re-evaluating the broader protest movement the 68ers set in train. Finally, it is also worth noting that the diversity of the group which produced *Deutschland 09* is further reflected in their ages. Contrast Dominik Graf, a filmmaker particularly well known for his television work, born in 1952, for example, with Tykwer (born 1965), or Hochhäusler (born 1972). This group does not constitute a single generation, despite Tykwer's assertions.

Like *Deutschland im Herbst*, *Deutschland 09* is only a selective snapshot of what contemporary German film has to offer. While the film includes work by a wide variety of filmmakers and reflects many of the broader social concerns facing the country, it is also

3 A now middle-aged 68er (Burghart Klaußner) contemplates his Heimat, *Die fetten Jahre sind vorbei* (2004).

interesting to reflect upon the areas of contemporary cinema that are *not* represented in the film. There are, for example, none of the country's recent spate of Oscar nominees or winners here – a sign of the mainstream international impact the country's film industry is currently enjoying – no Caroline Link (*Nirgendwo in Afrika*/Nowhere in Africa, 2001) or Florian Henckel von Donnersmarck (*Das Leben der Anderen*/The Lives of Others, 2006). More importantly in terms of the landscape of contemporary German cinema, there is no reference to the type of 'heritage film' that has brought the likes of Link and Henckel von Donnersmarck critical and commercial success, and which makes up a significant proportion of German films released abroad. These are films that at times offer a more affirmative image of the state of the nation than those of the filmmakers included in Tykwer's project. In similar vein, the work of comedians such as Michael 'Bully' Herbig or Gerhard Polt, hugely popular within Germany, is not present, nor are figures such as Roland Emmerich and Wolfgang Petersen, German-born filmmakers who are now part of a Hollywood elite given the right to the final cut of their movies (Haase 2007: 64). None of the major new stars of recent film are included in the cast list. There is no Franke Potente here, no Moritz Bleibtreu, no Daniel Brühl, no Julia Jentsch. However, perhaps the most significant omission is the lack

4 Konrad Wolf's classic of DEFA 'anti-fascist' filmmaking,
Ich War Neunzehn (1968).

of any sustained engagement with GDR film culture in *Deutschland
09*. While one of the self-declared stimuli for the film was the
twentieth anniversary of the fall of the Berlin Wall, the film, like
Deutschland im Herbst before it, is fundamentally a west German
project.[2] The one exception is the segment by the east German film-
maker Sylke Enders (*Kroko*, 2002; *Mondkalb*/Mooncalf, 2007). Like
the rest of her work, her contribution to *Deutschland 09*, *Schieflage*
(Bias) is set in the ex-GDR and highlights the difficulties faced by
the population as the nation grapples with the economic asym-
metries between the eastern and western regions of the country.
However, there are no filmmakers here from the DEFA (*Deutsche
Film-Aktiengesellschaft*) tradition, the East German state film-
making organisation that, despite the GDR's draconian censorship
laws, produced a number of aesthetically and politically significant
films by the likes of Konrad Wolf and Frank Beyer (Berghahn 2005;
Hake 2010). Today there remain several DEFA-trained filmmakers
who continue to work, most notably Andreas Kleinert and Andreas
Dresen, both of whom have explored the specific economic and
cultural challenges that the population of the ex-GDR still have to
confront.

The gaps and omissions in *Deutschland 09* as much as the 13 short

films themselves reveal the complex contours of the contemporary German cinematic landscape, a complexity that forces us to reflect on what we mean precisely by 'German cinema'. As Sabine Hake asks in the first edition of her history of the medium in Germany:

> How, then, should we define a national cinema? Are its charac-
> teristics determined by economic, political, or aesthetic forces?
> Does the national refer to actual practices, whether of filmmakers
> or their audiences, or is it a function of promotional strategies,
> public policies, and the ideology of nationalism? (Hake 2002: 5)

Of course, as Hake goes on to discuss, the straightforward answer is 'yes' to all of this. However, the weight given to politics over aesthetics, or filmmakers over film audiences continues to be contested, as all those involved in the production, distribution, exhibition and criticism of film debate the role and function of the medium, asking who has the right to speak, and for whom. If, then, we are to talk of a German national cinema, what particular nation do we mean, and what is the nature of the cinema at stake? How do changes in funding structures as well as the growing importance of Turkish-German filmmakers and numerous other migrant and ethnic minority voices trouble what we understand as 'national cinema'? How are we to understand the relationship of the domestic industry to the rest of the world's cinema, not least Hollywood, which has long played an important role for German artists, audiences and, as we shall see in the following chapter, financial investors in the industry? And, if we focus for the moment on the role of audiences, with the general decline in the number of people going to the cinema and the increasing availability of films through legal and illegal digital download, the type and number of films that are readily available to consumers has radi-cally increased, while the way in which they are often consumed has radically changed. Moreover, the rapidly growing potential of Web 2.0 technology is further reconfiguring the ways that audi-ences interact with films, be it through the re-editing of film clips to change their original meaning, such as we find in the countless 'mashups' on *YouTube* of Oliver Hirschbiegel's story of Hitler's final days, *Der Untergang* (Downfall, 2004) (Cooke 2010), or through the ability of fans to follow the every waking moment of stars such as Daniel Brühl on *Twitter* (Muntean and Petersen 2009). These are the issues that will guide my discussion throughout this book as I

explore the complexity of contemporary German cinema, the ways in which this has been shaped by changes in the industry since unification and how it reflects broader social and political trends at work in today's Berlin Republic.

The historical context:
the shadow of the New German Cinema

Before I outline the specific topics I wish to examine in the rest of this volume, the question remains, why would the makers of *Deutschland 09* look to *Deutschland im Herbst* specifically for inspiration, given the very different social, political and cultural context in which contemporary filmmakers find themselves? Broader comparisons between the present moment in German film culture and the New German Cinema are perhaps inevitable given the fact that German film is currently enjoying a level of visibility around the world it has not seen since the early 1980s, when the New German Cinema reached its zenith of international commercial and critical success with an Oscar win for Schlöndorff's *Die Blechtrommel* (The Tin Drum, 1979), quickly followed by Fassbinder's *Die Sehnsucht der Veronika Voß* (Veronica Voss, 1982) taking the top prize at the Berlin Film Festival, as well as awards for Werner Herzog as the director of *Fitzcarraldo* (1982) in Cannes and for Wim Wenders' *Der Stand der Dinge* (The State of Things, 1982) in Venice. The beginning of the New German Cinema is generally traced to 1962, when a group of filmmakers at the International Short Film Festival in Oberhausen, including Kluge, Hans Jürgen Pohland and Edgar Reitz, published the 'Oberhausen Manifesto'. This was a document that declared the end of commercial cinema in West Germany, the failure of which already seemed to have been confirmed in the government's refusal to award the Federal Film Prize the year before due to a perceived dearth of quality amongst the contenders. In its place, the 'Oberhausen Manifesto' called for an experimental form of filmmaking that was not constrained by the economic imperatives of the mainstream industry.

The main target of these filmmakers' ire would come to be referred to disparagingly as 'Papas Kino' (Daddy's Cinema), by which they meant the hugely popular domestic genre films of the 1950s, such as the Heimat films with their chocolate-box, seemingly escapist, depictions of the German province as a rural idyll, or the

5 Romy Schneider as the future Empress of Austria in *Sissi* (1955).

'Sissi' trilogy that celebrated a romanticised version of the life of the Empress of Austria and which catapulted the actress Romy Schneider to international stardom. As a number of recent studies have shown, the film landscape of 1950s Germany was rather more complex than the notion of 'Papas Kino' might suggest, with some of the aesthetic and political developments of the 1960s already apparent in certain films produced towards the end of the previous decade in both East and West German states (Davidson and Hake 2007; Pinkert 2008; Baer 2009).[3] Furthermore, others have revealed that there was perhaps more to the genre films of 'Papas Kino' than their characterisation as straightforwardly escapist film texts implies (Bergfelder 2005; von Moltke 2005). Nonetheless, it is against this characterisation that the New German Cinema came to be defined and upon which it built its reputation, a reputation that grew over the following two decades. In retrospect it has become clear that the success of the late 1970s and early 1980s actually signalled the beginning of the end for this wave of filmmaking, its demise marked symbolically by the death of the 37-year-old Fassbinder in June 1982 along with the subsequent success of Helmut

Kohl's conservative CDU in the Federal Elections of 1983. While the likes of Wenders, Schlöndorff or Margarethe von Trotta continued to make films, and were indeed joined by others who maintained the tradition of the critical *Autorenfilm* – a German variation of the French *auteurist* cinema – such as Monika Treut (*Verführung: Die grausame Frau*/Seduction: The Cruel Woman, 1985) and Percy Adlon (*Bagdad Café*, 1987; *Rosalie Goes Shopping*, 1989), German film became far less visible internationally.

From the mid-1980s to the late 1990s domestic production was dominated by genre films, in particular a series of romantic comedies, characterised by critics – somewhat hopefully perhaps in an echo of past glory – as the 'New German Comedy'.[4] This cycle of films brought a new, more commercially minded, generation of directors to the fore and made stars of actors such as Katja Riemann and Til Schweiger. However, it was largely ignored by both international awards ceremonies and audiences, defined famously by the film scholar Eric Rentschler as a 'cinema of consensus', an 'emanation of an overdetermined German desire for normalcy as well as of a marked disinclination towards any serious political reflection or sustained historical retrospection' (Rentschler 2000: 263). Such films, Rentschler and later others suggested, reflected the broader trend towards the 'normalisation' of Germany's place in the world, already mentioned in connection with its international relations, along with the mores of the much-vaunted *Spaßgesellschaft* ('fun society') of the mid-1990s. With the world ostensibly now existing in a post-ideological, post-historical phase, where the battles of the Cold War had been won by the forces of western capitalism, German society was gripped, its critics charged, by an addiction to amusement and the seductive pleasures of pop culture consumerism (Boberski 2004: 11–21). Mainstream domestic productions were invariably dismissed as superficial celebrations of contemporary society, far removed from the aesthetic heights of the New German Cinema and the project taken on by many of its number to hold the present-day nation accountable for its past. In terms of form, they were generally characterised as poor imitations of a style of filmmaking that many critics felt was better left to Hollywood. While such films continue to be made, and at times at least continue to enjoy success at home, they still have little or no impact abroad. Looking back on the comedies of the early 1990s, it is now possible to identify the ways in which these

films in fact reveal contemporary anxieties, showing filmmakers at times working through broader social concerns, however tentatively, as the nation sought to come to terms with the new reality of a unified German state. In the 2000s, however, these anxieties became more pronounced, as the *Spaßgesellschaft* gave way to a post-9/11 hangover world of global terrorism and economic recession. To an extent, the 'cinema of consensus' was replaced by what Sabine Hake defines as a 'cinema of dissent' (Hake 2008: 216). Simultaneously, German cinema once again started to attract international attention.

The current renaissance that began in 1998 with Tykwer's *Lola rennt* soon gathered pace, with numerous other films winning prestigious awards and gaining commercial success. Fatih Akın's *Gegen die Wand* became the first German film to win the top prize at the Berlinale for 18 years in 2004, the same year that Hans Weingartner's *Die fetten Jahre sind vorbei* became the first German film to be shown in competition at Cannes for 11 years. Becker's *Good Bye, Lenin!* and Hirschbiegel's *Der Untergang* (Downfall, 2004), made millions at the international box office.[5] Actors including Daniel Brühl, Julia Jentsch and Moritz Bleibtreu as well as cinematographer Michael Ballhaus began to receive international awards and at the Oscars German film became a regular feature.[6] Initially, the renewed international visibility of German films was seen as the natural fulfilment of the trend towards aping Hollywood, identified by critics from the mid-1980s and seemingly also evidenced in the resonance of German films with Oscar juries in particular. As Nick James notes in a retrospective on German cinema for *Sight and Sound*, the success of *Lola rennt* was 'thought to be as much a symbol of the Hollywoodising of German culture as any kind of breakout' (James 2006: 12). However, more recently, comparisons with the New German Cinema, and with them the identification of contemporary film as part of a specifically German cinematic tradition, are more common. Critics write of a 'New New German Cinema' (Weingarten 2005; Kriest 2007; Rodek 2007) or, evoking the formulation offered by the French prestige journal *Cahiers du Cinema*, of a 'Nouvelle Vague allemande' ('German New Wave': Loutte 2005; Corsten 2006; Lim 2009).

Within this context, the press appears to have a particular penchant for discovering the 'new Fassbinder' in order to set the seal on the present moment of success, Fassbinder being the

6 Franka Potente as Tykwer's eponymous heroine in *Lola rennt* (1998).

best-known 'star director' of the New German Cinema inter-
nationally. This is a definition that sat uncomfortably with one
early contender for the title, the late avant-garde artist Chris-
toph Schlingensief, who provocatively subtitled his *Die 120 Tage
von Bottrop* (120 Days of Bottrop, 1996) 'The Last New German
Film', advertising himself as Fassbinder's undertaker. As John E.
Davidson notes, Schlingensief's invocation of the New German
Cinema is entirely provocative (Davidson 1999: 198). While his
'German Trilogy', for example, might appear to recall Fassbinder's
'FRG Trilogy' – this earlier exploration of the first decades of the
West German Federal Republic updated to examine the immediate
impact of unification in 1990 – aesthetically the two cycles have
very little in common.[7] Instead, films such as *Das Deutsche Ketten-
sägenmassaker* (The German Chainsaw Massacre, 1990) – which
turns Tobe Hooper's horror classic *The Texas Chainsaw Massacre*
(1974) into a macabre comic vision of German unification as a
violent, cannibalistic consumption of the East by the West – have
far more in common with Lloyd Kaufmann's 'Troma' films, those
grotesque, at times highly exploitative, low-budget US productions
that brutally satirise mainstream Hollywood cinema (Cooke 2005:
108–9).

Other 'new Fassbinders' are generally more reverential in their
acknowledgement of his legacy and seem to offer more obvious

points of connection with his work. This might be reflected in the rediscovery of 'Fassbinder's Muse' Hanna Schygulla by Hans Steinbichler and Fatih Akın, or by the overt reworking of melodramatic motifs from his work again by Akın or, more self-consciously, by Oskar Roehler.

Roehler began his career writing for Schlingensief and some of his films, most notably his grotesque version of Jekyll and Hyde *Suck My Dick* (2001), clearly point to Schlingensief's influence. However, critics have been more keen to focus on the intertextual legacy of Fassbinder on Roehler's oeuvre, particularly on *Die Unberührbare* (No Place to Go, 2000), his breakthrough film based on the last days of his mother's life, and *Agnes und seine Brüder* (Agnes and His Brothers, 2004) which explores the relationship of the transsexual Agnes (Martin Weiß) with her family, both of which rework Fassbinder's melodrama of self-destructive love *In einem Jahr mit 13 Monden* (In a Year of 13 Moons, 1978) (Cooke 2004; Fisher and Prager 2010: 16–28). Similarly, Tykwer's cinephilia, along with his project to marry high art with popular genre film have been read as an echo of Fassbinder's sensibility (Garwood 2002; Schlipphacke 2006). More broadly, his production company *X-Filme* is seen to recall the creation of the *Filmverlag der Autoren* by members of the New German Cinema in the 1970s (Jekubzik 2005; Clarke 2006: 4–5). Finally, the Berlin School, and filmmakers such as Schanelec and Hochhäusler as well as the group's best-known member Christian Petzold (*Die innere Sicherheit*/The State I Am In, 2000; *Jerichow*, 2008), constitute in Marco Abel's words 'the first significant (collective) attempt at advancing the aesthetics of cinema within German narrative filmmaking since the New German Cinema' (Abel 2008a).

If we return to *Deutschland 09*, however, despite Tykwer's self-avowed positioning of the film as a reworking of *Deutschland im Herbst*, for many critics any comparison with the New German Cinema simply highlighted the film's failures. Far from recalling the complex critique of the earlier film, 'Grandpa's cinema is back', declares Christian Buß in *Der Spiegel*. 'It is a conservative film, of a particularly bitter kind, in that the Left has become conservative' (Buß 2009). If it evokes the position of the 68er generation, Buß suggests it would appear to be the position of those who have now themselves grown up and lost their anger towards their parents – the grandparents of this present generation. Thus, Buß implies, we see here a return to the film mores of the 1950s. Indeed, similarities

between *Deutschland 09* and *Deutschland im Herbst* would largely appear to lie in the continued ability of the German subsidy system to produce films that no one wants to see: 'Cheers to the German film subsidy system!' wrote the *Tagesspiegel* in its ironic riposte to the film 'Why our country is so great' (*Tagesspiegel* 2009).[8] Yet whether or not the film echoes the thematic or aesthetic concerns of *Deutschland im Herbst*, it is clear that its makers continue to draw inspiration from this period, the film reflecting a broader nostalgia for what in retrospect can be seen as the certainties of West Germany's pre-unification place in the world, manifest, moreover, in numerous popular forms of nostalgia culture discussed in detail later in this study.

The broader invocation of the New German Cinema by cultural commentators makes it clear that filmmakers are not alone in their nostalgic reference to this moment in cinema history. As I shall explore further in Chapter 1, this comparison highlights an important fault line in many contemporary media debates about the function and shape of the film industry in Germany. The New German Cinema similarly remains an important reference point within German film studies as an academic discipline. As William Rasch argues, speaking of the cultural and political legacy of Fassbinder's generation more broadly in his examination of post-war cinema, 'We are all "68ers" or their heirs', a view which has fundamentally shaped approaches to German film culture (Rasch 2008: 4). As we have seen, this has often led commentators to explore (or lament) what they consider to be the failure of today's filmmakers to match up to the New German Cinema's standards of either aesthetic experimentation or political engagement. This trend is particularly prevalent in a number of recent volumes on contemporary German cinema. Jaimey Fisher and Brad Prager's *The Collapse of the Conventional: German Film and its Politics at the Turn of the Twenty-first Century* (2010), for example, offers a highly illuminating investigation of the 'new Fassbinder' phenomenon. Here the authors celebrate the continuing place of Fassbinder as a reference point for contemporary filmmaking practice, expressing their nostalgic appreciation for his political role as the nation's 'guilty conscience' (Fisher and Prager 2010: 17). Similarly, Randalle Halle's study of transnational film production ends with a call for a reinvigoration of the type of 'politically engaged film' we find in the 1970s, but that can also utilise the possibilities of 'two-way

democratic communication' offered by the media in the digital age (Halle 2008: 192). As will be clear from the chapters that follow, I too am a fan of the New German Cinema and am attracted to contemporary films that engage in dialogue with this period, its aesthetics and its politics. In this sense, my study builds on existing Anglo-American scholarship. However, while I explore the agenda set by the New German Cinema, I also look to investigate contemporary cinema on its own terms, exploring less what it fails to do than what it, itself, sets out to achieve.

Throughout this volume I attempt to marry a text-based approach to the study of key films, such as one finds in much of the work already discussed, with an industry-based focus, an approach that is particularly prevalent within German film studies in the German-speaking world (Iljine and Keil 2000; Keil *et al.* 2006; Castendyk 2008; Hennig-Thurau and Henning 2009). I also draw on recent work that has begun to examine popular genre cinema in Germany (Rentschler 1996; Koepnick 2002b; Halle and McCarthy 2003; Bergfelder 2005; von Moltke 2005). This is an aspect of production that had tended to be ignored in a scholarly tradition often focused on a select canon of films from the Weimar period and from the 1960s and 1970s. My close readings are then further contextualised within broader trends in aesthetic approaches and thematic choices made by contemporary filmmakers. Given the diversity and volume of film production – the country currently produces over 200 films a year – I focus on feature films, only mentioning documentaries when they shed further light on a given feature film or trend under discussion. Moreover, as my title suggests, I also only examine films that have had a theatrical release and so do not examine the diverse range of television film production, or work produced primarily for other media (DVD, internet streaming etc.) That said, other media will, of course, be mentioned. As I shall also discuss, it is impossible to ignore the role of television completely in the country's visual culture given its importance to the funding of feature film production, or the internet given its role within the broader consumption context of films playing in cinemas. The reasons for my focus are, on the one hand, pragmatic, allowing me to keep the corpus of films under investigation to a manageable size. On the other, it is these films that gain the most widespread international distribution. Consequently, these are the films with which readers of this book are

most likely to be familiar. Nonetheless, I do not wish to look at
those films that have had an international release in a vacuum.
Instead, I attempt to balance close readings of work that will be
familiar to readers with a broader discussion of domestic films that
have not necessarily been shown outside of the German-speaking
world. Given the constraints of space, there are many films which
I could have included that I do not. These gaps are, however, more
than compensated for by other colleagues working in the field of
contemporary German film.[9] In spite of its limitations, I hope that
the reader of this book will gain a sense of the breadth and variety
of German feature film production in the 2000s.

In Chapter 1 I examine the industrial context of film production
during the decade, outlining the ways in which the film subsidy
structure reflects both continuities and ruptures with the industry
that brought international success to the New German Cinema,
along with the shift towards transnational funding patterns. I
discuss some of the limits of what might be defined as 'German'
cinema, looking at the relationship between German financing and
recent Hollywood blockbusters, as well as contemporary debates
on the value of German cinema either as a high-prestige cultural
product or as an important commercial enterprise dedicated to
mass entertainment. Chapter 2 explores the changing nature of
cinematic 'realism', investigating the ways in which filmmakers
self-consciously challenge the representational possibilities of the
medium itself. This compares the documentary-style realism of
the ex-GDR filmmaker Andreas Dresen – an artist who offers one
of the few points of connection between contemporary film and
the legacy of the East German DEFA tradition – with the aesthetic
experimentation of the Berlin School and the invocation by a
number of filmmakers connected with this grouping of Deleuze's
'time-image' along with a Bazinian conception of realism. Chapter
3 shifts the focus from realism to questions of 'authenticity' in my
examination of the heritage film and its frequent fetishisation of
'the authentic' in the presentation of German history. Looking at
the type of work produced by the recently deceased Bernd Eich-
inger – one of Germany's most successful producers commercially
– along with a detailed discussion of Henckel von Donnersmarck's
Das Leben der Anderen, I examine readings of such movies that
often see them as a worrying form of historical revisionism, a prob-
lematic continuation of the 'consensual' 'normalisation' process

already mentioned in connection with the New German Comedy of the 1990s. This is a process that has been actively sought by successive governments since unification as they seek to show that the nation has learnt the lessons of history and so now can move beyond its past. Elsewhere in this study, I shall examine potentially revisionist aspects of these tendencies in detail. In Chapter 3, however, I investigate the extent to which filmmakers use the aesthetics of the heritage film to exploit the affective nature of cinema in order to engage the contemporary spectator in a way that perhaps marks a necessary shift in the debate on how the nation should approach its problematic past. Chapter 4 continues my discussion of the heritage film, here within the context of transnational filmmaking. I discuss the ways in which such films often work in concert with the representation of Germany as a multicultural, multiethnic society. This is a discussion which highlights the continuing importance of the national context within debates on transnational filmmaking practice, a dynamic I examine across a range of filmmakers from Hans-Christian Schmid to Fatih Akın. In Chapter 5 my focus is on the legacy of efforts made by filmmakers in the 1970s both to reflect women's experience in society and to bring more women into the production process. The heritage film again plays a role, given the number that explore the past from a female point of view, often telling stories that have ostensibly long be seen as taboo or forgotten within the historical record. Equally, questions of transnationalism remain important. This we see, for example, in Angelina Maccarone's *Fremde Haut* (Unveiled, 2005) and its investigation of female sexuality, or in Doris Dörrie's *Kirschblüten – Hanami* (Cherry Blossoms, 2008) and its examination of ageing. As I shall also discuss, the question of ageing is becoming an increasingly important topic for contemporary culture as a whole, as life expectancy increases and society becomes ever more elderly. In Chapter 6 the discussion moves from the representation of ageing on the screen, to the movies made by an older generation of filmmakers, looking specifically at how the New German Cinema *enfants terribles* of the 1960s and 1970s, such as Wenders and Herzog, now approach their craft. Here we see a continuation of their long-held love-hate fascination with US film culture. This I examine as part of a transnational cultural encounter that long predates contemporary developments. This exploration of US culture is then set against younger filmmakers' at times easier

relationship with the United States, a shift in sensibilities that I relate, once again, to questions of German 'normalisation'. Finally, I turn to contemporary mutations of that resolutely national German genre the Heimat film. I investigate the ways that contemporary filmmakers do indeed often appear to be recuperating the mores of the 1950s – an attack levelled at the makers of *Deutschland 09* by the German press. At the same time, we also see filmmakers seeming to internalise elements of the New German Cinema's critique of 'Papas Kino', updated to take account of the changing constellation of the nation post-unification and the challenges of globalisation. Moreover, I examine the ways in which transnationalism also shapes contemporary approaches to the Heimat film, discussing the continuing pull of a specifically German understanding of national film culture, even as the very notion of national cinema, and along with it a straightforward understanding of German national identity, might indeed seem to be becoming as 'disparate' – to return to Tykwer's comments – as it is 'normal'.

Notes

1 For further discussion see Nagib 2009: xiv.
2 Throughout this study I adopt the convention of using West Germany and East Germany as synonyms for the pre-unification FRG and GDR respectively, and west Germany and east Germany to refer to the post-1990 regions within the present German state.
3 Indeed, the notion that the Oberhausen Manifesto marked a radical break with the films that went before had already been challenged in Thomas Elsaesser's seminal study, which highlights the ways in which it is a document that 'belongs at least as much to the 1950s as it does to the 1970s' (Elsaesser 1989: 2).
4 For further discussion see Coury 1997 and Halle 2000.
5 *Good Bye, Lenin!* and *Der Untergang* grossed $79 and $92 million worldwide respectively during their theatrical release. See *Box Office Mojo*, http://boxofficemojo.com/movies/?id=goodbyelenin. htm; http://boxofficemojo.com/movies/?id=downfall.htm.
6 Germany won the Oscar for Best Foreign Language Film in 2001 with Caroline Link's wartime drama *Nirgendwo in Afrika* and in 2006 with Florian Henckel von Donnersmarck's East German Secret Police thriller *Das Leben der Andreren*. A further four films have been nominated in this category since unification, including

Michael Haneke's *Das weiße Band – Eine deutsche Kinderge-schichte* (The White Band, 2009). Both Wim Wenders' *Buena Vista Social Club* (1999) and Byambasuren Davaa and Luigi Falorni's *Die Geschichte vom weinenden Kamel* (The Story of the Weeping Camel, 2003) received nominations for Best Documentary. Three German Short Films have won awards, including Jochen Alexander Freydank's Holocaust drama *Spielzeugland* (Toyland, 2007) and between 1998 and 2009 seven out of the twelve 'Student Oscars' were won by German productions.

7 See also Forrest and Scheer 2010.

8 Ironically, it might be noted that *Deutschland im Herbst* was one of the few films of the time that did not, in fact, need public subsidy to cover its production costs since most of those involved agreed to waive their fees.

9 To the volumes mentioned in this introduction can be added important editions of major German studies journals looking at aspects of German film since unification, including *Seminar: A Journal of Germanic Studies* 33/4 (1997), *New German Critique* (87) 2002 and *New Cinemas* 7/1 (2009). To these can be added Paul Cooke and Chris Homewood (eds), *New Directions in German Cinema* (2012), and Gabriele Mueller and James Skidmore (eds), *Cinema and Social Change in Germany and Austria* (2011), along with Nick Hodgin's study of east German film since 1989, *Screening the East: Heimat, Memory and Nostalgia in German Film since 1989* (2011).

1 Financing cinema in Germany: art, entertainment or commerce?

German film is enjoying enormous levels of success, be that defined in terms of financial returns, popularity with audiences at home and abroad or critical acclaim. On the one hand, the 2000s saw German productions become regular guests at all the major international film festivals, from Sundance to Tokyo, winning awards across the globe. As such, and as reviewers are keen to point out, the industry appears once again to be reaching the aesthetic heights that brought it the international praise of critics from the late 1960s to the early 1980s. On the other, domestic productions are becoming more popular and, as a result, more commercially viable. 2009, for example, built on the success of the previous year to see domestic films sell 33.9 million tickets in Germany, a market share of 27.4%, the highest the industry had enjoyed since 1991 (FFA 2009). Moreover, the number of domestic productions is increasing exponentially, from 50 in 1997 to 220 in 2009 (Spitzenorganisation der Filmwirtschaft e. V. 2009: 24). Little wonder, then, that Bernd Neumann, the Federal Minister for Culture, is optimistic about the industry's future, declaring the German film economy in 2009 finally to be 'on the right course' (Neumann 2009). It is the shape of this economy and its impact on the types of films being produced that is to be the focus of this chapter.

Given the industry's current state, it is perhaps surprising to see that there are few insiders who share Neumann's optimism. Indeed, for some, the industry is in a profound state of crisis. While the market share of German films is up, this is within the context of a general decline in cinema ticket sales, which in 2005 dropped suddenly by 29 million, a reduction of 18.8% on the previous year that brought with it a loss in revenue of €147 million

(Graton 2006: 77). 2009 did see something of a recovery, with an increase in sales of 16% (FFA 2009), a recovery largely due to the phenomenal success of James Cameron's *Avatar* (2009) and other 3D movies that reinvigorated demand amongst spectators (Schroth 2010). However, this still did not bring about a return to 2004 levels, which were themselves down 21 million on sales at the start of the decade (FFA 2001). Nor could this recovery prevent an increase in cinema closures, the number of theatres across the country continuing to drop from a high of 4,870 in 2004 (FFA 2004) to 4,734 in 2009 (FFA 2009), with no sign of the trend changing. At the same time, DVD and Blu-ray sales, which in many cases now generate far more income than a film's theatrical release, have stagnated. This is due largely, industry experts generally argue, to the growing problem of piracy, and specifically the illegal downloading of films from the internet. The annual 'Available for Download' Study, carried out by the *RESPE©T COPYRIGHTS* campaign, suggested that in 2009 29% of films were available for free on the internet before they appeared in German theatres, a number that increased to 40% within a day of their premiere. This included all of the most popular films. The study found that the top ten films were downloaded over 8 million times within the first month of release on the *BitTorrent* file-sharing network alone, a state of affairs that is estimated to cost the German industry up to €800 million annually in lost revenues (RESPE©T COPYRIGHTS 2009).[1] Moreover, while German films might have increased their market share, this is still a long way from the 35% average market share for domestic productions worldwide and far below the 47% that French films or the 60% that Korean films enjoy at home (*Blickpunkt: Film* 2009d: 18). 27.4% is still not enough to make the industry in any way self-sufficient. More worrying, for some, is the number of films required to achieve even this level of success. Rather than welcoming the increase in levels of production, for many in the industry this is simply forcing resources to be spread too thinly (Castendyk 2008: 101). While it took 220 German films to capture 27.4% of the market in 2009, 154 US productions took 66%. 'We have to ask the question, how many films can the German cinema landscape support', claims Thomas Negele, head of the *Hauptverband Deutscher Filmtheater* (Association of German Film Theatres). Producing a large number of films on tiny budgets is, he suggests, undermining the industry's 'Kinotauglichkeit' (fitness for cinema) – a key buzzword

in contemporary debates (Negele 2009: 20). The Berlin School filmmaker Christian Petzold puts the situation in blunter terms: 'We just don't have a proper film economy. Instead we have a television and subsidy economy.' Petzold quickly goes on to clarify his position, stating that 'there's nothing wrong with subsidies'. However, the present landscape is doing little, he argues, to help the development of cinema as an art form (Petzold 2009: 30), and, as I shall discuss below, Petzold is not alone in his criticism of both the nature of the subsidy system and, in particular, the influence of television on production.

Art versus commerce – a false dichotomy?

At the heart of the crisis outlined above lies a debate which was central to the development of the New German Cinema and which returns us to the opening of this chapter and the question of precisely how the industry defines 'success', a question that forces us to look at the tension between the two definitions encapsulated in the views of Negele and Petzold respectively. Should success be judged in terms of commercial sustainability, as Negele implies, and the ability of German films to attract audiences? Or should it be defined according to aesthetic criteria? The debate between film as 'art' and film as 'commerce' is, of course, practically as old as the medium itself. In the 1960s it was central to the Oberhausen Manifesto and its wish to see cinema freed from the shackles of the commercial industry in order to realise its aesthetic potential as an art form, the impact of which forced the government to rethink completely its approach to supporting German film.

The Oberhausen Manifesto led in 1965 to the foundation of the *Kuratorium junger deutscher Film* (Board of Young German Film) which initially supported films that enjoyed some notable critical success, not least Alexander Kluge's debut feature film *Abschied von Gestern* (Yesterday's Girl, 1966), a film that gained international acclaim, winning a Silver Lion at the Venice Film Festival. *Kuratorium* support allowed first-time directors such as Kluge, Hans Jürgen Pohland and Haro Senft a huge amount of aesthetic freedom to experiment with the representational possibilities of film. It was, however, quickly challenged by members of the mainstream commercial industry who saw it as unfair competition at a time when cinema audiences, then as now, were in decline,

at that point due to the increasing importance of television within the German media landscape. In response to lobbies by the mainstream industry the government passed the *Filmförderungsgesetz* (Film Subsidy Act, FFG) which founded the German *Filmförderunsganstalt* (Federal Film Board, FFA) in 1967 to support popular film by a levy on cinema tickets sold, operating according to a system of 'reference funding' contingent upon the previous success of the producer applying for funds. The *Filmförderungsgesetz* was, however, in turn itself challenged by the *Oberhauseners*, as *Kuratorium* funding began to dry up. While some of the films the *Kuratorium* supported achieved critical success, they invariably failed to generate any revenue that could flow back to the board to replenish this funding pot. At the same time, the likes of Kluge and Senft became ineligible for further support, either from the *Kuratorium*, which only funded the work of new filmmakers, or from the FFA since their films never met the bar of commercial success required to trigger subsequent reference funding. Thus, the *Oberhauseners* themselves began to lobby once again, now for changes to the FFG that would allow for 'project funding' not based on previous success (Elsaesser 1989: 8–35; Knight 2004: 19–27), their case being helped by the fact that they were not alone in calling for reform, since many felt that the FFG was not fit for purpose. The levy on the exhibition sector was putting further pressure on cinemas, forcing many out of business, while saturating the market with low grade 'B movies' that mutated from exotic adventure films in the 1960s, such as the Jerry Cotton and Fu Manchu series, into a wave of soft-core pornographic films in the 1970s, a long-running example being the *Schulmädchen Report* (School-Girl Report), a pseudo-documentary series of 13 films produced between 1970 and 1978, ostensibly revealing the sexual desires of German teenage girls (Bergfelder 2005: 207–36). During the first two renewals of the FFG in 1971 and 1974, the law was reformed to allow limited 'project funding' and to include a 'quality' clause that would disqualify the 'B movie' end of the market from funding, in order to open up opportunities to filmmakers who had achieved success in critical and cultural rather than in purely economic terms. During the 1970s other funding streams also began to develop. The *Kuratorium's* financial basis was stabilised, its money now coming from the various *Länder* (states) paying into the Federal pot. The *Länder* also began to set up their own regional film boards intent

upon attracting filmmakers to their part of Germany in an attempt
to stimulate the local economy. Finally, and particularly impor-
tantly, the public television networks began to fund production.
This was, as Elsaesser suggests, a major moment in 'reconciling
(by eliminating) the contradiction between commerce and culture'
(Elsaesser 1989: 32), and as the Young German Cinema devel-
oped into the often more audience-friendly New German Cinema,
television offered both financial support and a reliable exhibition
medium for the likes of Fassbinder and Wenders who still failed
to achieve box-office success at home while their international
reputation grew.

As we shall see in the rest of this chapter, the final resolution
of the culture/art versus commerce dichotomy seemingly offered
by the intervention of television was, however, short-lived. None-
theless, the resolution of this dichotomy remains an avowed aim
for much of the industry. Yet before looking specifically at the
issue of funding and the ways in which this has changed over
time, it is interesting to see that the broad parameters of the
debate have remained constant. Klaus Kreimeier points out that
the Oberhausen Manifesto was part of a tradition of manifesto
writing in post-war West German filmmaking (Kreimeier 1973:
78), a tradition that continued to inform debate in the decades to
follow (Elsaesser 1999). Most recently the 'Ludwigshafener Posi-
tion', published during the 2005 Ludwigshafener Festival of Film,
firmly concurred with Oberhausen: 'German film will be art or it
will not exist' its signatories declared (Albrecht *et al.* 2005), among
them the actress Hanna Schygulla and filmmaker Peter Lilienthal,
key figures within the New German Cinema, as well as a number
of artists who had received their training from this generation.
For Schygulla, Lilienthal and others, film must continue to be free
to exist on its own terms in order to maintain a critical debate
with its audience, forcing the spectator to think. This is a position
that resonates strongly with many contemporary commentators
on German film, who lament what they view as the continued
domination of a 'cinema of consensus', identified by Rentschler
in 1990s production (Rentschler 2000), with its tendency towards
filmmaking that is both politically and aesthetically conservative.
This is a tendency that some find particularly hard to take when
it comes to the small number of so-called 'prestige projects' the
industry generates, most notably the recent wave of heritage films

7 Markus (Andreas Müller) builds up the courage to commit suicide as his life unravels, *Sehnsucht* (2006).

that have had such resonance with audiences abroad, such as Caroline Link's *Nirgendwo in Afrika* (Nowhere in Africa, 2001) or Sönke Wortmann's *Das Wunder von Bern* (The Miracle of Bern, 2003), films described disparagingly by Georg Seeßlen as evidence of a new 'Supergenre of the Heimat-historical-family-feel-good movie', reminiscent of 1950s 'Papas Kino' (Seeßlen 2008: 27).

Countering the position of such critics are those who emphasise what they view as the rights of the spectator to watch films they enjoy. Here the 'commerce versus art' dichotomy is reconfigured as one of art versus entertainment. Günter Rohrbach, President of the German Film Academy, for example, writing in *Der Spiegel* condemned the critical elite of the German cultural press such as Seeßlen, who, he argued, long nostalgically for the avant-garde complexity of the New German Cinema, as 'autistic' and out of touch with the cinema-going public. He compared the relative popular success of a blockbuster film like Tykwer's *Perfume: The Story of a Murderer* (2006) – which was almost universally condemned by German critics – with the failure of Valeska Grisebach's low budget film *Sehnsucht* (Longing, 2006) to attract German audiences despite the critical praise lavished upon it. He questions the pejorative, patronising implications of the term 'consensus film'. Instead, he celebrates the rediscovery of mainstream domestic film production

by German audiences, challenging the very purpose of those critics who seem to approach explicitly commercial film with a preconceived resentment, unable to see any potential artistic merit in such films (Rohrbach 2007). Florian Henckel von Donnersmarck, the director of the Oscar-winning *Das Leben der Anderen* (The Lives of Others, 2006) was particularly vehement in his condemnation of those who attacked his film – a melodrama about the GDR's secret police – as 'consensual', redefining the term positively:

> Those who repeat this verdict presumably want Germany to be lumbered with the kind of mediocrity that has induced so many 'consensus people', from Wilhelm Weiller to Wolfgang Petersen, to flee the country! If 'consensus film' is supposed to mean the same as 'trivial' or even 'bad film', then I want to make a lot more bad and trivial films in my career. What would those critics say of films like *Casablanca* or *Godfather Part II*? They must be the worst films of all time, for absolutely everyone thinks that they are good, and not – as in my case – almost everyone. I wish that *The Lives of Others* was much more of a consensus film! (Rupprecht 2006)

For Henckel von Donnersmarck, it is perfectly possible to be both 'consensual', in the sense of being popular with audiences and aesthetically mainstream, and still have artistic credibility. However, for others, particularly notably the well-known Austrian filmmaker Michael Haneke, it is precisely this double aim which is undermining the industry. He laments the growth of the 'cross-eyed film', the product of a culture forced to have an eye on both commercial and aesthetic success, but frequently failing in the process to achieve either (quoted in Gansera 2009: 32). Of course, while one can define commercial success in terms of relative grosses, there is far less consensus on what one means by aesthetic success. A film that is seen as a mainstream piece domestically might well be marketed abroad as a niche 'art house' product, perhaps only due to the fact that it has subtitles. Contemporary mainstream cinema often itself adopts tropes that were previously confined to the avant-garde – one thinks, for example, of the cinema of Christopher Nolan (*Memento*, 2000; *Inception*, 2010), or, indeed Tykwer, to be discussed in more detail in Chapter 5. Returning to Henckel von Donnersmarck for a moment, while the American Academy of Motion Picture Arts and Sciences found the

film to be of artistic worth, this was clearly not a view shared by a number of German cultural commentators. Nonetheless, as I shall now explore in more detail, it is precisely this search to square this apparent circle, to be both artistically worthy – however this is defined – and commercially viable, that drives debate around the funding of German film.

The film subsidy system today

By the time Angela Merkel came to power in 2005, the number of people permanently employed by the film industry stood at over 37,500 and was on the rise; this at a time when the rest of the economy was in a slump (Rahayel 2006). No wonder, then, that the state of the industry was on the political radar, a place it had not been for some time. As the SPD politician Thomas Krüger noted the year before, Federal cultural policy had not had much to do with the film industry for many years (Krüger 2005). Merkel changed this, making a high-profile visit to the 2006 Berlin Film Festival, and declaring the improvement of 'the basic conditions for the German film economy, in order to ensure its ability to compete internationally' a key aspiration of the 'Grand Coalition' she led (CDU, CSU and SPD 2005: 72). Central to my discussion in this chapter is the way the Merkel government since 2005 has envisaged this improvement coming about, which, it declared in its original coalition agreement, would be through the mobilisation of private investment capital (CDU, CSU and SPD 2005: 72). This is very different from the days of the New German Cinema when Federal and regional funding bodies and public broadcasters were particularly concerned to support the work of individual artists to make their often esoteric films with limited commercial appeal.

As many commentators have noted, this is a development that has, in fact, been in train for some time. It can be seen particularly clearly in the shift away from the *Autorenkino* of the New German Cinema to a model more in step with Hollywood. Here we find a greater emphasis put on film development as a team project, especially on the role of the producer and a project's commercial viability, a model that is generally aimed at the production of mainstream genre cinema with mass appeal. As I shall argue, however, this does not mean, as some of the commentators cited above tend to suggest, that the German film economy has lost

sight of any artistic aspirations. Indeed, a strong industry, focused to whatever degree it might be on popular entertainment film-making, can, of course, also be of benefit to those filmmakers looking to produce more aesthetically challenging films with limited appeal. Moreover, as Oliver Castendyk notes, the processes of artistic creation cannot be defined solely or straightforwardly in terms of the funding provided by the state (Castendyk 2008: 1). If we explore the system of support in detail, a more complex, and indeed contradictory, picture emerges of the interrelation between art, entertainment and commerce. Film production remains heavily reliant on an array of regional, national and, increasingly, transnational public funding. Within this system there is often a concerted effort to drive a shift towards commercialism and an acknowledgement of the market. Applications are invariably only accepted from commercially minded production companies, rather than the individuals who would have received support during the heyday of *Autorenkino*. Nonetheless, many of the funding bodies still remain committed on some level to the development of film as 'art'. It is still accepted that they will often never see a substantial return on their investment. Indeed, and on the face of it seeming to contradict the shift towards commercialism, we are presently seeing the re-emergence of an *Autorenkino*, reminiscent of the New German Cinema, suggesting an increasingly diverse picture of domestic film production.

Germany is very well supported in terms of public funding compared to most other European nations. In 2007 German institutions funded the film industry to the tune of around €290 million (Castendyk 2008: 66), a level of funding that, in recent decades, has only ever been topped by France (Storm 2000; Gaitanides 2001; Rahayel 2006), and in fact, if one looks purely at the funding available to cinema production, this is always far in excess of France (Castendyk 2008: 129). How then does the present system work? One of the main differences between the contemporary funding landscape and that of the 1970s is, as Randall Halle has described in detail, the transnational turn within production and distribution globally, evidenced most obviously within the German context in the utilisation of European subsidy schemes by the national industry (Halle 2008: 30–59). On the European level there are two main funds available to German production companies, both of which have helped to consolidate a growing culture of transnational

co-production across the region: the European Union's 'Measures to Encourage the Development of the European Audiovisual Industry' (MEDIA) and the Council of Europe's 'Eurimages'. The MEDIA scheme, set up in 1990, has gone through various incarnations with slight changes in focus. However, its basic remit has remained the same: to 'strength[en] the competitiveness of the European audiovisual sector' as a global player in the face of Hollywood domination, supporting film production and distribution beyond its country of origin. In its current incarnation, the MEDIA 2007 scheme is particularly concerned both to capitalise on the potential of digital technology for the European industry and to 'contribut[e] to the spread of a business culture for the sector and facilitate[e] private investment' with the aim 'to preserve and enhance European cultural diversity and its cinematographic and audiovisual heritage', thereby enshrining both a commitment to film as commerce and film as culture within its foundational parameters (MEDIA 2007). That said, its main focus in practice has been the development of the commercial industry (Miller *et al.* 2005: 187). The biggest criticism of MEDIA over the years has been the level of funding available, suggesting to many that the European Commission, for all its warm words, has not really been serious about building up a European film industry (Jäckel 2003: 76; MEDIA 2007). In its present form, MEDIA 2007, which replaced MEDIA PLUS that ran from 2001–6, the budget was increased from €454 to €755 million. However, this has to cover a now greatly expanded EU and also, along with the development and distribution work of the previous scheme, has to accommodate the remit of the MEDIA Training programme which was previously funded separately.

Of more significance historically to the aesthetic development of European film, as Anna Jäckel notes, has been the Council of Europe's co-production, distribution and exhibition fund 'Eurimages' (Jäckel 2003: 76). This is a voluntary scheme set up in 1989 to support the film industries of those countries that have joined. These include a number of EU states such as Germany and France (but not the UK) as well as Turkey, Cyprus and Macedonia. Through Eurimages German production companies are actively encouraged to think transnationally since, to apply for funding, a production must involve at least two participating member states. Germany has made great use of this fund. In 2009 Eurimages invested

8 Rokko (Florian Lukas) enjoys a moment of transnational harmony in
Istanbul watching the Champions League final, *One Day in Europe*
(2005).

€195 million in 55 productions, of which 26 involved a German
production company (Eurimages 2009). At the heart of the Eurim-
ages project is the wish to foster a common (if necessarily loosely
defined) European cultural identity. It is not surprising, then, that
it has supported films which engage with the question of what is
meant by Europe, something that has given rise to a number of
very interesting German-driven projects in recent years. Here we
might mention several omnibus films, one of the most innovative
being the '99 Euro films' project. The second of these, for example,
Europe (2003), brings together nine European directors (including
Harry Kümel, Richard Stanely and Benjamin Quabeck) to present a
series of shorts (none of which cost more than €99 to make) which
join together to offer a morbid vision of the new Europe consumed
by the ghosts of its past. Other notable examples that have come
out of Germany recently include Stanislaw Mucha's meditation on
Europe's spiritual, cultural and geographical centre as the conti-
nent expands eastward, *Die Mitte* (The Middle, 2004), or Hannes
Stöhr's *One Day in Europe* (2005), which relates the experiences
of four European travellers on the day of the Champion's League
football final in a manner strongly reminiscent of Jim Jarmusch's
Night On Earth (1991).

Both MEDIA and Eurimages have had a good deal of inter-
national critical success over the years with the films they have
supported. In 2009, for example, Michael Haneke's *Das weiße Band
– Eine deutsche Kindergeschichte* (The White Ribbon), funded by

both MEDIA and Eurimages, won awards at the European Film Awards, Cannes and the Golden Globes and was nominated for the 'Best Foreign Language Film' Oscar. That said, the schemes have also received a good deal of criticism, accused of helping the development of the much maligned 'europudding', or films in which national specificity gives way to an insipidly transnational, and artificial, sense of Europeanness. In this regard Halle cites the example of *La Putain du Roi* (The King's Whore, Axel Corti, 1990), an Austrian-French-Italian-British co-production which was entered at Cannes as the first film designated as 'European':

> 'Europudding' arose as a term to denounce such productions whose good intentions so often yielded such bland results. Even if the films aspired to an art film status, they appealed to the lowest common denominator of cultured interest with little hope for broad social or political resonance. (Halle 2002: 33)

About a third of German productions are European co-productions, for which the MEDIA and Eurimages schemes have been particularly important, helping to put together budgets that can at least go some way towards allowing European film-makers to make the type of large scale 'spectaculars' that has helped Hollywood dominate international markets for decades. Jo Baier's epic *Henri IV* (2010), a German-French-Austrian-Czech Republic-Spanish co-production partly funded by MEDIA 2007, is a recent good example of such filmmaking, costing over €20 million. Although this is still a relatively small budget by Holly-wood standards, it is clearly a film with international aspirations, since these are costs that could never be amortised in any of the individual domestic markets involved in its production – the vast majority of films produced in Germany, for example, have budgets under €5 million (Castendyk 2008: 114). *Henri IV* was to show the world the large-scale potential of European film. It was, however, universally panned as a europudding, an example of what Daniel Brühl, who has played roles in films across the region, defines as 'synthetic' cinema that tries to create an artificial sense of a joint European project (quoted in Beier 2010). This does not, of course, mean that European co-productions necessarily have to resort to such homogeneity. Lars-Olav Beier, for example, points to Lars von Trier's *Antichrist* (2010) – a film that had more than 20 production partners from six European countries – as an example of what

can be achieved through transnational European cooperation. However, this is a film which, like Haneke's *Das weiße Band*, maintains its aesthetic individuality within a broader European context. Haneke's film, moreover, also points to the type of geographical individuality, the 'small, regional, authentic stories', that his producer, Stefan Arndt, claims spectators also often want in a European film, wherever they live (Beier 2010). This is a tendency, we shall see later in this chapter, that *X-Filme*, the company Arndt helped to co-found, defines as its hallmark.

On a national level, there are three main funding bodies for German productions. The *Beauftragte der Bundesregierung für Kultur und Medien* (Office of the Federal Commissioner for Culture and the Media, BKM) has a particular remit for supporting films of high artistic value. It part funds a variety of individual projects deemed to be of 'cultural worth' and administers a number of Federal prizes – most importantly, in terms of finance and prestige, the Federal Film Prize. Its total budget is around €30 million and the money it allocates to individual projects is only a very small portion of this – €1.7 million in 2009 (BKM 2009). However, many of the films it has supported do not require large budgets and so the fund does make a meaningful contribution to the development of films that are not first and foremost commercial projects, some of which have enjoyed a good degree of critical success, including work by Fatih Akın (*Auf der anderen Seite*/Edge of Heaven, 2007) and Maren Ade (*Alle Anderen*/Everyone Else, 2009). Second, the *Kuratorium* continues to fund the work of new filmmakers as well as children's films – both of which, like the BKM, focus on film as an artistic product rather than an economic commodity. Since 2005 the BKM and *Kuratorium* have begun to work together more closely, particularly with regard to children's films, the *Kuratorium* focusing on project development, the BKM on production. This might be signalling a gradual reduction in the importance of the *Kuratorium*, something that is also reflected in its budget. In 2009 it distributed only €700,000 (*Kuratorium* 2010: 2). Nonetheless, along with numerous very successful children's films, the *Kuratorium* continues to support low-budget projects that often have a major cultural impact. In recent years, for example, it helped to reignite interest in a new style of German Heimat film (to be discussed in Chapter 7), supporting Marcus H. Rosenmüller's black comedy *Wer früher stirbt ist länger tot* (Grave Decisions,

9 Gitti (Birgit Minichmayr) tries her hand at childcare, teaching her young charge (Paula Hartmann) to express her emotions honestly, *Alle Anderen* (2009).

2006), as well as Sung Hyung Cho's light-hearted Heimat-style documentary about the impact of an annual Heavy Metal festival held in the rural German village of Wacken in Schleswig-Holstein (*Full Metal Village*, 2007).

Finally, and most significantly, there is the FFA. This has a remit to ensure the quality of German language films but also to support and improve the structure of the German film economy, to market domestic production and to foster links between film and television (Gaitanides 2001: 103; Dress 2002: 170–7). From its inception, the FFA has been supported by a levy on cinema tickets and latterly the video, DVD and Blu-ray market, along with contributions from the public and private television networks. As we have already seen, the rules by which the FFA operates have always been much debated in the industry. Although initially set up to promote the commercial viability of film, it has over time also tried to negotiate its way between the poles of commerce and art. In its newest constellation the FFG, which controls its administration, has seen further shifts towards a concept of film as art with the extension of the 'quality' criteria within the reference funding system, putting a greater emphasis on winning or being nominated for festival prizes. Moreover, the commission that allocates funding now includes far more people from the 'cultural' side of the industry,

such as filmmakers and writers, with the aim of ensuring the aesthetic quality of the projects that are funded (Castendyk, 2008: 45). At the same time, the future of the FFA, along with its position as the core of the Federal subsidy system, is looking increasingly precarious. In the wake of the 2004 renewal of the FFG, the organisation was forced to fight a lengthy court battle with the Cinema Owners Trade Association who argued that the levy on them and the home-entertainment industry was unconstitutional since there was no compulsory levy on television – the contribution paid by the public and now also private television networks had always been by mutual agreement rather than by law. This claim was upheld by the Federal Court and the FFG was amended to make the television levy similarly legally binding. In so doing, the FFA's funding basis was saved, but for how long remains to be seen, since it is clear that the industry as a whole is becoming increasingly dissatisfied with this system of support. Complaints come from the distribution and exhibition sector, which continues to criticise the size of the levy it is forced to pay, as well as from those producers who feel that the FFA's resources are being spread too widely through the current reference system, or those filmmakers who feel that these same resources are not being spread widely enough, the popularity bar that triggers reference funding continuing, in the view of some, to be set too high and thus excluding too many interesting artists from being supported (Castendyk 2008: 12–14; *Blickpunkt: Film* 2010).

The FFA's total budget is currently €76 million (FFA 2010c) and accounts for approximately a quarter of the money available to filmmakers. Of far more significance financially are a range of regional schemes operated by the *Länder* which provide up to 70% of the public funding available. Indeed, in some cases the *Länder* have become more important European film funders than certain national governments, thus themselves acting as an impetus for transnational cooperation by attracting major international productions to facilities in their part of Germany. Examples in the 2000s include Gurinder Chadha's *Bend it like Beckham* (2002), which was partially supported by *Filmförderung Hamburg* (hence the inclusion of a German football tour in the script) and James McTeigue's British-German co-production *V for Vendetta* (2005) which took advantage of funding provided by the *Medienboard Berlin-Brandenburg* to use facilities at the Babelsberg Studio in

Potsdam. Traditionally, there was always a division between those regions, such as Hamburg and North Rhine-Westphalia, which were concerned with the development of film as art and Berlin and Bavaria which were driven explicitly by economic imperatives. Since the early 1990s, however, such divisions have become more blurred. Supported through a mixture of government, private and public television money, all the major regional film federations tie their funding to a project's 'regional effect', which generally means that for every euro they provide, €1.50 has to be spent in the region, seeing a core aim of their support to be the development of their local economic and artistic infrastructure. Some regions have been extraordinarily successful of late for a variety of reasons I shall discuss below. In 2008, the Bavarian film fund, for example saw a 300% 'regional effect' return on its €27 million investment in production (*Blickpunkt: Film* 2009: 42). Nonetheless, the regional funds are still not all entirely driven by commerce, as Eva Hubert, managing director of *Filmförderung Hamburg Schleswig-Holstein*, is at pains to point out. She, for example, insists that her region continues to be committed to funding 'culturally demanding' film rather than basing its support solely on a project's commercial viability (Hubert 2009: 18).

These are not the only schemes available to German filmmakers. In this age of increasing transnational production, they can also take advantage of a growing number of funds offered by other European states, most notably, in terms of the funding available, those of France. The industry also actively seeks co-production deals with countries around the world (Jäckel 2003: 64). Germany currently has 17 formal international co-production treaties with countries including Australia, Brazil, India, Canada and New Zealand, as well as with numerous EU member states. Finally, it should be noted that along with providing backing for many of the regional and national funding bodies, German public and private television is also a major co-production partner for the film industry, eager to find content for the increasing amount of airspace the networks have to fill in the digital age. As we shall see, although the level of direct funding provided by television is lower than many of the other bodies mentioned here, it has had a profound impact on the shape of German filmmaking, albeit one which, once again, seems to be working in competing directions with regard to the 'art versus commerce' dichotomy.

Around two-thirds of the budgets for German feature films come from public subsidies and when one adds up all these various pots of money, the funding available to German production companies is potentially very generous. However, the diffuse nature of the funding structure is regularly attacked by commentators, as well as by members of the industry itself. A production company will invariably need to seek support from a range of sources. This led, particularly in the early 1990s, to what the 'German Films Service + Marketing' (the Federal organisation tasked with promoting German film abroad) criticised as 'a hotchpotch of compromises, a German road movie in the worst sense of the word, the plot making sudden and unexplained relocations just in order to meet a particular fund's requirements'. In a sense, such films replicated on the national level what the europudding created on the transnational. In the last decade, this criticism has, to a degree at least, been addressed. The main regional funders have started to work together to allow the trade of 'local effects' between films (*German Film Quarterly* 2002: 8). Nonetheless, it is difficult to overcome this impulse completely. What Matthias Kurp calls 'sponsor tourism' continues as film productions travel the country. Indeed, its continued existence is parodied in Andreas Dresen's recent film about an ageing alcoholic actor *Whisky mit Wodka* (Whisky with Vodka, 2009), in which the director of the film within the film explains why he decided to relocate the 'true story' he wishes to tell from Bavaria to Rostock: 'we just got some cash from Mecklenburg-Western Pomerania'. If he wanted to make the movie he had no choice but to move. By making such allowances, a film's expenses are artificially increased, due to the need to support a mobile film crew, doing little to build a sustainable film industry with a life beyond the individual project being funded. Moreover, the complexity of the system can lead to films being made by committee, with the reason to go into production being based on a project's ability to guarantee funding rather than the possibility of either critical or commercial success, thereby working against the ostensible overall aims of the funding system. Kurp points, for example, to the €7.5 million poured into Joseph Vilsmaier's unsuccessful biopic *Marlene* (2000) which secured an audience of only 450,000, achieving only 85th place in the FFA's top 100 that year (Kurp 2004; FFA 2010b). Critics saw the film as a poorly thought-out and developed project that could never have been a

10 The director (Sylvester Groth) explains to Arno Runge (Markus Hering) the economic realities of the film business on a less-than-glamorous windy Rostock night, *Whisky mit Wodka* (2009).

commercial or critical success (*Spiegel* 2000: 250). Nonetheless, the film received the highest level of funding that year by some margin. Of course, since such funding accounts for two-thirds of the budgets spent in Germany, it has also been behind a good deal of the recent German productions that have enjoyed acclaim with critics and the public alike. From Wolfgang Becker's *Good Bye, Lenin!* (2003) to *Das Leben der Anderen*, all the films that have had success at home and abroad have received at least some of their funding from such public sources.

Another important source of domestic funding is public and private television. This can either take the form of a pre-sales agreement or a full co-production, in which case the company will often be heavily involved in the development of a project. During the days of the New German Cinema, television played a major role as a film funder and, more importantly, as a medium of exhibition for the work produced. The filmmakers, however, were able to maintain a high degree of autonomy. In the last two decades this has begun to change in some cases, with private television companies in particular, such as *Pro-Sieben*, being exercised by the commercial viability of a film project and its attractiveness to a mainstream, primetime audience. The increasing influence of television officials in the decision-making process has had a noticeable

effect on the type of films that have been made in Germany, much to the chagrin of many in the film production industry. This drive can, in fact, be traced back to the mid-1980s and Doris Dörrie's surprise hit comedy *Männer* (Men, 1985), a low-budget television movie that crossed over into cinemas, kick-starting the production of a whole range of so-called 'New German Comedies' which marked a radical break with the high art of the New German Cinema. Instead, such films looked to appeal to a mainstream audience, adopting Hollywood genre conventions which seemed deliberately to play down their German specificity. As such, they appeared to have an eye on the international market. Ironically, however, although a small number of these films did have limited international success, such as Sönke Wortmann's *Der Bewegte Mann* (Maybe, Maybe Not, 1994), a romantic comedy set in the urban gay scene, their audience was largely confined to Germany. Such films continue to be made and at times continue to enjoy success, most notably Til Schweiger's *Keinohrhasen* (Rabbit Without Ears, 2007) or the brief spate of homosocial 'bromance' comedies towards the end of the decade, such as *Männersache* (Men's Business, Gernot Roll and Mario Barth, 2009) and *Männerherzen* (Men in the City, Simon Verhoeven, 2009), a German variation on a Hollywood trend also prevalent at the time exemplified by John Hamburg's *I Love You, Man* (2009) (Dell 2009: 40). By the end of the 1990s, however, the domestic success of this wave was largely on the wane. For the producer Joachim von Vietinghoff, the failure of the New German Comedy was inevitable, since the main problem with the influence of the private television networks is that they are undermining the much discussed 'Kinotauglichkeit' of contemporary feature film production (*Blickpunkt: Film* 2009e). Particularly disputed is the role of the so-called 'amphibian film', designed to be released in both cinematic and extended television versions, but which is driven primarily by its ability to be transmitted in prime-time television slots. This led, for example, to a very public feud between Volker Schlöndorff, who was to direct a film based on Donna Woolfolk Cross's novel *Pope Joan* (1996) and Günter Rohrbach. Schlöndorff argued that it was impossible to make a film that can work in both formats without a far greater budget than that available to him, since he was in effect being asked to make two movies. Consequently, the need for the film to work on television was undermining any cinematic aspirations he had for a project

11 Philip (Maxim Mehmet) negotiating life as a restaurant advertisement, *Männerherzen* (2009).

to which he had committed eight years of his life. Rohrbach, on the other hand, accused Schlöndorff of biting the hand that fed him, reminding him of the role that television has long played in the survival of the German film industry and claiming, somewhat provocatively, that 'if the German cinema film wants to survive, it has to accept the reality that the golden age of cinema is clearly gone' (Zander 2007: 28). 'Amphibian films' have indeed enjoyed a reasonable degree of commercial success in recent years, particularly those made by Nico Hoffmann's teamWorx company, which has re-edited a number of its two-part historical docudramas, invariably marketed within Germany as high-end 'event television', for theatrical release.

Further countering the perception that private television has had a wholly negative impact on film's *Kinotauglichkeit*, at least in commercial terms, has been the popular success of some television comedy on the big screen, evident in the work of Tom Gerhard, whose *7 Zwerge – Männer allein im Wald* (7 Dwarves, Sven Unterwaldt Jr, 2004) sold over 6 million tickets on its theatrical release, or, on an even larger scale, the work of Michael 'Bully' Herbig. Herbig is a television comic well known for his Pro-Sieben show *Bullyparade*, the camp characters from which he has used in two films: *Der Schuh des Manitu* (The Shoe of Manitu, 2001), a spoof western in the style of the 1960s film versions of Karl May's popular novels, which achieved an audience of 10.5 million and *(T)Raumschiff Surprise – Periode 1* (Dreamship Surprise – Period 1, 2004), a parody science fiction movie that references a whole host of US

12 Herbig and his camp crew (Christian Tramitz and Rick Kavanian) perform 'Miss Waikiki' in his sci-fi parody *(T)Raumschiff Surprise – Periode 1* (2004).

movies and television shows, most obviously *Star Trek* but also *Star Wars* (George Lucas, 1977), *Back to the Future* (Robert Zemeckis, 1985) and *Minority Report* (Steven Spielberg, 2002) as well as many others, which sold just over 9 million tickes on its theatrical release. Highly reminiscent of Jim Abrahams' American parodies *Airplane* (1980) and *Hot Shots!* (1991), *Der Schuh des Manitu* and *(T)Raumschiff Surprise* are the second and third most popular German films with domestic audiences since the 1960s, beaten only by *Otto – Der Film* (Xaver Schwarzenberger and Otto Waalkes), the monster comedy hit of 1985, with its estimated 14 million spectators (FFA 2010b). Although both films have been a huge success at home, Herbig has failed to gain the widespread international release he hoped for, offering further evidence perhaps of the non-translatability of German comedy.

Herbig illustrates particularly clearly the shift in the funding ethos away from individual artists towards a model that, despite its limitations, wishes to emulate the popular entertainment and commercial ethos of Hollywood. Further evidence of this is offered by his close working relationship with Bernd Eichinger and Constantin Films. Until his death in 2011, Eichinger was Germany's most important commercial producer, responsible for a large number of the country's recent international successes, including Hirschbiegel's *Der Untergang*, Tykwer's *Perfume* and Uli Edel's *Der Baader Meinhof Komplex* (The Baader Meinhof Complex,

2008). Constantin, the company Eichinger bought in 1978, is the nearest that Germany comes to a major production company in the Hollywood sense, making what in German terms are big-budget blockbusting event movies for the international market, many of which, like *Perfume* or his adaptation of the Marvel comic strip *Fantastic Four* (Tim Story, 2005) are shot in English and have an international cast.

Constantin is driven by the bottom line, pushing German cinema, for better or worse, towards the international mainstream. Without doubt, this has had knock-on effects for the industry as a whole, helping to increase the visibility of German productions through the commercial success of some of Eichinger's German-language films abroad. This is of potential benefit to all filmmakers, whether they are interested in the production of work with mass appeal or more esoteric fare. Indeed, for all the discussion of a shift away from *Autorenkino*, it has far from disappeared. On the contrary, in recent years it has been making something of a comeback, albeit often in a far more media-savvy way, with filmmakers and producers attempting to marry the imperatives of the market and the German funding system with their own aesthetic agenda. The most obvious example of this is *X Filme Creative Pool*, set up by Tykwer, Becker, Levy and Arndt. On the face of it, the company would offer further evidence of the German industry's turn towards a Hollywood model. The company's publicity material, for example, emphasises its connection to an American filmmaking tradition by its founders' declaration that they took the inspiration for *X-Filme* from *United Artists* (*X-Filme* 2010). However, as Wim Wenders among others is keen to point out, the existence of *X-Filme* also recalls the *Filmverlag der Autoren*, the company he set up in 1971 with other key figures of the New German Cinema to produce *Autorenkino* (Jekubzik 2005). That said, although continuing to benefit from the German subsidy system, *X-Filme* is far more concerned with the marketability of its product than the *Filmverlag der Autoren* generally was, even at its most commercial under the stewardship of Mathias Ginsberg, who took over its running in 1976 (Corrigan 1983: 6). At the same time, unlike many of those involved in the comedy wave of the 1990s, their approach is informed by an 'art house' sensibility (albeit to a lesser extent than that of Wenders' generation) which views 'Germanness' not as a hindrance but as a means of accessing, above all, an international

market. As Arndt puts it, in a comment that further underlines his challenge to the europudding quote above:

> We intended to tackle really authentic German stories that are set in Germany and are about Germany, and we also wanted to find the kind of story ideas which would also function outside of Germany. (Halle 2002: 43)[2]

The impulse to approach authentic German stories that will work abroad is clear in Becker's *Good Bye, Lenin!* (2003), a film which explores the specifically German theme of unification and the legacy of the GDR in present-day German society. Although dealing with a German theme, in interviews Becker echoes Arndt's comments, playing on what he sees as the translatability of the plot, something hinted at from the outset in his use of English in the film's title. For the filmmaker, the GDR is intended largely to provide a backdrop for a universally applicable story: 'You don't have to know a thing about German history to understand it. A son who loves his mother – it's a story you find everywhere' (quoted in Funck 2003: 35). To a degree the film's success abroad might well be attributable to its translatability. However, it is also clear from foreign reviews that the GDR theme was very important in giving this universal story a 'unique selling point' on the international market (Bradshaw 2003: 27). Thus, it would seem to be foolish for German filmmakers who wish to sell their product abroad to play down the specifically German aspects of their work too much.[3]

X-Filme is not alone in maintaining links with the *Autorenkino* tradition of the New German Cinema as well as with a specifically German national cinema even in this time of increasing transnational cooperation. Of significance here is, once again, the Berlin School which has been fêted, particularly in the French press, as a new hope for German film, a 'Nouvelle Vague allemande' to rival the creative energy of the New German Cinema (Loutte 2005). In the work of artists such as Petzold (*Die innere Sicherheit*/The State I Am In, 2000; *Gespenster*/Ghosts, 2005; *Jerichow*, 2008), Angela Schanelec (*Mein langsames Leben*/Passing Summer, 2001; *Marseille*, 2004) and Ulrich Köhler (*Bungalow*, 2002; *Montag kommen die Fenster*/Windows on Monday 2006) one sees a slower-paced, more self-consciously avant-garde film aesthetic than that to be found in much of the rest of the German scene. We also often find a far more explicitly critical engagement with contemporary

issues than that of many of the most successful international German films. It is interesting to note, however, that this aesthetic development has been clearly aided rather than hindered by television. Practically all the first productions associated with the Berlin School of filmmakers were co-produced by Germany's second television channel, ZDF's series *Das kleine Fernsehspiel* (The Little Television Play). This series has been running since 1962, producing work by numerous figures connected with the Young and New German Cinema and was particularly influential in giving a voice to women filmmakers such as Helma Sanders-Brahms (Elsaesser 2005: 215–6). Within the present filmmaking landscape in Germany, it is seen as a prized space for artistic engagement, which, as Rüdiger Suchsland points out, has given contemporary filmmakers the opportunity to produce and exhibit their work 'without having to make the compromises that working with television usually entails' (Suchsland 2005: 8). Consequently, while some private television companies are helping to drive a shift towards commercialism and popular mass entertainment, public television, on occasion at least, continues to promote the existence, and indeed growth, of a tradition of German *Autorenkino.*

Mobilising private investment

While the German film industry can hardly be said to operate within a context that relies predominantly on private investment, as we can see from Merkel's first coalition agreement, this is clearly the direction that politicians wish the industry to go in. What is more, until 2005 it is precisely from private investment that most of the money spent on film production came. For years private media funds such as *VIP Medienfonds* or *Apollo Media* raised billions from rich Germans keen to invest in movies. The lion's share (often as much as 90%) of this money, however, did not go into German domestic film but rather into bankrolling major Hollywood productions such as *The Lord of the Rings: The Return of the King* (Peter Jackson, 2003), or *Terminator 3: Rise of the Machines* (Jonathan Mostow, 2003). Between 1997 and 2004 such media funds amounted to around €13 billion, exploiting a tax shelter system designed to support and develop certain German industries, including shipping, wind farms and film production (Meza

2005). This permitted German investors to write off their entire commitment to a film against tax, even before a film actually went into production, thus allowing them to postpone a tax bill to a more convenient time. Although in the last year of its existence attempts were made to tighten up this tax shelter – the SPD having failed to close the loophole completely due to the Greens' refusal to accept that it would also mean closing off investment in wind farms – the only real pre-requisite was that the film's copyright had to be owned by a German company which would also take a share in any future profits the film might make. There was no requirement that a film be shot in Germany or that any Germans be employed in its production, as is often the case with countries offering tax breaks to the industry and with the regional subsidies discussed above. This meant that wealthy Germans could invest in Hollywood blockbusters, which were far more likely to offer them a return on their money than a domestic German production. The Hollywood majors were also happy as the German tax shelter offered them a risk-free source of film funding.

The system worked like this: a Hollywood major would arrange to sell the copyright of their film to one of a number of German media funds. The studio would then immediately lease the film back, paying the German company about 10% less than had been paid to them. The Hollywood studio would thus effectively be given the extra 10%. Edward Jay Epstein gives the example of *Lara Croft: Tomb Raider* (Simon West, 2001) to illustrate the system:

> Paramount sold the copyright to a group of German investors for $94 million through Tele-München Gruppe, a company headed by German mogul Herbert Kloiber. Paramount then repurchased the film for $83.8 million in lease and option payments. The studio's $10.2 million windfall paid the salaries of star Angelina Jolie ($7.5 million) and the rest of the principal cast. (Epstein 2005)

Up to 20% of Hollywood's money came from this source, with very little benefit to the German industry, since the complexities of setting up these deals was such that the investment in legal costs was only really warranted for the sort of budgets commanded by Hollywood. No wonder then that this source of funding was commonly referred to in the boardrooms of LA as 'stupid German money' (Becker 2006). No wonder, too, that it was one of the first

actions of Merkel's Grand Coalition to pull the plug on these funds in November 2005.

Although up to 90% of this money flowed to Hollywood, the 10% that did not was very important to the German film industry. Merkel's decision was greeted with horror by many who felt that the government was throwing the baby out with the bath water in closing down these funds. Unsurprisingly, the biggest critics of the government's decision were the media funds themselves. The *medieninitiative! Deutschland*, formed by representatives of the media funds and other members of the industry in 2005 to lobby for a reform of the tax law, spoke for many when it called for a continuation of the tax break but with the inclusion of a 'German Spend' clause, so that a proportion of the money at least would flow back to the German exchequer and also support the domestic industry (dpa 2005). Towards the end of the law's existence, there were signs that more investors where becoming interested in domestic production (Castendyk 2006). Consequently, it seemed that keeping the law with the inclusion of a German spend clause could well be a positive move. As proof of this trend one could cite the small, but not insignificant, fund German Film Productions (GFP), founded by David Groenenwold, who saw his investment portfolio grow from €10 million in 2001 to 50 million in 2005. Groenenwold was committed to investing in German productions and achieved some notable domestic hits, including the TV dramatisation of the 1960s mining disaster *Das Wunder von Lengede* (The Miracle of Lengede, Kaspar Heidelbach, 2003) as well as the spoof comedy *Der Wixxer* (Tobi Baumann, 2004) (*Blickpunkt: Film* 2005). However, the highest-profile German beneficiary of the private media funds was the highly entrepreneurial producer and director Uwe Boll, a figure who did little to secure the reputation of such funding.

Boll made a name for himself producing films based on successful video games (*House of the Dead*, 2003; *BloodRayne*, 2005), the rights for which he purchased very cheaply from the games companies, thereby keeping his costs to a minimum and helping to maximise his return. Although his films are always panned by critics, the kindest of whom style him a German Ed Wood, Boll has been extraordinarily successful in engaging well-known international actors for his films (Ben Kingsley, Burt Reynolds, Michelle Rodriguez, Michael Madsen). Here he again shows his entrepreneurial wit, hiring his stars for very low fees by not approaching

them until the last minute before a film goes into production, simply taking whoever he can find who has space in their schedule (Rodek 2005b). Since the demise of the media funds, Boll has managed to continue making films, resorting to a variety of tactics to gain publicity and funding for his projects. These include a vain attempt to use 'cluster funding' for his film *Blackout* (2010), allowing anyone to become a 'co-producer' for a donation of €33 and, perhaps most bizarre of all, the staging of a boxing match between himself and five of his most vehement critics in the press – all of whom he beat – to promote *Postal* (2007) (Tillson 2006). Criticism of the filmmaker continues to grow, including in 2008 an online petition calling for him to stop making films (Martin 2008). Nonetheless, Boll remains in business and now seems to be readjusting to the post-media funds landscape, taking advantage of the new *Deutscher Filmförderfonds* (German Federal Film Fund, DFFF), set up in January 2007, which seems to have moved Boll away from the rampant exploitationism of his video adaptations to a historical biopic, telling the story of the famous German boxer Max Schmeling.

Although many in the industry called for a reformed tax policy that would encourage a German spend, the government rejected this idea, claiming that it was not compatible with European law. Instead Neumann created a new form of state subsidy, the DFFF. €60 million per year would be made available to allow the recovery of up to 20% of the costs a production incurs in Germany. With this, the industry was given its 'German spend' clause. And, despite initial fears that this would be perceived as just another complicated level of state subsidy which would inhibit rather than mobilise the private capital that the government claimed it wanted to attract into the industry (Fischer 2006; Vermögen & Steuern 2006), the DFFF is now overwhelmingly praised. Since 2007 the fund has invested €178 million in film production and has seen a return on that investment of €1.1 billion. Moreover, it is also helping to maximise the benefit of regional funding. About half of the DFFF money allocated to date has flowed to Berlin-Brandenburg, with the region estimating a 500% 'regional effect' through the many major international productions it has attracted to Studio Babels-berg (*Blickpunkt: Film* 2009a), helping to turn the trickle of films at the start of the decade into a steady stream. These include *Valkyrie* (Bryan Singer, 2008), starring Tom Cruise, Stephen Daldry's *The*

Reader (2008), Tykwer's *The International* (2009), Quentin Tarantino's *Inglourious Basterds* (2009), and, of course, Boll's *Max Schmeling* (2010), all of which helped to make Babelsberg one of the most successful European studios of 2008, in both financial and critical terms – over twenty of the films made with the support of the studio were, for example, shown at that year's Berlin Film Festival. The fund has also helped to raise the profile of German actors abroad with such films frequently mining the German past for their subject matter. These include David Kross, who plays the young Michael in Daldry's adaptation of Bernhard Schlink's international bestselling novel about the legacy of the Holocaust in the Berlin Republic, *Der Vorleser* (The Reader, 1995) and Christoph Waltz, who was unknown internationally until his part as the charming yet menacing Nazi in Tarantino's 'spaghetti' war film, for which he won the 'Best Supporting Actor' Oscar.

Changing demographics and the return of film as art?

The DFFF would seem to have brought about a major change in the state of the overall film economy in Germany, stemming the tide of funding flowing to Hollywood with no real benefit to the German industry. The rationale of the fund, like so much of the contemporary funding landscape in Germany, is fundamentally economic. However, it has also already had an impact on the cultural reputation of the German industry, attracting international projects of higher than average cultural prestige, like Daldry's literary adaptation, or Tarantino's self-reflexive auteurist piece, even while these films also play to international stereotypes, presenting an image of the nation still wholly defined by its Nazi past. In addition to such work, the DFFF has supported numerous smaller-scale domestic productions, Neumann taking the decision to spread the available funds widely, despite the concerns raised about this strategy by some of the country's biggest producers (FFA 2010a). The majority of these films have been commercially oriented genre pieces. Nonetheless, the DFFF has also funded work by some of the country's most important *Autoren*, thus helping to continue the present-day reinvigoration of this tradition, including work by its elder statesmen, such as Wim Wenders (*The Palermo Shooting*, 2010), along with key figures from the younger generation, including Hans-Christian Schmid (*Die wundersame Welt der Waschkraft/*The

Wondrous World of Laundry, 2009), Andreas Dresen, (*Whisky Mit Wodka*) and Akın (*Garbage in the Garden of Eden*, 2010).

Thus, even within a context where the most important funding pots are driven in large part by commercial concerns, the aesthetic qualities of film nonetheless continues to inform decisions about the types of films that are supported. And, as we have also seen, even though the funding allocated according to purely 'cultural' criteria is only a small proportion of that available, it often has a disproportionately large impact, due to the fact that such films tend to require relatively small budgets to make. Finally, it might be noted that the role of film as art rather than commerce shows some signs of growing in importance amongst consumers. This is in part due to the changing demographics of contemporary cinema audiences in Germany. As already discussed, in recent years the industry has been particularly exercised by falling cinema ticket sales, as well as the problem of piracy, both issues which affect the amount of money available to German production companies in terms of revenue but also (and of more substantial importance) due to the fact that they are both linked to the public funding system and the amount of subsidy available to filmmakers. Cinema marketing professionals have generally based their policies on attracting young audiences to major Hollywood event movies, the type of films the media funds supported until their demise. In this regard, the films that German audiences go to see are largely the same as those shown in cinemas across the western world. However, the current situation is changing. As Steffen Uhlmann notes, on the one hand younger audiences who are now 'more interested in the internet, video games and DVD recorders are avoiding cinemas more and more. On the other hand the proportion of the audience that is over 50 is noticeably increasing' (Uhlmann 2005).[4] In Germany, the FFA has not been taking the loss of the youth market lying down and responded in 2006 with a €1 million advertising campaign focusing on what is unique about seeing a film in the cinema. Whether this campaign had any real impact, however, is doubtful, not least given the fact that its attempt to rekindle enthusiasm was based on advertising in cinemas – perhaps not the best medium to target if the FFA wishes to reach a new audience (ddp 2006). At the same time, as the proportion of the audience over 50 continues to grow, distributors and exhibitors are having to take greater account of this group's tastes which, as

Uhlmann also suggests, in Germany tend not to be Hollywood blockbusters but rather 'quietly told German and European productions' (Uhlmann 2005). Cinema owners are increasingly orienting their service culture to an older clientele (*Blickpunkt: Film* 2009b), and giving increased screen space to the types of films normally only seen on the art house circuit. 'Art House Films Conquer Multiplexes', as the industry journal *Blickpunkt: Film* put it in an article on this demographic shift (*Blickpunkt: Film* 2004). Of significance to film production is that the growing over-50s market could also help increase demand for the type of *Autorenkino* that is currently making something of a resurgence, thus countering still further any overwhelming trend towards films normally considered to be the safest bets commercially, namely popular entertainment with mass appeal. It is unlikely that such *Autorenkino* will ever be anything more than a niche product in the overall film landscape. Nonetheless, its new significance highlights the continuing diversity of German film culture. Funding plays a very significant role in shaping the types of films produced. Finally, however, it should be noted that this is only one element within the creative process. Filmmakers invariably see themselves, of course, as making films that are artistically credible *and* entertaining, whatever their commercial aspirations might be. It is to the films themselves, and the creative strategies their makers employ, that I shall now turn.

Notes

1 It is impossible to be completely accurate about the impact illegal downloading has on cinema ticket sales and even less so on the broader issue of home entertainment sales (DVD, Blu-ray, legal HD downloads etc). It might be argued that the decrease in ticket sales is due rather to a general turn away by the youth market in particular from the viewing of feature films to other forms of entertainment (video games, social networking etc). Indeed, illegal downloads are better conceptualised, others suggest, as a 'trailer' for the legal product. However, whether they are a benefit or a curse, it is clear that legislation cannot straightforwardly prevent this activity and so the industry is increasingly looking at ways to bring the world of illegal downloading into the mainstream marketing of its products. For further discussion see Burbidge 2009.

2 For a more detailed discussion of the history of *X-Filme* and Arndt's approach to film production see Arndt 2009. In 2010 Arndt finally stepped down from running the company in order to focus exclusively on producing his own projects. Here he seemed to be following in the footsteps of Eichinger, who stepped down from running Constantin in 2005 but continued to work for the company until his sudden death from a heart attack in 2011.

3 For further discussion of the role of 'Germanness' in the marketing of German films abroad see Cooke 2006.

4 For a detailed examination of the changing demographics of German cinema audiences see Keil *et al.* 2006. This will be discussed further in Chapter 5 of this study.

2 Representational strategies and questions of realism

On 10 September 2009, the German Press Agency (dpa) received a telephone call from a journalist working for the American network KVPK-TV reporting a possible suicide attack on a cafe in the town of Bluewater, California by a German rap band dressed as Arab terrorists. Supported by messages appearing on Twitter and entries on Wikipedia, as well as videos on YouTube and MySpace, the journalist pointed the dpa to his network's website which contained eyewitness accounts of the attack along with US contact numbers. The dpa immediately ran the story. Within half an hour the attack was uncovered as a publicity stunt for the band, although not before numerous worried Germans had tried to contact emergency services, causing outrage both for the trouble the stunt had caused and its timing – the day before the eighth anniversary of the attacks on the Pentagon and World Trade Center – which was seen to be in extraordinarily bad taste (Dettweiler 2009). Every aspect of this story was a fiction. The television network did not exist, neither did Bluewater. No attack took place and the US numbers simply linked back, via Skype, to the hoaxers in Germany. The outrage then increased as it was subsequently revealed that not even the band was real, that their publicity hoax was itself a hoax, and that the entire stunt was the creation of the comic Jan Henrik Stahlberg aimed at promoting his new feature film *Short Cut to Hollywood* (2009).

The construction and impact of the 'Bluewater Attack' goes to the heart of this film, as well as the approach of Stahlberg and his filmmaking partner, Marcus Mittermeier, to cinema more generally. Moreover, it offers us a useful starting point for a discussion of the various strategies contemporary German filmmakers use to

explore the relationship of film to the 'real' 'profilmic' world, both in terms of the topics they are choosing and in terms of the ways they are engaging with questions of cinematic realism. *Short Cut* is Stahlberg's and Mittermeier's second joint feature, following their similarly quirky mock documentary about a vigilante undertaking an obsessive quest to correct the minor misdemeanours of his fellow citizens, *Muxmäuschenstill* (Quiet as a Mouse, 2004), a film which also adopted 'guerrilla' tactics – epitomised by the 'Bluewater Attack' – in both its production and marketing, the filmmakers grabbing any opportunity to set up their camera without necessarily waiting for the required permissions. In their second feature, such tactics become the very point of the film itself. Johannes Selinger (Stahlberg), an insurance salesman, and his two 'loser' life-long friends, who spend their evenings playing kitschy pop to empty bars, have nothing going for them. Now in their mid-thirties, Johannes decides that they will rebrand themselves *John F. Salinger and the Berlin Brothers* and seek fame in the United States. The 'unique selling point' of their act is to be John's eventual suicide, live on television, making him the ultimate 'reality TV' star and allowing the band to exploit his celebrity to market their music. Constructed in similar fashion to *Muxmäuschenstill* as a mock documentary, the film charts the development of the *John F. Salinger Show*, as it becomes known to the world, from his initial 'teaser' act of self-destruction – the amputation of his little finger, the film of which is used to drum up media interest – through the band's staged terrorist attack on a small-town café to increase the hype around the story, footage from which was used for the 'Bluewater Attack', to a series of increasingly dramatic amputations and ultimately the global media event of his death. For its makers, the film is a deliberately grotesque comment on the prevalence of contemporary 'reality TV', which seems to play to a tendency Mary Ann Doane identified long before the present predilection for such formats for television to give the viewer the sense of an immediate connection with real events as they happen, while at the same time neutering their impact in television's tendency 'to banalize all events through a kind of levelling process' that allows the containment of the real world within television's own format (Doane 1990: 228). *Short Cut* challenges what Stahlberg and Mittermeier consider to be the increasingly dangerous banality of the world on offer through our television screens: 'Form has beaten content.

No one asks "why?" anymore. And if another unknown television personality lies down in a terrarium full of spiders no one laughs at him for being an idiot. Instead he just sells twice as many records' (Presseheft 2009a: 9). The film explores the very ontological status of 'reality' in 'reality TV', repeatedly pushing to the limits the degree of such reality the audience finds acceptable, asking the spectator to confront the indexical value of the images with which they are presented.

Short Cut is one of a number of films that began to appear in the late 1990s, including the much better known *The Truman Show* (Peter Weir, 1998) and *EDtv* (Ron Howard, 1999), which sought to challenge the illusion that television can give an unmediated image of the real world. Of course, the notion that *any* representation of the external world can give an immediate, somehow 'non-mediated' image of reality is illusory. The world with which the spectator is presented is always subjective, always partial. Where Stahlberg and Mittermeier differ from such films, or other German films of the 2000s, including Hans Weingartner's *Free Rainer – Dein Fernseher lügt* (Free Rainer – Reclaim Your Brain, 2007) which explores what Weingartner sees as the deleterious impact the competition for television ratings is having on German culture and society more broadly, is that it also implicitly acknowledges what Joel Black refers to as 'film's own status as an artificial (and artificing) medium'. Black continues: 'When the protagonists Truman and Ed renounce their fake TV world for real life, no acknowledgement is made that "real life" in these movies is nothing but another media fiction – that of *The Truman Show* and *EdTV* themselves' (Black 2002: 16). Importantly, as Black goes on to note, 'even as these end-of-century-films critique television as an artificial medium, a case can be made that movies themselves have historically been a fantasy medium and that it is in fact TV that has led the way in presenting the real in all its gritty, graphic immediacy' (Black 2002: 16).

As was discussed in the previous chapter, the relationship between German television and cinema has often been fraught. Nonetheless, it has played a particularly important part in the development of film realism, not least as a funder of documentary filmmaking, a tradition that continues to have a strong presence on German television screens (Frickel 2010: 3). With regard to feature film production, the main focus of this book, ZDF's *Das kleine*

Fernsehspiel supports the growing exploration of the contemporary real world amongst younger filmmakers, along with the aesthetic possibilities offered by film in the representation of this world. This is a particularly obvious connection between the present generation of filmmakers and those of the New German Cinema, when television was similarly central to the growth of what Elsaesser defines as the 'contentist' tendency of many filmmakers to use film as a means of analysing the social and political issues of the real world, a tendency which was, in turn, crucial to the development of the national audience for their work. This he contrasts with the work of the more romantically oriented 'sensibilists', primarily identified with those who achieved success on the international art house circuit such as Wenders and Herzog and who saw the cinema screen as a means of transfiguring material reality in order to reveal its transcendent potential (Elsaesser 1989: 56–60) – an attempt, as Brad Prager suggests with regards to the work of Herzog, to find 'something more authentic than the everyday life-world we inhabit' (Prager 2007: 5). Yet, whether 'contentist', or 'sensibilist', or – most commonly – a mixture of both, the self-conscious exploration of the relationship between the profilmic world and the screen was a key element in debates on the nature and function of German film from the time of the Young German Cinema onwards (Kroner 1973: 52). Much of the film during this period, be it Kluge's Brechtian experiments in montage, Herzog's expressions of human physicality or Fassbinder's self-conscious reworking of Hollywood genre cinema, attempted to explore the aesthetic limits of the medium's representational capabilities, while also seeking to provoke the spectator explicitly into reflecting upon the political implications of the version of reality constructed for them on the screen.

However it has been constituted, the role, shape and limits of cinematic realism have, in fact, been discussed throughout the medium's history. Siegfried Kracauer, for example, indentifies this tendency in the tensions between what he terms the 'strict realism' of Lumière's presentation of incidents from everyday life, such as *L'arrivée d'un train à La Ciotat* (Arrival of a Train at La Ciotat, 1896) and of Méliès exploitation of the new medium to create fantastic spectacles, exemplified in his *Le Voyage dans la lune* (A Trip to the Moon, 1902) (Kracauer 1960: 30). In the 1990s, if there was a debate on the representational potential of cinema, in much mainstream

German production it appeared to have been won by the fanta-
sists, and their escapist presentations of a yuppified, bourgeois
society identified by Rentschler as the 'cinema of consensus' (Rent-
schler 2000). As noted in the previous chapter, this is a tendency
that continues in some films produced primarily for the domestic
market. More explicitly in the tradition of Méliès, as Michele
Pierson, Julia Hallam, Margaret Marshment, Black and others
have discussed, the development of computer generated images
(CGI) as well as other forms of digital reproduction can now almost
perfectly falsify 'the real', be this the creation of 'authentic' dino-
saurs in Spielberg's *Jurassic Park* (1994), or an exploding White
House in Roland Emmerich's Hollywood production *Independence
Day* (1996) (Hallam and Marshment 2000: 82–7; Black 2002: 11–13;
Pierson 2005). Other German examples one might mention are the
much-discussed digitally enhanced construction and subsequent
destruction of the Guggenheim Museum in Tykwer's conspiracy
thriller *The International* (2009) (Suchsland 2009b), or the CGI
effects used to create the dark anthropomorphic fantasy world
in Marco Kreuzpainter's *Krabat* (2008), an adaptation of Otfried
Preußler's classic children's novel (Kleiner 2008).

The increased ability to create, rather than simply represent,
reality in the digital age returns us to Stahlberg's 'Bluewater
Attack', and his attempt to create the illusion of a terrorist attack
by mobilising the potential of digital technology, specifically in
his case the interactive capabilities of Web 2.0 tools such as Wiki-
pedia and Twitter.[1] However, it is also important to note that in
this as in the other examples mentioned above, the 'illusion' of
reality almost immediately collapses in the face of the external,
physical world. External reality always remains the most impor-
tant reference point for the fantasies produced. The purpose of
Stahlberg's illusion, for example, was to reassert the importance
of the real in the face of its ostensible debasement in 'reality TV'.
With regard to *Krabat*, reviewers noted the ultimate failure of
Kreuzpainter's special effects to reach the level of verisimilitude
achievable in the work of a Georg Lucas with multi-million-dollar
budgets at his disposal. Nonetheless, for Felicitas Kleiner at least,
the smaller budget available to Kreuzpainter compared to the
producers of Hollywood spectaculars gives his film a feeling of
'raw authenticity' not to be found in Hollywood (Kleiner 2008).
Similarly, Rüdiger Suchsland praises Tykwer for his ability to keep

his spectacular action film rooted in reality and the socio-political context of global capitalism, working in the realist tradition of European political thrillers by the likes of Francesco Rosi or Jean-Pierre Melville (Suchsland 2009b).

It is this claim to 'authenticity' which, since the turn of the millennium, has increasingly become a signifier of German film of all types as a growing number of filmmakers move away from the mainstream aesthetics and politically conservative sensibilities of 1990s 'consensus' films to offer an at times more troubling, and with it more self-consciously realistic, version of contemporary society. These films, not least Stahlberg and Mittermeier's piece, are often marked by a film grammar that is generally coded as 'realist', including aspects of the *cinéma vérité* documentary style, such as the use of a hand-held camera, producing jerky shots that appear to react to situations as they arise as opposed to a pre-planned script (Rothman 2004: 281–97), as well as the employment of 'amateur' film formats in order to present an ostensibly more 'authentic', less 'mediated' image of the profilmic event – however illusory this goal might be. Interestingly, then, it is the same digital turn that allows the creation of evermore 'realistic' spectacular fantasies that has also fuelled this exploration of the potential for film to present an 'unmediated' image of the world, as filmmakers exploit the flexibility of lighter, easier to use and thus potentially less obtrusive digital equipment to capture the physical world as it happens. For Nicholas Rombes this highlights the 'double logic' of digital production (Rombes 2009: 81), that permits the creation of perfect digital images, where reality can be airbrushed to fit one's needs, but which also almost immediately gave rise to forms of cinema such as the Danish Dogme 95 movement, and its 'preference for disorder, for shaky, degraded images, for imperfection' (Rombes 2009: 1). Examples of this shift among mainstream German filmmakers can be found in the work of Detlev Buck, who moved from making comedies in the 1990s to, at times at least, grittier fare, including *Knallhart* (Tough Enough, 2006), the story of a teenage boy forced to adjust to life in the underworld of inner city Berlin, and *Same But Different* (2010), based on the true story of Benjamin Prüfer and his wife Sreykeo Sorvan, an HIV-positive former sex worker from Thailand. In both these cases, the real world narrative is accompanied by elements of *vérité* camera work, even if Buck cannot always resist his predilection

for the happy ending of his earlier comedies. Nor were these the only films he made, lest we forget his hugely successful children's Heimat movie *Hände Weg von Mississippi* (Hands off Mississippi, 2007). Buck, like many mainstream filmmakers, adopts aspects of a realist style without fundamentally challenging his approach to storytelling. A more radical example of a shift towards realism, however, that explores the tensions between form and content can be found in Dominik Graf's *Der Felsen* (A Map of the Heart, 2002). Known for mainstream television work and genre feature films, *Der Felsen* was a radical departure for Graf in terms of film style, for which he employed a Mini-DV Camera – not normally used for professional production – to film this psychological drama about a woman's breakdown after she is abandoned by her married lover on Corsica. The film is clearly marked as a fiction in its opening sequence of a Senegalese storyteller using the objects he has to hand to help him create the story that is about to unfold. Its form, however, seems to work against this, the film being endowed with a strong sense of authenticity in the way in which it recalls the loose aesthetics of a holiday video, albeit a holiday that goes tragically wrong.

The shift from the seemingly straightforward escapism of 'consensus cinema' towards the explicit exploration of contemporary social concerns, along with the widespread employment of a realist aesthetic ostensibly intent upon presenting an unmediated image of the world, can be read as further evidence of a reaction against the *Spaßgesellschaft* discussed in the introduction. The post-*Spaßgesellschaft* hangover is reflected almost literally in films such as *Chill Out* (Andreas Struck, 1999), *Julietta* (Christoph Stark, 2001) and *Berlin Calling* (Hannes Stöhr, 2008), all of which examine the consequences of their protagonist's drug-fuelled party lifestyles. It can also be found in films that deal with difficult social issues including *Kombat Sechzehn* (Combat Sixteen, Mirko Borscht 2005), which explores the violence of the German neo-Nazi scene, or *Der freie Wille* (The Free Will, Matthias Glasner 2006), the graphically depicted story of a multiple rapist starring Jürgen Vogel, one of a number of 'grittier' stars who came to the fore during the decade. It can be felt in films that portray the continuing social and economic asymmetries between the 'old' (western) and 'new' (eastern) *Länder*, such as we find in the work of Andreas Dresen which is discussed in more detail below, one

13 Jürgen Vogel playing a multiple rapist overwhelmed by guilt, *Der freie Wille* (2006).

of the few areas in the contemporary film landscape to offer an engagement with the legacy of East German film culture and its project of Socialist Realism. It is also evident in the need to work through the traumas of 1970s urban terrorism in, for example, Christian Petzold's *Die innere Sicherheit* (The State I Am In, 2000), Connie Walter's *Schattenwelt* (Long Shadows, 2008) and Susanne Schneider's *Es Kommt der Tag* (The Day Will Come, 2008). All these films reformulate the stories of the rift between the terrorists' generation and their parents, the supporters of Hitler often depicted in the films of the New German Cinema, into an equally fraught battle between these same terrorists, now in middle age, and their own children. To these can be added films that reflect the growing sense of crisis about Germany's participation in 'Out-of-Area' military operations, not least the war in Afghanistan (for example the feature films *Mörderischer Frieden*/Murderous Freedom, Rudolf Schweiger, 2007, and *Nacht vor Augen*/A Hero's Welcome, Brigitte Bertele, 2009, or the curious ornithological war documentary *Der Tag des Spatzen*/Day of the Sparrow, Philip Scheffner, 2010).[2] Finally, one might mention the plethora of films that examine the experiences of those forced to exist on the margins of mainstream society, such as Germany's migrant workers, a topic to be discussed in the Chapter 4. Throughout these films, a variety of self-consciously realist aesthetic strategies

are used to underline the authenticity of the stories their makers wish to tell.

In the rest of this chapter I explore in more detail two very different ways in which filmmakers are engaging with the concept of cinematic realism. I begin with the work of Andreas Dresen, a GDR-trained filmmaker who continues to focus on the nature of life in the formerly communist part of the country. Though he is often viewed by commentators as strongly influenced by Dogme 95, a connection that the filmmaker himself refutes, I look rather at the legacy of the East German state film company DEFA and its Socialist Realist tradition on his work, a tradition that Dresen can be defined both through and against. This I then contrast with an examination of the Berlin School, exploring how many of its films seem to draw on a tradition of realism found throughout the history of the medium, but which received its first detailed theorisation in the work of André Bazin. Here I focus on the manner in which Angela Schanelec and Christian Petzold seek to 'render sensible', as Marco Abel puts it, the underlining 'reality' of the world around them overlooked in much mainstream film production (Abel 2008a).

'If you want authenticity, you should look out the window' (Abel 2009): transfiguring reality in Andreas Dresen's *Halbe Treppe*

Andreas Dresen's work is synonymous with the shift towards 'realism' in both the form and content of his films. 'Realism's Great Hope' (Tittelbach 2001); 'Director Andreas Dresen brings the wonder of reality back to cinema and television' (Freydag 2001), are typical of the reviews. His films are invariably praised for their rootedness in the everyday experience of their characters which gives them an unquestionable sense of 'authenticity' (Köhler 2002), an authenticity underlined by his frequent use of documentary techniques, far removed, as Kerstin Decker notes, from the tone of the 1990s comedies (Decker 2000). At the same time, as I shall discuss below, in his work one finds elements that transfigure his use of documentary techniques to reveal what David Lode describes, in an invocation of Pasolini, as 'the poetry in the everyday' through the stories he tells (Lode 2009: 133).

Dresen's breakthrough came in 1999 with the release of

Nachtgestalten (Night Shapes), a series of interlocking stories about
a group of characters existing on the margins of Berlin life, told in
a form reminiscent of Jim Jarmusch's *Night on Earth* (1992). The
film was praised as a welcome return to the type of social criticism
for which the New German Cinema was famed (Seeßlen 1999). As
he was growing up, Dresen was very aware of the work of the New
German Cinema, the left-leaning tendencies of these filmmakers
and their criticism of the West German state making their work
largely acceptable to the GDR authorities. He was also able to see
their films on the West German television available almost every-
where in the East. However, the filmmaker insists, more influential
on his work were the Eastern European and Soviet traditions of
realism, exemplified by the likes of Vasili Shukshin (Abel 2010).
Dresen belongs to the last generation to have been trained under
the auspices of the GDR's state-run film studio DEFA, studying
from 1986–91 at the GDR's *Hochschule für Film und Fernsehen
'Konrad Wolf'* in Potsdam (*HFF 'Konrad Wolf'*). Until the state's
demise in 1990, official cultural policy insisted that all artists,
irrespective of the medium within which they worked, follow the
doctrine of Socialist Realism (Erbe 1993: 28), a concept coined by
Andrei Zhdanov at the first Writers' Congress of the Soviet Union
in 1934 and later developed by the Hungarian critic Georg Lukács
(Lukács 1969). Socialist Realist art was to provide a clearly compre-
hensible model for socialist behaviour. It was to 'reflect reality'
through the prism of 'Marxist-Leninist ideology', in which a 'posi-
tive', 'historically aware' hero would inspire society onwards to the
communist Utopia (John 1964: 20). 'The typical' was prioritised
over the subjective experience of the individual, which was then
to be combined with a strong sense of socialist 'partisanship' and
'affiliation with the people'. In so doing, artists were to provide the
ruling East German Communist Party with an invaluable didactic
weapon in its propaganda armoury (Jäger 1994: 32–57). Over the
years numerous filmmakers in the GDR refused to be constrained
by the aesthetic and ideological limitations of Socialist Realism.
Nevertheless, as calls for increased liberalisation amongst the
nation's artists grew in the 1980s, it remained an important refer-
ence point, with many younger filmmakers ostensibly wishing
to do just what Socialist Realism called for, namely to 'positively
influence the development of the nation through their films – but
through criticism of real problems rather than a whitewashing

of reality', which was, they argued, in practice the real hallmark
of such filmmaking (McGee 2003: 458). Thus, while many film-
makers saw *Socialist* Realism as an ideological constraint that they
needed to negotiate, much DEFA filmmaking could, nonetheless,
be defined by a commitment to *social* realism, often marked by the
use of documentary techniques along with stylistic elements from
other European traditions, particularly that of Italian Neo-realism,
and the type of Eastern European and Soviet traditions cited by
Dresen as having influenced him.

Many of the filmmakers who had been most vociferous in their
criticism of DEFA in 1980s, such as Jörg Foth and Evelyn Schmidt,
failed to make the transition to feature film production in the
unified Germany, being perhaps too old to learn to negotiate a new
system, while not being old enough to have an established reputa-
tion upon which they could trade. For those ex-GDR filmmakers
that came in their wake, however, as Daniela Berghahn notes, the
DEFA tradition of social realism continued, and indeed continues,
to define many of their films (Berghahn 2005: 252). This is most
obviously evident in the work of Dresen and, to a lesser extent, his
contemporary Andreas Kleinert, both of whom explore the social
reality of life in the eastern regions, albeit it in very different ways.
Dresen's use of quasi-documentary elements differs starkly from
Kleinert's Tarkovsky-inspired depictions of the social devastation
left in the aftermath of the GDR's collapse in films such as *Neben
der Zeit* (Out of Time, 1995) and *Wege in die Nacht* (Paths In The
Night, 2000). Both Dresen and Kleinert were young enough at the
time of unification to come to terms with a new industrial context,
in which filmmakers have to struggle not with the censor but with
the machinations of the subsidy system. Nonetheless, they have
clearly been shaped by their GDR training, a legacy which, as we
see elsewhere in this study, continues to be felt in the work of the
following generation of filmmakers who, although born during
the existence of the GDR, were wholly trained in the unified state,
such as Sylke Enders (*Kroko*, 2003; *Mondkalb*/Mooncalf, 2007) or
Robert Thalheim (*Netto*, 2005; *Am Ende kommen Touristen*/And
Along Come Tourists, 2007).

Yet although Dresen's training has been influential on his work,
he nonetheless has a contradictory relationship with the DEFA
tradition. On the one hand, his style is obviously indebted to the
foundational training that all HFF students had to undergo in

documentary techniques, the importance of which Dresen only gradually came to understand:

I really did not want to learn how to make documentaries. But their rationale for forcing us to deal with the documentary form was: 'Before you sit down at your desk and make up life, please take first a look at real life as it exists. Go on the street, talk to people, try to find your stories there; and then, once you know everything, sit down, play God and try to create it yourself.' So, I reluctantly began to deal with documentary filmmaking, and I gradually began to enjoy it more and more. I really discovered through documentary filmmaking with what gifts reality presents storytellers. (Abel 2009)

Dresen's experience with documentary techniques shaped his aesthetic approach to telling stories, as well as the nature of the stories he would choose to tell. In particular, he became interested in the lives of ordinary people, again a result of the specific emphasis of his time as a student in the GDR, where he was encouraged to experience for himself life as a factory worker (Sylvester 2005). DEFA also gave him what he defines as a 'humanist' approach to filming, in which all members of his team are integrated into the creative process. Indeed, he sees his role as that of *Spielleiter* ('referee' or 'master of ceremonies') rather than that of director (Wengierek 2002),[3] signalling a collaborative approach to his artistic practice that is shared by many of the people he met through DEFA and with whom he continues to work. These include, most notably, the famous DEFA scriptwriter and director Wolfgang Kohlhaase, the author of many of the studio's more important and controversial works spanning almost the entire history of the GDR, from *Berlin – Ecke Schönhauser* (Berlin – Schönhauser Corner, Gerhard Klein, 1957) to *Solo Sunny* (Konrad Wolf, Wolfgang Kohlhaase, 1980). Kohlhaase has worked with Dresen on two productions to date, *Sommer vorm Balkon* (Summer in Berlin, 2005), the story of two women in their thirties who live together in a block of flats in Berlin, clinging to their friendship as they try to survive in the city, and *Whisky mit Wodka* (Whiskey with Vodka, 2009), a comedy about an ageing alcoholic actor forced to compete with a younger man to ensure his place in a movie. In these films, as in all his work, Dresen reflects the changing fortunes of the inhabitants of the ex-GDR, highlighting

his wish that the seemingly unremarkable stories of the ordinary people living there find expression. On the other hand, Dresen's films clearly go beyond their DEFA-inspired roots. While invariably located in the new regions of the Federal Republic, his films are often not limited to an exploration of GDR-specific topics, be it the anxiety of loneliness examined in *Sommer vorm Balkon*, or the controversial topic of sexual relations amongst the elderly in *Wolke 9* (Cloud 9, 2008). Moreover, with regard to his film style, this can to a degree at least be seen as a reaction against, as much as it is a product of, his DEFA training. In particular, this style would seem to work against the meticulous planning and large production teams that were a hallmark of DEFA (Decker 2002). Over his career Dresen has sought to pare down the process of filming. In this regard he has been keen to take full advantage of advances in digital recording technology, using a small digital camera that is extremely light sensitive and so requires very little extra equipment. This allows him to work with a tiny crew which in turn helps him to achieve an intimacy in the stories he tells, as if he were producing a fly-on-the-wall documentary in which an unobtrusive camera team were objectively capturing reality as it happens. Furthermore, in Dresen's view this pared-down approach to filming also encourages experimentation and spontaneity within his team which need not be confined to a strict production schedule (Kirschner 2002).

Along with the work of British social realists Mike Leigh and Ken Loach, the look of Dresen's films has most frequently been compared to that of Lars von Trier, Thomas Vinterberg and the films made according to the Dogme 95 'vow of chastity', a set of 'rules' which stripped the filmmaking process down to its essentials, identified by Lode as 'a camera, a sound recorder, actors and imagination', in order to give their films a strong sense of immediacy (Lode 2009: 141). Dresen clearly feels some affinity with this movement. However, again in reaction to his DEFA training perhaps and his experience of the GDR's socialist experiment, Dresen insists that 'all dogmas are in every respect idiotic'.[4] Instead it is content which must dictate form, rather than a preordained aesthetic ideology (Köhler 2002). If Socialist Realism sought to shape life into narratives with a clear didactic intent, Dresen wishes to invert this process, using the world he finds around him to dictate the nature and style of the stories he tells. That said, Dresen is also keen to

challenge the celebrated 'authenticity' of his films. 'There is no authenticity in the cinema! If you want authenticity, you should look out the window', he claims (Abel 2010). Instead, as I shall now discuss in relation to one of his most successful films, *Halbe Treppe* (Grill Point, 2002), for which he won numerous prizes including the Silver Bear at the Berlinale and a silver German Film Prize, Dresen wishes to transfigure and thereby intensify 'authentic' reality, to offer the spectator something which, at times, comes close to a form of 'magic realism' (Wengierek 2002).

Halbe Treppe is one of Dresen's most 'pared down' films to date. As Decker suggests: 'for a long time Dresen has thought about what he can do without. Cameras and camera assistants. Lighting and lighting assistants. Travel lighter. Throw off the ballast! Finally Andreas Dresen came to the script' (Decker 2002). Financed largely through the prize money earned from *Nachtgestalten*, Dresen decamped for three months to a hotel in Frankfurt/Oder with a small group of actors and crew in order to develop and produce a film without even having a script, a step he could never have taken if the film had been reliant on the type of subsidy available from most other sources. His team, made up of people with whom Dresen had had a long working relationship, was to live and work together throughout the project (Lode 2009: 126), developing the film through improvisation. The inspiration for the film came from a snack-bar Dresen discovered in the town after which the film is named. *Halbe Treppe* means 'halfway up the stairs', the location of the snack-bar tent run by Uwe (Axel Prahl) in the film, but which became the impetus for a narrative based around two married couples approaching middle age – their own *Halbe Treppe* as it were. The biographies of the four main characters, along with the core of the plot, were fixed before the group came together. One couple would consist of Uwe, the snack-bar owner, and Ellen (Steffi Kühnert), a saleswoman in a perfume shop; the other, Chris (Thorsten Merten), a failed journalist who now works for the local radio station as 'Magic Chris' reading horoscopes and Katrin (Gabriela Maria Schmiede) who works at a truck stop just outside the town on the German-Polish border. Ellen and Chris would have an affair. However, how the plot was to develop and how the characters would react to the discovery of the affair was worked out during the filming process in a deliberately and self-consciously democratic manner in which all members of the team had an equal say

(Kirschner 2002). Each scene began with improvisation. Through repetition, the dialogue and action would gradually be formalised while the whole process was captured on digital camera. From the 70 hours of material produced Dresen and his editor Jörg Hauschild then distilled the final film, marrying shots from the often chaotic initial improvisation with the gradually more formalised elements from later versions. In so doing, Dresen and Hauschild sought, in the first instance, to capture a feeling of immediacy which could subsequently be shaped in order to intensify the emotional impact of the images on the screen, the result of which is a tragic-comic account of the destruction and reconfiguration of these charac-ters' relationships as they struggle to negotiate middle age in this depressed east German town.

The process of formalising an initially spontaneously produced event is further reflected in the ways in which the film team responded to the very experience of living in Frankfurt/Oder. In an echo of Dresen's time as a student at the HFF, all the charac-ters spent time working in the jobs played by their characters. Crucially, this was not to be understood as a form of method acting, an approach consistently dismissed by the actors (Schmeide 2003: 36). Instead, their actual experience of working life was to provide further material upon which the narrative could draw, but which would subsequently itself go through the process of intensification and careful editing. Notable examples include the way in which actual drunk customers from the snack-bar become part of the narrative. We see, for example, Uwe throw out one of his customers who spills beer on his son's homework, an event which both reflects the social reality of life amongst the underclass of Frankfurt/Oder as well as the emotional strain experienced by Uwe as he attempts to come to terms with the breakup of his marriage. Elsewhere, we are given a glimpse of Katrin taking a stroll through the snow in the truck stop, a seemingly incidental moment almost caught by chance as the actress wandered between the parked vehicles. It is a moment rooted in the immediacy of her location but which is transfigured through its position in the diegesis into an external reflection of Katrin's inner emotional state as she comes to terms with her conflicted feelings towards her philandering husband.

The sense of immediacy presented in the film is, therefore, a deliberate illusion. It appears to break down the barrier between the world of the film and the experience of the spectator through

14 Katrin (Gabriela Maria Schmiede) wanders through her snow-covered truckstop, *Halbe Treppe* (2002).

the careful crafting of a seemingly 'authentic' environment. Yet through its editing, the film seeks to transfigure the real world within the filmic world of imagination. This is made explicit in a series of interview sequences in which both major and minor characters in the film discuss their roles. Through these sequences, the illusion is maintained that we are watching a documentary, the characters offering the spectator a window onto their everyday lives. At the same time, they also operate as a distanciation device, as the characters appear to step out of their immediate situation to comment on their role in the narrative, thereby undermining any documentary-like realism. Such distanciation is nonetheless only ever fleeting. The characters are invariably drawn back into the main diegesis, blurring the boundary between the real and the fictional, or rather implicating the real within the fictional. In an interview with Chris, for example, whose affair with Ellen has just been revealed to his wife, the man attempts to justify himself to the camera, as if this was an extra-diegetic commentary on the main narrative. But the interview is soon interrupted by a telephone call from Uwe who, having himself just learnt of the affair, has called his friend to meet up with him and help drown his sorrows. Consequently, the fictional narrative breaks into and overwhelms the interview sequence, placing us once more in the world of the diegesis while maintaining an illusory indexical link to the

real world through its performance of a 'to camera' documentary interview which in turn seems to highlight the 'authenticity' of the fiction.

The notion that the world of *Halbe Treppe* offers not an immediate but a transfigured representation of reality is also evident in the film's recourse to elements of magic realism. At the start of the film there would appear to be little hope either for Dresen's characters or for the town of Frankfurt/Oder itself, its location on the German-Polish border – which at that time was also the eastern border of the EU – defining it as a transient space on the edge of society, where life always seems to be happening elsewhere (Decker 2002). Over the course of the film, as both couples are forced to re-evaluate their lives, new hope begins to appear within the town and with it new hope that the characters will overcome the sense of crisis they all experience in the wake of the affair. First, the horoscopes made up by Chris in his persona of 'Magic Chris', shaped by the changing state of his relationship with the two women in his life, appear to come true, suggesting that there is a higher order at work in the town, beyond its day-to-day drudgery. A businessman is convinced that his life was saved by the advice he received from the DJ which apparently led him to avoid a major accident on the motorway. A town-wide blackout is seemingly predicted by a horoscope in fact inspired by the blackness of the DJ's mood during one of his shows at a time when his relationship with his wife is at its nadir. What the horoscopes point to on the macro-level for the town as a whole is then reflected on the micro-level for Uwe by the increasing number of musicians that begin to busk outside his snack-bar. The group that starts to form, playing an international brand of folk music, is in fact 17 Hippies, the group that provides the non-diegetic soundtrack to the film. Through their daily encounter with Uwe as he opens up his snack-bar each morning, the soundtrack enters the diegesis, in turn helping to transfigure Uwe's world from a social realist documentary about the difficulties he faces both at home and at work into a realm of fantasy and imagination, once again blurring the boundary between the real and the fictional. In the process, Uwe's world is opened up to the possibility of change, in which the characters that frequent his snack-bar, be it Uwe himself or the wasters and drunks who form his clientele, might well ultimately experience the type of happy ending more usually reserved for the fantasy world of

15 17 Hippies play to the 'real' clientele of *Halbe Treppe* (2002).

movies. This reaches its culmination in the closing sequence of
the film. Uwe has finally realised that Ellen does not want him
back: nonetheless he snatches a moment of joy by inviting the now
complete group of 17 Hippies to perform an impromptu concert
to his customers, played by the real clientele of the real snack-bar
Halbe Treppe, who very visibly enjoy their few minutes of escape
into the magic of living a film world 'for real'. Thus the film finally
performs its own aesthetic relationship to the actual environment
we see on screen. The film gestures towards a magical world that
might exist within the everyday life of Frankfurt. The mystical
nature of this world is debatable. The connection between the
blackout and Chris's prediction, for example, is surely just coin-
cidence. Yet, it is a coincidence that self-consciously infuses the
profilmic event with an intensifying artifice that plays to the film's
complex layering of reality and fiction. And, in the final sequence
as Uwe and his customers drink and dance, the power and func-
tion of this reality-infused artifice is very apparent. The figures
on the screen are both characters in a fiction and the real inhab-
itants of this depressed part of Germany. Clearly their moment
of joy is fragile. Such 'magic' cannot be sustained within the
everyday experience of the snack bar's clientele. Ultimately the
non-professional actors used by Dresen will return to their more
mundane lives. However, the 'magic' realism of this final sequence
suggests an underlying optimism that runs throughout Dresen's

work which is, potentially, more sustainable. This 'magic' might better be described as human resilience. The happiness of the 'real' people who dance to the 17 Hippies points to the film's celebration of the very ordinary characters that populate Dresen's screen and his belief in their capacity to cope with change, and thereby to survive the difficulties with which they are faced in the everyday reality of life in the ex-GDR.

'Manipulate less to give the spectator more room' (Hochhäusler 2006: 351): the Berlin School

The term 'Berlin School' can be traced to a 2001 review of Angela Schanelec's *Mein langsames Leben* (Passing Summer, 2001), in which Merten Worthmann identified aesthetic similarities between this filmmaker's work and that of two other graduates of the *Deutschen Film- und Fernsehakademie Berlin*, Thomas Arslan and Christian Petzold. All three had learnt their craft under the tutelage of the experimental filmmaker Harun Farocki (with whom Petzold still collaborates), and had been making films since the early 1990s, sharing, Worthmann suggests, a 'love of the elliptical and a tendency towards distanciation', through which they revealed 'a similar understanding of space and time', cast in a similarly 'sober but intensive light' (Worthmann 2001). By the middle of the following decade the term had gained traction amongst critics. Indeed, it was now being used to describe the work of a growing number of filmmakers from across the German-speaking world, including graduates of the *Hochschule für bildende Künste*, Hamburg, Ulrich Köhler and Henner Winckler; of the *Hochschule für Fernsehen und Film* in Munich, Benjamin Heisenberg and Maren Ade; of *HFF 'Konrad Wolf'*, Potsdam-Babelsberg, Maria Speth and Matthias Luthardt; as well as Valeska Grisebach, a graduate of the Viennese film school and Aysum Bademsoy, who studied theatre at Berlin's *Freie Universität*, most of whom had subsequently begun to live and work in the capital. During the decade the notice taken of this group also grew amongst critics and judges at the major festivals. Particularly in France these filmmakers attracted a good deal of attention, being fêted by the *Cahiers du Cinema* as a 'Nouvelle Vague allemande' (Loutte 2005; Corsten 2006; Lim 2009) – praise, it might be noted however, that has done little to overcome the disinterest of domestic audiences, with very few of their films attracting

more than 100,000 spectators (notable exceptions include Petzold's *Die Innere Sicherheit* and Maren Ade's *Alle Anderen*/Everyone Else, 2009),[5] with the vast majority selling less than 15,000 tickets on their theatrical release (FFA 2010b). The term itself is also now viewed with increasing scepticism by some of the group, with Arslan and Schanelec dismissing it as an example of lazy journalistic shorthand that ignores the important differences between individual filmmakers and films (Hanich 2007). Such concerns notwithstanding, it is now established nomenclature. Moreover, the numerous aesthetic and thematic points of correspondence between these filmmakers which suggest they might be viewed as a group would appear to be underlined in the collective approach they often adopt in their filmmaking practice, with many of those mentioned above working either formally or informally on each other's projects, be it writing together, assisting in productions or simply acting as a sounding board for ideas. As Heisenberg put it in an interview for the magazine *Revolver*, which he set up with a number of other artists including Hochhäusler, Köhler, Jens Börner and Nicolas Wackerbarth and which functions as something of a house publication for the group, 'we are the type of people who like integration [...] None of us is a complete autocrat – or a dictatorial director' (Heisenberg *et al.* 2006: 21), Hochhäusler goes on to explain in the same interview that 'even when we say "I've written the script alone" this will have involved very lively and intense discussions with others' (Heisenberg *et al.* 2006: 22).

A central point of connection between these filmmakers is their exploration of cinematic realism in both the form and content of the work produced. 'Reality is the key to the Berlin School', suggests critic Hanns-Georg Rodek. However, as Worthmann's characterisation of the work of Schanelec and others quoted above also suggests, 'it's not the shaky hand-held camera reality captured on the street. This distinguishes them from Dogme vitalism; puts them miles away from the commercial auteur cinema of *X-Filme* and light-years apart from Bernd Eichinger's populism' (Rodek 2006). To this list could be added the social realism that informs the work of Dresen and other ex-GDR filmmakers. Like Dresen, Berlin School films are generally located in the reality of a post-unification German society coming to terms with the pressures of globalisation and economic downturn. However, unlike the working-class milieu explored in *Halbe Treppe*, much of the Berlin

School focuses on the experience of the middle class and what Petzold describes as the 'melancholia of the new bourgeoisie' (Graf et al. 2006: 4). In so doing, they turn the world depicted in the 1990s comedies on its head, focusing on the malaise that ostensibly surrounds those members of the 68er generation who, having put their days of protest behind them, are now going through their mid-life crisis as the elite of mainstream society. At the same time their children, the central focus for much of this work, who have lived their lives in the comfortable affluence their parents have always provided, have also been left with a profound sense of crisis as they struggle to find a role for themselves in society independent of their parents. This is the world to be found in Köhler's study of a young national service conscript who goes AWOL at his parents' holiday home, *Bungalow* (2002), Hochhäusler's *Falscher Bekenner* (Low Profile, 2005), the story of a young man who resorts to falsely claiming responsibility for violent crimes as a way of escaping the bourgeois life mapped out for him by his parents, or the worldview of Maren Ade's young couple walking a tightrope between integration into the professional world of adult life and their need to find individual self-expression, *Alle Anderen*.

At times, the characters of such films seem to evoke the 'slacker' ethos made famous in the work of the US independent filmmaker Richard Linklater, whose communal approach to filmmaking would also seem to echo that of many Berlin School artists. The middle-class drifters of Linklater's 1991 film *Slacker*, as well as the walking and talking would-be lovers of his *Before Sunrise* (1995) and *Before Sunset* (2004) make a virtue of their directionless lives, transcending the apparent banality of their bourgeois existence in the elective affinities they find in the temporary communities created through the intellectual banter of their conversations. Such interaction allows them to reconfigure and find new value in their previous education and experience, redefining the geography of the spaces they inhabit as one of possibility rather than alienation.[6] However, the directionless protagonists that inhabit Maria Speth's *In den Tag hinein* (The Days Between, 2001), Jan Krüger's *Unterwegs* (En Route, 2004) or Köhler's *Montag kommen die Fenster* (Windows on Monday, 2006), who journey through their filmic worlds largely in silence, are unable to communicate, finding little or no solace in the community of others. Nor, as David Clarke observes, are they able in any way 'to impose their own desires on their physical

surroundings' as Linklater's characters might, at times seeming to pass through their environment as a ghostly presence, the camera affirming their ephemeral sense of isolation and loss (Clarke 2011). The empty bourgeois world of these films is in turn reflected in what Abel defines as 'an aesthetics of reduction reminiscent of Robert Bresson, Michelangelo Antonioni, Michael Haneke, the Dardenne brothers' (Abel 2010: 260). As already suggested, one might also find parallels with the work of American independent filmmakers such as Linklater or Gus Van Sant, as well as the French New Wave auteur Eric Rohmer, an influence particularly evident in the frequent use of holiday locations for these films' settings. It can, furthermore, be viewed as part of a broader trend within contemporary world cinema, defined variously as 'slow cinema' (Romney 2010), 'the school of indirection and inconsequence' (James 2008) and 'unspoken cinema' (Tuttle 2007), to be found in the work of Abbas Kiarostami, Apichatpong Weerasethakul, Carlos Reygadas, Béla Tarr and others (de Luca 2011). For the Berlin School filmmakers themselves it is clear that the New German Cinema is also an important connection, reflected in the choice of Fassbinder holding a pistol on the front cover of the first edition of *Revolver*, or the interviews included in the magazine with the likes of Herzog, Syberberg and Kluge, filmmakers chosen in a deliberate attempt to 'reconnect' with a German tradition of *Autorenfilm* that they felt had been lost for much of the 1990s (Heisenberg *et al.* 2006: 13). Specifically the 'aesthetics of reduction' are manifest in the slow pace of these films, often dominated by long takes and wide shots. The camera is often static and when it does move the use of a Steadicam avoids the jerkiness associated with the documentary realism discussed in connection with Dresen. The acting is invariably understated. Indeed, many of the people we see on screen are not actors at all. There is only limited use of extra-diegetic sound effects and music in these films, which offer few of the normal external markers of plot development that help narrative exposition in mainstream films. Thus, a character's attempted suicide, such as is glimpsed in Valeska Grisebach's *Sehnsucht* (Longing, 2005) is presented, in structural terms, as if it were no more or less significant than the previous sequence of the same man building a rabbit hutch, or a woman abandoning her family by mobile phone in *Montag kommen die Fenster* as no more profound than a group of young men acting out a role-playing

fantasy game. While such juxtaposition might be read as signifi-
cant within the symbolic economy of the films, this symbolism
is generally deliberately downplayed, its construction stripped of
anything that would highlight a sequence's status as a moment of
climax within the narrative. In similar vein, the decisive narrative
moments often happen elsewhere in these films, either in the cut
or outside the frame, having to be inferred from what the spectator
hears or sees. That said, there is in actual fact often very little that
happens anywhere in these films. As a result, they at times reflect,
again as Abel notes, what André Bazin describes as a 'true realism',
their cameras 'staring' unremittingly at the everyday, often banal
world they present in order to force the spectator to look at it
anew, 'render[ing] sensible', rather than simply 'capturing' the
profilmic event (Abel 2008a). Consequently, a more profound sense
of 'reality', immanent within the images on the screen, is revealed,
a manifestation of what, as I shall discuss further below, Gilles
Deleuze would later describe in an extension of Bazin as the
'time-image', with representational and expressive possibilities
that challenge the limitations of the type of mainstream narrative
cinema one often finds in Hollywood. This is realised in the space
Berlin School films create for the engagement of the spectator.
As such, many of these filmmakers also evoke Dresen's aim of
transfiguring the everyday. However, the methods used by Berlin
School filmmakers tend to differ radically from those of Dresen. In
the rest of this chapter I shall examine how Angela Schanelec and
Christian Petzold, two of the first generation of Berlin School film-
makers, both explore the cinematic possibilities of Deleuze's 'time
image' in their engagement with realism. In so doing, I also hope to
show the variety of approaches to filmmaking amongst the group,
even within the stylisation offered above, a variety elided in the
construction of the Berlin School as homogenous.

 As Sabine Hake points out, the formal characteristics of the
Berlin School are at their most pronounced in the work of Schanelec
(Hake 2008: 206). Within the context of Abel's 'aesthetics of reduc-
tion', her work is amongst the most 'reduced', offering little in terms
of character development or narrative resolution. Instead, through
a series of long takes Schanelec's films tend to present a sequence
of portraits, capturing partial moments in the lives of her gener-
ally female protagonists as they negotiate the contemporary urban
world. This might involve coming to terms with pregnancy and

motherhood as is the case for the nineteen-year-old student Mimmi (Sophie Aigner) in *Plätze in Städten* (Places in the City, 1998) or the realisation that one might have to negotiate life without family as many of the collection of thirty-something characters in *Mein langsames Leben* (Passing Summer, 2001) are forced to contemplate. The emotional impact of such contemplation is, however, only ever intimated in Schanelec's films. Their explicit focus is, instead, the extended periods of banal normality that define her characters' lives, rather than any specific moments of narrative drama. In the process, the spectator is always kept at a distance from her characters' stories, forced to imagine the details of the narrative as well as its emotional ramifications in their lives from the fragments of conversations we overhear or from the way they engage with the world around them.

Marseille (2004) is an extraordinarily spartan example of Schanelec's work that cemented her reputation particularly with French critics, garnering her a second invitation to the Cannes Film Festival. In the film we follow Sophie (Maren Eggert) who has swapped flats with a woman in the French city for two weeks. She meets a mechanic, Pierre (Alexis Loret), and seems to begin a relationship with him. She returns to Berlin. Here we are introduced to her best friend, Hanna (Marie-Lou Sellem) who appears to lead a life that Sophie longs for, having what Sophie sees as a wonderful young son and partner, the successful photographer Ivan (Devid Striesow). Does Sophie in fact love Ivan? Have they even had a relationship? Did she go to Marseille to escape her feelings for Sophie's family? We can surmise, but we are not told. Hanna, for her part, is clearly dissatisfied with her life, frustrated by the limitations having a child puts on her acting career and resentful perhaps of her partner's apparently easy success. Hanna's life is, to a degree, constructed as a parallel version of Sophie's, hinted at in mirror sequences of the two women staring out of a window as they travel by train: Hanna in Berlin returning home with her son, frustrated by the boy who has run off and caused her to lose her lines for the play she is rehearsing; Sophie on the way back to Marseille at the end of film, having decided to leave Berlin for a longer period, where she might develop her own career as a photographer – we have seen her taking pictures of the Marseille streets during her earlier stay – or revisit her relationship with Pierre. However, such mirroring only gestures towards parallels

in the lives of the two women. Ultimately, we can only guess at Hanna's motivation. It is never made explicit.

Central to Schanelec's approach to film is the refusal to show the main events that drive the narrative. Instead, we are given glimpses of the characters' reaction to what has happened to them. This is shown most obviously at the end of the film, when we learn that Sophie has been robbed of her clothes and other belongings on her return to the French city. We do not see the attack on Sophie. Instead we are given a close-up of the lower body of a policewoman handing Sophie a dress to put on and a cut to a shot of Sophie sitting at an interview table in the police station, framed by a door – a frequent perspective in the Berlin School's work, foregrounding the distance the spectator is from the space of the film. From off screen we hear a series of questions in French, rendered into German by a translator sitting next to her but ignored for a prolonged period by Sophie until suddenly she recapitulates in detail the events of the attack. Thus the world beyond the frame, outside that which is represented, is evoked, a strategy that is used throughout the film. In so doing, Schanelec seeks, on the one hand, to avoid the clichés to which representing 'events' such as a robbery might lead her, instead offering her audience, she hopes, images that they will not have seen before (Schanelec 2006: 412). On the other, it moves the focus away from the narrative itself to the impact of the narrative on the characters. The camera highlights the difficulty Sophie faces as she tries to relate events, finally beginning to break down into tears, perhaps as a response to the attack, perhaps to some broader sense of crisis in her life, lingering for a moment on her face as she slowly starts to be overwhelmed by emotion. More frequently, however, the off-screen space is utilised to intimate a more complex story of which the moments we are given access to are just a small part. These include a sequence in a bar where Sophie meets Pierre and is treated rudely by one of his acquaintances for no apparent reason, or a moment outside Sophie's flat on her return to Berlin when we learn that the woman with whom she swapped flats in Marseille never came to stay. Because we never learn why or what happened to her, the glimpses we are given into Sophie's life seem to be part of a much larger world we sense but cannot know. This feeling is further emphasised in Schanelec's frequent use of wide shots, such as in the final moments of the film when we watch a sequence of long takes of a

16 Sophie (Maren Eggert) sits in a police station next to a translator (Frederic Moriette) trying to compose herself, *Marseille* (2004).

Marseille beach over the course of a day, culminating in an image of Sophie wandering along its edge. Sophie cannot be seen until the final take. This is not to say that she is not present somewhere in the earlier more crowded shots of the day. However, crucially the camera also captures everything else that is going on, moments in the numerous other narratives taking place within the same frame. As Schanelec suggests, 'I don't like it, when everything that one sees in a picture tells you something about the character. I get nervous when everything is there to make something understandable' (Schanelec 2006: 407).

The contingency of the images we see on screen is also highlighted in the way the film is edited. *Marseille*, like all of Schanelec's work, avoids the use of shot/reverse shot sequences. For example, in the film's opening we see the French woman driving Sophie to her flat. The frame is dominated by the driver, shot from the backseat of the car, accompanied by the hum of the car's engine, the sounds of the street outside and an occasional response to a question from the woman's passenger, who remains off screen. By refusing to give the spectator the typical reverse shot, the other half of the conversion is heard but unseen, requiring the imaginative engagement of the spectator for its completion. The use of elliptical framing that excludes and yet evokes the off-screen space in turn reflects a broader gesture of the film as a whole, the continual use of

long takes opening up representational possibilities that reject any sense of resolution or narrative closure. In this regard, *Marseille* is evocative of the type of film described by Deleuze in his discussion of the 'time-image', namely films that, he suggests, escape the reductionism of mainstream narrative cinema and its impulse to limit the world to a mediated version of reality constructed around the movement of a hero towards narrative closure. Such 'movement-image' films were seen by Deleuze as the defining mode of film production in the first half of the twentieth century. In the wake of the Second World War, however, he identifies a shift towards the 'time-image', often characterised by the use of the long take in the films of the Italian Neorealists, the French New Wave and other post-war avant-garde film movements (Deleuze 1989: 1–41).[7] In such cinema, rather than marking the passing of narrative time through character movement, 'time-images' ostensibly offer glimpses of a world somehow beyond mediation, allowing the spectator to experience time itself as it is happening, as 'duration', thereby opening up the infinite possibilities of space that eschews the manipulation of character or the limitations of a plot heading inexorably to its resolution.[8] Thus, such films can present a world 'which cannot even be said to exist, but rather to "insist" or "subsist", a more radical Elsewhere' that problematises the construction of time and space as a straightforwardly homogenous continuum as suggested by the movement-image with its clearly demarcated narrative universe (Deleuze 1986: 18). It is this world which is evoked at times in Schanelec's work and which, in turn, emphasises the broader gesture in many films of the Berlin School to 'render sensible', as Abel puts it, rather than straightforwardly to represent the profilmic event.

The 'rendering sensible' of this 'radical elsewhere' is particularly clear in the ways *Marseille* foregrounds moments of affect without offering their resolution into emotional expression or action. One sees this, for example, in what might be termed the 'open-ended' shots of characters' faces, be it a close-up of Sophie peering intensely along a Marseille street as she looks for a subject to photograph, or in the final close-up of her face described above which cuts before she is entirely overwhelmed by her tears. In both these cases emotions begin to erupt on to the woman's face. However, the camera cuts before such emotions become completely clear, before they can be resolved into an 'event', freezing them at the moment

of their most affective potential. It is, moreover, through the use of affect that the film also points towards an underlying political project within Schanelec's films that challenges the limitations perceived by many of her female protagonists within the world they inhabit. This can be seen most obviously in a photo-shoot sequence during which a series of women have their picture taken by Ivan. Each woman sits uncomfortably in the frame, staring at Ivan who takes their picture off screen, at times trying to strike up conversation with the women, at times giving them instructions about how to fix their hair or how to hold their hands. The women subtly challenge Ivan's authority, refusing to speak to him or insisting that they remove their hair band for their picture. In so doing, the women gently rebel against the constraints imposed upon them by Ivan's gaze and the frame of his pictures which defines them specifically as factory workers. Consequently, unlike Ivan's implied still camera, Schanelec's moving camera captures their rebellion and gestures to what else these women are, finally coming to rest on an image of a woman sitting behind the man, having a break from work. She slowly lifts her eyes, staring up at Ivan off screen, Schanelec's camera refusing to constrain her gaze as she stares at the photographer, perhaps in trepidation, perhaps irritation, at his disturbing presence in the predominantly female space of the factory. The protests of the women claim both the space and, crucially, the time that they inhabit. Instead of fitting within Ivan's time and space, they reterritorialise both to make them their own. In the process, Schanelec's shot captures the potential of resistance and thus change within the female subjects of the factory, elided in the controlled stillness of Ivan's photographs, photographs which also contrast starkly with the people-less pictures Sophie takes of the Marseille streets we see her attach to the wall of her French flat. Her own photographs, like Schanelec's film itself, refuse to fix human – and in particular female – subjects into an eternal moment of stillness.

Christian Petzold, the best known of the Berlin School filmmakers, like Schanelec, is intent upon 'rendering sensible' Deleuze's 'radical elsewhere' that subsists within the everyday world he presents in his films in a manner that also evokes Bazin's concept of 'true realism'. 'You have to behold the most everyday space,' he suggests, 'until it looks back, until it becomes mysterious' (Abel 2008b). In a gesture that would seem to evoke some of the aims of

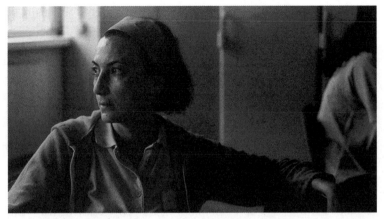

17 The women of the factory (here Özen Erfurt) refuse to submit completely to Ivan's (Devid Striesow) camera, *Marseille* (2004).

Dresen's realism but nothing of his method, Petzold uses film as a mechanism to reconfigure the profilmic world in a way that can reveal what he perceives to be its underlying essence, forcing the spectator to look at the everyday anew. His approach also differs from Schanelec in at least two respects. First, Petzold has a more explicit and self-conscious preoccupation with the political than Schanelec, his films seeking to provide 'new images', as he puts it, of a contemporary German society in the grips of late capitalist globalisation. 'Sure, we have these airport boarding zones, where we see modern people with laptops, reading high-gloss magazines, wearing Rolexes and Burberry clothes. All this is only a surface, but we do not have images for how this new form of capitalism *operates*' (Abel 2008b; emphasis in original). This is particularly evident in his *Ghost Trilogy* (*Die innere Sicherheit*/The State I Am In, 2000; *Gespenster*/Ghosts, 2005; *Yella*, 2007), films in which his protagonists pass through the landscape they inhabit almost as spectres, unable to make their presence felt. As already suggested, this is a motif in a number of Berlin School films: however, it is at its most pronounced in Petzold's trilogy. It is at work, for example, in the left-wing 1970s terrorists returning home with their teenage daughter in *Die innere Sicherheit* to a now 'normalised' society where their former comrades have become members of the bourgeois elite; or in Nina (Julia Hummer), the teenage orphan of

Gespenster who lives on the edge of society and yet at the heart of Berlin, the spaces around Potsdamer Platz where she spends her time presented to the spectator as a parallel universe immanent within, and yet separated from, the metropolitan life images this area usually connotes in the media (Abel 2010: 270–1).

Second, and somewhat counter-intuitively perhaps, in his attempt to find 'new images' to reveal the essence of the new reality in the Berlin Republic, Petzold continually revisits the old conventions of classical genre cinema. While Schanelec's films challenge the notion of narrative in their invocation of the Deleuzian 'time-image', Petzold's 'time-images' deliberately evoke and play with traditional forms, deconstructing classic genres in a fashion reminiscent of Fassbinder in his engagement with the Sirkian melodrama or, as I shall discuss below, the mores of film noir. In so doing, Petzold, like Schanelec, presents the spectator with an open-ended, irresolute image of reality, rooted in the social traumas of contemporary society, while also highlighting his awareness of the images and stories he has inherited from his broader cultural history. 'I make films in the cemetery of genre cinema,' Petzold claims, 'from the remainders that are still there for the taking' (Abel 2008b). This might involve adopting tropes from the vampire movie to reflect the status of West German urban terrorism as unresolved, 'undead' history within post-unification society, as Chris Homewood discusses in his analysis of *Die innere Sicherheit* (Homewoood 2006), or reworking Herk Harvey's horror film *Carnival of Souls* (1962) in *Yella* (2007), a film that 'render[s] sensible' the grotesquely ephemeral workings of white-collar corporate capitalism (Abel 2010: 266–9; Fisher 2011).

Jerichow continues Petzold's exploration of genre cinema, reinterpreting James M. Cain's hardboiled fiction *The Postman Always Rings Twice* (1934), adapted for cinema on numerous occasions, notable examples including *Ossessione* (Obsession, 1943) by Luchino Visconti – generally considered to be the first Italian neo-realist film – and Tay Garnett's classic film noir *The Postman Always Rings Twice* (1946), starring Lana Turner and John Garfield. Cain's narrative tells the story of a young drifter drawn to commit murder by a femme fatale who wants to be rid of her husband in order to take over his business. In Petzold's film this becomes the story of Thomas (Benno Fürmann), an ex-soldier who has served in Afghanistan and who has been dishonourably discharged for

reasons we never learn. Thomas returns home to his house in the east German provincial town of Jerichow after the death of his mother. He takes a job as a driver for Ali (Hilmi Sözer), a rich Turkish businessman who owns a string of snack-bars and, in accordance with the love-triangle narrative of Cain's original story, soon falls for Ali's wife, Laura (Nina Hoss). Ali seems to hold Laura hostage, having agreed to pay off the huge debts she has accrued and for which she has served time in prison, if she will stay with him. Through Thomas, Laura sees a way of escaping her marriage with Ali and the lovers plot the man's murder. As is clear from this outline, the film adopts many of the key elements of Cain's novel, as well as tropes from Tay's adaptation. However, in Petzold's retelling, the story is stripped to its generic bones, challenging expectations of a film noir in order to reveal the social reality that lies beneath. In the process, Thomas and Laura become what Michael Sicinski calls 'place holders' for their respective functions in the noir narrative, without convincingly delivering the expectations such roles normally bring (Sicinski 2009: 8). Consequently, instead of being introduced as a destructively beautiful femme fatale who immediately entrances her future lover – epitomised by the introduction of Lana Turner in Tay's film in a shot that slowly tracks up her body, fixing her as the knowingly desired object of the young man's gaze – Laura in Petzold's film is generally oblivious to Thomas's initial glances. The famous shot of Turner's toned legs contrasts starkly with the image of Hoss wiping the sweat from her armpits as Laura loads her husband's van with supplies for his snack-bars. Similarly, when Laura and Thomas are first overwhelmed with passion, falling on each other in the corridor outside Laura's bedroom as Ali lies in a drunken stupor within, the violence of their ardour is out of step with the generally understated, slower-paced calm of their previous interactions. Unlike the equally famous sex scene involving Jack Nicholson and Jessica Lange in Bob Rafelson's 1981 version of the story which this moment overtly recalls, the voracious sexual attraction of the two characters in *Jerichow* is so over the top that it appears almost deliberately *not* to engage the spectator. Here the film evokes the tired rendition of the genre's expectations one finds in Fassbinder's early gangster-noir cycle (*Liebe – kälter als der Tod*/Love is Colder than Death, 1969; *Götter der Pest*/Gods of the Plague, 1970; *Der amerikanische Soldat*/The American Soldier, 1970), in which the

18 Laura (Nina Hoss) works up a sweat, *Jerichow* (2008).

characters simply go through the motions of their generic function. Both Petzold's and Fassbinder's slow pace of storytelling allows for prolonged periods of hollow time created through their characters' inaction, moments that, once again, fulfil the requirements of the 'time-image' in their ability to gesture towards a realm of experience beyond the confines of plot. In Petzold's film, however, the characters are somehow less knowing, or perhaps simply more accepting, of their specific function within the narrative than in Fassbinder. Nonetheless, the formal requirements, in this case of a noir *l'amour fou*, similarly seem to jar with them.

This sense of jarring in Petzold is due in large part to the specific social context of his characters. As a result, the escapism of Tay and Rafelson is ultimately replaced by Visconti, his neo-realist focus on the difficulties of everyday life for ordinary people in Italy towards the end of the War, with a specific emphasis on the labour required for survival during the period, transposed here to the ex-GDR province. Notably, this is a space which seems to have been largely evacuated of people, its emptiness punctuated by a few misfits like Thomas and Laura or migrants such as Ali and the far less wealthy workers who run his snack-bars. In the process, the film points to the transformation of this former communist landscape – the legacy of which is implied in the address of Thomas' house, 'Friedrich-Engels-Damm 1' – into a space controlled by the vicissitudes of late capitalism, where a migrant workforce has come

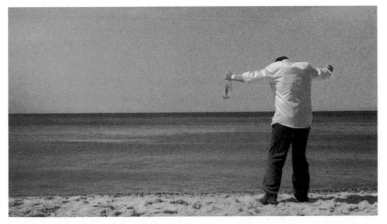

19 Ali (Hilmi Sözer) dances on the beach in a drunken stupor to music from his Heimat, *Jerichow* (2008).

to fill the spaces left by the indigenous ex-GDR population that has moved to seek its fortune in the more affluent west. This is a space where everything is contingent on one's economic circumstances, even love, as Laura insists in a moment of clarity when she briefly breaks out of her role as a doomed noir lover, not to reveal her status as a femme fatale using her wiles for economic betterment, but to acknowledge her lack of agency against the forces of global capitalism that define the rules by which they all have to live. At the same time, it is a place where economic power still does not necessarily bring with it acceptance into mainstream society, as Ali makes clear towards the end of the film. Having been diagnosed with a fatal heart condition – a diagnosis that undermines the very motivation for the noir murder plot – the man declares to his wife that, for all his success, he lives in a country that does not want him, a country where he has to buy the love of a wife and where he is forced to create an artificial sense of belonging, or Heimat, in drunken moments of sentimentality listening to Turkish love songs.

Petzold's film noir, told at a far slower pace than Tay's version of the story against a mise-en-scène largely evacuated of people, forces us to look anew at the economic and social challenges faced by those few characters we do encounter. Importantly, unlike many recent examinations of life at the periphery of German society, but in a manner that is typical of films throughout the Berlin School, Petzold's main protagonists are not members of

the social underclass. Ali is a wealthy man. He and his wife live in a bourgeois house. Even Thomas, who Laura suggests 'lives like a tramp' – a further invocation of his character's role in the original *Postman* narrative – owns his detached family home, a sign of particular affluence, as the woman in the unemployment office makes clear to him when he goes there to seek a welfare payment. In transposing his presentation of bourgeois society to the world of the ex-GDR and refracting it through the prism of film noir genre conventions, Petzold seeks to provide 'new images' for the social reality of the Berlin Republic: presenting the experience of the people who are a direct product of this society, who live at its edge, and yet whose experience speaks to and challenges those who live at its centre. As such, his approach to filmmaking is far removed from the guerrilla tactics of Stahlberg and Mittermeier's 'Bluewater Attack'. It is also very different to the type of 'magic' realism, with its bitter-sweet, but fundamentally optimistic, view of life in the ex-GDR found in Dresen's *Halbe Treppe*, or the cinema of Schanelec with its rejection of narrative in favour of an optic on the world that focuses on the spaces between narrative events. What unites all these filmmakers, however, is their urge to exploit the indexical qualities of the cinematic image, to utilise but also to question the camera's ability to capture an immediate, 'authentic' image of the external world. The role of 'authenticity' in cinema will continue to be central to our discussion as we turn to contemporary heritage filmmaking, one of the dominant genres in Germany during the 2000s. As we shall see in several of the following chapters, heritage films speak to many of the issues that are central to the debates presented in this volume. In the following chapter, however, we look at the key question they provoke, namely how the nation should confront the competing legacies of its problematic past.

Notes

1 It is perhaps worth noting, of course, that the general urge to create the illusion of reality in order to increase the 'hype' around a media event is not in itself new. One thinks, for example, of Orson Welles' Mercury Theatre production based on H.G. Wells' *The War of the Worlds*, broadcast on 30 October 1938. Welles' radio play was presented as a series of news bulletins in order to create the illusion that New York was actually being invaded by Martians.

Press reports at the time suggested that the broadcast provoked mass hysteria amongst listeners. The impact of the event amongst the general public has long been debated. Less debatable is the outrage the broadcast caused within the press, largely attributable to its apparently unacceptable level of 'realism' due to the play's format. For further discussion see Flynn 2005: 31–46.

2 For further discussion see Plowman 2010.

3 Interestingly, this was also the term preferred by Goebbels, who insisted upon its use during the Third Reich in order to avoid usage of the French word 'Regisseur'. As will be obvious from my discussion of Dresen's approach to filmmaking, however, it is clear that this connection is entirely coincidental.

4 With regard to the place of Dogme 95 in the tradition of realist filmmaking, it is worth noting that the 'vow of chastity' had little to do with questions of realism. Rather the rules von Trier and others set out were simply a means of restricting creative freedom in order, ultimately, to further inspire it. As their careers have developed, the Dogme 95 artists have happily broken their own rules. That being the case, it should be noted that they would also tend to agree with Dresen in his approach to dogmas per se (Kelly 2000).

5 These films gained broader public attention due to the mainstream publicity they received after their success at important German awards ceremonies. *Die innere Sicherheit* won the German Film Prize in 2001, *Alle Anderen* the Silver Bear at the 2009 Berlinale.

6 For further discussion see Stone 2012.

7 The historical accuracy of Deleuze's characterisation of a broad shift from 'classical' to 'modern' filmmaking in the wake of the war, and with it a shift from films dominated by the 'movement-image' to the 'time-image' has been much challenged by scholars. David Martin-Jones, for example, discusses the continued role played by the 'movement-image' in various mainstream and more avant-garde films in recent years. While the concepts of the 'movement-image' and 'time-image' remain useful heuristic devices for an exploration of film's ability to represent time, Deleuze's historical contextualisation is largely a result of his own subjective predilection for certain types of movies (Martin-Jones 2006: 19).

8 Deleuze takes his definition of 'duration' from Henri Bergson and the concept of time existing in a 'pure state', as part of an eternal present. The 'time-image', Deleuze suggests, gives us a glimpse of time in this state. For further discussion see Rodowick 1998: 18–37.

3 Heritage cinema, authenticity and dealing with Germany's past

The films of the Berlin School often seek to offer the spectator access to a 'true reality' that goes beyond the surface of the world they present, looking to open up the potential of the cinematic landscapes they explore. As such they point to a depth of expression that would seem to be far removed from what Hanns-Georg Rodek describes as 'Bernd Eichinger's populism' (Rodek 2006). Eichinger and *Constantin Film*, the company with which he was associated from the 1970s until his death in 2011, are the closest the German film industry comes to a Hollywood-style film mogul and major production company. Over the years Eichinger produced a huge number of very successful commercial films both at home and abroad, including international hits such as *Die unendliche Geschichte* (Never Ending Story, Wolfgang Petersen, 1984) and *Resident Evil* (Paul W.S. Anderson, 2002) along with Michael 'Bully' Herbig's parody of the German *Winnetou* Westerns, *Der Schuh des Manitu* (Manitou's Shoe, 2001), which achieved the largest domestic audience for a German production for decades (10.5 million). During the 2000s Eichinger's impact could be particularly felt within the heritage film boom that was at the centre of the renewed international interest in the nation's cinema, one of his most notable success in this regard coming with Oliver Hirschbiegel's *Der Untergang* (Downfall, 2004), which grossed €76 million against a budget of around €13.5 million and garnered an Oscar nomination for best foreign-language film. Telling the story of Hitler's final days, *Der Untergang* fed into the continued international fascination with the legacy of National Socialism. As such, it was a highly visible example of perhaps the most pronounced trend within German film production from the late 1990s onwards.

Other examples of this trend include Max Färberbock's *Aimée & Jaguar* (1999), the story of a lesbian love affair between a Jewish woman and her non-Jewish lover as the couple negotiate life in a war-torn Berlin, or *Rosenstraße* (2003), Margarethe von Trotta's portrayal of the non-Jewish women who protested against the internment of their Jewish husbands. These films present what could be termed 'Schlindler's List' moments, that is, stories which, like Spielberg's 1993 blockbuster, give heroic accounts of non-Jewish solidarity with Jewish victims, thereby suggesting the continuation of a kernel of German humanity during the period that was not extinguished by the Nazi takeover and has once again taken hold in the present-day state. One could also point to a range of narratives from Volker Schlöndorff's *Der neunte Tag* (The Ninth Day, 2004), to Marc Rothemund's Oscar-nominated *Sophie Scholl – Die letzten Tage* (Sophie Scholl – The Final Days, 2005) or Roland Suso Richter's hit television mini-series and, less successful, 'amphibian' cinematic film *Dresden* (2006) which present similarly heroic moments but through an overtly Christological prism, offering audiences a redemption narrative, their stories of noble suffering and sacrifice seeming to point forward to, and thus provide a moral foundation stone for, the post-unification democracy of the Berlin Republic. There has also been a whole raft of films that consider the extent to which 'ordinary' Germans themselves might be seen to have been 'victims' of the National Socialists and the ways in which the population at large suffered during and in the aftermath of the war, a suffering that, it is often suggested in the press, can only now be acknowledged. Such films include Sönke Wortmann's *Das Wunder von Bern* (The Miracle of Bern, 2003), which gives an account of a returning Soviet POW against the backdrop of the German football World Cup win in 1954, or Max Färberböck's *Anonyma – Eine Frau in Berlin* (A Woman in Berlin, 2008), based on an originally anonymous account of the mass rape of German women by the Red Army in the final days of the war first published in 1954. To this could be added numerous other television mini-series, including Kai Wessel's story of the plight of a group of expellees – the name given to those Germans forced to leave their homes east of the Oder-Neisse line at the end of the war – *Die Flucht* (March of Millions, 2007), and Joseph Vilsmaier's *Die Gustloff* (The Ship of No Return, 2008), which depicts the sinking of the refugee ship the *Wilhelm Gustloff* on 30 January

1945. Most controversial of all in this regard are films such as Hirschbiegel's *Der Untergang*, or Dennis Gansel's story of life in an elite Nazi boarding school *NaPolA: Elite für den Führer* (Before the Fall, 2004), a homoerotically charged world reminiscent of Marek Kanievska's *Another Country* (1984). These films almost entirely ignore broader questions of German culpability for past crimes, asking to what extent we should now even forgive certain National Socialists. Should we even view some members of the regime itself as 'victims' of the time? Or, if seeing a figure such as Hitler as a 'victim' is impossible, can we at least acknowledge his 'suffering' at the end of the war?

This period in German history has long been of interest to film-makers at home and abroad (Cooke and Silberman 2010). Indeed, representing Hitler in film can be traced back at least as far as Chaplin's *The Great Dictator* (1940). Such history films were particularly important for the international success of the New German Cinema towards its end in the 1970s and early 1980s, with Volker Schlöndorff's *Die Blechtrommel* (The Tin Drum, 1979), Helma Sanders-Brahms' *Deutschland bleiche Mutter* (Germany Pale Mother, 1979) and Fassbinder's *FRG Trilogy* (*Die Ehe der Maria Braun*/The Marriage of Maria Braun, 1979; *Die Sehnsucht der Veronika Voß*/ Veronica Voss, 1982; *Lola*, 1981) all addressing Germany's National Socialist past and garnering great acclaim around the world. In the GDR, depictions of the Third Reich and the War were also common. Here they invariably engaged the state's official doctrine of 'antifascism', a key element in its foundational narrative as the 'better' of the two post-war Germanies. As Sabine Hake notes, although they have tended to be overshadowed by West German films, the GDR produced a number of fascinating explorations of Germany's recent past, including Frank Beyer's *Nackt unter Wölfen* (Naked Among Wolves, 1963) and Konrad Wolf's *Ich war neunzehn* (I Was Nineteen, 1968), films that offer a more complex and nuanced engagement with state ideology than many readings of GDR film history suggest (Hake 2010). While such DEFA films were rather less successful internationally than West German film during the Cold War, it is, nonetheless, interesting to note that it was the Nazi period, and specifically the Holocaust, that provided the GDR with its one Oscar nomination, for Frank Beyer's *Jakob, der Lügner* (Jacob the Liar, 1975). With German unification, interest in this period grew exponentially, fuelled by a series of very public

debates. These included the controversy surrounding the 'Wehr-macht Exhibition' of the mid-1990s that depicted atrocities carried out by German soldiers on the Eastern front, the protracted debate around the building of the Holocaust memorial in Berlin, the status of the Allied destruction of German cities such as Dresden and Cologne as war crimes or the proposed memorial to the expellees (Niven 2001). It is no surprise, therefore, that the period should continue to attract the attention of filmmakers, and that such films, like those of previous generations, have played a key role in igniting interest in German film amongst international audiences. What has changed, however, is the dominant tone of the films produced. As Rentschler suggests in his 'cinema of consensus' essay, while the films of the New German Cinema 'interrogated images of the past in the hope of refining memories and catalysing changes', much cinema in the 1990s seemed to lack 'oppositional energies and critical voices' (Rentschler 2000: 263–4). By the start of the following decade, as he later notes – and as can be inferred from the brief description of some of these films given above – while the comedies he focuses on in the earlier essay were on the wane, they were now being replaced by an 'equally emphatic culture of commemoration and retrospection' (Rentschler 2002: 4), which seemed to shift the focus away from the question of German culpability for past crimes to an exploration of the extent to which the nation itself suffered under the Nazis and later under the Allied occupation. This shift was part of a broader political, cultural and social process of 'normalisation', much discussed since the 1990s, which sees the nation, having learnt the lessons from the past, now able to be treated like any other western power – the culmination of efforts by successive governments to embed the country within western transnational democratic structures (Taberner and Cooke 2006). In this and later chapters I highlight many of the broader fault lines in debates about the relationship between normalisation, German history and its impact on contemporary society. However, the main focus of this chapter is to be the ways in which normalisation relates to questions of representational 'authenticity', an issue which allows us further to explore the role of realism in contemporary film and specifically the extent to which such realism continues a conservative 'consensual' impulse, or whether the aesthetic choices taken by filmmakers can, at times at least, in fact open up a space for critique, continuing in a different

form, rather than drawing a line under, the debate on the nation's past. This is a debate, moreover, that has become even more complicated since the end of the Cold War as the nation must not only face the legacies of National Socialism but also those of GDR authoritarianism, along with the violent legacies of West German 1970s terrorism.

I begin this chapter by looking at the ways in which contemporary history films, both those dealing with the Nazi past and those looking at other problematic moments in German post-war history, can be seen as part of a broader transnational trend in the production of so-called 'heritage' cinema, to which the question of 'authenticity' has been central, particularly in the marketing of such films internationally. I then examine the types of discussion these films tend to provoke in the German press, as well as in their broader popular reception, not least in the various ways they are consumed on the internet. Finally, I turn to a more detailed examination of one such heritage film, Florian Henckel von Donnersmarck's Oscar-winning, *Das Leben der Anderen* (The Lives of Others), a melodramatic thriller depicting a surveillance operation carried out by the East German Secret Police, the infamous Stasi. Unsurprisingly given its dominant place in contemporary German cinema, the aesthetics and politics of the heritage film, particularly those films that look at the Nazi past, intersect with a number of the concerns explored in this study and will be discussed in further detail in subsequent chapters. Consequently, I choose a film here as a case study that looks at the GDR past. Although very positively received internationally, *Das Leben der Anderen* was a hugely controversial film in Germany. Central to this controversy was, once more, the question of 'consensus' and the extent to which the film offered an 'authentic' portrayal of the past. In my reading, however, I suggest that the focus in particular on the issue of verisimilitude in the film ignored a potentially more complex understanding of the ways in which it might trouble the very notion of historical truth in its engagement with the historiography of the GDR since unification.

German heritage cinema

As Lutz Koepnick argues – and as is suggested in the connection between *NaPolA* and *Another Country* mentioned above – many

contemporary German history films can be viewed as part of a transnational trend towards the production of heritage cinema, presenting the past as a spectacular museum to be consumed by the present-day spectator: 'What typifies heritage filmmaking is the production of usable and consumable pasts, of history as a site of comfort and orientation' (Koepnick 2002a: 49). The heritage film first rose to prominence in 1980s British cinema with the international success of films such as Kanievska's, along with even more successful Merchant Ivory productions such as *A Room with a View* (James Ivory, 1986) and *Maurice* (James Ivory, 1987). These were films that wallowed in the lost world of the British Empire, focusing on the experience and lifestyles of a past elite. In so doing, such films tend to privilege setting over the stories they tell in their painstaking recreation of an authentic image of the past, producing cinema that celebrates the continuity of British heritage culture – as signified most notably by their presentation of the British 'country house' – into the post-imperial present. However, on the level of narrative, many of these films actually tend to challenge the conservative outlook their setting seems to indulge. The stories they tell often problematise the social mores of the time, calling into question the racism, sexism and homophobia at the heart of the British imperialist worldview they present.

While German filmmakers have been influenced by the popularity of the heritage film, the German variation often differs in a number of important ways from the earlier British form. This is due, fundamentally, to the nature of the history depicted. Although there is clearly a tendency to turn the past into a kind of museum in many of these films, its status as a past to be consumed and its relation to the present-day spectator is more problematic. An image of a British country house is not the same as that of a German war-torn building adorned with swastikas. Instead we see a rejection of the concept of 'heritage' as a nation's physical inheritance which is, as Andrew Higson points out, central to the concept in the British film tradition (Higson 2003: 28). Instead, through the films' setting the spectator is allowed to indulge the continued international fascination with the pageantry of fascism and the public's seemingly insatiable appetite for depictions of the war. On the level of narrative, however, the stories they present tend to transmit a timeless sense of 'Germanness', based on an Enlightenment humanist tradition, which can look beyond the barbarity of

20 A country house within a German heritage context, *NaPolA* (2004).

National Socialism and create an inclusive, multicultural notion of a democratic German community.

During the 2000s, the aesthetics of the heritage film also began to be applied to history beyond that of National Socialism to representations of other problematic moments in the nation's recent past, continuing the inversion of the concept of heritage discussed above. In a wide variety of films, the spectator was invited to enjoy the spectacle of a past turned into an easily consumable product, while simultaneously drawing a line under this same period of history in order to confirm the legitimacy of the unified nation. *Wie Feuer und Flamme* (Never Mind the Wall, Connie Walther, 2001), a story of star-crossed lovers told against the backdrop of the East German punk scene of the 1980s, *Der Rote Kakadu* (The Red Cockatoo, Dominik Graf, 2006), a similarly romantic story set on the eve of the building of the Wall and Henckel von Donnersmarck's *Das Leben der Anderen* all attempt to recreate an authentic image of the GDR past that can, on the face of it at least, be clearly bracketed off from the present-day German state. Particularly controversial for some commentators in this regard was the role comedy played in many GDR heritage films, including *Kleinruppin Forever* (Carsten Fiebeler 2004) which transports elements of David Swift's comedy

of errors *The Parent Trap* (1961) to 1980s divided Germany, Leander Haußmann's comedic vehicle for the pop star Kim Frank about the world of the conscript in the GDR's National People's Army, *NVA* (2005) or *Boxhagener Platz* (Matti Geschonneck, 2010), an affectionate look at life around this square in East Berlin in the tumultuous year across Europe of 1968. Throughout these and other films by the like of Haußmann one finds elements of *Ostalgie* ('Eastalgia'), the much-discussed phenomenon of nostalgia for aspects of GDR life reflected most obviously in the popular rediscovery of certain GDR consumer goods. This was viewed as a worrying trend by many who saw such nostalgia as nothing short of an apology for the East German dictatorship. I shall return to the question of *Ostalgie* in my discussion of *Das Leben der Anderen* and again, in more detail, in Chapter 7, where I examine Wolfgang Becker's international hit comedy *Good Bye, Lenin!* (2003), a film that engages explicitly with this phenomenon. It is at this point that I shall also explore the linkages between heritage filmmaking and that peculiarly German genre of the Heimat film, a crossover that has been noted by several commentators. Remaining for the moment with the broader representation of history in contemporary film, elements of a heritage aesthetic can also be found in a number of cinematic representations of West German terrorism, including Christopher Roth's *Baader* (2002) and Uli Edel's *Der Baader Meinhof Komplex* (The Baader Meinhof Complex, 2008), which tell the story of the first generation of the German Red Army Faction, as well as Volker Schlöndorff's *Die Stille nach dem Schuß* (The Legend of Rita, 2000), which contrasts the world of 1970s terrorist violence with the authoritarian state violence of the GDR. There are many other films that could be added to this list, along with numerous television docu-dramas, more often than not produced by Nico Hoffmann's teamWorx company which specialises in such heritage fare (Cooke 2008b). It was, however, not only these difficult areas of Germany's past that began to be represented through a heritage aesthetic, reflecting the drive to turn the past into a straightforwardly consumable product. GDR nostalgia was increasingly accompanied by a form of nostalgic recollection for the pre-unification West German state. Elements of such *Westalgie* are in fact present in some of the terrorist films mentioned above, a connection that, as I shall discuss further, was central to the controversy such films evoked. More pronounced

examples of *Westalgie* can be found, however, in Gregor Schnit-
zler's worrying homage to direct action in the West German squat
scene of the 1980s, *Was tun, wenn's brennt?* (What to Do in Case
of Fire, 2001), as well as Benjamin Quabeck's rather less problem-
atic recollection of the 1980s *Neue deutsche Welle* (German New
Wave) musical trend, *Verschwende deine Jugend* (Play It Loud!,
2003). Films such as *Was nützt die Liebe in Gedanken* (Love in
Thoughts, Achim von Borries, 2003), set during the Weimar period
and reminiscent of Ivory's *Maurice*, or *Der rote Baron* (The Red
Baron, Nikolai Müllerschön, 2008), the story of the famous First
World War flying ace Baron Manfred von Richthofen, extend the
nostalgic/heritage treatment of the German past back to a time
before National Socialism. This was a time, it would seem, when
Germany was like any other western state, when it was still a
'normal' nation that had not yet been tarnished by the crimes
of National Socialism and so could unproblematically celebrate
'war heroes' like von Richthofen. Finally, we also find a number
of adaptations of classic literary works. Such films are a long way
from the Nazi films identified by Koepnick as German heritage
films. They are, however, often more strongly reminiscent of
the types of films made during the early British cycle than these
films. Many of the early Merchant Ivory productions, for example,
looked to classic English literary texts for their material. As Higson
notes, this is a trend which has continued in numerous British
television adaptations, one of the best-known examples being
the Simon Langton and Andrew Davies version of Jane Austen's
Pride and Prejudice (1995) (Higson 2003: 44). Literary adaptations
were also a prominent trend within the New German Cinema
(Elsaesser 1989: 87–9; 107–8). However, recent versions of *Effi
Briest* (Hermine Huntgeburth, 2009) and *Buddenbrooks* (Heinrich
Breloer, 2008) are far less self-reflective in their approach to such
adaptation than those produced particularly in the early days of
the New German Cinema. Instead, they seem deliberately to ape
contemporary British television adaptations, similarly focusing on
the presentation of a lusciously authentic image of the past with no
need to negotiate the moral problems that films which look at later
periods in German history must face to whatever extent, broader
calls for 'normalisation' notwithstanding.

'Present the facts, tell the story' (Eichinger 2004):
fetishising authenticity

Throughout German heritage cinema, whatever the subject, one finds continuity-style films populated with the major stars of the German industry, from Julia Jentsch to Daniel Brühl. These are films squarely aimed at attracting a mainstream audience. Within the context of these films' attempts to increase their audience share, in the marketing of such heritage films a production's attention to detail is invariably foregrounded. In the material to accompany *Sophie Scholl – Die letzten Tage*, for example, the scriptwriter and director made a great deal of their use of recently discovered archival material to highlight the ways in which their film offers a more authentic representation than any of the earlier cinematic accounts of the final days in the life of this young student who resisted the Nazis (Breinersdorfer and Rothemund 2006: 317).[1] Others highlight the attention paid to their film's mise-en-scène. Henckel von Donnersmarck, for example, insists that every detail in his film had to be 'real', down to the bugging devices used as props, in order to present a perfect re-enactment of the past. 'I wouldn't know how one could make a film look more authentic,' he declares (Henckel von Donnersmarck, 2006). The search for historical accuracy in films looking at the past is, in itself, nothing new. The makers of the huge-budget Hollywood epics of the 1950s and 1960s, such as *Ben-Hur* (William Wyler, 1959) or *Spartacus* (Stanley Kubrick, 1969), similarly prided themselves on their historical veracity, employing large teams of researchers to make sure they got their mise-en-scène right. In *Das Leben der Anderen*, however, this attention to detail becomes almost fetishistic, the camera lingering on shots of the state's draconian tools of oppression, from the jars where the Stasi would keep samples of its victims' sweat, so that they could be tracked by dogs if necessary, to the recording equipment used during the organisation's surveillance operations. Its image of the workings of the Stasi at times has the feel of a chamber of horrors exhibition within a contemporary GDR museum such as one might find in any major city in the eastern region, the result being a chillingly authentic-looking set, augmented by cinematographer Hagen Bogdanski's use of a colour palette of grey and brown tones and a decision to record in analogue rather than digital. As a result, the spectator seems to be

transported back to the GDR of the 1980s in its replication of the sound and hue of images from television of the time.

For these films' detractors, however, this same attention to detail and fixation on authenticity is their main weakness. The historian Thomas Lindenberger, for example, questions the status of Henckel von Donnersmarck's film as an authentic reproduction of the past. While he appreciates that this is a fiction film and not a historical treatise, Henckel von Donnersmarck's explicit claims of authenticity mean, Lindenberger argues, that the film must be judged not only aesthetically but also as history. In this regard, while the bugs used in the film might well be real, its presentation of the workings of the Stasi is not. Instead, he suggests that the Stasi is used as the backdrop for a classic 'exploitation film', simply designed to attract international audiences with no real wish to engage with the historical truth of the period (Lindenberger 2008). Petzold is equally dismissive of the heritage genre as a whole. Echoing Rentschler, he attacks such film as a 'nauseating' form of 'over-narrated history' that tries to construct the past as a type of virtual reality which allows no space for the reflective engagement of the audience. It is, of course, such spaces that were of central importance to the New German Cinema and remain so for much of the Berlin School (Hauser and Schroth 2002: 45). Given what many critics see as the essentially conservative ethos of such filmmaking, for their detractors this same lack of space ultimately tends towards the production of worryingly revisionist movies. This might involve producing films that seem to want to paper over guilt for the Holocaust in their focus on moments of Jewish and non-Jewish solidarity during the war, such as Färberbock's *Aimée & Jaguar* or *Das Leben der Anderen* which, as I shall discuss below, appears to be intent upon drawing a line under the crimes of the East German Secret Police.

In relation to Bernd Eichinger and his heritage productions, the issues of both exploitation and revisionism have been a particularly frequent charge. *Der Untergang* and *Der Baader Meinhof Komplex*, with large budgets for German productions (€13.5 million and €20 million respectively) were clearly made with at least one eye on the international market. However, unlike the europuddings discussed in Chapter 1, these films foreground their German specificity, using the traumas of Germany's past, their critics claim, and the 'authenticity' afforded such productions by their German-speaking cast as

their 'unique selling point' (Cooke 2006; Halle 2008: 112–15). This
is particularly obvious with *Der Untergang*, a story that has been
portrayed numerous times – this was not cinematic 'new territory'
as some critics would have it (Schulz-Ojala 2004). The historian
Ian Kershaw suggests that 'Of all the screen depictions of the
Führer, even by famous actors such as Alec Guinness or Anthony
Hopkins, this is the only one which to me is compelling. Part of
this is the voice. Ganz has Hitler's voice to near perfection. It is
chillingly authentic' (Kershaw 2004). Ganz does indeed give a very
convincing portrayal of the man in the last stages of his life. Along
with his perfect mimicry of Hitler's speech, one might also mention
his constantly shaking arm, signalling the first signs of Parkinson's
Disease. At the same time Eichinger is also clearly intent upon
maximising the impact of these films at home through his use
of major stars. As Chris Homewood notes, both *Der Untergang*
and *Der Baader Meinhof Komplex* offer a 'veritable "who's who" of
the German star system' that is clearly looking for the broadest
possible appeal. 'The spectator is not just presented with the char-
acter of Andreas Baader but rather Moritz Bleibtreu *as* Andreas
Baader', giving the film's portrayal of the terrorist a layer of the
star's off-screen charismatic hipness that appeals particularly to
a younger audience (Homewood 2011: 140; emphasis in original).

Eichinger himself always insisted that the main aim of these films
was rather more altruistic. It was, he claimed, to portray the past
'as it really was', giving depth to the images by which such history
is now invariably represented. This is at its most pronounced in *Der
Baader Meinhof Komplex* which repeatedly restages iconic photo-
graphs from the period, offering the spectator the backstory to the
creation of these images and thereby appearing to give them an
added degree of realism, reconnecting them to the 'live' moment
of their taking. The famous picture of the student Benno Ohnesorg
bleeding to death after being shot at a demonstration against the
Shah of Iran in 1967 is brought to life in every detail, even down to
the number plate of the car that stands behind him. Or, with regard
to *Der Untergang*, the authenticity of Ganz' performance as Hitler is
further underlined by what Christine Haase describes as the film's
explicit 'fetishisation of realism and authenticity' which constantly
parades the filmmakers' attention to detail (Haase 2006: 197). As
is typical of this type of filmmaking, there are several protracted
shots of the everyday items with which people at the time lived,

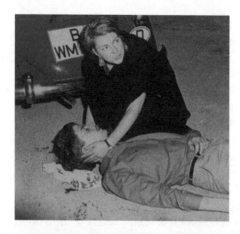

21a and 21b 'Real' and
staged depictions of a
fatally wounded Benno
Ohnesorg, *Der Baader
Meinhof Komplex* (2008).

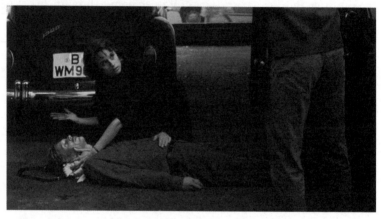

from the omnipresent military insignia of the Third Reich to the
toy soldiers with which children played. We are even given a close-
up of Hitler's dinner as he eats one of his last meals in the bunker,
the image of a half-eaten plate of mashed potato and spinach high-
lighting the fact that Eichinger and Hirschbiegel know the man
was a vegetarian. The spectator is then sutured into these apparent
virtual realities, at times adopting the position of a participant
in events. Homewood notes, for example, the way Edel positions
the spectator at one point in *Der Baader Meinhof Komplex* as a
passenger in the car with Baader out on a joy ride, inviting the
audience 'to share directly in the exhilaration that the sequence
provides' (Homewood 2011: 138). In *Der Untergang*, we generally

watch the world collapse in Hitler's bunker from the perspective of his private secretary, Traudl Junge, upon whose memoirs the film is based. Junge is presented in the film as a doe-eyed innocent providing a usefully 'objective' perspective on the activities of the Nazi elite. At times, and more controversially, however, we are in fact sutured to Hitler's point of view, most notably, as Johannes von Moltke observes, when Hitler has to say farewell to his close friend Albert Speer, a moment which brings the man to the point of tears (von Moltke 2007: 27).

For Eichinger, the use of realism in these films is deliberately aimed at going beyond the type of political presentation of the past that dominated the New German Cinema. As the producer put it in an interview with the television channel NDR:

> There's no moral here. It is the fundamental aim of the script and the project not to moralise in any way, because that would mean that we were just offering another interpretation. What we are trying to do, as far as it is possible, is to present the facts, tell the story. And not to interpret the story. (Eichinger 2004)

For others, however, the suggestion that this, or any other heritage film, can be straightforwardly objective is extraordinarily naive (Nord 2008). Moreover, for some the identificatory potential of the films' aesthetic is deeply worrying. This might allow, for example in the case of Edel's film, the crimes of the RAF to be overwhelmed by Bleibtreu's star persona which, in turn would seem to play to the contemporary revisionist cultural phenomenon of 'terrorist chic' epitomised in the Prada-Meinhof fashion range that appeared in the late 1990s, seemingly intent upon the unproblematic fetishi-sation of the terrorist past for consumption by the youth of the *Spaßgesellschaft*. This is a tendency that would seem to be even more worrying when it comes to *Der Untergang* and those moments in the film which call on the spectator to identify with Hitler. This is an impulse, the film's critics suggest, that ultimately leads to a trivialisation of the past which ignores questions of the nation's complicity with the Nazi regime. It would be unfair to say that the film completely elides the issue of German culpability. This is addressed directly in the sequences that book-end the main narrative. Taken from the 2002 documentary *Im totem Winkel – Hitlers Sekretärin* (Blind Spot – Hitler's Secretary, André Heller and Othmar Schmiderer), the real Traudl Junge reflects upon her

life working for Hitler and acknowledges she has been tainted by
her past. In the second of these sequences, she claims that one day,
as she walked past the memorial to Sophie Scholl, she noticed that
they were both the same age and that Scholl was killed the year
that Junge took the job as Hitler's secretary: 'And in that moment
I finally realised that being young is not an excuse and that one
could have found things out.' Thus the final shot of the film is of
an individual accepting her responsibility for the past and with it
the culpability of her generation. As such, *Der Untergang* would
seem finally to offer an engagement with National Socialism that
acknowledges the complicity of the nation as a whole in the crimes
of the past, reminding the spectator that it is not only the elite
inside the bunker that must carry the burden of guilt. In so doing,
the film acknowledges the agenda of much of the New German
Cinema, ostensibly offering a more complex image of history than
the one depicted in the main body of the film. For Wim Wenders,
however, perhaps the film's most notable critic, the inclusion of
these sequences at best only pays lip service to the agenda of his
generation:

> Hitler asks his adjutant to procure petrol 'so that the Russians
> cannot put my corpse on show'. 'A terrible order, but I will
> follow it', responds the subordinate. And what does the film
> do? It actually carries out Hitler's order! You see everything in
> *Der Untergang*, except Hitler's death. He (and his Eva) are given
> poison and the bullet behind closed doors. Just as Hitler turns
> away when his Alsatian Blondie dies, so the film turns away
> when the *Führer* dies. (Wenders 2004)

For Wenders, Eichinger's wish simply to present the 'facts', delib-
erately eschewing any *reflection* on the question of German
culpability in the main body of the film, ultimately neuters the
film's own potential to challenge the spectator from within its
realist mode. Even when the film could give a new dimension to
the telling of this story, shocking the spectator by presenting a
'realistic' image of the dead Hitler, this it fails to do.

Yet does *Der Untergang* specifically, or heritage films more gener-
ally, with their fetishisation of an 'authentic' image of the past
with which spectators can readily identify, have to be read as
revisionist? The obvious answer is that it depends on the film.
However, as Johannes von Moltke suggests with regard to *Der*

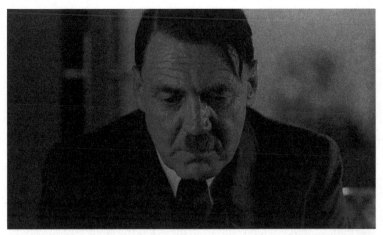

22 Hitler (Bruno Ganz) sheds a tear as his friend Albert Speer leaves him,
Der Untergang (2004).

Untergang at least, the film does have the potential for a more
challenging reading of the past than Wenders allows. It is surely
impossible to watch Bruno Ganz's portrayal of Hitler in a vacuum.
The very fact that we are, at times, put into a position as spectators
where we are asked to identify with Hitler's point of view within a
film presented in a realist mode does not mean that we can simply
forget his crimes. Instead, von Moltke suggests, it in fact forces us to
reflect anew on the nature of these crimes and the ways they have
been, and can be, represented (von Moltke 2007: 42). Similarly,
Brad Prager asks in his discussion of *Der neunte Tag* and *NaPolA*,
whether such heritage films in fact help us 'to find new ways
of triangulating relations of sympathy' ultimately allowing 'new
images' to emerge through their reconfiguration of iconic pictures
of the past (Prager 2010: 190). Ironically, given Petzold's quest for
'new images' in his presentation of contemporary society, if this is
the case, might such films actually have more in common with the
impulse behind much of the Berlin School than one would think?

Furthermore, with regard to the popular history film generally,
commentators have begun to argue for the value of the emotional
power of mainstream cinema to produce what Alison Landsberg
has termed 'prosthetic memory', allowing spectators to 'suture'
themselves 'into pasts they have not lived', thereby offering them

a 'visceral' empathetic experience of history (Landsberg 2004: 14). For Landsberg, it is the identificatory narratives of popular films with mass appeal that are particularly well placed to achieve this. She rejects the notion that a mainstream, ostensibly 'consensual', aesthetic necessarily produces a conservative, political message. Working at the interface of 'public' history and 'private' individual memory, such films can, in her view, complicate and problematise both, allowing the spectator to 'inhabit other people's memories *as* other people's memories and thereby respecting and recognizing difference' (Landsberg 2004: 24; emphasis in original). Of crucial importance in relation to the German context is, as Daniela Berghahn notes, the generational shift that has taken place (Berghahn 2006: 296). The accusatory glare of the New German Cinema, which sought to question the silence of the 68ers' parents about their acceptance of the Hitler regime, is now giving way to the perspective of a younger generation of artists and, more importantly, audiences who have a less fraught relationship with the past and who are hungry for knowledge. Thus, for this new generation, the recent wave of heritage films with their personalised, often melodramatic, accounts of the past, provides, it would seem, a far more immediate and accessible *experience* of history than is to be found in earlier films.[2]

As such, these films can be seen as a particularly obvious example of what has been identified by the German writer Martin Walser and others as a new 'feeling for history' at work in the representation of the past across society and marking a new phase, with regard to the Nazi period in particular, in the process of coming to terms with the nation's history (*Vergangenheitsbewältigung*) (quoted in von Moltke 2007: 17). For their supporters, such films are a 'sign of emancipation', as Eckhard Fuhr puts it, writing in *Die Welt* about *Der Untergang*. For Fuhr, 'Germans still have their history, but they no longer have it around their throat'. This distance from the past in turn allows filmmakers 'to look Hitler in the eyes' at last, and thereby effect a final 'reconciliation with the perpetrator generation' (Fuhr 2004). Alternatively, far from marking a moment when the past can finally be put to rest, perhaps such films actually mark the beginning of a genuine process of *Vergangenheitsbewältigung*. Elsaesser hints at this in his discussion of the presentation of history in the New German Cinema. Drawing on Freud's essay 'Trauer und Melancholie' ('Mourning and Melancholia', 1917) and its

analysis of 'parapraxis', Elsaesser suggests that the world reflected in much of the New German Cinema was caught in an ultimately self-destructive loop of melancholic repetition, in which the films' protagonists were invariably able only to perform the failure of the nation to mourn its past, a process of mourning which is necessary for a true comprehension of the nation's guilt and which in turn could bring about the population's final redemption (Elsaesser 2002: 182–91). For a real process of working through the past to begin, such 'performed failure' must give way to a more direct, emotional response that can mourn the loss of both the 'right' and 'wrong' people, as Elsaesser puts it, a response that we see, perhaps, in this new phase of filmmaking where critical reflection is giving way to the straightforward sentimental expression of the pain of the past. Consequently, far from drawing a line under this history, might these films not actually support a continued engagement with it, allowing the German spectator to find an affective point of connection with earlier times and thus the possibility of finally undertaking a process of mourning work contingent on evoking the kind of emotions these recent films present? In the process, we are left with the question, does the emotional power of these films, their frequent use of identificatory narratives and realistic mise-en-scène become a means of troubling the type of consensus often offered in their diegesis, suggesting that they do, in fact, have the ability to 'refin[e] memories and catalys[e] changes', to return once more to Rentschler's critique of post-Wall German film? (2000: 263–4).

Consuming heritage in cyberspace

As Mathias Fiedler notes, for better or worse, German heritage films have had a major impact on debates about the politics of memory in Germany (Fiedler 2006). And, within the media discussion such films invariably provoke, there would appear to be anything but consensus in their reception.[3] This same lack of consensus becomes even clearer when we look at the competing ways these films are consumed by spectators not only in cinemas but in a variety of internet forums. Here the films tend to engender passionate responses by participants, continuing to keep alive public discussion of this period of history and constantly calling into question the place of National Socialism in the pre-history of the Berlin

Republic. Of specific interest in this regard is the phenomenon of so-called 'Hitler-Kunst' (Hitler art), which as Harald Martenstein notes, is a genre of art that swept the cyber world in the 2000s (Martenstein 2007). Such art can take a wide variety of forms, but of interest to this present discussion is the way internet users are exploiting Web 2.0 technology to create their own films, commonly referred to as 'mashups' combining video and sound from a number of sources to produce, often humorous, new film texts. There are, for example, numerous mashups to be found on YouTube that parody *Der Untergang*, much to the annoyance of Eichinger (Bowcott 2010). Many of these spoofs change the film's subtitles to suggest Hitler is ranting about his computer crashing or a football team losing a match.[4] However, amongst the most interesting and developed of these spoofs is the 'Hannerbersch' series, produced by two young filmmakers from Rheinland-Pfalz who redubbed clips from the film with comedy voices, the thick 'Eifler Platt' accents of the new sound track presenting the Nazi elite as provincial 'bumpkins', thereby undermining any pathos for them that might be evoked in the original film, showing how ridiculous these pompous men were, and rejecting a view of the film as a serious war movie, as it was advertised with great effect around of the world.[5] In this series, through their choice of accent, the creators highlight the Germanness of the Nazis. They reject any sense that the ruling elite was divisible from ordinary, 'normal' Germans, as the film tends to suggest in its presentation of the world inside the bunker that seems to be far removed from the experience of the inhabitants of Berlin living with the constant threat of death from the Russian artillery beyond its protective doors. Instead, the Nazis themselves are presented as 'normal' Germans from the provinces and National Socialism as a specifically German problem with which the nation must still deal.[6]

Beyond the *Untergang* mashups, a number of other web phenomena connected to the consumption of contemporary cinema highlight the ways in which these films provoke particular debate. These include film sites that point out continuity and factual errors in many of the films mentioned. 'dieSeher.de', for example, notes that if Siegfried (Martin Goeres), one of the school children in *NaPolA*, had really wet himself while sleeping, as the narrative at one point suggests, the stain on his pyjamas would have been a completely different shape.[7] Or, one can follow contributors' argu-

ments about the accuracy of having Goebbels' 'Total War' speech playing on the radio as Sophie is brought for interrogation in *Sophie Scholl*, when these events took place on different days.[8] Such error sites specifically, and internet fan community sites more generally, can of course be found on a huge range of films. As Marnie Hughes-Warrington notes, they are increasingly becoming part of the mainstream industry, with production companies using them to feed information to fans about their films in order to increase ticket sales and, often more importantly in terms of revenues, to promote the tie-in DVD which gives the spectator the opportunity obsessively to re-watch and scrutinise scenes from the movies, not least in order to find further errors (Hughes-Warrington 2007: 180). In the less capitalised German industry there is little evidence of such subtle manipulation, although film companies do appear to intervene if they do not like the tone of the discussion, as is evident in one posting on the 'dieSeher.de' site which refutes the rumour that right-wing extremists were employed as extras on Hirschbiegel's film.[9] The overwhelming feeling one gleans from reading postings on this and other sites is that commentators wish to celebrate the failures of these films, thereby implicitly highlighting their own superior historical knowledge and the fact that they have not been taken in by the comfortable, 'consensual' message these films often deliver.

Conversely, in numerous blogs and discussion boards that continue to debate this crop of films, one also finds the opposite impulse, namely that spectators are learning from these narratives and that these films are, indeed, being consumed as forms of Landsberg's 'prosthetic memory'. If one explores the reception of some of these films on the International Movie Database, for example, we find users praising the affective power of the melodrama in these stories, as well as their attention to detail which, it is often felt, is helping to bring this period of history alive to at least some present-day spectators both in Germany and abroad. One might also mention the 'Fan Fiction' phenomenon in this regard, where internet users write their own stories based on films they have seen. One 30-year-old author from Hessen, who writes under the pseudonym Allaire Mikháil, for example, has written several stories about the relationship of the two main protagonists in *NaPolA*, Albrecht (Tom Schilling) and Friedrich (Max Riemelt). In the film this is a relationship that ends in tragedy when Albrecht,

the son of the local Gauleiter, commits suicide, unwilling to live up to the expectations of his thuggish father and feeling let down by his friend who has given in to the Nazis' violent ideology. Writing from the perspective of Friedrich, with strong homoerotic overtones, the author imagines a world in which Albrecht survives.[10] Following Landsberg's model, Mikháil clearly empathises with the film's characters, looking to explore and enhance the emotive power of the melodrama in his texts, re-visiting Friedrich's trauma as it is presented in the film in order to overcome it. Finally, it should be noted that many of the sites which discuss the films in a variety of ways also include threads that spin off into broader discussions about the War in general and at times quite complex debates on the place of National Socialism in the historical consciousness of contemporary society. On the International Movie Database, as well as a whole host of other fan discussion boards, one finds questions or comments about a particular film develop into debates about German national identity, anti-Semitism or the status of events such as the bombing of Coventry or Dresden as war crimes.[11]

From such discussions it is clear that, despite the notion that Germany has at last become a 'normal' western nation that can move on from its past, the past continues to be debated. Moreover, the type of engagement with National Socialism found throughout the 'Hitler-Kunst' phenomenon has now also folded back into mainstream film production. Dani Levy's *Mein Führer – Die wirklich wahrste Wahrheit über Adolf Hitler* (Mein Führer – The Truly Truest Truth About Adolf Hitler, 2007), like the various YouTube mashups discussed above, directly challenges the type of obsession with an 'authentic' image of the Nazi past to be found in *Der Untergang*, along with other examples of the Nazi heritage film. Levy brings together an all-star cast to tell the story of Professor Adolf Grünbein (Ulrich Mühe), a fictional Jewish actor who is taken out of Sachsenhausen to give Hitler acting lessons, in the hope that the Führer will be able to recover his spirits and lead the population to victory. Played by the well-known comedian Helge Schneider, Hitler is presented as a bed-wetting, impotent child who has been damaged by an abusive father. As such Hitler is clearly a 'victim' for whom Grünbein cannot help but feel sorry, much to the frustration of his wife and, in particular, his son who berates his father for refusing to kill the man while he is alone with him in his study. The

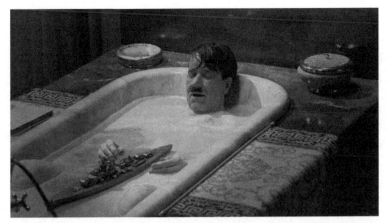

23 A childish Hitler (Helge Schneider) plays with his toy battleship in the bath, *Mein Führer – Die wirklich wahrste Wahrheit über Adolf Hitler* (2007).

film owes much to the tradition of Hitler caricature that goes back to Charlie Chaplin's *The Great Dictator* (1940) and Ernst Lubitsch's *To Be or Not To Be* (1942), as well as later work such as Mel Brooks' *The Producers* (1968) or the British BBC Sitcom *'Allo 'Allo* (1982 to 1992). All these depictions point to a ridiculous pomposity at the heart of National Socialist pageantry. Levy's film, for example, makes much of the difficulty of conducting a conversation when every encounter has to begin and end with 'Heil Hitler', or the impossibility of being treated as the Führer when Hitler is trying, in vain, to have sex with Eva Braun (Katja Riemann).

At the same time, however, and going beyond the issue of veri-similitude pointed to in his choice of title, Levy is also intent upon the deliberate and provocative trivialisation of the Nazi past. As he notes in an interview for the book that accompanied the film's release, Levy was becoming fed up with the way the past was being presented in German films at the time. Unlike Wenders, this he sees not as a departure from the approach to history of the previous generation, but as the continuation of their tedious tradition of German political correctness: 'I was finding these discussions of the past, discussions that sought to moralise, increasingly boring. They never said anything new. These films just show what we all already know' (Levy 2007: 209). In this regard, *Mein Führer* offers

a further moment of German 'normalisation'. It is a direct plea to move beyond political correctness and let Germany laugh at its past, the place of Hitler in this history, and along with the obsession with generational conflict that was central to the 68ers' attack on their parents. Grünbein's son, a 68er *avant la lettre*, berates his father for not challenging Hitler. However, it is clear that such conflicts are not wholly the product of Germany's problematic history but are simply part of the human condition. Hitler himself is shown to have had a similarly abrasive relationship with his own father. Nonetheless, the film differs from other comic presentations of National Socialism due to the fact that, as Henryk M. Broder notes, Levy has to keep the 'handbrake' on his comedy so as not to run the risk of being misunderstood (Broder 2007). As a successful Jewish filmmaker, Levy felt in a good position to make Germany's first mainstream comedy about Hitler (Levy 2007: 175–7). However, even Levy had to be careful to avoid being seen as trivialising National Socialism too much, evident in his decision to re-edit the film and shift the emphasis away from Hitler's character to that of Grünbein. This was a decision that greatly angered Helga Schneider, who subsequently distanced himself from the production.[12] Thus, while the decision to make the film might be read as further evidence of German normalisation, Levy's apparent need to 'keep the handbrake on', ultimately resulting in a film that flopped both with critics and at the box office, also implicitly points to the continuing limits of such normalisation.

Das Leben der Anderen: re-reading German historiography through the heritage film

Levy's film is deliberately provocative, even if it ultimately pulls back from the full potential its grotesquely 'true' image of Hitler might offer for a radical critique of contemporary debates about the historical appraisal of National Socialism. This is a discussion to which I shall return in subsequent chapters. However, to conclude the present discussion, I would like to move away from the heritage films that look at the Nazi period and its aftermath to *Das Leben der Anderen*, a film that Henckel von Donnersmarck himself explicitly celebrates as a 'consensus film' (Rupprecht 2006). Through his painstakingly 'authentic' mise-en-scène, the filmmaker also considers the film to be an important corrective to the

phenomenon of *Ostalgie*, which in Henckel von Donnersmarck's view simply wishes to 'indulg[e] the shabby communist regime', ultimately trivialising its crimes (Bradshaw 2007). Set in 1984, *Das Leben der Anderen* instead offers the spectator a suitably Orwellian image of the 'Second German Dictatorship', in which the writer Georg Dreyman (Sebastian Koch) is placed under surveillance by the state security service on the advice of a corrupt communist party official, Minister Bruno Hempf (Thomas Thieme), who claims to suspect him of dissidence – an accusation which at the start of the narrative is entirely false. During the surveillance operation, the controlling Stasi officer, Captain Gerd Wiesler (Ulrich Mühe), a man initially wholly convinced of the GDR's status as the better of the two post-war German states, and the need of his organisation to protect it against Western counter-revolutionary forces, begins to lose faith in the GDR's draconian understanding of its 'socialist' project. He is drawn, instead, to the humanist artistic worldview to which he is introduced by spying on the writer and his actress partner Christa-Maria Sieland (Martina Gedeck). As a result, rather than relaying to his superiors Dreyman's gradual turn to dissidence, he protects him, producing innocuous reports and even removing an incriminating typewriter from the man's flat which would have provided his Stasi colleagues with evidence that Dreyman was the author of an inflammatory essay published in the West.

Internationally, the film garnered great acclaim, critics invariably pointing to the realism of its staging (Ansen 2007; Bradshaw 2007). As already noted, this was an aspect of the production of which the filmmaker was very proud. Within Germany, too, there were those that commented positively on its authenticity, not least the ex-GDR writer and musician Wolf Biermann, himself a victim of a prolonged Stasi surveillance operation, who praised the film for its accurate picture of life in the East, a remarkable achievement for a 'debut director who grew up in the West' (Tilmann 2007). The film even appeared to gain a degree of official state backing. Manfred Wilke, a historical consultant on the film and member of the Federal Enquete Commissions that investigated the nature of the East German Communist dictatorship in the 1990s, for example, could not praise the film's authenticity highly enough (Wilke 2008). For the Federal Agency for Political Education, this same attention to detail also made the film an ideal text

for teaching schoolchildren about the oppressive reality of life in the East. And the positive reviews of the numerous film screenings organised specifically for children supported its view, the organisers of such events precisely seeing the film as a way for the younger generation to gain a non-*Ostalgie*-tainted view of the GDR (Harmsen 2006; Rössling 2006).

However, the film also received some particularly vitriolic comments. Rüdiger Suchsland, for example, condemned the film as 'Disney's GDR-Melo[drama]', a reference to its distribution in Germany by Buena Vista. Suchsland is scathing of both the film's official endorsement and its potential educational value:

> This is one of those films that culture ministers like. A palatable melodrama, from the brown, dusty days of the GDR, seasoned with some sex and art, lots of horrible repression, some dead people, still more heartache, a few cold, evil perpetrators, lots and lots of German victims and a Saul who becomes a Paul. [...Henckel von Donnersmarck] presents the GDR so simplistically, clearly and unambiguously that one doesn't have to think about it much. One knows where one stands. He divides the past up into small, bite-sized, consumable pieces, into teaching units. School classes will be shown it until they can't stand it anymore. (Suchsland 2006)

Of course the authorities liked the film, Suchsland suggests. Its straightforward melodramatic narrative allowed a clear-cut reading of the past that required no reflection. In this regard, it is no surprise that the film's historical adviser was part of the Government's Enquete Commissions, since Henckel von Donnersmarck seems to construct a similar view of Germany's 'Second Dictatorship' to their findings, namely that the GDR was a period of history under which a line can now be drawn, the problems of the past now having found their resolution in the present-day Berlin Republic (Cooke 2005: 27–60). Moreover, while its presentation of the past would seem to be far removed from the type of *Ostalgie* one finds, for example, in a number of comedy films since the late 1990s, its drive to turn the GDR into a consumable heritage product at times in fact seems to continue rather than correct *Ostalgie*'s broader tendency to fetishise aspects of GDR culture. In the style of the *Ostalgie* comedies, we are given shots of everyday GDR styles and products, from Trabis to television sets to bottles of Berliner

24 Wiesler (Ulrich Mühe) takes up residence in his surveillance suite, *Das Leben der Anderen* (2006).

Pilsner, upon which the camera repeatedly dwells, and which allow the audience to indulge its present-day fascination with such items. Nonetheless, such indulgence would seem to be tempered by the film's focus on the Stasi's mechanics of surveillance and oppression, including a detailed tour of the room from where the surveillance operation against Dreyman is carried out. We are first introduced to the surveillance suite as Wiesler enters it. He walks in, flicks a switch and the room is lit up in a flash of neon, revealing a GDR chamber of horrors from where the Stasi can both listen to and influence life in the flat below. While we are left in no doubt as to the destructive capabilities of Wiesler in particular and the Stasi in general; the focus on original artefacts allows the spectator once again to indulge their fascination for the past, rather than critically engage with it. One is reminded of numerous moments in those heritage films that depict Germany's other, even more marketable, difficult past. As we have seen, *Der Untergang*, for example, similarly allows audiences to indulge western society's perennial fascination with Nazi paraphernalia in its detailed visual presentation of the period, offering the spectator a virtual tour of Hitler's bunker.

Yet while the film indulges any gruesome fascination for the nation's past its audience might have, within the narrative itself it at times also problematises contemporary popular accounts of GDR history, although in a very different way to that suggested by Henckel von Donnersmarck himself in his claim that the film is to be read as a correction to the trivialising tendencies of

contemporary *Ostalgie*. As already mentioned, the film has been used as a didactic tool to engage the generation that has grown up since unification about the nature of life in the GDR, its mainstream aesthetic allowing Henckel von Donnersmarck to speak to a far wider audience than would have been achievable for a more esoteric film text, providing an example of Landsberg's 'prosthetic memory'. For its critics this is problematic because its representation of the past is misleading, not least in its suggestion that a Stasi officer could change sides, an event for which there is little or no historical evidence (Lindenberger 2008: 560). For others, however, it is necessary to move beyond the question of historical accuracy. In his discussion of the film, Owen Evans examines the use of melodrama as a tool in the film's widespread appeal, arguing that even within a mode which traditionally relies on the kind of polarised '"Manichean" world-view' Barry Langford identifies in such films, where emotion is prioritised over critical distance or the presentation of facts from the past, Henckel von Donnersmarck nonetheless provides a degree of psychological depth to his characters which allows a more nuanced reading of the GDR past than that acknowledged by the film's critics (Evans 2010: 8).

Central to this reading is the character of Wiesler. On the one hand, his conversion might be seen as an apology for the crimes of the Stasi, a conversion that sets up the final moment of 'consensus' at the end of the film that allows a line to be drawn under this period in German history, the former officer realising that he has been forgiven by his former victim through the dedication of Dreyman's book to 'HGW XX/7', Wiesler's official title. Wiesler now knows that Dreyman understands the efforts the Stasi officer made to protect him. On the other, the presentation of Wiesler's humanity also recalls the experience of Timothy Garton Ash when he met the Stasi officer tasked with conducting a surveillance operation on him during his time as a student in East Berlin in the late 1970s, a meeting that left him with a strong sense that this was a good man, a man of conscience (cited in Evans 2010: 12). Might the film, like Garton Ash's experience, suggest a more complex and less consensual reading of the Stasi as an organisation, a reading that allows it neither to be forgiven nor to be dealt with straightforwardly as yet another monstrous moment of aberration in German history?

The place of the Stasi in GDR society is similarly problematised

in the central relationship between Wiesler and the object of his surveillance. *Das Leben der Anderen* is part of a long tradition of films, from Alfred Hitchock's *Rear Window* (1954) to Tony Scott's *Enemy of the State* (1998), which explore the question of surveillance. Most obviously Henckel von Donnersmarck's film recalls Francis Ford Coppola's *The Conversation* (1974). Coppola's representation of a paranoid corporate America wallowing in the corruption of the tail end of Nixon's administration translates easily to Henckel von Donnersmarck's GDR and helps to explain for some commentators the reason why the film was so successful in the US, where a post-9/11 public could see its own dystopian future reflected in the film's portrayal of a government obsessed with state security (Beier 2007). Echoes of *The Conversation* are most obviously located in the striking similarities in the mise-en-scène, particularly in the spartan surveillance room of both films. In both, the main protagonist also uses sound to compensate for the lack of a visual narrative. In so doing, and as has been discussed by generations of critics, such films draw attention to the leap of the imagination which, in the classic Metzian construction of spectatorship based on Lacanian psychoanalysis, is seen to be at the very heart of cinema itself (Metz 2000). Through the process of watching the watcher, these films play to and simultaneously deconstruct the scopophilic impulse of the spectator. In *Das Leben der Anderen*, as in these earlier films, we find a performance of the fantasy of a transcendent, all-seeing, all-powerful spectator as described by Metz, his primary identification between the spectator and the screen here transferred to the secondary level of the diegesis. Crucially for Metz, of course, along with other theorists associated with the journal *Screen* during the 1970s, the power of the spectator is an illusion. Indeed, the very apparatus of film ultimately undermines the processes by which the spectator attempts to give himself (sic) meaning, presenting the subject position that he constructs (via the film text as 'other') to be a chimera. Thus, we see the male all-seeing I/eye exposed as a fantasy, and replaced by a disempowered, interpolated voyeur, inevitably subjected to the machinations of ideology, be that patriarchy, capitalism or imperialism.

This Metzian framework allows us to relocate the film within the media debate it sparked, particularly with regard to the film's socio-historical representation of the GDR and, in particular, its

construction of the relationship between the state security service and the broader population. At the outset of the film, Wiesler is constructed as a transcendent all-seeing, all-powerful spectator, a position that is established in a sequence where he first sees the man who is to be the victim of his surveillance operation. He is taken to the theatre by a superior officer, Anton Grubitz (Ulrich Tukur), to watch a production of one of Dreyman's plays, starring Christa-Maria. Wiesler sits in a box, at a distance from the rest of the audience, able to look beyond the performance itself, which transfixes the rest of the public. In cinematic terms, Wiesler creates his own 'frame', his use of binoculars highlighting his status as the 'master' spectator in the room, to whom we are subsequently sutured in a series of point of view shots: of Christa-Maria's performance; of Dreyman talking to a journalist already under suspicion by the state; of Hempf whispering to his aide, a conversation that perhaps suggests to the astute agent the reason why he has been asked to come to this performance. Most importantly, and in contrast to these other men, it would seem that Wiesler can see beyond the beauty of Christa-Maria, the woman Dreyman loves and who Hempf, we subsequently learn, is determined to have. Wiesler appears to maintain his distance, always standing at the edge of the main action, silently making notes and never participating actively. When he does decide to intervene it is, initially at least, in order to direct events. He decides, for example, to reveal to Dreyman the Minister's desire for Christa-Maria, ringing the doorbell to Dreyman's flat remotely from his observatory so that the writer comes down just as the woman is getting out of Hempf's car. Within the diegesis, Wiesler once again controls the frame, turning Dreyman into a spectator in his own narrative, dictating the view of the world that he is given.

However, there are in fact indications from the start of the film that Wiesler's objective distance, and with it his spectatorial power, are illusory. Indeed, even during the initial theatre performance there is the suggestion that he, like Hempf and Dreyman, is in reality transfixed by Christa-Maria's performance. For the briefest of moments Wiesler's point of view shots are interrupted by a shot/reverse-shot sequence between himself and Christa-Maria. Just for a second the woman seems to return his gaze, leaving the man momentarily mesmerised and thereby breaking the illusion of his objective distance from events. The Stasi operative's position as a

25 Wiesler (Ulrich Mühe) mesmerised for a moment, *Das Leben der Anderen* (2006).

transcendent, detached observer is undermined. Wiesler is drawn into the traditional libidinal economy of mainstream cinematic texts of desiring and objectifying the female 'other' in order to empower his own subject position.

As the narrative progresses and Wiesler increasingly rejects the State's position, desiring instead the life of the artist he spies on from his surveillance suite, he becomes ever more embroiled in his case. Crucially, however, the more he intervenes, the less he is in control of events, his cool observation turning into a confused emotional stare. When, for example, he hears Dreyman's plea that Christa-Maria should not go to meet Hempf, Wiesler leaves his attic for the street outside, hiding in the shadows to see if Christa-Maria comes out. 'What are you gawping at?' he is asked by a drunk passer-by, a question which makes it clear that Wiesler can no longer stand outside the narrative. Then, in the final moments of the main story arc, as we watch Christa-Maria commit suicide, unable to live with the guilt of having betrayed her partner – during the course of the narrative she is forced to become a Stasi informant, agreeing to spy on the writer – Wiesler's impotence is complete. He can only look on as Christa-Maria steps off the pavement into the path of a passing lorry. He rushes to her side, able to touch the blood seeping from her body but unable to give her a final embrace before being jettisoned backwards out of the frame as Dreyman enters and picks her up to let her die in his arms. While Wiesler's observation tactics give the impression of control, he discovers that, like the fantasy of spectatorship itself, this control

is ultimately illusory. His narrative has a life of its own, finally expelling him to its periphery, allowing him only to look on, an impotent voyeur. Yet while he has been rejected by the narrative, he is still implicated within it, the blood on his hands from Christa-Maria's body highlighting that he can neither transcend events nor escape his at least partial guilt for her death.

In this reading of the relationship between Wiesler and the subject of his surveillance operation, the credibility or otherwise of Wiesler's conversion to the enlightened protector of Dreyman becomes less important than how the place of the 'other' in the construction of the self speaks to contemporary GDR historiography. Like the Metzian all-powerful spectator, the Stasi was an organisation assured of its own agency, of its ability to steer events and of its unassailable position of authority. However, as we know from what happened in 1989, the organisation was itself ultimately impotent in the face of the mass demonstrations by the GDR population as a whole. At the end of this particular operation, Grubitz knows that the officer has betrayed him and assures the man that he will have his revenge: 'At best, you'll be opening letters in a cellar somewhere for the rest of your career. That's the next twenty-five years.' Of course, as the audience knows and as is made explicit in the following sequence, time will run out for the Stasi. The film cuts to an intertitle: 'Four years and eight months later'. Wiesler, having been demoted to steaming open the population's mail, listens to the news that the Berlin Wall has fallen. He gets up from his desk and walks away, free from Grubitz's authority. Here Wiesler becomes a representative of the GDR masses who were ultimately themselves able to reverse the Stasi's gaze and challenge state oppression.

The relationship between Wiesler and Dreyman, as well as Wiesler's final relationship with the organisation he has served his whole career, troubles a unidirectional conceptualisation of the power dynamic one might assume to be at work between the Stasi and the rest of the population. Henckel von Donnersmarck's engagement with the tradition of the surveillance film perhaps adds little to the discussion on the scopophilic nature of cinema as a medium that we do not find in Hitchcock or Coppola. However, it does potentially allow a reading of the organisation's legacy in post-unification Germany that counters a view of the GDR that dominated early popular assessments of life in the East. As I have

discussed elsewhere, in the immediate aftermath of the fall of the Berlin Wall, it was commonplace to present the GDR as a state completely in thrall to its secret police, a view that was fuelled by the rapid opening of the miles of files the Stasi produced during its lifetime. As victims, academics and journalists began to pore over their contents, a string of scandals ensued, numerous public figures being 'outed' for their involvement with the organisation, from Lothar de Maizière, the first democratically elected premier of the GDR, to the internationally renowned writer Christa Wolf (Lewis 2003; Cooke 2005: 61–101). Henckel von Donnersmarck's film troubles the place of the Stasi files in popular readings of the GDR. Towards the end of the film, when Dreyman discovers the truth about Wiesler – that the man tried to protect him from arrest – we find a further level of inversion in the spectatorial 'self/other' relationship at work between Wiesler and the object of his surveillance. Now the Stasi file acts as 'other' to the writer. By revisiting his past as it is presented in Wiesler's account, he can at last overcome the trauma of Christa-Maria's death and finally 'arrive' in the Federal Republic, a development symbolised in his rediscovery of the ability to write. But as with the image of Wiesler discussed above, or Wiesler's relationship to Dreyman, the film's presentation of the Stasi file is open to competing readings. On the one hand, Dreyman's revisitation of the past allows the type of narrative resolution demanded by mainstream cinema, thereby again laying the film open to the charge of being a reactionary form of consensus cinema. On the other, the specific example of its usage here potentially challenges the broader question of historical 'closure' the opening of the Stasi files seemed to offer. The importance of the Stasi archive in contemporary readings of the GDR cannot be underestimated. Yet through Dreyman's engagement with the files as historical archive, their status as a repository of absolute truth, as the final word on the reality of life in the GDR, is called into question. The Stasi file is only helpful to Dreyman because it does *not* hold the truth. Like the rest of the archive, Dreyman's file is a written text constructed within a specific socio-political context, by people with their own agenda, abilities and competing desires. Thus, the file's presentation of events might be shaped by Grubitz's request not to put anything in the reports about the relationship between Christa-Maria and Hempf, or by Wiesler's assistant's only partial knowledge of the background to an argument he hears

between the lovers in the flat below. Through the presentation of the Stasi files as a flawed, incomplete archive of the past, the film once again calls into question the filmmaker's own view of his work as a straightforward corrective to the earlier *Ostalgie* films. As I shall discuss in Chapter 7, these were films that were themselves often intent upon troubling a view of the GDR as a one-dimensional, totalitarian 'Stasi state', a perspective that Henckel von Donnersmarck's film seems to play to even as it simultaneously indulges in the fetishisation of GDR material culture for which the *Ostalgie* films were often attacked.

Through its reflection on the competing relationships between the various defining 'others' in the film, alluded to, of course, in its title, *Das Leben der Anderen* can be read as offering a more complex engagement with recent German history than its critics claim. Its adoption of a popular narrative form and a self-consciously 'authentic' mise-en-scène also offers the potential for it to reach a far wider audience than most of the films of the New German Cinema ever could. That said, and as numerous critics cited here suggest, this is simply one possible reading. It is also possible to identify the type of conservative, 'consensual' tendencies that we see in many contemporary heritage films, for all their ability to generate public debate. As will be discussed later in this study, in a number of heritage films, this might be reflected in a return to some of the aesthetic and political tendencies to be found in the type of 1950s 'Papas Kino' rejected by many younger filmmakers in the 1960s, in the construction of gender relations according to a very traditional set of prescriptive norms, discussed in connection with the contemporary *Frauenfilm* (Women's film), or in the equally prescriptive conceptualisation of ethnicity – indeed its apparent erasure – in some European heritage filmmaking, an issue to which I shall now turn in my examination of such films within the broader landscape of transnational filmmaking.

Notes

1 For further discussion of the use of archival material in the film see Evans 2011.
2 For a more detailed examination of the debates around the representation of history on film and the potential of identification

versus the need to ensure critical reflection see Landy 1997; Toplin 2002; Rosenstone 2006.

3 It might also be noted that this is a debate which is not just confined to Germany. See, for example, David Bathrick's analysis of the reception of *Der Untergang* in the US (Bathrick 2007).

4 One particularly amusing example of an *Untergang* mashup is the clip that ridicules *Constantin*'s attempts to have such mashups removed from YouTube. 'Hitler reacts to the Hitler parodies being removed from YouTube': www.youtube.com/watch?v=kBO5dh9qrIQ (accessed 29 October 2010). For further examples of this trend see Cooke 2010.

5 See, for example, 'Untergang Part 4 "leck mich am A..Abend"': http://de.youtube.com/watch?v=V5ecvugDONc&feature=related, posted 7 May 2007. Information on the filmmakers gathered by email 13–14 December 2007.

6 The film has also inspired a cartoon by the well-known cartoonist Walter Moers, similarly to be found on YouTube, where we see the Führer singing in his bunker, refusing to give up as the world collapses around him. Walter Moers, 'Der Bonker': www.youtube.com/watch?v=IC41_2yBaiY, posted 30 July 2006.

7 Posting by Jens: www.dieseher.de/film.php?filmid=1120 (accessed 19 February 2008).

8 Discussion posted by various: www.dieseher.de/filmnk.php?filmid=899 (accessed 16 December 2007).

9 Posted by casino: www.dieseher.de/filmni.php?filmid=832 (accessed 19 February 2008).

10 Allaire Mikháil: allaire.skeeter63.org/AllaireFanfic.htm (accessed 19 February 2008).

11 See, for example, the discussion on Jewish identity in *Aimée & Jaguar*: http://uk.imdb.com/title/tto130444/board/nest/7087545 (accessed 5 December 2007), or the discussion about the representation of Nazis in German war films, which takes as its starting point the Oscar-winning German-Austrian co-production *Die Fälscher* (The Counterfeiters, Stefan Ruzowitzky 2007), but which spins off into various threads about the guilt or innocence of those responsible for allied bombing, or the legacy of the SS and contemporary normalisation debates. See www.imdb.com/title/tto813547/board/nest/71696011 (accessed 24 December 2007). See also the discussions on film.the-fan.net: http://film.the-fan.net/?titel=15294&word=mein%20fuehrer, or 'Movie Infos': http://

community.movie-infos.net/thread.php?threadid=7239 (accessed 19 February 2008).

12 Specifically, Levy deleted a framing device in which a 117-year-old Hitler offers his services to the Berlin Republic of today. This is included on the DVD release of the film, where, it should be noted, Levy himself denies that his decision to recut the film was in any way the result of concerns about going too far with his portrayal of Hitler. See 'Die frühe Schnittfassion' (The earlier cut) on the DVD release, *Mein Füher – Die wirklich wahrste Wahrheit über Adolf Hitler*, X-Filme, 2007.

4 Transnational cinema, globalisation and multicultural Germany

In July 2009 a small group of Berlin cinephiles set off along the German-Polish border with a mobile cinema, showing a collection of short films from both countries to audiences on either side of the Oder and Neisse rivers which, until recently, had not only marked the boundary between these two nations but also the frontier of the EU (Anon 2009). Germany has long had a strained relationship with its eastern neighbour. On Poland's accession to the EU in 2004, it might have been hoped that relations would improve. However, the prolonged debate over the proposed memorial to the millions of Germans expelled from lands east of the Oder-Neisse line at the end of the Second World War – now Polish territory – as well as the so-called *Kartoffel-Affäre* (Potato Affair) – sparked by comments in late 2006 in the daily newspaper the *Tagesspiegel* which compared the Polish President to a potato – highlighted the continuing tensions.[1] The *Kinomobilny* project, funded in part by the EU, hoped to use cinema to foster greater understanding between the two nations, focusing on the intercultural potential of this now open but still culturally and economically contested border region.

The image of a mobile cinema travelling along the German border strongly recalls that defining moment in the New German Cinema, Wim Wenders' *Im Lauf der Zeit* (Kings of the Road, 1976), the story of a similar journey along the old Cold War border between the East and West German states. For the protagonists of Wenders' road movie, the border acts as a mirror, allowing them to reflect upon the state of West Germany in the 1970s, the legacies of Germany's problematic past and the contemporary dominance of American culture. 'The Yanks have colonised our subconscious' one

of the film's two leads laments, presenting an image of Germany as the willing victim of post-war, US-driven, neo-colonial forces. The way the border is envisaged in Wenders' film and in the *Kinomobilny* project respectively neatly highlights what has been identified by Andrew Higson, Randall Halle, Elizabeth Ezra, Terry Rowden and others as a shift towards 'transnational' modes of production and consumption within European film, impacting on both the ways films are being made and the types of subjects filmmakers are choosing to explore (Higson 2000; Ezra and Rowden 2006; Halle 2008). A conceptualisation of the German/German border as a fixed barrier that might act as a mirror onto the German social psyche, in turn, reflects a view of the New German Cinema as a quintessentially national product, supported by a national government and dedicated to a critical engagement with the post-war 'national project' of integrating the Federal Republic into an American-led western alliance. Even when its filmmakers look either beyond national borders, such as in the South American films of Werner Herzog (*Aguirre, der Zorn Gottes*/Aguirre, the Wrath of God, 1972; *Fitzcarraldo*, 1982), or at the experience of non-German migrants at home such as in the work of Fassbinder (*Katzelmacher*, 1969; *Angst essen Seele auf*/Ali: Fear Eats the Soul, 1974) and Helma Sanders-Brahms (*Shirins Hochzeit*/Shirin's Wedding, 1975) or, later, in Günter Wallraff and Jörg Gförer's award-winning documentary *Ganz unten* (Lowest of the Low, 1986), commentators have been keen to point out that the focus remains on the critical exploration of the state of the nation from a western point of view, rather than offering any real investigation of the non-German subject positions such films ostensibly also present. Consequently, as John Davidson notes, films that seem to offer 'a critique of European/colonized relations […] unfold under closer examination as a reproduction of the very patterns they "oppose"' (Davidson 1999: 22).

Since the end of the Cold War, and the dismantling of the Iron Curtain, Germany's eastern border has become increasingly porous. The *Kinomobilny* project reflects this shift, conceptualising the German-Polish border less as a self-reflexive mirror than as a contact zone between communities, a contact zone that has been supported in recent years by a Polish-German co-development film fund, one of a number of co-production deals and transnational European funding programmes upon which filmmakers in the region increasingly rely in order to produce and distribute

their films (Newman 2006). Of course, film has always been a particularly *inter*national industry. From almost the beginning of the medium, Hollywood, for example, understood the exportability of its product. If one looks at the European market at least since the 1990s, this has been driven by a small number of Hollywood blockbuster event films, the release of which is invariably preceded by a multi-million-dollar marketing campaign designed to entice spectators into theatres and protect the film studios' investment against the vagaries of critical opinion. Hollywood has, moreover, always been very adept at adjusting to changing international markets. With the growing importance of globalisation as an economic force, the major studios have been quick to make the most of the opportunities this has brought them, maximising the economic potential of exchange rates, local tax breaks offered by national governments designed to attract film production, or of cheap labour and location costs.[2]

Similarly, albeit it on a far smaller scale, German film culture has also always understood itself as part of a global film industry. For example, with regard to the New German Cinema, to see this wholly as the product of a national film culture ignores the important irony that the likes of Fassbinder, Wenders and Herzog only found a national audience once they had been praised by critics and festival audiences abroad, particularly in the United States. As Herzog put it in 1972, 'one should get used to the fact that Germans just don't go to the cinema. Which is why it makes no sense to produce films for the German market alone' (quoted in Elsaesser 1989: 39). The New German Cinema could only become a national phenomenon once it had been perceived internationally. Since the end of the Cold War, however, there has been a noticeable development both in the scale of engagement between national film industries and the nature of the films produced. As Halle suggests, be it 'big-budget mega-blockbusters as well as film-school debuts, from the work of the most dogmatic art-house independent director to the amateur wielding his or her first discount digicam [...] Film is globalised', from financing to the equipment available to filmmakers. However, more importantly, this has brought with it a step change in what he defines as 'sociopolitical ideational processes' (Halle 2008: 4–5). That is, if globalisation describes the broader development of global economic interconnectivity since the late 1980s, transnationalism, for Halle, best describes some of the ways

in which national film industries have adapted to this cultur-
ally. While globalisation might allow Hollywood to consolidate
its position as an international brand, transnationalism suggests
a more reciprocal understanding of the relationship between
film cultures, evidenced variously in terms of film policy and the
increased cross-border exchange of technical expertise and talent,
as well as the increased support for the types of projects which
encourage national film industries to interact. This can be seen, for
example, in the way that supra-national organisations such as the
EU and the Council of Europe play an increasingly important role
in the funding of film, promoting a European-specific version of
transnationalism seeking to open up the internal national borders
of member states, while at the same time strengthening those at
its perimeter. On one level, such schemes are simply intent upon
the creation of a viable European film industry in economic terms.
However, as was discussed in Chapter 1, and as is suggested in
Halle's concept of 'ideational processes', at times they also attempt
to propagate a transnational, and often somewhat artificial, sense
of 'Europeanness', epitomised in the much-maligned europudding.
Here we might return to discussion of the heritage film. While
in the previous chapter I examined the potential of such films to
open up debate on the past, particularly in their reception, in this
chapter I look at the ways in which some of these films also attempt
to delimit this debate. European heritage films, as Halle points out,
are a key cultural product of the EU's film policy. He cites movies
such as Jean-Jacques Annaud's *Enemy at the Gates* (2001) which
turns the battle for Stalingrad into a universally understood story
of heroism, love and betrayal, where all nationally specific 'moral-
ethical engagement with the past gives way to entertainment'
(Halle 2008: 126). A major impetus behind this development is,
of course, the drive to maximise the potential audience for such
European heritage fare. However, in so doing some of these films
also seem to imply a transnational 'European project' that posits
a collectively owned understanding of modern Europe's historical
origins. As I shall discuss in more detail below, at the heart of this
project is what has been described by Lothar Probst and others as
the 'Europeanization of the Holocaust' (Probst 2006). With regards
to visual media culture specifically, Elsaesser suggests that 'While
thirty years ago, Auschwitz and the persecution of Jews was still
very much a catastrophe that the Germans had to show themselves

repentant and accountable for in the eyes of the world', historical milestones, such as the anniversary of *Kristallnacht* or the liberation of Auschwitz, 'have since become European days for joint acts of reflection and solemn commemoration, where Europe can affirm its core values of democracy and commitment to human rights, while condemning totalitarianism in all its forms' (Elsaesser 2005: 73). Thus, it would seem that national heterogeneity can be subsumed within a form of transnational uniformity in which all European identities, including that of post-unification Germany, can find their democratic self-perception reflected and affirmed.

Working against this impulse, however, we also find filmmakers explicitly challenging such homogeneity. Particularly within smaller budget films – some of which, it should be noted, also receive funding from European schemes – filmmakers also self-consciously thematise tensions within the ideational processes the transnational production mode has set in train. Thus, much contemporary film tells the stories of a globalising world in which populations are on the move, where social mobility, largely driven by economics, defines some as tourists, others as migrant workers, yet others as illegal immigrants. These are processes that have now been in train for some time. Consequently, films also increasingly explore the longer-term ramifications of such migration, reflecting the experience of second- and third-generation immigrants living in a variety of multicultural contact zones. This is a world with a huge potential for international communication and understanding, in which cinema can help the marginalised find a voice, highlighting the interdependency of the global community and the potential of the 'hyphenated', hybrid nature of so much identity formation such mobility often provokes. At the same time, with the eastern expansion of the EU and discussions about the future inclusion of Turkey, the events of 9/11 and subsequent 'War on Terror', along with changes to the German immigration law in 2005 to bring it more in line with the rest of Europe, issues of ethnicity, identity politics and national allegiance have become ever more contested – brought to the fore in a particularly worrying speech made by Angela Merkel in October 2010 where she declared multiculturalism in Germany to have 'utterly failed' (Weaver 2010).

The potential of, and tensions within, Germany as a multicultural/multiethnic society participating in a globalising world, in which the country is a particularly important economic power, is

one of the most visible 'transnational' topics examined in contemporary German cinema. While a number of New German Cinema films explored the extent to which the nation was the willing colonial subject of post-war Americanisation, numerous contemporary films point to the ways in which the 'coloniser' and 'colonised' now exist within a dynamic nexus that impacts upon both the 'oppressor' and 'oppressed'. Be this describing the US and its relationship to Germany – discussed in more detail in Chapter 6 – or Germany and its at times apparently neo-colonial links with its eastern and southern neighbours, many films today insist that the world must be envisioned 'polycentrically', as Lutz Koepnick puts it, where identities 'emerge as multiple, in flux, historically situated and heterogenous' (Koepnick 2000: 66). Of course, this characterisation of the shift from a national to a transnational mode of production ignores certain important aspects in the trajectory of both the New German Cinema and the contemporary moment in German filmmaking. First, as already noted, the New German Cinema must be understood within an international, if not specifically transnational, context. Second, although the national cinema audience has declined in recent years, the market share for domestically produced films has increased, reaching a post-unification high in 2009 of 27.4%. While some German films can, and do, circulate beyond Germany's borders, their main audience remains national. Moreover, and returning to the question of reception discussed in the previous chapter, the way a film is received will inevitably be inflected by a specific national context, invariably challenging any clear-cut notion of transnational film production as a homogenising cultural force. Even europuddings do not 'taste' the same everywhere and will be read differently according to where, and by whom, they are being consumed. Over and above the various debates about the past that these films often provoke in Germany, which already suggests the potential of these films to generate competing readings, one thinks, for example, of how German heritage films have sparked discussions about Vichy collaboration in France or Franco in Spain (Paoli 2009).

In this chapter I examine the tensions between the transnational mode of production and the often more nationally specific elements at play within a film's consumption, focusing in particular on representations of multiculturalism within Germany today. Here I explore some of the ways in which a number of films

that are the product of transnational funding sources, populated by transnational casts and/or shot by transnational crews have begun to re-imagine the German nation and German national identity. In so doing, I examine the continued importance of the concept of national cinema, both for filmmakers themselves and for the ways in which their films are often received, despite the increased transnational interaction between film cultures. How does transnationalism in Germany reflect and respond to the broader challenges of economic globalisation and the competing demands of homogeneity versus diversity? Specifically, I examine the increasingly multicultural make-up of German society and the ensuing production of plural concepts of Germanness, as well as the manner in which film defines national identity 'against' its external neighbours. Initially I look at the German-Polish contact zone and the various ways German filmmakers use this border region as a liminal space to explore the limits of German identity formation. Second, I turn to Turkish-German cinema, focusing in particular on the work of Fatih Akın, internationally the best-known contemporary Turkish-German filmmaker working in Germany today. In his films, Akın explores the potential of multicultural identity formation for his protagonists who understand and can exist in either, or indeed across, German and Turkish cultures. Interestingly however, in the reception of this self-consciously transnational filmmaker in Germany and Turkey, we invariably find him re-appropriated as a figure who helps to define the corresponding *national* film culture. Third, I return to the heritage film and its presentation of a transnational version of German history, examining the way transnationalism need not ultimately elide national specificity. Here I examine the limits of transnational homogeneity in the way films since the late 1990s have explored the much discussed 'German-Jewish symbiosis' which has been increasingly constructed as central to the development of the modern German nation. To discuss the place of Germany's Jewish community within the context of transnationalism is, of course, problematic, potentially playing to worrying clichés that this part of the population is somehow foreign, somehow 'other' to non-Jewish Germans. Clearly this is not the case. An exploration of Jewish-German identity raises very different issues to, for example, discussions of Turkish-Germanness. In my examination of Margarethe von Trotta's *Rosenstraße* (2003) I examine some of

these issues, in particular the ways in which this heritage film, for all its explicit political correctness, at times seems implicitly to play to some of these clichés in order to highlight 'German' tolerance, in the process using concepts of transnationalism as a way of overcoming – or perhaps evading – the trauma of the nation's past. This is a tendency that is lampooned in Dani Levy's *Alles auf Zucker* (Go for Zucker!, 2004), also discussed here. Levy's film satirises the political correctness of the likes of von Trotta through its construction of multicultural identification as a performative act, echoing elements of Akın's presentation of multicultural identity formation. Finally, I turn to a discussion of how the present-day conception of Germany as a neo-colonial power within Europe also interacts with the continuing legacies of the country's problematic history in work far removed from the heritage film. This is a history that seems to allow some easy access to film material that can confirm the nation's position at the heart of a 'European project' of integration, while for others suggesting the continuing problems at work within Germany's national self-identity as well as its position in the region.

Germany's oriental other? Poland in contemporary German film

Until recently, the relationship between Poland and Germany received little attention by filmmakers from either country, notable exceptions notwithstanding, such as Michael Klier's story of a Polish man's journey from his homeland to New York in *Überall ist es besser, wo wir nicht sind* (The Grass Is Greener Everywhere Else, 1989) or the depiction of the same journey in reverse in Jan Schütte's *Auf Wiedersehen Amerika* (Bye Bye America, 1993). In the 2000s this changed noticeably, due not least to the co-production deal already mentioned. In the work of a number of filmmakers, eastern Europe in general and Poland in particular became an important locus, often functioning as a liminal space of self-discovery for the films' German protagonists. This can, for example, be found across a number of films by members of the Berlin School. Christoph Hochhäusler's *Milchwald* (This Very Moment, 2003) reworks the Grimms' fairytale of *Hansel and Gretel* as the story of a woman's breakdown after abandoning her step-children on the Polish-German border; Henner Winckler's

Klassenfahrt (School Trip, 2002) examines a love rivalry with tragic consequences between a Polish and German boy during a winter school trip by the German boy's class to the Polish Baltic, while Jan Krüger's *Unterwegs* (On the Road, 2004) again uses the Polish coast to play out a typical scenario in work by the Berlin School, namely of a family on holiday torn apart as it is forced critically to reassess its value system. In each film, the Polish mise-en-scène is set against the realist signature style of these filmmakers to present a series of classical narratives, centred on the psychological development of their bourgeois German protagonists. In a similar vein, but located in the experience of the working classes in post-unification Germany, Dresen's *Halbe Treppe* adopts elements of documentary realism – albeit in a far more laconically comic key – in his depiction of life on the German side of the German-Polish border. Here, the proximity of the film's setting to Poland foregrounds the distance of this ex-GDR world from the centre of German society and with it the instability of the population's peripheral existence.

The image of the east we find in such films is not only limited to the relationship with Poland. Stefan Betz's *Grenzverkehr* (Border Traffic, 2005), for example, turns a story of three Bavarian boys looking to lose their virginity by indulging in sex tourism across the Czech border into a Heimat film. The boys return home, still virgins, with a young pregnant Ukrainian whom they have found on their travels and whom they welcome into their rural homeland in an affirmation of German family values. Didi Danquart's *Offset* (2006) depicts the perils that await Germans looking to build partnerships with Romania, be they based on business or love, and Lars Büchel's road movie *Erbsen auf halb 6* (Peas at 5:30, 2004) reworks Frank Capra's *It Happened One Night* (1934) to present a journey of self-discovery across Europe to Russia by a theatre director who loses his sight in an accident, played by the well-known Icelandic actor Hilmir Snær Guðnason (*101 Reykjavík*, Baltasar Kormákur, 2000), and his blind counsellor (Fritzi Haberlandt). Moreover, the images of the east we find throughout these films are not only reflected in the representation of eastern Europe as a geographical location. Fred Kelemen's *Abendland* (Nightfall, 1999), transports the liminal space of the east to the German underworld, presenting the migrant population of eastern Europe in Germany as inhabiting a bleak realm of violent crime and prostitution. This contrasts starkly with Till Endemann's coming of age romance, *Das Lächeln*

der Tiefseefische (The Smile of the Deep Sea Fish, 2005), where the Polish inhabitants of the Baltic island of Usedom are shown to be a happy-go-lucky bunch, providing a necessary counterpoint to the world-weary German population. In all these films, while the presentation of eastern Europe can be more or less positively encoded, it is always 'other' to Germany, always a foil for existential self-reflection, offering the spectator a reworked version of Edward Said's *Orientalism*, which has long been a defining impulse within western cultural representations of the eastern world. For Said, the Orient is less a geographical entity than a metaphorical space through which the colonial west of the eighteenth and nineteenth centuries in particular could prop up its sense of superiority towards the east. 'The Orient was always in the position of both outsider and of incorporated weak partner for the west', an imagined locus defined wholly in terms of 'its sensuality, its tendency to despotism, its aberrant mentality, its habits of inaccuracy, its backwardness', values which in turn helped to establish an equally imagined antithesis, 'the Occident', inhabited by the colonising west (Said 1979: 205–8). As such, contemporary German films looking at Germany's relationship with eastern Europe generally, and Poland in particular, often seem to move deeper into the east the kind of images previously associated with the former GDR to be found in a number of films by west German filmmakers produced during the early days of unification, films that will be discussed further in Chapter 7 of this study.[3]

If there has been a transnational turn in film culture as a whole, in this regard at least, it has not shifted the focus very far from that of the state of the German nation to be found in some of the best-known films of the New German Cinema. Interestingly, most of these films were produced entirely with German money and none had any eastern European production partners. It is perhaps no surprise, then, that the image of the east we see in such films has been challenged by some eastern European filmmakers. The German-trained Polish director Stanislaw Mucha's comic documentary *Die Mitte* (The Centre, 2004), for example, presents the search for the geographical centre of Europe as a satirical reworking of his countryman Joseph Conrad's *Heart of Darkness*. As Mucha's film crew travels ever further east, they uncover increasingly exotic peoples, each of whom claim ownership of the heart of Europe and, consequently, to live at the centre

of western 'civilisation', whatever that might mean. However, it is not only eastern European filmmakers who have attempted to challenge orientalist views of the east, seeking to engage explicitly in a form of transnational dialogue with Germany's eastern neighbours. Hans-Christian Schmid, a highly eclectic director both in terms of his style and the topics he chooses to depict, has made a number of films that explore the relationship between eastern and western Europe in a far more nuanced and reciprocal manner than many German filmmakers. These include the documentary *Die wundersame Welt der Waschkraft* (The Wondrous World of Laundry, 2009), which looks at the economic links between Poland and the German hotel industry, as well as *Storm* (2009), a thriller set against a Yugoslavian war crimes trial in the Hague. But Schmid's first film to deal explicitly with Germany's transnational relationship with the east, *Lichter* (Distant Lights, 2003) remains one of his most critically acclaimed, winning him the Silver German Film Prize for Best Feature.

Released just before Poland joined the EU and part funded by the Franco-German television network Arte, *Lichter* explores the nature of life for the inhabitants on both sides of what was then the frontier of 'Fortress Europe' in a series of interlocking narratives. At times the film seems to follow the orientalist pattern outlined above. The opening sequence shows a group of Ukrainians being dumped on the outskirts of a town with the promise that they are just outside Berlin. However, both they and the audience soon learn that they are in fact still on the 'wrong' side of the Oder, in the Polish border town of Słubice, a seemingly lawless place, populated by disreputable 'Schlepper' (People Smugglers) ready to fleece such economic migrants of their life savings. The Polish border region is presented as a version of the Wild West, where all social interaction is based on exploitation, and where everything – most noticeably, and disturbingly, women's bodies – is for sale. While on the western side of the river, Sonja (Maria Simon), an interpreter working for the border authority, can altruistically decide to risk everything to help one of the Ukrainians who has been caught trying to make his own way over the Oder, on the other side, Beata (Julia Krynke), a woman with a similar role interpreting for a building company, spends her evenings helping to oil the wheels of commerce by prostituting herself to the company's rich clients, the disparity between the social standing of

26 Crossing the River Oder: for some a simple journey by train or car, *Lichter* (2003).

the women's roles highlighting particularly starkly the economic asymmetries between the two states.

However, beyond this particular disparity, what is striking about the borderland as it is presented in Schmid's film is that the depressingly exploitative nature of life actually permeates *both* sides of the river, thereby ultimately 'denationalis[ing]' the border space, as Kristin Kopp puts it (Kopp 2007: 31), undermining any orientalist tendency, and de-exoticising the eastern experience by highlighting the extent to which the whole region, indeed the whole of Europe, is caught up by the exploitative forces of globalisation. We see how Frankfurt is also underpinned by an underground economy, symbolised in the story of a makeshift criminal 'family' held together by a cross-border cigarette-smuggling operation and brought to the point of destruction by a female fugitive from a children's home one of its members picks up, played by the young rising star Alice Dwyer, reprising elements of her role from Philipp Stölzl's *Baby* (2002) as a juvenile femme fatale. The economic situation of the German population is at times just as precarious as that to be found in Poland. While a Polish woman working illegally in Frankfurt can be summarily dismissed from her job, it quickly transpires that her boss Ingo (Devid Striesow), the west German owner of a mattress shop, will fare no better when his parent

27 Crossing the River Oder: for others a near-death experience. Antoni (Zbigniew Zamachowski) tries to lead a family across by foot, *Lichter* (2003).

company decides that it wants to open up a new branch in the town. Here, the film resonates with the image of Frankfurt/Oder in *Halbe Treppe*, spreading the liminality of the Polish space westwards. However, it also deconstructs any orientalist view of the ex-GDR to which this could give rise by highlighting the region's connection to the rest of the global economy. From a sequence shot in Berlin it is evident that this metropolitan city is just as reliant on the 'black economy' as Frankfurt/Oder. Whether one lives on the border or in the metropolis one is subject to the impossible constraints of the competing 'realities' that exist within market-oriented capitalism, to invoke the film's strapline 'Welcome to Reality'. And it is these competing realities that are central to the invariably tragic lives of the characters we meet, characters that are forced to adopt a necessarily narrow focus in their negotiation of the difficulties they face every day. In a number of reviews, parallels were drawn to Robert Altman's *Short Cuts* (1993) and its depiction of life on the margins of American society through a series of similarly interlocking stories (Bax 2003). A more direct parallel, however, can be drawn with Ken Loach's *Raining Stones* (1993), not least in its portrayal of a father driven into the under-world to buy a dress for his daughter's first communion, a parallel that points to a moment of transnational correspondence not

only in these films' similar depiction of the demands of consumer society but also in the aesthetic response of the filmmakers to their material.

In Loach's film, an unemployed man borrows money from a loan shark with violent consequences. In Schmid's, a Polish taxi driver, Antoni (Zbigniew Zamachowski), tries his hand at people-smuggling for the same reason. Significantly, however, there is no redemption for Schmid's characters as there is in *Raining Stones*. While Loach's Bob (Bruce Jones) is ultimately given a chance to live an honest life away from the underworld of loan shark violence, Antoni is left distraught at the back of his local church having failed to buy his daughter's dress in time, unable to gain forgiveness for stealing the money to buy it from the Ukrainian family he failed to bring across the Oder. That said, the root of the problem in both films is the same: the inability of their protagonists to see the futility of their aspiration to provide expensive dresses for their daughters. And they are not alone. In a variety of ways, all the characters in Schmid's film are caught up in the false consciousness of their immediate situation. All the main protagonists are focused either on their own survival or on assuaging their sense of guilt for being able to do more than survive. The necessarily self-centred, narrow view of the inhabitants of this world is reflected particularly clearly in Schmid's extension of the hand-held documentary style we find in many representations of the region in recent films, along with other European films depicting the economic challenges facing the population more broadly. Here we can again find echoes of Ken Loach, not least in Schmid's at times seemingly casual approach to framing. In this regard Schmid is aided by the camerawork of Bogumil Godfrejow, an accomplished Polish cinematographer who has worked with the director on a number of projects. In *Lichter*, Godfrejow's camera follows the movement of the characters so tightly that it often fails to keep up with the action, the protagonists repeatedly being lost from the frame. There is only very limited use of establishing shots. Instead the spectator is continually, and disorientingly, plunged *in media res*. Unlike Schmid's characters, the spectator can ultimately gain a more objective view of life in the region through the aggregation of the individual perspectives depicted in the various narrative strands. Yet once gained, this overview does not grant any greater insight, offering no easy answers to the inhabitants' predicament.

Instead, we simply find a world rushing headlong into a globalised dystopia. This is a 'reality' that transcends national boundaries while, at the same time, confining its eastern inhabitants to these same boundaries.

Turkish-German 'hyphenated' identities: transnational production versus national reception

The German-Polish transnational border encounter we find in *Lichter* can be characterised as one of tension and constraint. Until recently this was also a dominant feature more generally in the presentation of the migrant population living within Germany itself. As the 'guest worker' communities – invited to Germany from the 1950s onwards to fill shortages in the labour market – began to settle, have children and eventually to represent themselves on screen, the limitations and constraints put on migrant workers and their families continued to dominate, a continuity underlined, as Deniz Göktürk notes, by the funding patterns set at the time which often attracted film projects that focused on the 'foreignness' of migrant culture, with the aim of raising awareness of the need for greater social integration, particularly with regard to Germany's Turkish population, the biggest ethnic minority living in the country (Göktürk 2002: 250). Often seen as part of a broader 'Cinema of Duty' that depicted the experience of migrant communities across Europe, the overwhelming mood of such films is one of claustrophobia (Malik 1996). Tevik Başer's *Vierzig Quadratmeter Deutschland* (40 Square Meters of Germany, 1986) is one of the best-known examples of this type of film depicting a young Turkish bride imprisoned in her Hamburg flat by a husband who subjects her to his highly oppressive patriarchal authority, ostensibly to protect her from the dangers of western society.[4] Kutluğ Ataman, a Turkish artist trained in the US and living in the UK, continued this trend, causing a huge stir at the Berlin Film Festival of 1999 with his German-funded feature *Lola + Bilidikid* (Lola and Billy the Kid, 1999), an exploration of the problems of life as a gay Turkish teenager within the Berlin transvestite scene. As already discussed in connection with Petzold's *Jerichow*, the difficulties of the migrant experience continues to be examined in more recent film. The presence of the 'Cinema of Duty' can also be found, for example, in Feo Aladag's *Die Fremde* (When We Leave,

2010), the story of a Turkish-German woman fighting to escape the oppressive cruelty of her Turkish husband and build a new life for herself in the west.

However, we also see the topics filmmakers chose to explore change at times to reflect demographic shifts in the types of people moving to Germany as well as the broader range of challenges the 'migrant' population must face as this community becomes ever more embedded within German society and the original moment of migration becomes a distant memory. Esther Gronenborn's *Adil geht* (Adil's Going, 2005), for example, tells the story of a group of young Albanian asylum seekers facing deportation to a country they left as small children and to which they feel no attachment. Angelina Maccarone's *Fremde Haut* (Unveiled 2005) – discussed in the following chapter – similarly explores the world of the asylum seeker, in this case narrating the experience of a young Iranian woman persecuted at home for her sexuality and forced to live illegally in Germany as a man in order to escape deportation. Or, we see filmmakers examine the changing attitudes towards the migrant population within the country post-9/11. Thus, Max Färberböck's *September* (2003), Elmar Fischer's *Fremder Freund* (The Friend, 2003) and Benjamin Heisenberg's *Schläfer* (Sleeper, 2005) offer early uncomfortable reflections on the impact of the attacks on the World Trade Center and the Pentagon on Germany's self perception as a tolerant, multicultural society, when Muslim 'friends' can reveal themselves as potential terrorists.

With regard to the specific representation of the Turkish-German experience that we find in the films from the 1970s onwards, although the earlier tendencies of the 'Cinema of Duty' continue, there has also been a major shift away from its conceptualisation of the migrant experience as one defined by the limitations and problems these communities must face. A generation of Turkish-German filmmakers has come of age, more often than not themselves born in Germany, that has been central to the renaissance of German cinema. This led the filmmaker and journalist Tunçay Kulaoğlu to declare in 1999, somewhat provocatively, that 'the new "German" film is "Turkish"', as a whole host of Turkish-German filmmakers, such as Fatih Akın, Thomas Arslan, Sülbiye Günar Ayşe Pola and Yüksel Yavuz began to be fêted in the German press as the future of the domestic industry (Kulaoğlu 1999). Within this generation, one finds Turkish-German

scriptwriters and filmmakers adopting internationally recognisable genre forms to depict the experience of a population that can exploit its cultural bilingualism, including Züli Aladag's multicultural reworking of *Raging Bull* (Martin Scorsese, 1980) starring Daniel Brühl, *Elefantenherz* (Elephant Heart, 2002), culture clash comedies such as Anno Saul's *Kebab Connection* (2005) and Torsten Wacker's *Süperseks* (Supersex, 2004), co-written by the Turkish author and cabaret artist Kerim Pamuk, as well as a whole host of Tarantino/Scorsese-inspired gangster dramas from Lars Becker's adaptation of Feridun Zaimoglu's *Kanak Attack* (2000) to Özgür Yildirim's *Chiko* (2008). The use of international genre forms to tell the stories of the Turkish-German community might suggest a mainstreaming of this community away from the art house niche of earlier decades and of contemporary films that focus on the specific problems these communities face. This is also highlighted in the increasing integration of such films into the German star system, with the likes of Brühl or Moritz Bleibtreu regularly appearing in these types of movies. At the same time, of course, it might equally suggest the continued marginalisation of the Turkish-German experience within the German social imaginary, this community often being depicted as existing in a gangster underworld, however glamorously it is conceived. Yet since 2000, we have also begun to see a development in Turkish-German filmmaking away from such ethnically specific reinterpretations of Tarantino or Scorsese. Mennan Yapo, for example, eschews all definition as a Turkish-German filmmaker, his slick assignation thriller *Lautlos* (Soundless, 2004) drawing inspiration from Luc Besson's 'Cinéma du look' and paving the way for him to follow in the footsteps of German-Hollywood filmmakers Wolfgang Petersen and Roland Emmerich, directing the Sandra Bullock vehicle *Premonition* (2007). Similarly, Thomas Arslan has moved from the representation of the Berlin underworld in *Dealer* (1999) to the depiction of a German bourgeois family as it self-destructs in *Ferien* (Vacation, 2007).

For those filmmakers who have remained with specifically Turkish-German topics, as Rob Burns points out, we often also see them looking less at the confinement of their protagonists and instead exploring the transnational experience as one defined by transition and mobility (Burns 2009). This is particularly pronounced in the best known of this group of filmmakers

internationally, Fatih Akın, who, even in his first Scorsese-inspired gangster film, *Kurz und schmerzlos* (Short Sharp Shock, 1998), explored more explicitly than many the liberating potential of a Turkish-German 'hyphenated' identity that can exist both within and between migrant and non-migrant society, a topic that he has continued to mine, be it the Turkish-German experience depicted in his comedy road movie *Im Juli* (In July, 2000) and the melodramas *Gegen die Wand* (Head On, 2004) and *Auf der anderen Seite* (The Edge of Heaven, 2007), or the German-Italian experience of *Solino* (2002). Much of Akın's work is the product of transnational funding models. The distribution of *Gegen die Wand* – Akın's breakthrough film internationally – for example, was part-funded by the Council of Europe's Eurimages scheme, its production by a broad variety of Turkish, French and German funding. The breadth of funding might seem to point to a film with the potential to become a europudding, here being used to bring Turkey into its purview. The film itself, however, avoids this, exploring instead the tensions between national and transnational identity formation, while also pointing to the creative potential of the latter. That said, the film's reception – be that by the media or the broader industry in Germany – tended to ignore the complexities of the film's engagement with the issue of transnationalism, in so doing highlighting the continuing dominant perception of cinema as the product of a specific *national* culture, for all the talk of the transnational turn potentially signalling its demise.

If the transnational milieu in Schmid's films highlights the constraints on those living at the margins of Europe, either physically or socially, the limitations of life in the Turkish diaspora of Hamburg are set against the possibilities available to this community. That said, at first sight, this would seem to be far from the case. *Gegen die Wand* is a melodrama of doomed love, telling the story of Sibel (Sibel Kekilli), a young woman looking for a marriage of convenience to escape the oppression of her home life and Cahit (Birol Ünel), an alcoholic waster she meets in a rehabilitation clinic, convincing him to marry her as they both recover after failed suicide attempts. On one level, the film once again seems to play to the kind of orientalist othering discussed above. The Turkish characters we meet exist in a world almost entirely separate from the non-Turkish population. This, it might be assumed, is the much discussed *Parallelgesellschaft* (Parallel

Society), often presented in the German press as a worrying development for contemporary society – and part of the impulse behind Merkel's speech – which ostensibly rejects the enlightened values of western democracy in favour of an honour code enforced by violence. Both Sibel and Cahit initially reject this world. Sibel, in particular, wants to experience life beyond the constraints of her draconian home, dominated by the rule of her father and brother, looking to experiment with drugs and enjoy sexual freedom as non-Turkish-German women of her age can. In so doing, however, the space she inhabits with Cahit remains fundamentally 'other' to mainstream German society. It is a seedy, night-time world of hedonistic excess, where Cahit can descend into alcoholic stupor and Sibel can go to bed with a different man each night. As might be predicted, the couple soon fall in love for real. But as befits the film's melodramatic mode, before the marriage can be consummated the couple is torn apart. Cahit kills one of Sibel's lovers, a crime of passion that condemns him to prison. Vowing to stand by her man, Sibel moves to Istanbul in order to avoid the threatened retribution of her family for the disgrace she has brought on them by her promiscuity. Istanbul, however, brings no real escape for her. Instead she sinks into a world which parallels that of Cahit's life in Hamburg, taking on her husband's mantel of alcoholic self-destruction, until she is finally left for dead in the street after a violent attack during a particularly heavy night of excess, the symbiosis of the couple's experience underlined in the film's repetition of the grinding guitar of Depeche Mode's drug-inspired 'I Feel You' during this sequence, first heard as Cahit tried to kill himself at the film's opening.

Like *Lichter*, any orientalist reading of the film is ultimately challenged, in this case through the film's self-conscious deconstruction of its own melodramatic form, which in turn undermines an understanding of the film's depiction of life in the Turkish-German community as straightforwardly 'other' to German society. This is achieved through the interplay of the western and eastern cultural forms upon which the film draws. On the one hand, *Gegen die Wand* can be placed in the tradition of Fassbinderian melodrama, the story of the marriage and separation of Cahit and Sibel in this, the first part of his 'Love, Death and the Devil Trilogy', offering a transnational twist on the central plot conceit of *Die Ehe der Maria Braun* (The Marriage of Maria Braun, 1979), the first

part of Fassbinder's 'FRG Trilogy'. On the other, the film draws on Turkish *Yeşiliçam* popular cinema and the violent passions that are the stuff of Arabesk music and film (Berghahn 2010). Thus, the film can be viewed, as Akın himself notes in an interview with the writer Feridun Zaimoğlu, as a hybrid cultural product, a German, Turkish, or Turkish-German film, depending on the optic of the spectator.

This is a view that was also supported in the film's reception as well as in the reception of the filmmaker more broadly. That said, this reception equally shows how such transnational cultural work, when successful, invariably seems to be 're-territorialised' within a specific national context. In Germany, Akın is seen, as already noted, as part of the vanguard of a new and exciting development in German cinema, part of Kulaoğlu's new 'German' film. However, this is generally viewed less as evidence of the transnational credentials of the contemporary industry than as proof of German national cinema's multicultural tolerance, a tolerance that was subsequently confirmed when *Gegen die Wand* was awarded the top prize at the Berlinale unambiguously as a *German* film – the first to win this award in 18 years – and when *Auf der anderen Seite* was selected as Germany's nomination for the Oscars in 2007. And, as if to complete the declaration of such film as a new 'German' cinema, Akın has been fêted in the German press as Fassbinder's heir, his films continuing not only Fassbinder's aesthetic traditions but also his project of social critique (Beier and Matussek 2007; Borcholte 2007). Thus Akın offers continued proof to the rest of the world, it would seem, of Germany's credentials as an enlightened, self-critical nation, now able to explore its multicultural make-up, as Fassbinder's generation had evidenced the nation's ability to reflect upon its problematic past.

In Turkey, on the other hand, Akın – who has dual nationality – is constructed in the press as the nation's cultural ambassador in Germany, an advocate for Turkey's accession to the EU, albeit an ambassador who sometimes goes too far, such as when he apparently claimed he would not complete military service in Turkey, saying that if he were forced to do so he would give up his Turkish citizenship. As Nezih Erdoğan points out, in the Turkish press this was viewed wholly as a form of anti-patriotism, as a dig at his mother country. What was ignored was the broader context of Akın's passifism. It is military service per se, rather than Turkish

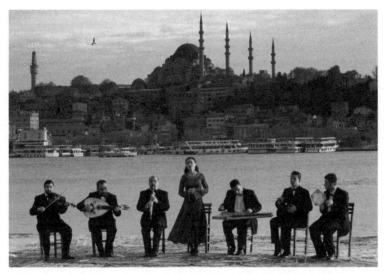

28 A picture-postcard representation of Istanbul in the film's musical tableaux, *Gegen die Wand* (2004).

military service, that he rejects (Erdoğan 2009: 35). Without doubt Akın himself at times plays up to his popular construction as either a Turkish or German filmmaker. However, as I shall now discuss, while *Gegen die Wand* draws freely from what Sujata Moorti describes as the multilayered 'warehouse of images' available to the 'diasporic imaginary' (Moorti 2003: 355), what tend to be ignored in the popular reception of Akın's work are the ways in which he plays these specific traditions off against each other, offering an interconnected critical commentary on the subject positions they represent.

The film opens with a musical performance of a mournful ballad about unrequited love, sung by the Turkish-German actress Idil Üner to an accompaniment by the well-known Roma clarinettist Selim Sesler's ensemble. Dressed in evening wear and set against the backdrop of the Golden Horn and Süleyman Mosque in Istanbul, the sequence provides a striking tableau that presents a stereotypical, picture-postcard image of Turkey as exotic paradise. The film then cuts to a sequence of what looks like lights on a movie set being switched on, before we are subsequently introduced to Cahit as he sets off towards the suicide attempt that will bring him

to Sibel. The musical tableau, which will be reprised five times throughout the film, can be read, as Burns notes, as a Brechtian distanciation device, an extra-diegetic chorus that comments on the unfolding narrative (Burns 2009: 18). However, the subsequent shots of the lights potentially troubles this relationship, drawing attention to the fact that we are watching a film and thus asking us to consider if the main diegesis is not in fact itself a performative commentary on the clichéd image of Turkey depicted in the opening music sequence. Where does the 'reality' of the film lie and for whom is this image of reality, wherever it exists, performed? Is the film an ironic presentation of a western gaze, challenging the German spectator's expectation of a Turkish-German film? Or does the film speak to Turkish-German, or Turkish audiences that might see themselves as the victims of German marginalisation? In support of the latter reading, as the narrative develops, the musical tableaux seem to run out of steam. By the group's third appearance Üner no longer even sings. Instead, her voice is replaced in the main narrative with Cahit's friend's ironic performance to Sibel of another arabesque ballad, which he sings to take her mind off her husband's imprisonment. In so doing, however, he also challenges her own position in the narrative as tragic melodramatic heroine. It would seem that the clichéd exoticism of the extradiegetic performance (if that is in fact what it is) is no longer sustainable in the face of the transnational reality of life in Hamburg. At the same time, and seeming to work against this impulse, within the diegesis, the characters themselves are drawn ever more closely to a traditional notion of Turkishness. As Sibel falls for Cahit, she takes refuge in her public identity as a married Turkish woman in order to distance herself from the life of promiscuity she has built for herself, thereby further complicating the relationship between the main body of the film and the performance of Turkishness in the musical interludes.

Gegen die Wand neither dismisses nor allows the straightforward appropriation of a Turkish subject position. Simultaneously, it offers a similarly ambiguous presentation of western (German) values. On the one hand, the respectable world of western mainstream culture, while less violent than Cahit and Sibel's night-time world, is depicted as patronising and vacuous. The spectator cringes at the doctor's awkward attempts to be politically correct in his clichéd questions to Cahit in the rehabilitation centre as to the meaning

29 'Punk is not dead': Cahit (Birol Ünel) and Sibel (Sibel Kekilli) dance to The Sisters of Mercy, *Gegen die Wand* (2004).

of his name – 'your names all have such nice meanings [...] much more than ours' – at his 68er left-liberal tone, suggesting that Cahit might do something 'useful' with his life, like 'go to Africa and help people', as well as his recourse to western popular music as a commentary on Cahit's predicament. 'Do you know the band The The?' he asks a bemused Cahit, who we might surmise from his life in Hamburg clubs has a more immediate connection than the doctor with the post-punk sensibilities of such music which dominates the soundtrack of the main body of the film. On the other hand, although cringe-worthy, the doctor's recourse to popular culture nonetheless points to a broader engagement with western music in the film that begins to suggest a similar ambiguity in the relationship of the film's protagonists to western culture to that which we see in relationship to their Turkishness. This, in turn, begins to reflect the transnational potential of Cahit and Sibel's position in society, reaching a climax in the couple's ecstatic dance to *Temple of Love*, a song by the UK band The Sisters of Mercy, noticeably infused here with the eastern vocals of Ofra Haza. 'Punk is not dead' screams Cahit, his exuberance signalling his excitement at his burgeoning relationship with Sibel, but also his celebration of this music's potential to offer liberation from social constraint in its ability to adapt to, and thereby develop through, new cultural influences.

A straightforwardly dichotomous relationship between Turkey and Germany is also questioned when Sibel escapes to Istanbul, where she encounters a world that is very different to the one depicted in the musical interludes. It is, instead, simply a hotter version of Germany, a globalised space dominated by English-speaking media, and hardly an exotic 'other' to the west. However, while there might be no fundamental difference between Hamburg and Istanbul, the characters' change of location itself does offer new possibilities. It is in Istanbul that Sibel and Cahit both eventually find a way out of their mutually self-destructive relationship. Sibel survives her attack and ultimately discovers a new life as a mother. Cahit, on his release from prison, follows Sibel to Istanbul and is briefly reunited with her, only to be separated again as Sibel decides to stay with her partner and child rather than travel to Mersin with Cahit, the town of his birth. To a degree, the end of the narrative simply fulfils, yet again, one's expectations of a melodrama. The couple's final brief encounter culminates in their final separation, the melodramatic poignancy of this moment underlined in the rediscovery by Üner of her singing voice in the final musical tableau. At the same time, the film also under-cuts such poignancy, pointing to the continued potential of its protagonists' 'hyphenated' status, of the fact that their identities are not fixed and essential but are rather always in process. Cahit ends the film by 'returning' to the town where he was born but that he has never known. This could be read as a conservative declaration of the essential authenticity of his Turkish roots over his German upbringing, continuing the development we see at work in Sibel as she declares to one of her many one-night stands in Hamburg that she is a married Turkish woman who must now be left alone. The ending of the film can, however, also be read as working against such an essentialist understanding of identity formation. Crucially, we do not see Cahit reach his 'final' destina-tion but simply set off for it. We do not know if this is, in fact, the end of the journey for these characters. 'Life's what you make it' declares the film's closing music – an interpretation of the British band Talk Talk's 1985 hit by the German group Zinoba. This western transnational pop song thus acts as a commentary on Cahit's Turkish journey, highlighting the continued importance of both western and eastern culture to the continuing development of his sense of self. Ultimately, it is the journey itself, within and

across cultures, that is important to Akın's characters in this and all his films. The continuing potential of motion offered by their transnational identity always gives them the possibility of a new life on 'the other side', as he terms it in the title of the second part of his 'Love, Death and the Devil Trilogy' *Auf der anderen Seite*. It is this motion that finally keeps in balance both sides of 'the hyphen' around which his protagonists invariably locate their sense of self, and which holds both the Germanness and the Turkishness of his central characters in a productive tension, far removed from the 'blanding out' of difference one often finds at work in some self-consciously 'European' filmmaking, specifically in some of its German manifestations, to be discussed in the following section.

The German-Jewish symbiosis: the heritage film and German normalisation

As Leslie A. Adelson notes, in the 1970s 'the Turks are the Jews of today' became 'a common political metaphor' of the Left in its critique of 'a perceived continuity of fascist attitudes in West German society' (Adelson 2000: 93). Of course, and as Adelson goes on to discuss, the experience of German Jews cannot be mapped straightforwardly onto that of German Turks. Rather, she suggests that the relationship between Jewish and non-Jewish Germans has shaped the ways German society continues to negotiate its relationship with the Turkish minority, the spectre of the Holocaust and the much discussed 'crisis of representation' that this has engendered setting to a certain extent the discursive framework for the contemporary exploration of the Turkish-German cultural encounter. While this same discursive framework highlights as many differences as similarities in the experience of these two communities – at its most worrying potentially playing to anti-Semitic notions of Jews as 'foreigners' living within Germany – it nonetheless sets up 'some vague linkage between "things Jewish" and "things Turkish"' as, in Adelson's view, German writers 'negotiate the German present' (Adelson 2000: 101). The linkage is signalled most obviously in Akın's film in the figure of the doctor, his awkward political correctness shaped by his 68er sensibility and this generation's drive to distance itself from Germany's Nazi past.

In the rest of this chapter, I wish to 'reverse the gaze' of Adelson's discussion, looking at the possibilities of the 'hyphenated' identities we find in Akın's work as they play against the representation of the German-Jewish experience in contemporary film. Here we return to discussion of contemporary European heritage cinema, which Halle notes often plays to a homogenising, transnational European project that seems to elide national specificity. At the heart of this project, as Lothar Probst argues and Adelson's article implies, one finds the Holocaust, viewed now as a foundational myth of the European Union, born out of the attempt to ensure this event can never be repeated and where responsibility for this historical moment is now collectively owned by all nations across Europe. Indeed, at times it is suggested that any German exceptionalism within contemporary European Holocaust discourse resides not in the nation's particular guilt but in the exemplary way it has come to terms with this past, an exemplar from which other nations can now learn. Thus, in Probst's words, 'the Holocaust, which for so long has marked Germany out as "abnormal," is now, paradoxically, contributing to the normalisation of the status of the Federal Republic in the European Union' (Probst 2006: 72).

One of the most obvious ways in which this particular aspect of normalisation is enacted on German screens is in a number of heritage films that tell extraordinary stories of Jewish survival during the Third Reich. The best known of these internationally is Caroline Link's Oscar-winning *Nirgendwo in Afrika* (Nowhere in Africa, 2001), a film that like a number of recent German movies uses the powerful vistas of the African landscape as the setting for a journey of European self-discovery, highly reminiscent of the earlier Oscar hit *Out of Africa* (Sydney Pollack, 1985). Here the Meryl Streep blockbuster is recast as the story of a Jewish family that finds refuge on a British colonial farm in Kenya, Link foregrounding the Germanness of her protagonists who learn to respect the indigenous population, in turn learning to contextualise and so better understand the importance of their western values and cultural traditions.[5] Although the Holocaust provides the impulse for Link's story, there is ultimately very little exploration of the place of Jewish cultural identity within German society. In numerous other German heritage films, particularly those made in the latter half of the 1990s and the first part of the 2000s, however, this becomes the central focus, such films often

depicting what I termed in the previous chapter *Schindler's List*-like stories of non-Jewish solidarity with Jewish victims. While these films acknowledge the crimes of the Holocaust, they also suggest the reconciliation between the nation's Jewish and non-Jewish citizens in today's Berlin Republic. In so doing, they posit the reconstitution of the much-fabled 'German-Jewish symbiosis' that was destroyed by the Holocaust, but which has been constructed in recent years as having been central to Germany's intellectual and cultural development, and moreover, as a lynchpin in the present-day construction of Germany as an enlightened, European democracy, equivalent to any number of other nations (Taberner 2005). Consequently, such films ultimately seem to elide the hyphen in German-Jewish identity construction, celebrated in Akın's construction of Turkish-German identity, setting up instead a symbiotic equivalence between German and Jewish cultural heritage.

One example of this type of film is Margarethe von Trotta's *Rosenstraße* (2003), the story of a group of women who protested against the internment of their Jewish husbands during the war. Von Trotta is a well-known figure from the days of the New German Cinema who has made a particular name for herself since unification depicting the nation's history, albeit with far less critical edge than her earlier work of the 1970s and 1980.[6] *Rosenstraße*, a German-Dutch co-production which also received substantial support from Eurimages, depicts an explicitly transnational encounter between a German and a Jew in order finally to reconstitute the German-Jewish national symbiosis. In the process, the film plays to certain stereotypes implicit within many portrayals of this symbiosis, not least – and seemingly paradoxically – of the 'Jews' being somehow distinct from the 'Germans'. Jewish Germans are, moreover, constructed in the film as the passive victims of the Nazis – another common cliché in the representation of the Jewish experience during the Third Reich – protected by an enlightened German minority that managed to avoid the corruption of the state's anti-Semitic ideology.

The film opens in New York in the 1990s. Ruth Weinstein (Jutta Lampe), a Jewish refugee from Germany, is observing the Jewish ritual of Shiva, the death of her husband having triggered a rediscovery of her Jewish identity, much to the consternation of her family, and more specifically her daughter Hannah, played by

Maria Schrader, an actor who has made her name starring in a number of such German-Jewish heritage films. What Hannah finds particularly galling is the fact that her mother's renewed faith has caused her to reject Hannah's South American gentile fiancé Luis (Fedja van Huêt), a rejection that becomes all the more confusing when, during the mourning period, Hannah learns that her mother was protected during the war by a non-Jewish German in Berlin. Unable to get any answers from her mother about her past life in Germany, or her return to the Jewish faith, Hannah embarks on a trip to Berlin, where she finds the former concert pianist Lena Fischer (Doris Schade), the woman who protected her mother during the war. Through a series of flashbacks, the audience travels back in time learning of the marriage of the younger Lena (Katja Riemann) to the Jewish violinist Fabian (Martin Feifel), a union that led to her being rejected by her aristocratic family, of Fabian's subsequent internment, along with a number of other men, in a Jewish community centre on Rosenstraße and his wife's efforts to save him, culminating in a somewhat incredible moment when it is implied that Lena prostitutes herself to Joseph Goebbels (Martin Wuttke) in an attempt to secure the prisoners' release. At the same time, we witness the developing bond between Lena and the young Ruth (Svea Lohde) who waits in vain for her mother – ignorant of the fact that the woman has already been transported to Auschwitz – as well as the growing community of protesting women who stand on Rosenstraße outside the building where their husbands are being kept.

The film's structure is reminiscent of von Trotta's *Die Bleierne Zeit* (The German Sisters, 1981), which offers a semi-biographical account of the life of the RAF terrorist Gudrun Ensslin. In *Rosenstraße*, von Trotta again uses flashbacks to excavate German history in order to overcome the silence of those who lived through the period but who refuse to share their experience with the generation that did not. However, here the focus is not on the legacy of those who were culpable for the past, as it was in the earlier film, but on those who were the victims of the regime. The Jewish men inside the building are shown remaining stoically civilised in the face of their barbaric treatment by the Nazis. They spend their time playing chess or in philosophical discussions about the nature of Germanness, highlighting their status as the torch-bearers of Germany's Enlightenment tradition. When one

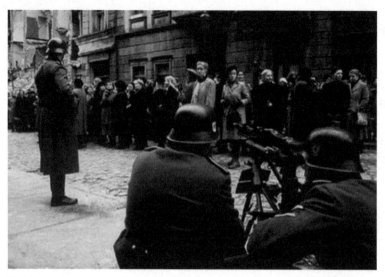

30 Protesting women facing Nazi machine guns, *Rosenstraße* (2003).

man is asked why he did not escape when the Nazis first took power, he insists, 'I'm German, and I'm waiting until the Germans come back', confirming his status as part of an 'authentic' German tradition, a quotation which, as Stuart Taberner notes, recalls the words of one of the most famous Jewish survivors of the Holocaust in Germany, Victor Klemperer (Taberner 2005: 366). Meanwhile, outside on the street, the Nazis are presented as a perversion of this tradition, as monsters intimidating the protesting German women by firing machine guns above their heads.

In a manner typical of many heritage films, the mise-en-scène presents us with a seemingly authentic image of a city that has to live with nightly air-raids, allowing the spectator to indulge in the cinematic spectacle of the nation's destruction, clearly marked as a product of Nazi barbarity which has perverted German values to its own ends. At the same time, through these flashbacks, a nostalgic image of another older, more cosmopolitan Germany is revealed, a Germany which at times actually seems more 'modern' than that of the war period. In a sequence that depicts Lena and Fabian's pre-war courtship, we are able to enjoy the vibrant cabaret nightlife of the Weimar Republic, a world in which the freedom of artistic creativity, it would seem, flourished, and where a transnational,

multicultural society was already blossoming. Although Lena and Fabian's relationship is rejected by Lena's aristocratic father, her fun-loving brother Arthur (Jürgen Vogel), a symbol of the next generation, embraces the union, celebrating with the couple in a jazz club where a black woman performs, a further gesture to the cultural openness of this world and prefiguring the multicultural potential of today's Berlin Republic. The exuberance of Arthur in this early flashback is then contrasted with the man we see once Fabian is taken. Now, having returned from the Eastern front, shattered both physically and mentally by what he has experienced there, the potential of Weimar is shown to have been lost. Nonetheless, through the heroism of the Rosenstraße women it is clear that it might be rediscovered, their bravery pointing to a kernel of humanity that would eventually return. Thus, although the story is the product of German oppression of the Jews, its real focus is on the bravery of the non-Jewish women which is constructed as the product of a Germanness synonymous with the modern, democratic, European version of national identity found in the contemporary Berlin Republic.

Within the broader conceptualisation of European identity discussed in the introduction to this chapter, the memory of the Holocaust and the fractured German-Jewish symbiosis actually becomes a form of glue that can help heal the wounds of the country's post-war division, in turn pointing to the way that this process of healing sits at the centre of a wider European project. By night, Hannah works through her conversations with Lena in her hotel room on Potsdamer Platz, a symbol of the now unified capital and of Germany's status as a 'normal' nation, no different to the United Kingdom or France, as von Trotta makes clear in the director's commentary on the DVD release of the film. By day, this visitor from America talks to her mother's German saviour, traversing the city, visiting key memorials to the treatment of the nation's Jewish citizens on both sides of the former Wall, the Scheuenviertel in the east and the Levetzow Synagogue Memorial in the west. Thus, Hannah's journey highlights the way Berlin knits together. This is a historical crime with which Germans on both sides of the old East-West divide must engage, and through which they can all now finally reconnect with a pre-Nazi, non-tainted, non-divided German tradition and ultimately with their European neighbours. It is also an impulse that is symbolised particularly strongly in the

piece of music by the Belgian composer César Franck that Lena and Fabian play in a flashback to their Weimar performing days, and which spills over into the soundtrack of a present-day sequence in which Hannah looks for the same piece in a Berlin music shop. The music of this past time, when anything was still possible for this German-Jewish couple, forms a bridge with the present. However, for now, the utopian potential of the music cannot help Hannah's mother. This will not be achieved until the end of the film, when the same music is played once again by the elderly Lena after she has dispatched Hannah back to her mother with a ring the young girl left behind when she was sent to America after the war to live with her aunt, a separation that broke both their hearts. In a moment of extraordinary sentimentality, the music again breaks into the soundtrack of Hannah's reunion with her mother. We see Ruth accept the ring, acknowledging the fact that Lena never stopped loving her. Through her daughter's journey from America to Germany and back again, Ruth can at last move beyond the trauma of her past, the death of her Jewish mother and the separation from her German ersatz mother. Finally, she can accept that her and her family's future must lie in an engagement with, rather than the rejection of, the gentile world, Hannah's transnational encounter reinstating the place of Germany within her mother's heart, in turn allowing her daughter to build a psychologically healthier future, symbolised in her own transnational relationship with her South American fiancé.

In *Rosenstraße* the declaration of Jewish/non-Jewish solidarity replaces Nazi anti-Semitism with a form of philo-Semitism that nonetheless maintains a problematic sense of Jewish exceptionalism within German society, encapsulated in the wider post-unification 'fashion' for 'things Jewish' of which these German-Jewish heritage films are a highly visible part (Taberner 2005: 257). At the same time, and somewhat paradoxically, it seems to elide any notion of Jewish distinctiveness. German culture becomes a manifestation of Jewish culture behind which the post-Wall nation, and ultimately Europe, can unite. For the director Dani Levy who made his name as part of the *X Filme Creative Pool*, the question of Jewish/non-Jewish relations has similarly been central to his work since *Meschugge* (The Giraffe, 1998), a neo-noir about a Nazi war criminal who escapes detection for decades masquerading as a concentration camp survivor, in which he played the

lead opposite Schrader. However, the emphasis of Levy's films is very different to von Trotta's *Rosenstraße*. The differences in his approach are most obvious in his hugely controversial and critically slammed comedy *Mein Führer – Die wirklich wahrste Wahrheit über Adolf Hitler* (Mein Führer – The Truly Truest Truth About Adolf Hitler, 2007), discussed in Chapter 3, which depicts the efforts of a Jewish actor to help the ailing Führer regain his confidence as a public speaker, along with the far more commercially and critical successful *Alles auf Zucker* (Go for Zucker!, 2004), which won six German film prizes, including those for best feature and best director, and sold well over a million tickets domestically during its theatrical release. While one might immediately understand why making a German comedy about Hitler's encounter with a Jewish actor would cause controversy, no less potentially explosive was the subject of this earlier film, at least as far as many of the potential funders were concerned when Levy approached them as he embarked on the project. It took him four years to secure the required finance, finally gaining funding from a patchwork of regional and transnational sources. As a result, we can see that although this, like *Rosenstraße*, is a product of transnational European funding, it has a far more critical take on German-Jewish relations than von Trotta's larger-budget heritage film, highlighting the critical potential of transnational film often ignored if one focuses on the more expensive films such funding often generates. While transnational film funding has received a good deal of criticism for the creation of the europudding, it has also supported numerous films that might well otherwise not have received funding or wide-scale exhibition.

Levy is a Jewish filmmaker and *Alles auf Zucker* is a comedy self-consciously working in a tradition of Jewish humour, found in the work of Ernst Lubitsch, Billy Wilder and the Marx Brothers and which has seen a recent boom in Hollywood in the work of directors and stars such as Judd Apatow (*Knocked Up*, 2007), Ben Stiller (*Meet the Fockers*, Jay Roach, 2004) and Adam Sandler (*Grown Ups*, Dennis Dugan, 2010). This is a tradition that both plays to and debunks Jewish stereotypes and as such challenges the type of political correctness at work in a film like *Rosenstraße*, potentially leaving him open, Levy himself feared, to charges of anti-Semitism, attacks that largely did not materialise (Levy 2004). *Alles auf Zucker*, like *Rosenstraße*, is set around the observance of

Shiva, an event which similarly sets in train a process in which the film's protagonists are forced to reflect on their past and the nature of their identity. It is here, however, that the similarities between the two films end. The comedy in *Alles auf Zucker* revolves around two Jewish brothers Samuel (Udo Samel) and Jakob Zuckermann (Henry Hübchen), separated by the Berlin Wall when their mother took Samuel to the West for an operation, where he subsequently lived a life as an orthodox Jew and built a substantial business. Staying behind in the GDR, Jakob changed his name to Jaeckie Zucker, rejecting both his family and his Jewish heritage for what he sees as his family's rejection of him, and in the process developed a successful career as a sportsman and sports reporter. Since unification, the brothers have remained estranged, only now coming together at the request of their recently deceased mother, who insists that the sons sit Shiva together and reconcile their differences. If not they will lose their inheritance.

And both men and their families need the inheritance. While Samuel's business is struggling in the post-unification economic downturn, the collapse of the GDR has also seen Jaeckie's luck change, the man now reduced to hustling pool to make a living, an ex-GDR comic version of Paul Newman's Fast Eddie from those classics of the pool-hall movie genre, *The Hustler* (Robert Rossen, 1961) and *The Color of Money* (Martin Scorsese, 1986). These films are evoked not only in Hübchen's performance as a chancer pool shark, but also in *Alles auf Zucker*'s cinematography which at times strongly echoes that of (the coincidentally German) cinematographers Eugen Schüfftan and Michael Ballhaus from the earlier films, Carl-Friedrich Koschnick's camera similarly sweeping extravagantly around the pool table during match sequences. Given their mutual need to inherit, both families are keen to fulfil their mother's request. The problem is that Jaeckie's home is 'about as kosher as a pork chop', as Samuel's wife Golda (Golda Tencer) puts it. To make matters more complicated, Jaeckie also has the chance of a lifetime to win the European Pool Championship, taking place that very weekend in Berlin – participation in such events, as one might expect, being forbidden during Shiva. What ensues is a rapidly paced farce, as Jaecki tries to win the tournament, sneaking out to matches during the mourning ceremony by feigning a series of heart attacks, while his wife Marlene (Hannelore Elsner) tries to maintain the illusion that they are a 'normal' Jewish family,

31 Marlene (Hannelore Elsner) playing it (literally) by the book as Jaeckie (Henry Hübchen) looks on in disbelief, *Alles auf Zucker* (2004).

reading up on Jewish rites and playing it (literally) by the book. Meanwhile Golda and Samuel ignore the obvious failures in the other family's construction of Jewishness in an attempt to fulfil the requirements of the inheritance.

Through Jaecki and Marlene's ridiculously parodic performance of Jewishness, Levy ironises the elision of German-Jewish difference we see in heritage films such as *Nirgendwo in Afrika* or *Rosenstraße*. As Seán Allan puts it, 'the harder [Marlene] tries to erase cultural difference, the more clearly it reasserts itself' (Allan 2007: 30). Both families have been brought up in different cultural traditions, differences that are impossible to elide. However, at the same time such differences cannot be seen in essentialist terms. Neither 'Germanness' nor 'Jewishness' are fixed categories. Rather they are aspects of the complex web of influences that make up an individual's sense of self. Such identities can be adopted as necessary strategies that help the characters negotiate life, and as such they are fundamentally 'performative' in nature. The problem with the performance of Jewishness in much recent German film culture, however, as can be seen in *Rosenstraße* and as Allan also points out, is that it actually seems intent upon hiding a deeper process of 'othering' which condemns Jewish protagonists to the role of passive victim of history (Allan 2007: 25). Levy's film challenges such othering; this is suggested most obviously in the way

the film maps the presentation of 'German-Jewish' relations onto a standard unification narrative of a family, divided by the Wall, finally learning to come together again. This is a story reminiscent of *X-Filme*'s earlier international hit, *Good Bye, Lenin!* (Wolfgang Becker, 2003), which *Alles auf Zucker* evokes strongly in Marlene's attempt to turn the family flat into an illusory Jewish space, rather than the GDR space of Becker's film, following the instructions she finds in her *Wie Juden Leben* (How Jews Live) book. What is particularly noticeable in Levy's film, however, is that the usual power dynamic of these two narrative levels is reversed. Jaecki is the 'Ossi' who has lost out by unification, supported, unbeknown to him, by his 'Wessi' brother who bought the block of flats in which he lives so as to keep his rent down, an individual example of the financial support of the ex-GDR by the transfer of billions of euros from the West to the East. This narrative, in turn, works against the expectation of the type of heritage films discussed above, where the 'German-Jewish symbiosis' is contingent on the Jewish protagonists performing the role of passive victims of history who are saved by the 'good' Germans. It is the orthodox west German who has the ability to save his more or less gentile relations in the east. Moreover, when Jaecki and his family adopt a Jewish persona it is a positive decision to help them survive. Indeed, in a deliciously politically incorrect moment when the film makes one of only two direct mentions of the Holocaust, Jaeckie deliberately plays the victim of history in order to regain entry to the pool tournament from which he has been ejected, claiming that his disqualification is a result of anti-Semitism. 'Are you doing this because I'm Jewish?' he asks the promoter of the tournament 'I lost my family, first in the Holocaust ...' But his challenge soon trails off, Jaecki quickly realising that this argument is not going to wash with the promoter who is well aware that this is just a ploy and that the man has no real connection to his Jewish heritage. At the same time, the film continues to celebrate Jaecki's performative energy. A self-confessed 'player' in all senses of the word, he, and ultimately the rest of his family, understand the potential of identity as performance, as they learn to accommodate both their new relationship with each other and, in the process, the opportunities offered by a unified Germany. Consequently, Levy's film challenges the easy construction of the 'German-Jewish symbiosis' as a building block of the new Europe, rejecting the elision of the

'hyphen' in such identity formation and recalling Akın's celebration
of a subject position that can embrace the potential of living within
and between Jewish and non-Jewish cultures.

Redefining the national within the transnational: the Holocaust, Europe and Germany as a neo-colonial power

While *Rosenstraße* highlights the ways in which Germany can be
seen as a model of multicultural integration and, as such, at the
heart of a project of European integration, rooted in a common
understanding of the place of the Holocaust in Europe's recent
history, Levy challenges the implicit cultural homogeneity upon
which this conceptualisation of history is built. By way of conclu-
sion to this chapter, I wish to return to the nature of German-Polish
relations, here focusing on the manner in which these too can
trouble an easy acceptance of the Holocaust as the foundation
of a common European project, in turn returning to the role of
Germany as a neo-colonial power within the world's globalising
economy and concomitant questions of economic disparity easily
forgotten in the mythos of the heritage film, or indeed, at times at
least, in Akın's work. In Robert Thalheim's *Am Ende Kommen Tour-
isten* (And Along Come Tourists, 2007), co-written and produced
by Schmid for his 23/5 production company, as in *Lichter* we are
presented with the economic asymmetries between life on either
side of the German-Polish border and the impact this has on
German-Polish relations. Although produced entirely with German
money, this low-budget film benefited from exhibition through the
Eurimages network of Europa Cinemas, showing how transna-
tional structures can help new filmmakers find an audience and,
once again, potentially mitigating the ostensibly homogenising
tendencies of larger-budget European films.

In Thalheim's film it is the historical legacy of the German-Polish
transnational encounter that is the focus, a focus which specifically
challenges the 'Europeanisation' of the Holocaust as the founda-
tion stone of European integration identified by Probst. Instead,
the film asks the question: who owns historical memory within the
present-day, neo-colonial, relationship between these two nations
and how does this impact upon the question of German and Polish
national identity construction? Set in the Polish town of Oświęcim,
better known in the west by its German name Auschwitz, the

32 A train arrives at Oświęcim Station, the opening shot of *Am Ende Kommen Touristen* (2007).

film tells the story of 19-year-old Sven (Alexander Fehling) as he embarks on a year's work placement at the Concentration Camp memorial, his original choice, a job in Amsterdam, having fallen through. Through Sven's eyes we are given a view of a town that for its German visitors is synonymous with the crimes of the Holocaust, but for its inhabitants is a place where they simply live and work. Sven himself has no real interest in the memorial. Indeed, the Camp itself, more often than not, appears as an absent presence in the film, not least because Thalheim, like many filmmakers before him including most famously Steven Spielberg, was not given permission to film in the memorial. However, this constraint becomes an important dynamic within the film, helping Thalheim to challenge the spectator's visual expectations of a narrative set in this particular town. In the opening sequence, for example, we are presented with a shot of Oświęcim's railway station, its tracks in the centre of the frame. This is an image that immediately calls to mind that archetypal Holocaust image of the Auschwitz railway tracks which brought millions to their death in the camps but which here simply brings a bemused Sven to his placement. Elsewhere, similarly iconic images are recontextualised, such as a shot of the camp's barbed-wired fence which is used to frame an image of Sven and his young landlady Ania (Barbara Wysocka) with whom he is falling in love, as they take a bicycle ride in the sunshine. A stock image of the Holocaust is consequently juxtaposed with a romantic image of young love.

Oświęcim is presented as a real place, in which real people live, rather than an 'authentic' image of the past, as one might expect it to be in a heritage film. It is a place where the young go to discos, play music and have fun, just like anywhere else, but where the overwhelming attitude to the population from the outside world is one of condescension and pity. The film asks the spectator to reflect upon well-worn images of the Holocaust anew, exploring the ways such images circulate in contemporary culture and how they relate to specific individual experience, rather than to a generalised 'European Project'. This is noticeable, for example, in the variety of ways the film utilises as a motif the Jewish suitcases that were taken from prisoners on their arrival at the camp. We first encounter the suitcases during a tour of the memorial, led by Ania, where she is explaining their significance to a group of Germans, including Sven. The group all affect suitable facial expressions of horror and shame. For Sven, however, the significance of this encounter with the suitcases is not that it offers him a powerful material connection to the past but that it introduces him to the woman with whom he will fall in love. Sven's main duty on his placement is to look after Stanislaw Krzeminski (Ryszard Ronczewski), a survivor of the camp now in his eighties, who has continued to live there since its liberation by the Soviets. Stanislaw helped build the camp museum and now earns a living giving talks about his experience and repairing the suitcases that are exhibited in the memorial. The museum curators, however, no longer want Stanislaw's help with the suitcases which for them are important historical artefacts that need to be authentically 'preserved', rather than 'repaired'. For Stanislaw, on the other hand, the suitcases form a crucial psychic link to the past. It was his job to collect them from the prisoners as they arrived, promising them that he would look after their property until he could give it back. Unable to fulfil his promise, he spends his final days looking after the suitcases he took in order to assuage his guilt both for the lies he told his fellow prisoners and for surviving the ordeal himself.

The multilayered significance of the suitcases in the film becomes a microcosm of the multilayered circulation of Holocaust memory as it impacts upon contemporary German-Polish relations. If, as Peter Bender argues, during the Cold War, 'the Polish thought historically, the West Germans ideologically' when it came to their relationship (Bender 2005: 3), this has now become more

complicated. History is clearly at the forefront in many of Sven's encounters with the local inhabitants. 'Ask him if his Grandpa also worked here,' one of Stanislaw's friends says when he realises that the man has a German carer. Conversely, the young are keen to look to the west when it comes to ideology. While Sven can condemn the takeover of the local chemical plant by a German company as a form of neo-colonial exploitation, for Ania, who is desperate to leave the town to become a translator for the EU in Brussels, it is a sign of economic hope. On the face of it at least, all German activity in the area is rooted in the quest to deal with the past, from the school teachers who bring their classes to the camp to the new director of the chemical works who engages Stanislaw to speak to her German workers about his experience. That said, the real focus of this specific engagement with the past is clearly economic, the success of this venture being contingent on eliciting good PR for a German chemical company that must be extraordinarily careful about its public perception in a town where memories of the exploitation of Jewish and Polish slave workers by the German IG Farben are never far from the surface.

Thalheim's film ultimately leaves open the key question it asks, namely, where does German society go today with the process of coming to terms with the past, if it is going to mean anything beyond the kind of bland collective reflection on history seemingly propagated within the 'European Project'? This is encapsulated, for example, in the well-meaning comments by one of the teachers Sven meets towards the end of the film, a man who already knows how he will respond to the material he will encounter in the town before he ever arrives there. What are the specific national constraints on the transnational circulation of Holocaust memory, and how do they relate to a European population faced with very different and competing social and economic challenges? The films discussed in this chapter, all of which, like much German cinema of recent years, owe their existence to some extent to a transnational mode of production, distribution and exhibition, highlight the complex dynamics at work in the nation's relationship with its eastern and southern neighbours, as well as its internal make-up as a multicultural society. At times they point to the continuing challenges faced by Germany's migrant community; at times they celebrate the potential of multicultural hybridity for the development of plural understandings of contemporary

Germanness. As we shall see in later chapters, most obviously in
my discussion of the representation of the US in recent film, Polish,
Turkish and Jewish cultural encounters, while amongst the most
often depicted, are not the only ones to be found in contemporary
German films. Nor is the question of multiculturalism the only
issue to be found in transnational cinema. This will also become
clear in subsequent chapters. With regard to the heritage film, it
is, moreover, not the only way in which this type of filmmaking
seems to offer easy answers to the challenges faced by the nation
in the quest for 'normalisation'. However, as was discussed in the
previous chapter and as can be seen in Dani Levy's work examined
here, it is clear that the presentation of German history through a
heritage optic – in this case perhaps suggesting the contemporary
reconstruction of the German-Jewish symbiosis as an example of
'best practice' for the rest of Europe – still sparks critical debate. In
so doing, many of these films also point to the continuing nation-
ally specific challenges faced by German society as it deals with
its past, challenges that are explored in detail in Thalheim's film.
Consequently, whether one laments or welcomes the development
of transnationalism as a mode of production, viewing it as an
opportunity for artists to make films that could otherwise not be
made, or as a mechanism to make films that perhaps should not be
made, it is clear that the concept of 'national cinema' and the ques-
tion of German national identity remains a major impulse behind
many of the films produced, even as these same films challenge
the spectator to rethink what such terms might mean in the age of
globalisation.

Notes

1 For a more detailed discussion of German-Polish relations since
 the end of the war see Golz 2005.
2 For further discussion of Hollywood as a form of 'World Cinema'
 see Miller et al. 2001; Cooke 2007.
3 For further discussion of the orientalist representation of the GDR
 see Cooke 2005: 103–39. As I shall discuss in Chapter 7, these films
 have also been characterised by Leonie Naughton as 'Wild East'
 movies, where the region has an equivalent function to the old
 western frontier in classical Hollywood films (Naughton 2002).
4 Although praised by feminist critics for giving a voice to exploited

Turkish women, Göktürk rightly points to the problem of gener-
alising the experience shown in such films to the experience of
all Turkish women living in Germany. For further discussion see
Göktürk 2002: 250. It is also worth noting, as Ayça Tunç points
out, that Başar's position within the broader Turkish community
was somewhat atypical. Born in the city of Cankiri, Başar came
to Germany to study for a limited period of time in the 1980s
and had a very different background to the mainstream migrant
community, most of whom were from rural Anatolia, often with
a far lower level of formal education than the filmmaker (Tunç
2011: 115).

5 See also Kopp 2002.

6 Sabine Hake points to von Trotta's *Das Versprechen* (The Promise,
1995) as an early example of this shift in sensibility. The film tells
the story of a young couple separated by the building of the Berlin
Wall and thus forced to grow up in two different states. Having
endured great hardships, the couple are finally reunited on the
night of 9 November 1989 when the Wall opens. As Hake puts it,
the film 'presents the post-war division as the story of two young
lovers divided by ideology but meant to be united; the happy
ending for the nation comes with the post-ideological identity of a
unified Germany' (Hake 2008: 195). The cathartic outcome of *Das
Versprechen* is a far cry from von Trotta's earlier films, such as *Die
bleierne Zeit* (The German Sisters, 1981), for example, which chal-
lenged dominant readings of West Germany's recent experience of
terrorism (see Homewood 2006).

5 'German cinema today is female': gender and the legacies of the *Frauenfilm*

If Tunçay Kulaoğlu could claim in 1999 that 'the new "German" film' was 'Turkish' (Kulaoğlu 1999), a decade later journalists would declare it 'weiblich' (female) (FAZ 2007; Stumpf 2009; Matschenz 2010). Rainer Stumpf, for example, pointed to a whole raft of recent productions featuring strong female protagonists played by the likes of Barabara Sukowa, one of a number of major female stars from the days of the New German Cinema whose reputation was continuing to grow, along with other established and up-and-coming actors, including Iris Berben, Johanna Wokalek and Veronica Ferres (Stumpf 2009). In this regard one might mention numerous other figures, from icons of the 1970s and 1980 on both sides of the Berlin Wall – Hanna Schygulla, and Hannelore Elsner in the West, Katrin Sass and Corinna Harfouch in the East – to the younger Katja Riemann and Franka Potente as well as the still younger Julia Jentsch and Alice Dwyer. Along with 'strong women' in front of the camera, Jacob Matschenz also highlighted the significant presence of women filmmakers at the 2010 Berlinale, where Anna Hoffmann (*Die Haushaltshilfe*/Domestic Help), Evi Goldbrunner (*WAGs* with Joachim Dollhopf), Juliane Engelmann (*Narben im Beton*/Scars in Concrete) and other women directed 50% of the work shown in the *Perspektive Deutsches Kino* section (Matschenz 2010). Major contemporary women filmmakers already discussed elsewhere in this volume include Margarethe von Trotta, Angela Schanelec, Maren Ade and Caroline Link, to which can be added the names of Doris Dörrie, Hermine Huntgeburth, Valeske Grisebach, Vanessa Jopp, Monika Treut and Maria Speth who also achieved significant commercial and/or critical success in the 2000s. Women are, moreover, playing an increasing

role in other parts of the production process beyond the 'traditional' female roles of editor or costume designer (Arnold 2007). Finally, the demographics of cinema audiences are also shifting. The proportion of women going to the cinema grew to 56% in 2010 (Nörenberg 2010: 6), compared to 46% in 1991 (Neckermann 2000: 17), with some films attracting an audience that was as much as 88% female (Nörenberg 2010: 6). Indeed, by the mid-1990s, the German industry was beginning to take more notice of the influence of female audience members on consumption patterns than it had in the previous two decades. 'Women control pic picks', suggested Brad Hagen in the trade magazine *Variety*, identifying a growing propensity within the industry to produce 'softer films' – however these might be defined – designed to meet increased female demand, women now identified as a 'central target group' for production companies (Hagen 1996). This was a situation the country had not seen since the first two post-war decades, when, as Hester Baer shows, women similarly dominated cinema audiences (Baer 2009: 1–21).

The degree of women's involvement in both the production and consumption of film in Germany might be seen as the fulfilment of the aims of a range of feminist filmmaking activities that began in the Federal Republic during the 1970s as the reputation of the New German Cinema grew. Although filmmakers in both German states sought to explore the experience of women in society, or to critically engage with genres traditionally aimed at women, most notably melodrama (Gledhill 1987; Cook 1991), women themselves were largely marginalised within the production process. In order to address this gender imbalance in the West at least, in 1973 Helke Sander and Claudia von Alemann set up the first International Women's Film Seminar in West Berlin, which led the following year to the founding by Sander of the journal *Frauen und Film* (Women and Film). This quickly became an important forum for discussion of the emerging field of feminist film theory in Germany, critically examining the representation of women in film and calling for contemporary cinema to reflect and speak to women's experience more directly. In addition, it sought to interrogate women's past and present involvement in the industry, in particular the impact of policy and economics on contemporary filmmaking practice. The involvement of more women in the industry subsequently brought about the foundation at the end of the decade of the *Verband der*

Filmarbeiterinnen (Association of Women Filmworkers), a support and lobbying group committed to raising women's participation in the industry, which demanded that 50% of all available resources should support women's projects and that 50% of all industry jobs and training places should be taken up by women. Aided by these institutional support structures, the 1970s saw the rise of the *Frauenfilm* (women's film) which helped establish the reputation of numerous filmmakers, most notably Sander (*Die allseitig reduzierte Persönlichkeit-Redupers*/The All-Round Reduced Personality, 1977), von Trotta (*Das zweite Erwachen der Christa Klages*/ The Second Awakening of Christa Klages, 1977; *Die bleierne Zeit*/ The German Sisters, 1981), Jutta Brückner (*Hungerjahre*/Years of Hunger, 1980), Ulrike Ottinger (*Bildnis einer Trinkerin*/Portrait of a Female Drunkard. Ticket of No Return, 1979) and Helma Sanders-Brahms (*Deutschland bleiche Mutter*/Germany Pale Mother, 1980), all of whom produced challenging work that sought to uncover the marginalisation and oppression of women's experience within patriarchal society.[1] In so doing, such films attempted to speak directly to the female spectator, a part of the audience identified by such film theorists as Laura Mulvey and Mary Ann Doane at the time as either ignored – even in those films ostensibly made for them – or as forced into a masochistic relationship with mainstream cinematic texts built on an economy of desire that constructed women as the passive objects of a male gaze, seeming to give the female spectator the 'Hobson's choice' of either identifying with the passive female on screen, or the implied active gaze of the male (Mulvey 1975; Doane 1981).

The efforts made by women in the 1970s and 1980s to achieve equality had a major impact upon the German film industry. In 1989 Elsaesser suggested that in West Germany there were 'proportionally more women filmmakers than [in] any other film-producing country' (Elsaesser 1989: 185).[2] Within this context, the 50% participation rate of women directors at the Berlinale in 2010 is an important milestone in light of the agenda set by the *Verband der Filmarbeiterinnen*. Compare this to the 7% of women who directed the top 250 grossing Hollywood films in 2009 (Silverstein 2010). Indeed, it was not until 2009 that Kathryn Bigelow became the first woman to win an Oscar for best director with *The Hurt Locker*. That said, if one looks at the top 100 grossing German films in 2009 – a more significant statistic than participation rates at an

individual festival – while the figure of 23% female filmmakers is a considerably higher participation rate than in Hollywood, it is perhaps clear why some women continue to feel marginalised within the industry (FFA 2010b). At the start of the new millennium Claudia Lenssen pointed to the continued exclusion many women sensed, particularly within the broad range of informal professional networks that exist in the industry and that are a crucially important route to getting work. This led to the establishment of a German branch of 'Women in Television and Film' in 2005, an international organisation that attempts to create networks of women professionals that can mitigate such exclusion (*Blickpunkt: Film* 2006). Women moreover still tend to attract smaller budgets than men for their productions, the one notable exception identified by Lenssen being the Oscar-winning Caroline Link (Lenssen 2001: 11–12). Yet at the same time, there is also a strong sense amongst some filmmakers that the world has moved on and with it both women's place in society and the role of feminism as a critical foil in both film theory and practice. Lenssen goes on to note, for example, the ways in which a new generation of filmmakers who started to enter the profession from the mid-1980s onwards felt 'that the program for emancipation followed by the older generation led to a dead end', and as a result many artists were tending to distance themselves from the *Frauenfilm* label (Lenssen 2001: 7).[3] This shift in sensibilities amongst filmmakers is particularly evident in the work of Doris Dörrie, whose surprise 1985 hit *Männer* (Men) marked a watershed moment in the industry. It kickstarted a wave of relationship comedies which focused on the issue of women's representation as well as questions of gender, sexuality and identity more broadly. These 'New German Comedies' were far more commercially oriented than many of the *Frauenfilme* of the previous decade. At the same time, as Dickon Copsey notes, and as already implied in Hagen's comments outlined above, such films also marked a development within the industry 'towards a more audience-orientated filmmaking practice', deliberately targeted at female consumers (Copsey 2006: 182). This development was mirrored in film theory, with scholars such as Jackie Stacey and Janet Staiger moving the critical focus away from the construction of the female spectator within a given film text, such as one finds in Mulvey and Doane's work, to the place of 'real' audiences in film consumption (Stacey 1991; Staiger 1993). Within German

film studies as an academic discipline this led to work highlighting the pivotal role of female cinema audiences at various moments in German film history (Petro 1989; Baer 2009), including the rediscovery of ground-breaking audience research during the 1910s by Emilie Altenloh (Altenloh 2001). Such research, in turn, challenged straightforward notions of a male gaze operating in films that were directed self-consciously at female audiences, not least in the comedies that were particularly prevalent in the 1990s.

Of specific importance to this chapter is the debate to which the romantic relationship comedies gave rise, including, along with Dörrie's *Männer*, Sönke Wortmann's *Allein unter Frauen* (Alone Among Women, 1991) and *Das Superweib* (The Superwife, 1996), Katja von Garnier's *Abgeschminkt!* (Making Up!, 1993) and Rainer Kaufmann's *Stadtgespräch* (Talk of the Town, 1995). For their critics, these films, which play with traditional gender roles in their presentation of strong, professional women – more often than not played by Katja Riemann – negotiating their male and female social relationships, and seeming to challenge traditional cultural representations of passive female protagonists, in fact marked the end of the feminist-inspired *Frauenfilm*.[4] 'The big bang of feminism has died away and left only trace elements of emancipation. What does a girl want? As always, a man; but not the first one that comes along. Nor do they have to be a provider, but rather someone who understands "I'm a miserable patriarchal arsehole"', declared *Der Spiegel* (1996: 224). Ulrike Sieglohr goes further, seeing this cycle of films as an entirely retrograde development, suggesting that what she describes as 'post-feminist filmmaking resembled more pre-feminist filmmaking', intent upon undoing all the achievements gained by Sander and her colleagues (Sieglohr 2002: 119). For such critics, that much-contested and nebulous term 'post-feminism' is ultimately synonymous with 'anti-feminism'. For others, however, while often still sceptical about such work, there is the potential within these films to offer a more positive understanding of a 'post-feminist' sensibility which can move beyond, rather than retreat from, the agenda of the past.[5] Temby Caprio for example, suggests that such films might offer a way out of the critical dead-end of the 1970s *Frauenfilm* signalled by Lenssen, through their ability to marry a degree of feminist critique with popular entertainment. Building on the work of Jane Gaines, she explores the ways in which these films at times celebrate the

possibility of a 'feminist heterosexuality and its politically incorrect pleasures' (Caprio 1997: 386). In similar vein, Copsey suggests that the work of Dörrie, von Garnier and others reclaims the potential of 'heterosexual desire that both patriarchy and an idealist feminist matriarchy have historically denied to women', while also subverting the expectations of traditional mainstream romantic comedy 'in their playful, if not parodic, engagement with key culturally and discursively defined constituents of female identity (namely, motherhood, heterosexuality, romantic longing, sexual desires, friendship, marriage and career)' (Copsey 2006: 202). In the process, they reject what von Garnier terms 'the feminist hang-ups of the 1970s' (quoted in Copsey 2006: 184), a legacy of the 68ers that ostensibly no longer had a place in contemporary society. Instead, they reformulate the politics of the *Frauenfilm* by negotiating 'a *mainstream* imaginary space in which a male-centred female reality is problematized and a female-centred alternative is explored' (Copsey 2006: 203; my emphasis).

In what follows I shall examine the ways this debate continues to resonate in the 2000s, examining what legacy, if any, exists of the 1970s *Frauenfilm*. I begin by returning to the heritage film. Many of these films, made by both men and women, focalise their view of the past through a female protagonist. On the face of it, such films thus seem to engage with the agenda of the *Frauenfilm* and its project to redress the historical marginalisation of women's experience. However, as I shall argue below, the representation of gender in these films frequently has more in common with the 'New German Comedies', often being read by critics as 'post-feminist' interpretations of history. That said, if these films can be described as in any way 'post-feminist', it is often a 'post-feminism' that is ultimately rooted in very traditional conceptualisation of gender. In the rest of the chapter, I then explore films that challenge the more straightforward understanding of gender roles we see in the heritage film and that resonate with some of the broader themes discussed elsewhere in the volume. First, I examine Angelina Maccarone's *Fremde Haut* (Unveiled, 2005), a film that looks at female sexuality through the prism of the kind of transnational filmmaking discussed in the previous chapter. Second, I examine the implications of the changing age demographic of the nation's cinema audience. As noted in Chapter 1, along with shifts in the proportion of women going to the cinema, there has also been a

movement away from the under-25s towards the over-50s amongst audiences. I explore how this is mirrored in the concerns of film-makers, discussing Doris Dörrie's *Kirschblüten – Hanami* (Cherry Blossoms, 2008) and its protagonist's quest to understand both the performative nature of gender identity as well as his own mortality. Dörrie is widely considered to be the most important filmmaker to emerge from the comedy wave of the 1980s and 1990s. In *Kirschblüten*, we see a further example of the broader shift away from comedy in the 2000s. At the same time, we find a rigorous engagement with the feminist agenda of the 1970s, which also highlights Dörrie's generation's wish to move beyond the position of Sander and others.

'The super woman' through the ages

In the 2000s, one of the most obvious ways in which Caprio's quest to marry entertainment with the agenda of the *Frauenfilm* could be seen in the heritage film. A number of productions focused specifically on the experience of women, either telling the stories of important female figures from history or the impact of major historical events on ordinary women – films that, moreover, gener-ally attracted an above-average proportion of female spectators on their theatrical release.[6] This was a trend that had, in fact, been developing for some time. As Sabine Hake notes, since the 1980s Sanders-Brahms, von Trotta and other women connected with the *Frauenfilm* have sought to 'pay closer attention to the suppres-sion of female voices in the master-narratives of German history and cultural identity' (Hake 2008: 177). From the turn of the millennium onwards, however, while many of the films produced seem superficially to continue the project of the *Frauenfilm*, they often in fact reproduce a set of traditional gender norms, albeit norms filtered through a 'post-feminist' optic, familiar – for better or worse, depending upon one's point of view – from the 1990s romantic relationship comedies.

Von Trotta's *Rosenstraße* (2003), for example, the story of the women who protested to protect their Jewish husbands during the Third Reich, continued her project of uncovering the role played by women at key moments in history begun in her fictionalised account of the relationship between the RAF terrorist Gudrun Ensslin and her sister Christiane, *Die bleierne Zeit* (The German

Sisters, 1981).[7] *Rosenstraße* was followed at the end of the decade by *Vision – Aus dem Leben der Hildegard von Bingen* (Vision, 2009). Starring the filmmaker's long-time leading actor Barbara Sukowa, the film presents a portrait of the twelfth-century Benedictine abbess and renowned herbalist Hildegard von Bingen who challenged the male authority of the church. Von Trotta presents a woman driven by a thirst for knowledge, who, through her subtle and imaginative engagement with the politics of the time, manages to break free from the control of her abbot and his monks, to found a separate convent based on her more enlightened, matriarchal value system. Here, von Trotta shifted her focus from the history of the twentieth century, which had been central to her work up to that point, to the middle ages, while continuing to question the dominance of male-centred readings of history.

Similarly, Sanders-Brahms' *Geliebte Clara* (Clara, 2008) left the twentieth century, and specifically the Nazi period and its aftermath that she had explored in her critically acclaimed breakthrough film *Deutschland bleiche Mutter*, to tell the story of the virtuoso pianist and composer Clara Schumann. Clara's achievements have been long overshadowed by those of her husband Robert Schumann and Johannes Brahms (a distant relation of the filmmaker), whom the Schumanns took under their wing as a young man. Clara Schumann is a role previously played by Hilde Krahl (originally to be Zarah Leander, *Träumerei*/Dreaming, Harald Braun 1944) and Katharine Hepburn (*Song of Love*, Clarence Brown 1947). In Sanders-Brahms' version, Martina Gedeck – an actor present in a number of high-profile heritage films – emphasises the ways in which Clara negotiates the competing roles in her life of wife and, ultimately, nurse to her mentally ill husband, mother to seven children, romantic muse to the young Johannes and creative force in her own right.

Amongst the generation that rose to prominence during the comedy wave of the 1990s, Sönke Wortmann also moved to heritage filmmaking, directing Eichinger's production *Die Päpstin* (Pope Joan, 2009), a hugely expensive (€20 million) adaptation of Donna Woolfolk Cross's bestselling novel about a legendary female pope who is said to have risen to the head of the Catholic Church in the early Middle Ages.[8] This is a story previously told by Hollywood in Michael Anderson's *Pope Joan* (1972), starring Liv Ullmann. In Wortmann's movie the legend similarly forms the basis of a

33 Pope Johanna (Johanna Wokalek) dies in a moment of high
melodramatic excess, *Die Päpstin* (2009).

melodrama about a woman forced to hide her gender in order to
gain an education, attaining high office in the Church through her
extraordinary intellect and judgement. Unlike her male predeces-
sors, Johanna (Johanna Wokalek) uses her tenure of the papacy to
improve the lives of the people around her, rather than simply to
increase the wealth of the Church, much to the annoyance of the
patriarchal church elite. Finally, however, she is destroyed by male
plotters as well as by her own biology. In a finale of high melodra-
matic excess, the film cross-cuts between shots of the murderous
blows inflicted upon Johanna's secret lover and protector, and the
woman's cries of pain as she begins to miscarry their baby, the
tragedy of her final demise subsequently underlined in the elision
of her time as pope from the historical record by a vindictive male
chronicler.

While von Trotta, Sanders-Brahms and Wortmann began to
look beyond the twentieth century for their cinematic material,
others continued to be exercised by twentieth-century history,
and in particular the National Socialist period. Within this trend,
stories focalised through a female protagonist were also common,
not least within the numerous narratives which look at moments
of Jewish/non-Jewish solidarity discussed in the previous chapter.
Along with *Rosenstraße*, Max Färberböck's *Aimée & Jaguar* (1999)
highlights an extraordinary moment of such solidarity in its depic-
tion of a lesbian couple attempting to cope with life in war-torn
Berlin, based on the true story of the Jewish Felice Schragenheim
(Maria Schrader) and her non-Jewish lover Lilly Wust (Juliane

Köhler). Similarly, and of particular relevance to the discussion of this chapter, Kaspar Heidelbach's *Berlin 36* (2009) inverts the performance of gender roles found in *Die Päpstin* to depict the Nazi regime's efforts to prevent the Jewish high-jumper Gretel Bergmann (Karoline Herfurth) from competing in the 1936 Olympics, replacing her with Marie Ketteler (Sebastian Urzendowsky), an athlete subsequently proven to be a man. In the film, Marie is profoundly damaged by being forced to live his whole life as woman, his mother unable to accept having a boy. Through his growing friendship with Gretel he begins to face this trauma, ultimately undermining the Nazis' Olympic ambitions by deliberately losing the competition out of respect for Gretel's superior talent.

In their attempt to uncover women's forgotten stories of the past – or in the case of Ketteler, of a trans-gendered male who identifies with women's experience under a highly authoritarian version of patriarchy – such films also often fed into the 'discovery' of the ways ordinary Germans, and particularly in this case women, suffered during and in the aftermath of the Nazi regime, stories which were often constructed as moments when apparently long-held taboos in German history could be broken. This is most obviously the case in Färberböck's later feature *Anonyma – Eine Frau in Berlin* (A Woman in Berlin, 2008), based on the account of a journalist who lived through the mass rape of women by the Red Army in the final days of the war, first published in 1954 but largely ignored until its republication in 2003 as part of Hans Magnus Enzensberger's series the *Andere Bibliothek* (Alternative Library).[9] The film reconstructs the nightmare world of Berlin during those days. Avoiding the direct representation of rape, the film focuses on the psychological impact the continuous waves of attacks had on the women, as well as the ways in which the female population sought to survive, the film's anonymous protagonist (Nina Hoss) choosing to prostitute herself to a Russian officer in exchange for his protection, a man whom she ultimately learns to love and respect. The romantic feelings Anonyma begins to develop for her officer, while fulfilling the expectations of a mainstream movie, are somewhat problematic in a narrative concerned with the phenomenon of wartime rape. They can, nonetheless, be seen as part of a broader trend within this genre of filmmaking. The impulse to challenge the 'taboos' of recent history is invariably balanced by a strong didactic element, their female protagonists often exhibiting

an extraordinarily broad understanding of their historical position and consequently easily able to empathise with the position of the enemy. While the women of Berlin live in fear of molestation by the Soviet soldiers, many nonetheless understand that this treatment is in retribution for equally, if not more, barbaric crimes committed by their own troops on the Eastern front, and that the Soviets, too have suffered. Anna (Felicitas Woll), a nurse in Roland Suso Richter's account of a love affair between a German nurse and a British pilot during the destruction of Dresden in February 1945 (*Dresden*, 2006), can similarly see beyond a narrow German perspective, grasping that her own nation bears ultimate responsibility for the bombs falling around her. When her German fiancé discovers her lover during the raid, he accuses Anna of betraying her country, pointing emphatically at the sky shouting 'That is him!', 'No, that is us!' she retorts, highlighting the Germans' culpability for all that has happened.

The presentation of the past as a carefully constructed history lesson is particularly profound in Marc Rothemund's Oscar-nominated account of the arrest, interrogation and execution of Sophie Scholl (Julia Jentsch), a member of Munich student-resistance group the *Weiße Rose* (White Rose) (*Sophie Scholl – Die letzten Tage*/Sophie Scholl: The Final Days, 2005). This is a story that has been told twice before on film (Michael Verhoeven's *Die Weiße Rose*/The White Rose and Percy Adlon's *Fünf letzte Tage*/Five Last Days, 1982). However, Rothemund's film claimed a far greater degree of authenticity than earlier depictions, due to its grounding in recently discovered historical material. The main body of the film is based on the detailed notes of Sophie's interrogation which came to light after unification and the opening up of the GDR's state archives, the factual basis of the script, along with Rothemund's painstakingly authentic heritage mise-en-scène, seeming to allow us, as Owen Evans notes, to get closer to the 'real' Sophie than any previous film, emphasising the ordinary nature of the young woman as a person, and in the process 'creating new, more powerful, images' of the past that give us a more 'complete' understanding of both the historical narrative and the character of Sophie herself (Evans 2011: 58). Evans is not alone in his praise. The didactic potential of this and the other films discussed here is repeatedly mentioned in their critical reception. Adrian Kreye, for example, is similarly positive in his appraisal of *Anonyma*,

identifying as a key strength in the film the opportunity it offers the contemporary spectator to identify with the women's experience (Kreye 2009). Thus, whether it is the story of Sophie Scholl, wartime rape victims or Hildegard von Bingen, for some critics at least, these films are to be praised for their ability to construct a form of 'prosthetic memory' – to return to Alison Landsberg's terminology discussed in Chapter 3 – that can speak to mainstream cinema audiences, allowing them not only to see but also to *experience* the stories of these women from history. In the tradition of the *Frauenfilm*, these stories appear to give their female protagonists a voice, reconfiguring history from a woman's point of view. At the same time, in line with the comedies of the 1990s, they also seem to update the agenda of the previous generation, making their representation of the past both relevant and comprehensible to the contemporary spectator.

For others, however, the proposed 'authenticity' of these films, and with it their ability to speak to audiences today, is often nothing more than a marketing trick. Such films, it is claimed instead simply play to the 'fetishisation of authenticity' we find in so much contemporary German filmmaking, as Cristina Nord puts it in her far more negative discussion of *Anonyma*, the explicit didacticism in this and other recent heritage films invariably leading to a lamentably 'naïve' reading of history (Nord 2008). Dietrich Kuhlbrodt also challenges the apparent authenticity of such films in his analysis of Rothemund's *Sophie Scholl*, pointing out that, for all the film's much-vaunted basis in archival evidence, the script is not constructed from the actual words spoken by Scholl but rather from the notes made by the Gestapo during the interrogation. Consequently, Scholl is speaking 'Gestapo German. As is well known, there was no literal transcript. Thus, the student Sophie Scholl is actually robbed of her voice in this film' (Kuhlbrodt 2006: 144). Similarly, Rüdiger Suchsland's review of *Die Päpstin* is scathing in this regard, and in the process highlights explicitly the link between the heritage film and the relationship comedies of the previous decade while also suggesting their distance from the *Frauenfilm* of the 1970s. *Die Päpstin* is dismissed as '*Das Superweib* (Super Woman) of the Middle Ages', a disparaging reference to Wortmann's 1996 film about a woman negotiating the pressures of domestic and professional life. In similar fashion to the 'New German Comedies', for Suchsland, the likes of Wortmann, von

34 Sophie (Julia Jentsch) as serene victim, *Sophie Scholl – Die letzten Tage* (2005).

Trotta and others offer no more than a form of 'tuppenny-ha'penny feminism' with no critical or aesthetic merit, intent upon the straightforward, and reductively simplistic, transposition of the 'post-feminist' protagonists of the 1990s – here conceived of as a form of 'anti-feminism' – to an earlier historical moment (Suchsland 2009a). Superficially, like Wortmann's 'Super Woman', the female protagonists of these films reject the position of passive victim into which they are initially inscribed by the narrative, in order to carve out for themselves a more active subject position. At the same time, they are also cast as desiring, heterosexual, romantic female leads, the final tragedy of their position more often than not reinforced by the ways in which the narratives prevent them from forming long-term relationships with the men they love, be it Johanna's lover, from whom she is violently separated at the end of the film, or Sophie's fiancé whom she fondly recalls to her cellmate as she awaits the inevitable outcome of her trial. Consequently, for Suchsland, while these films might pay lip-service to the agenda of the 1970s *Frauenfilm* in their focus on women's history or in their presentation of idealised images of matriarchal social structures, updated to take account of some of the 'post-feminist' shifts we find in the 1990s, their representation of female identity construction is ultimately both very conventional and very conservative.

In gender terms, it is hard to argue with Suchsland's analysis. Indeed, the conservativism he identifies is further emphasised by the extent to which the female protagonists of these films are almost always destroyed in their attempt to take on male gender roles. This happens literally in the cross-dressing narrative of *Die Päpstin*, but is also evident more metaphorically throughout these films, where the adoption of 'male' gender traits, which these female protagonists inflect with their 'naturally' feminine sensitive and caring nature, generally ends in failure. In the process, however, these women tend to embody a broader symbolic role that points the way to the ostensible values of today's German society. As Daniela Berghahn suggests in her characterisation of films such as *Sophie Scholl* or *Anonyma*,

in these historical melodramas German women take centre stage, because through their self-sacrifice, suffering and goodness they are better suited than men to rehabilitate the unified German nation. The good German woman embodies humanity in inhuman times. She represents eternal values and virtues that allow her to transcend shifting ideological agendas. (Berghahn 2010: 183)

The use of a woman to symbolise the German nation has a long history. Patricia Herminghouse and Magda Mueller trace the invocation of *Germania* as the mother of the nation to the early middle ages (Herminghouse and Mueller 1997: 2). In film, one thinks of the symbolic role played by the female protagonists of Fassbinder's FRG Trilogy or Sanders-Brahms' *Deutschland bleiche Mutter*. In the woman-centred heritage films of the 2000s, the timeless humanist values that seem to survive the Nazi takeover, values which work to counterbalance the 'chamber of horrors' invariably presented in the mise-en-scène, embody an idealised form of femininity that can, at the same time, adopt an active subject position. This is perhaps most overt in the construction of Scholl in Rothemund's film as a Joan of Arc figure. Joan is a woman who, as Marina Warner notes, is both female and yet transcends the traditional categories of femininity (Warner 1981: 6), the serene martyr status of Rothemund's Scholl underlined by the manner in which Jentsch is lit, the repeated shots of her heaven-cast gaze recalling at times Maria Falconetti's performance in Carl Theodor Dreyer's *La passion de Jeanne d'Arc* (The Passion of Joan of Arc, 1928).[10] The love

and understanding the active, yet suffering, women who popu-
late these films show for both the nation's other victims (such as
their Jewish husbands) and the nation's enemies (the conquering
Russians – or at least their officers, British bomber pilots), or even
for their fellow National Socialist countrymen who, it is suggested
in the presentation of Sophie's Gestapo interrogator, might yet
learn the error of their ways, becomes crucially important in this
regard. It is from the perspective of these women that we are asked
to understand the world. While their behaviour might lead to their
own death, the women themselves being punished in the short
term for usurping male power, ultimately it points forward to the
democratic, enlightened, forthright but yet non-aggressive values
that, such films often suggest, underpin the Berlin Republic of the
twenty-first century.

'What is "masculine", what is "feminine"?' (Maccarone 2006): gender, sexuality and ethnicity

The heritage films discussed here invariably play to traditional
gender norms, even as films such as Die Päpstin or Berlin 36 might,
on the face of it, seem to challenge these norms in their presenta-
tion of cross-dressing protagonists. However effective the attempt
might be to pass as a member of the opposite sex, it ultimately
proves impossible for an individual to hide her or his 'true' nature.
Johanna uses her disguise to reconfigure the papacy as a more
'caring', 'feminine' institution. Marie is profoundly damaged by
being forced to pass himself off as a woman. Elsewhere in the
cinema of the 2000s, however, one finds a far more fluid construc-
tion of gender identity. Oskar Roehler's Die Unberührbare (No Place
to Go, 2000), and Agnes und seine Brüder (Agnes and His Brothers,
2004), for example, rework elements of Fassbinder's appropriation
of camp excess found in In einem Jahr mit 13 Monden (In a Year
with 13 Moons, 1978) or Die Sehnsucht der Veronika Voß (Veronika
Voss 1982), in order to highlight what Alice A. Kuzniar describes
as 'the impossibility of assuming an identity via gender' (Kuzniar
2000: 80). In Die Unberührbare, Hanna Flanders (Hannelore
Elsner), a left-wing 68er writer whose career collapses in the wake
of German unification – a narrative based loosely on the life of
Roehler's mother – is presented as a woman who seeks refuge
from the collapse of her social standing and emotional wellbeing

in the role of a hyper made-up fire-brand diva, a role that proves impossible to maintain, leading her eventually to take her own life. In the process we find, once again, the use of women as allegories for the state of the nation. However, while in some heritage films the 'naturally' morally virtuous and compassionate nature of an essentialised version of femininity stands as a symbol for a now normalised German nation, in Roehler's film, the nation is revealed to be far less healthy. The Berlin Republic, it would seem, continues to suffer the traumas of the past, specifically here the social ramifications of the student revolt. Flanders is the product of a time when a left-wing elite could enjoy an ultimately cosy existence of permanent opposition to a supposedly fascistic mainstream. With unification, the ideological certainties of the Cold War have been lost, leading her to grip nostalgically to an anachronistic and ideologically empty self-image. Roehler constructs gender identity entirely in terms of 'performance', evacuated of any sense of an 'internal core or substance', to evoke the terminology of gender theorist Judith Butler. As was discussed in the previous chapter, Dani Levy uses the concept of performativity parodically to challenge ethnic stereotyping. For Butler, however, performativity is implicit within the very notion of gender itself, her work describing how the widespread promotion of 'the disciplinary production of gender effects a false stabilization of gender in the interests of the heterosexual construction and regulation of sexuality'. Gender constructions, in this regard, are '*performative* in the sense that the essence or identity that they otherwise purport to express are *fabrications* manufactured and sustained through corporeal signs and other discursive means' (Butler 1990: 184–5; emphasis in original). The explicit and exaggerated performance of gender identity one finds in *Die Unberührbare* consequently troubles the 'discipline' of society's normative construction of identity, highlighting the artificial nature of gender, built as much on their deliberate exclusion of the possibility of a range of subject positions as they are on the illusion of a coherent, identifiable, gendered whole.

Butler's theorisation of gender performativity within a 'heterosexual matrix' (Butler 1990: 6) that works to exclude non-normative identity constructions is also a productive framework for understanding the films of Angelina Maccarone. During the 1990s, through her work as a writer and director for German television Maccarone became known as 'the *Wunderkind* (child prodigy)

35 Hanna Flanders (Hannelore Elsner) playing the diva in *Die Unberührbare* (2000).

of the lesbian film', writing and directing the romantic comedies *Kommt Mausi raus?!* (Is Mausi Coming Out?!, co-directed by Alexander Scherer 1995) and *Alles wird gut* (Everything Will Be Fine, co-written by Fatima El-Tayeb 1998), a film which also crossed over into cinemas (Funke 2005). Maccarone is very different to many contemporary gay filmmakers in Germany, offering what Kuzniar identifies as 'a predominantly American version of the coming-out story – where an individual comes to terms with his or her homosexuality (often concurrently with his or her coming of age)'. This is a tendency, she suggests, that 'is largely foreign to the openly queer German cinema' (Kuzniar 2000: 18). In the 2000s, however, Maccarone began making films specifically for cinema which adopted a more serious tone, reminiscent, however faintly, of iconic gay filmmakers such as Monika Treut, while also maintaining her mainstream sensibility in a series of features that explored female sexuality and gender constructions.[11] In these films, gender is portrayed as an ambiguous, dynamic mode of identification. Thus, such films also engage, more broadly, with the present state of German society, attacking racist, homophobic and sexist attitudes towards their protagonists.

Maccarone's *Fremde Haut* (Unveiled, 2005) tells the story of Fariba (Jasmin Tabatabai), a lesbian forced to flee from Iran to Germany after her relationship with a married woman is revealed to the authorities. When her asylum petition is refused, she adopts

the persona of a young man she befriended in the transit camp who committed suicide at the news of his brother's execution in Iran before he learnt that he could stay in the country. Fariba begins to live life as Siamak deep in provincial Germany, hiding both her gender and sexuality with great difficulty within the cramped conditions of an asylum-seekers' hostel and as part of the nation's black economy, eking out a living as a seasonal worker in a local Sauerkraut factory. For Maccarone, fundamental to the film are the questions 'What is "masculine", what is "feminine"?' – questions the film, however, ultimately refuses to answer (Maccarone 2006). Instead, Fariba's performance of Siamak troubles straightforward binary distinctions between male and female identity formation. She is forced to abandon her life as a woman, and yet, in the process, is given the opportunity to express her sexuality more openly. As Siamak, she begins to form a relationship with Anne (Anneke Kim Sarnau), an apparently straight woman who is attracted to this seemingly sensitive Iranian man as a way of escaping the tedious machismo of the German men around her as well as the interminable provinciality of her everyday life. Thus, Fariba's male disguise works in competing directions. On the one hand, it constrains her, shown most obviously in her nightly routine of painting stubble on her face and binding her breasts. On the other, it offers her liberation both from her life in Iran and enforced heterosexuality, allowing her the potential to develop a relationship with Anne. In the process of Fariba's self-development, a similar ambiguity also begins to define Anne. As she senses that she has feelings for Siamak, the narrative simultaneously suggests that Anne might suspect Siamak is in fact a woman. Anne caresses the young 'man's' hands, sensuously yet suspiciously, struggling with her feelings. As the moment arrives when the couple might at last kiss, Anne pulls back, declaring she cannot go on. Significantly, however, the reasons for her hesitation are not made clear. Is this because she suspects Siamak loves another woman in Iran, that 'he' is a woman, or, in fact, both? The narrative logic works whether Anne considers her would-be lover to be either a man or a woman and as such allows the spectator to construct either a 'straight' or 'queer' reading of the film, being unable to pinpoint the gender and/or sexual subject position of either character.

Within the history of German film, the 'cross-dressing' narrative has a long tradition. It was particularly prevalent in the cinema

of Wilhelmine and Weimar Germany in the so-called *Hosen-rolle* (trouser role) films, such as Reinhold Schünzel's *Viktor und Viktoria* (Victor/Victoria, 1933), a tradition that continues into the New German Cinema in the work of Fassbinder and Werner Schroeter (*Der Tod der Maria Malibran*/The Death of Maria Malibran, 1972; *Poussières d'amour – Abfallprodukte der Liebe*/Love's Debris, 1996), as well as during the 2000s in, for example, Nana Neul's *Mein Freund aus Faro* (To Farao, 2008), and *Die Päpstin* discussed above. Amongst reviewers of Maccarone's film, however, the most frequent frame of reference was Kimberly Peirce's American independent production *Boys Don't Cry* (1999), a film based on the true story of the rape and murder of the female-to-male pre-operative transsexual Brandon Teena (Hilary Swank) (Fainaru 2005; Lee 2005). Although the tone of Maccarone's film is less abrasive than that of Peirce, and the rationale for Fariba's performance of a male role very different, the response to her performance by the unreconstructed 'macho' men she meets is very similar. While the film foregrounds the ambiguities that Fariba brings out in Anne's self-construction as a straight woman, ambiguities that she increasingly wishes to explore, in similar fashion to Peirce's film, the discovery of Fariba's gender provokes a violent response in Anne's male friends. Unambiguously racist towards Fariba's relationship with Anne when they assume she is a male immigrant, they erupt into violence when they learn she is a woman, unable to accept her transgression of black and white definitions of gender boundaries. This is a transgression that reveals, to return to Judith Butler, the 'fabricated' nature of all 'normal' conceptualisations of male and female identities, and which, in the process, highlights the emptiness of their own gender performance (Butler 1990: 189). In order to reaffirm their masculinity, they use their fists.

 As can be seen from the treatment of Fariba, the film's exploration of the performative nature of gender identity construction is interwoven with an examination of ethnicity and German national self-perception. While many heritage films are the product of the shift towards a transnational mode of production, even when they use transnational encounters as a motif, such as in von Trotta's *Rosenstraße*, their stories often tend to present a clear-cut and affirmative conceptualisation of Germanness as a national construction. In Maccarone's film, however – itself a transnational co-production (Germany/Austria) – as we see in the work

of filmmakers such as Fatih Akın, transnationalism becomes an element within the narrative itself, using the question of gender construction as a foil for its concurrent exploration of (trans) national identification. As Macarrone herself suggests, Fariba's simultaneous and seemingly paradoxical confinement and liberation through the Siamak identity functions as a form of 'internal' exile, mirroring her physical 'external exile' from her homeland (Maccarone 2006). The experience of exile more generally in the film is presented as very damaging. While Fariba's male Belarusian roommate appears to negotiate life reasonably well in Germany during the day, at night he is locked into a never-ending melancholic loop of homesickness, drinking vodka and obsessively watching a video of his village to assuage his sense of dislocation. Similarly, Fariba is presented as having to endure a profound sense of homelessness, suffering under the forced separation from her lover in Iran. Yet unlike her roommate, whose identity is inextricably linked to his identification with a physical homeland, Fariba's sense of belonging is much more fluid and so can be reconfigured by means of a series of elective affinities through which she begins to define herself within the narrative. She increasingly identifies with the character of Siamak, creating a virtual identity for herself by means of her regular correspondence with his parents, presented as a series of voiceovers to the visual presentation of Fariba's performance of her male role, through which she gives them the illusion that their son is still alive.

The liberatory potential of Fariba's gender performance as a means of transgressing both gender and national boundaries is suggested particularly clearly in the shifting ways in which she is positioned in relation to the camera's gaze. We first meet the woman as she sits on the plane coming to Germany, wearing a hijab, her eyes hidden by large dark sunglasses, her gaze cast down, away from the camera. As she is processed by the German authorities, she is framed within a sequence of shots that highlight her subjugation to the gaze of the German authorities, be it of an official watching her through the blind of an office window, her reflection in the glass at the border crossing, or the image of a border guard helping her with her luggage filmed through the grille of a van that separates the asylum seekers from the officials who will take them to their detention centre. As the narrative reaches its denouement, Fariba has almost escaped the control of

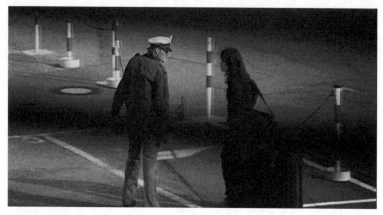

36 Fariba (Jasmin Tabatabai) watched through a venetian blind, caught in the stare of the border authorities, *Fremde Haut* (2005).

the German state. She and Anne are in love and she has procured a false passport that will allow her now to live as a woman. However, this escape is never realised. The couple cannot remain together. Fariba's true identity is discovered by the authorities and, in the final moments of the film, we see her once again on a plane, this time returning to Iran. This sequence deliberately recalls the film's opening while also highlighting the fact that her relationship to the camera has completely changed. As the plane enters Iranian airspace, and the other female passengers adjust their hijabs to comply with the requirements of the Iranian authorities, Fariba goes to the toilet, destroys her own papers and once again adopts the disguise of Siamak. Her final act of defiance against both the Iranian and German authorities is encapsulated in a close-up of the woman staring at herself in the mirror, having just put on the glasses that complete her impersonation of the man. Rather than being the object of another's gaze, she is now both the subject and object of the image we see, controlling her own view of the world. She escapes into her male persona, declaring her intention to return to her German lover in a final voiceover letter to Siamak's parents. It is ultimately left open as to whether the couple will be reunited. We know nothing of Anne's future. All that we can be sure of is Fariba's refusal to be constrained. She is resolved to continue her provocative performance of an ambiguous gender identity. In so doing, she will clearly continue to try and evade the limitations

37 Fariba defiantly re-appropriates Siamak's gaze, *Fremde Haut* (2005).

imposed upon her sense of self by others. As a result, the film ends in a gesture of defiance, Fariba/Siamak's performance of gender standing as a continuing challenge to national borders as well as the heteronormativity of mainstream society.

Gender, mourning and mortality

Doris Dörrie's *Kirschblüten – Hanami* also explores the performative nature of gender identity. Here, however, it becomes a means of coming to terms with old age and one's mortality. *Kirschblüten* is one of a number of films produced since 2000 that reflect what Irene Jung identifies as cinema's 'discovery of old age' (Jung 2009). The increased visibility of those over 60 in contemporary film can be related, in part at least, to the increasing age of society as a whole. Around 20% of the German population is now made up of people over the age of 65, a figure that is predicted to rise to about 33% by 2050 (McGee 2011: 219). We are also seeing a shift in the age demographic of cinema audiences. I have already noted the increasing importance of the over-50s market to cinemas. However, further up the age demographic, the number of people aged 60+ going to the cinema increased by 185% between 2000 and 2009, with a disproportionally higher increase of two female spectators to every one man (FFAc 2010: 19). This same 'discovery' of age could, in fact, be seen around the world during

the decade, be it Jin-pyo Park's *Jukeodo joha* (Too Young To Die, 2002, South Korea), Alexander Payne's *About Schmidt* (2002, USA), Nancy Meyers' *Something's Gotta Give* (2003, USA), Charles Dance's *Ladies in Lavender* (2004, UK) or Bettina Oberli's *Die Herbstzeitlosen* (Late Bloomers 2006, Switzerland). With regard to German cinema specifically, along with *Kirschblüten*, Andreas Dresen's *Wolke 9* (Cloud 9, 2008) explored the controversial topic of sexual desire amongst the elderly. *Jetzt oder nie – Zeit ist Geld* (Now or Never, Lars Büchel 2000) and *Dinosaurier* (Dinosaurs, Leander Haußmann 2009) depict pensioners refusing to end their days in dignified silence, as society would seem to wish them to, rejecting the confinement of the rest home and forcing the younger generation to rethink its values, the latter – a remake of Bernhard Sinkel's *Lina Braake* (1975), the story of a pensioner taking revenge against a heartless bank-manager – seeming particularly timely, appearing at a moment when the public was outraged at the behaviour of the banking system in the aftermath of the 2008 'credit crunch'.

Similarly, Michael Schorr's *Schultze Gets the Blues* (2003) depicts one elderly man's refusal simply to wait for death, having been assigned to the scrapheap in an ex-GDR forced to adjust to the economic instability of life under capitalism. Reworking elements from the German Heimat tradition, as well as Ingmar Bergman's *Det sjunde inseglet* (The Seventh Seal, 1957), Schorr's eponymous protagonist, a retired east German mine worker with a passion for the accordion, sets off on a quest to the Louisiana Bayou to find the source of Zydeco music. This film will be discussed further in the following chapter.

As already noted in regard to some heritage films, at the heart of many of these films is the question of generational shift. This is reflected particularly clearly in a number of films that use stars from the 1960s and 1970s in stories that seek to come to terms with the political and cultural ramifications of '68 and the place of this generation in society as it approaches retirement. Roehler's *Die Unberührbare* saw the return of Hannelore Elsner to the cinema screen after 15 years. Elsner made her name as a sex symbol in popular film and television in the 1960s. In *Die Unberührbare*, however, she firmly established her position as a serious actor, playing a role that challenged the comfortable assumptions of the left-wing 68ers in the wake of unification. Similarly, Susanne Schneider's *Es kommt der Tag* (The Day Will Come, 2009) stars

Iris Berben – like Elsner, an actor now in her 60s who is best known for her earlier television work, as well as for her political activism. Here Berben plays the role of a former urban terrorist forced to confront her past when she is tracked down by the daughter she abandoned thirty years earlier. Along with her role in *Vision*, Barbara Sukowa, star of numerous works by von Trotta and Fassbinder, enjoyed success in Hans Steinbichler's Heimat story, *Hierankl* (2003), a film which again examines the impact that the decisions made by the 68er generation have had on its children. This impact is also central to the role played by 'Fassbinder muse' Hanna Schygulla in Fatih Akın's *Auf der anderen Seite* (The Edge of Heaven, 2007), a film which helped to cement the filmmaker's position in Germany as the heir to Fassbinder's mantel.

Yet, as Sascha Koebner notes, while there has been a growth in the number of films exploring the concerns of older members of society, with respect to the question of gender, despite the pronouncedly female make-up of this part of the cinema audience and the highly visible role played by well-known older women in many of these films – some of whom were important figures in the *Frauenfilme* of the 1970s – they often do little to challenge gender stereotypes. More often than not such films will, for example, focus on an elderly male protagonist who is given the chance to learn from past mistakes and leave a legacy for the next generation, such an active role seldom being given to their female counterparts (Koebner 2006: 39). On the face of it, Dörrie's *Kirschblüten – Hanami* is typical of this trend, as well as the broader question of inter-generational relations. Rudi (Elmar Wepper), a 'traditional' Bavarian man close to retirement age, is left alone after the sudden death of his wife Trudi (Hannelore Elsner) while the couple are on a trip to the Baltic coast as they attempt to recover from an uncomfortable visit to their children in Berlin. Through the process of mourning Rudi comes to appreciate the woman far more than he ever did during her life, taking a trip to Tokyo to visit his estranged son, a country, he discovers after her death, his wife would have always loved to see. Here Dörrie presents another example of the types of transnational encounter we find throughout contemporary German film, the man's journey to Japan offering him a form of catharsis. He begins to dress in Trudi's clothes, hidden under his long overcoat, symbolically taking 'her' to the places he never did in life, learning to appreciate Japanese culture, as well as

the fundamental transience of life – encapsulated in the fleeting beauty of the cherry blossom that fills the park through which he wanders. Specifically, Rudi comes to accept the passing of his wife through his encounter with a homeless girl Yu (Aya Irizuki), her name revealing her symbolic function within the narrative as a spiritual mentor to the man; 'I am Yu,' she explains (in English) on their meeting. Yu introduces him to the ritual of Japanese Butoh dancing. In the process, and as is typical of this wave of 'old age' films, Rudi is given the opportunity to make amends for his past behaviour. He comes to understand his inadequacies as a husband and father, finally leaving his money to the girl when he himself dies at the end of the film, thus allowing her to start a new life.

Yet the film also challenges the gender clichés it appears to play to through its self-conscious exploration of the role of performance and ritual in the construction of gender identity. In so doing, the film provides a further example of Dörrie's complex relationship with the tradition of the *Frauenfilm*, already identified by some critics in her earlier comedies, offering an image of gender relations that – as Hake describes in her positive assessment of the filmmaker as 'post feminist' – is 'committed to the goals of feminism but also surprisingly open about the messiness of ordinary life' (Hake 2008: 184). *Kirschblüten* is Dörrie's fourth film to use Japan as its backdrop, a cycle which began with her 2000 comedy set in a Japanese Zen monastery *Erleuchtung garantiert* (Enlightenment Guaranteed), a film that also saw Dörrie adopt the kind of stripped-down production style already discussed in connection with Andreas Dresen, similarly incorporating elements of documentary realism into both her mise-en-scène and camera work, and encouraging her actors to improvise. For Dörrie, Japanese culture offers strong parallels with Germany, specifically in the ways in which it had to negotiate a post-war reconstruction caught between the wish to maintain a sense of tradition and an enforced 'Americanisation' of society. This connection is suggested for Dörrie particularly clearly in the role of Butoh dancing as it is depicted in *Kirschblüten*. Butoh, an art form that first appeared in Japan in the wake of the Second World War, depicts a shadowy, transient world caught between life and death, a world which took its cue, Jan Stuart notes, from the sensibility and iconography of German Expressionism (Stuart 2009). It would, without doubt, be a huge oversimplification to argue for any straightforward equivalence

between the German and Japanese engagement with the legacies of the past in the post-war period. However, for Dörrie at least, Japan offers a kind of parallel reality to Germany, a tendency that Margaret McCarthy identifies as a hallmark of Dörrie's oeuvre, her use of 'foreign forms' helping to point out 'emotional gaps in the German psyche' (McCarthy 2003: 384).

In *Kirschblüten*, this is underlined by Dörrie's use of Yasujirô Ozu's *Tokyo Story* (1953) as the model for her narrative. Ozu's elegiac story depicts an elderly Japanese couple from the country paying a visit to their children in Tokyo, their children making little time to spend with them. This is transposed in Dörrie's film to the story of Rudi and Trudi's journey from Bavaria to Berlin to visit their equally inhospitable offspring. For Dörrie, her westernised take on Ozu's story is particularly apt given the fact that Ozu's own story was adapted from Leo McCarey's Hollywood movie *Make Way for Tomorrow* (1937). Parallels between Ozu and Dörrie's films are largely confined to the level of narrative, Dörrie feeling an affinity with Ozu's 'themes, his sensibility of how to talk about relationships'. She could never adopt aspects of his style, she suggests, even as she seems to evoke his well-known autodidactic approach to filmmaking. To look for artistic role models is 'something that you just don't do as a woman because it's so completely out there to be making films at all that you don't *dare* put yourself in this line of famous ancestors' (Filmmaker 2009). To be sure, Dörrie's camera work, in particular, is generally very different to that of Ozu, being far more fluid while maintaining the sense of slow contemplation that pervades his films. That said, there are moments when Dörrie does seem to gesture towards Ozu's static shots that capture the world as it happens. In similar fashion to the Japanese filmmaker, the private story of familial crisis is punctuated throughout by documentary-like images of the external world. A series of tableaux of the family's grief at the death of their mother, for example, is set against the image of genuine tourists enjoying a day at the seaside who happen to be caught in the frame. In one particularly striking tableau, the screen is filled with two wicker beach chairs. One in the foreground contains the couple's son and his wife, dressed in black sitting in silent reflection, the wife awkwardly attempting to console her husband, while in the background another couple dressed in their swimming costumes, enjoy a moment of intimacy, the happiness of the holidaymakers throwing into stark relief the

38 The family (Felix Eitner and Floriane Daniel) grieves while tourists enjoy a day at the beach, *Kirschblüten – Hanami* (2008).

pain of the family at their mother's loss. The fraught family scenes we see in Berlin and subsequently Tokyo are then further interspersed with images of the everyday pressures the populations of these cities face. We catch a glimpse of a tramp rummaging through a bin in search of food, as well as Japanese commuters cramming onto a train, their mouths covered with masks. Thus Dörrie firmly roots what might otherwise seem to have the qualities of a fairy tale – suggested in the rhyming names of Dörrie's couple – within the high-speed reality of modern life, highlighting the specific connection of her story to contemporary society.

At the start of the film, both Rudi and Trudi live a life that, externally at least, is defined by the ritual and routine of their mutual performance of highly traditional gender roles. In a moment particularly reminiscent of Ozu's famously contemplative approach to storytelling, we see the couple's lives pared down to their routine core, accompanied by a voiceover commentary from Trudi. Rudi travels to work each morning on the train, automatically swapping sections of the newspaper with a colleague without a word. At one o'clock he eats the sandwich Trudi has prepared for him, throwing the apple she has also packed to the same colleague, despite Rudi's own regular declaration to his wife that 'an apple a day keeps the doctor away'. Each evening she greets him at the door of their home, helping him into his cardigan and slippers, sitting at the table while he eats the dinner she has also always prepared. The

performative nature of Rudi's self-construction is already hinted at in his refusal to eat the daily apple he, himself, insists upon to his wife. After Trudi's death, however, he is finally forced to come to terms with the limitations of this performance, and the ramifications it has had on his relationship with his wife and children. This becomes most obvious in his trip to Japan, where he is confronted by a highly exaggerated performance of a male version of female sexuality, a kind of 'hyper femininity' that pervades contemporary Japanese culture, which ultimately forces him to confront his own conception of masculinity. Abandoned by his son to fend for himself, completely disorientated and overwhelmed by the size and foreignness of the city, Rudi stumbles across a crowded strip club and bathhouse. To the sound of a high-energy kitschy dance song, Rudi is filmed in medium close-up, framed at close quarters by dancing girls who are shown to be naked beneath their short skirts, up at whom Rudi stares awkwardly. His awkwardness is then compounded by his subsequent visit to the bathhouse, where he himself is stripped naked and washed by two similarly naked geisha girls, the only item he keeps on being his wedding ring. Here Rudi breaks down, unable to perform the role of the desiring male voyeur, instead bursting into tears, refusing to look at the women and holding his head in his hands. The image of Rudi's naked body marks the final symbolic loss of his previously comfortable gender identity. In its place he tries to adopt the role his wife had previously played within the family, cleaning his son's flat, preparing his wife's speciality dish of cabbage rolls for the young man. Rudi's performance of his wife's maternal role is, however, only partially successful. It is at this point that the man sets out to understand his wife's fascination for Japanese culture. By wearing her clothes, Rudi self-consciously attempts to re-embody the woman, finally putting on his wife's much-loved kimono and covering his face in white make-up to perform a Butoh dance at the foot of Mount Fuji. Here Rudi performs a classically Freudian process of mourning, the subject attempting to 'resuscitate' and 'incorporate' the lost loved one into his own sense of self, in order eventually to overcome the trauma of this loss (Clewell 2004: 44). Through the process of Rudi's embodiment of Trudi, he finally breaks free from his wife. In his mind we see the man dance not as, but rather with, the woman, at last coming to appreciate her not as a wife and mother but as a woman with her own fantasies and desires.

39 Rudi (Elmar Wepper) dancing as/with Trudi (Hannelore Elsner) at the foot of Mount Fuji, *Kirschblüten – Hanami* (2008).

On one level, then, the film operates within the conventions of other films that examine the experience of older people. Dörrie explores Rudi's journey, his wife dying before she could make any journey of her own. However, the film is more fundamentally driven by the quest to understand *Trudi*'s desires and the constraints with which she is faced in her life with her husband. That said, a straightforward reading of the film either as the fulfilment of its male protagonist's quest for understanding, or as a feminist declaration of its female protagonist's marginalisation is troubled by Dörrie's representation of gender relations. Like Rudi, Trudi's sense of identity is shown to be constructed around the notion of performance. While for Judith Butler, the performance of gender roles is socially proscribed, in Dörrie's film Trudi deliberately chooses to play the role of the housewife. There is no sense that she is forced into this role. As her daughter's girlfriend insists, when she reveals to Rudi his wife's fascination with Japanese culture after her death, Trudi was not unhappy with her husband and family, for all her children's ingratitude during the couple's visit to Berlin. Her Japanese fantasy life was just another possibility, another version of herself. In this sense, Dörrie questions any conceptualisation of one's identity being defined by an essential core, while rejecting the idea of performance necessarily being a product of social constraint, as discussed by Butler.

40 Alice Dwyer as a damaged teenager negotiating her dysfunctional life, *Torpedo* (2008).

The non-essentialist nature of Trudi's identity is also reflected in the way Dörrie asked Elsner to approach the role. Dörrie insisted that the actor be filmed without any make-up and that she speak in the Bavarian dialect of her youth. Thus, as the filmmaker herself notes, she forced Elsner away from the role of sexy diva she has so often played in the past (Noh 2008). In the process, it might seem that Dörrie was intent upon revealing a more 'authentic' side to the actress that lies beneath the roles that have made her famous. However, for some critics, including Sibylle Berg, Elsner's accent is very jarring: 'Why does she have to speak Bavarian when she can't do it anymore?' (Berg 2008). Consequently, in Elsner's performance it becomes clear that there is no 'authentic core' to be revealed by stripping back her public persona. Indeed, her 'original' self would seem to be even more explicitly performative than the role she has frequently adopted during her career. Similarly, Dörrie suggests that there is ultimately no authentic 'core' to be revealed in the character of Trudi. Rather her identity is made up of a series of possibilities. This is the lesson that Rudi learns in the film, his embodiment of his wife ultimately functioning as part of his own mourning process rather than as an admission of the error of his ways.

Neither Rudi's nor Trudi's lives are finally revealed as tragic. Trudi was not unhappy with her lot. She was clearly in love with her husband, as is shown by the loving dance they enjoy together the

night before her death. Trudi is not a woman who was prevented from reaching her true potential. In this way, Dörrie offers the audience a story that recuperates the value of traditional, herterosexual gender relations within the context of her broader feminist agenda. For her fans, this and her other films chronicle the continued development of the role of women in German society. For her critics, on the other hand, her valorisation of the potential of performance, which seems to ignore the constraints put upon the construction of gender identity by society as a whole – a society that is, moreover, deliberately and self-consciously inserted into the film through moments of documentary-like realism – is far more worrying. From this perspective, the film would seem to further signal the end of the feminist agenda set by the *Frauenfilm*. Ultimately, however, as was suggested in my discussion of authenticity and the heritage film, it is, perhaps, the continued debate that films such as Dörrie's provoke which is more important than the attempt to pin the filmmaker herself down to a straightforwardly definable ideological position, either as part of the critical left in the tradition of the New German Cinema or as part of a conservative trend within recent popular film – for all that she was seen as the herald of this trend in the 1980s.[12] It is to the continued provocation of debate that Dörrie is clearly committed, even as she eschews any clearcut political position, or what she herself dismisses as the type of 'didacticism' one finds in the work of the previous generation (Phillips 1998: 178). The ambiguity of Dörrie's form of feminism is similarly found amongst many contemporary women filmmakers. Incidentally, while in this chapter we have looked at the increasing importance of ageing, this same ambiguity can be found if we look at the opposite end of the demographic spectrum. *Torpedo* (2008), made by the 'child prodigy' director Helene Hegemann – only 15 years old at the time – for example, adopts a similarly ambiguous position towards a feminist agenda in its jarring presentation of a dysfunctional teenage girl seeking to cope with life in Berlin after the death of her mother. Mia (Alice Dwyer) has been damaged by her past; she revels masochistically in her status as a victim while also craving the stability of a traditional family life in which her aunt would fulfil her motherly duties towards the children in her care.[13] As we have seen, in many large-budget heritage films that focus on the stories of women from the past, the exploration of gender relations is far less nuanced than those found in the work

of Dörrie, Maccarone or Hegemann, and is ultimately far removed from the work of the 1970s *Frauenfilm*. Nonetheless, in these and the other films discussed here, we see the growing role that women play within the industry. It is this, along with the development of new structures to further increase women's participation that are, perhaps, the most tangible legacies of the *Frauenfilm*.

Notes

1　For a far more detailed examination of the development of women's cinema during this period see Knight 1992; Frieden *et al.* 1993; Sieglohr 2002. For a good contemporaneous account of developments see Silberman 1982.

2　The situation in the GDR, however, was very different. While, as in the West, there was a growth in the number of films produced that sought to explore women's place in society from the 1960s onwards, very few were made by women or had the explicitly feminist agenda evident in Western productions. For further discussion see Berghahn 2005: 175–211.

3　Further evidence of this shift can be seen, for example, in an interview in *Die Welt* with Katja Mildenberger at the 2000 *Feminale*, a women's filmmaking festival in Cologne, were she explains the festival's reasons for distancing itself from the term *Frauenfilm* (Mildenberger 2000).

4　For discussion of the role played by Riemann, as well as other stars of this cycle of filmmaking, see Lowry and Korte 2000: 245–74.

5　For an overview of the competing definitions that circulate within discussions of post-feminism see Jones 1994; McRobbie 2004.

6　If one examines the FFA's regular surveys of the top 50 grossing films, heritage films that focus on the story of a female protagonist invariably attract more women than men into cinemas. Rothemund's *Sophie Scholl – Die letzten Tage*, for example, attracted 53% women when the average attendance that year was 51%; Wortmann's *Die Päpstin* 60% when the average was 56%; Link's *Nirgendwo in Afrika* 58% when the average was 48%.

7　For further discussion of this film and its reception see Silberman 1995: 198–213.

8　Wortmann was employed by Eichinger after the very public departure of Volker Schlöndorff from the project. For further discussion see Chapter 1 of this study.

9 The republication of the book followed the death of its author, after
 which her identity was revealed by Jens Bisky in the *Süddeutsche
 Zeitung* as the journalist Marta Hillers (Bisky 2003).

10 Interestingly, *La passion de Jeanne d'Arc* is a film that also sought
 self-consciously to reveal the 'real' woman behind the legend.
 Like Rothemund, Dreyer made much of his film's basis in archival
 evidence, in this case the original transcript of Jeanne's trial.
 Dreyer, however, goes further than Rothemund, using the tran-
 script itself as a framing device for his account of Jeanne's trial
 and execution.

11 In recent years Monika Treut's work, most notably her 1980s films
 (*Verführung: Die grausame Frau*/Seduction: The Cruel Woman,
 Elfi Mikesch, 1985; *Die Jungfrauenmaschine*/The Virgin Machine,
 1988), has achieved a cult status. Treut is also a filmmaker who
 explores the relationship between transnationalism and sexuali-
 ties that 'cross boundaries', adopting a decidedly transnational
 approach to US-German cultural relations, in a similar fashion
 to some of those discussed in the next chapter. More recently she
 has explored Taiwanese culture as a transnational space in her
 critically acclaimed documentary *Made in Taiwan* (2005) as well
 as in the less successful *Ghosted* (2009), Germany's first German-
 Taiwanese co-production.

12 For a discussion of Dörrie's critical reception as well as the film-
 maker's own response to it see Philips 1998.

13 Hegemann was heralded as a precocious talent with the release of
 Torpedo in 2008 (Demmerle 2008). Her position as a spokesperson
 for young women seemed confirmed when she subsequently
 appeared in Nicholette Krebitz's contribution to *Deutschland 09*,
 Die Unvollendete (The Unfinished), which stages an imaginary
 meeting in 1969 between Hegemann, the cultural commentator
 Susan Sontag and the journalist Ulrike Meinhof, before she became
 a member of the RAF. However, more recently, her rising star has
 been challenged, when it was revealed that her follow-up project
 to *Torpedo*, the novel *Axolotl Roadkill* (2010), was partially plagia-
 rised from an internet blog. In her defence Hegemann argued that
 her approach to art is informed by the 'mashup' aesthetics of her
 generation, which sees recycling other cultural texts as part of
 its practice. For further discussion of the broader cultural debate
 the accusation of plagiarism set in train see, for example, Schäfer
 2010.

6 Visions of America across the generations

The relationship between the German and American film industries is practically as old as the medium itself. The first American film company, Lubin Cineograph, was set up in 1897 by Sigmund 'Pop' Lubin, a German optician turned film entrepreneur.[1] However, the history of the German contribution to US film really took off with Carl Laemmle, the founder of Universal and a giant of the early industry. Laemmle kick-started an exodus of figures from the German and Austrian industries to Hollywood in the first half of the twentieth century when he invited Erich von Stroheim to work with him as a director. Von Stroheim would soon be joined by many of the big names of Weimar cinema, including the actors Emil Jannings (winner of the first Oscar for best actor in 1928), Peter Lorre and Marlene Dietrich, cinematographers Karl Freund and Eugen Schüfftan, other directors such as F.W. Murnau, Fritz Lang and Samuel 'Billy' Wilder, as well as the producer Erich Pommer, all of whom made the move, more or less successfully, from Germany to Hollywood, bringing with them the styles and sensibilities of Weimar film and in turn profoundly shaping the development of American cinema during the classical period (Petrie 1985; Krämer 2002).

America has also long played a pivotal role in the domestic industry's history, not least as a key arena for German product, beginning with Pommer's marketing coup in the wake of the First World War, convincing American audiences to watch films made by their former enemy. His influence also ensured investment in the German industry when UFA – the nation's largest film company at the time – was facing bankruptcy in the mid-1920s and again post-Second World War when he returned to Germany from Hollywood

to attempt once more to revitalise the reputation of an industry tarnished now by National Socialism (Hardt 1996). This was a time when film production and exhibition was tightly controlled by the Allied powers in both German states, in the West the German population being fed a carefully selected diet of Hollywood movies designed both to secure the West German market for Hollywood's back catalogue and to educate the masses in the ways of democracy.[2] With the advent of the New German Cinema in the 1970s, it was not until American festival and art house audiences started to enthuse about the work of Fassbinder, Wenders, Herzog, von Trotta and others that German critics really took notice of this new generation of artists.[3] In turn, this international acclaim brought with it a new period of migration which, as I shall discuss below, at times highlighted the deep ambivalence the 68er generation felt towards the USA. Ironically, it was also at this time, when German cinema was having the type of international success it had not enjoyed since the 1920s, that Hollywood began to dominate screens in Germany (Garncarz 1994), a domination that has continued to the present with Hollywood movies taking the lion's share of annual ticket sales, despite the inroads made by domestically produced films of late. Beyond the money spent by the cinema-going public, until recently up to 90% of all the money spent by German investors on film production went to Hollywood – funding around 20% of Hollywood movies per annum – further underlining the domination of Hollywood cinema within the German domestic sphere.[4] And this is not to mention television, where American product has had a profound influence upon German viewing habits and consequently television production (Krämer 2008: 241). One particularly significant, if exceptional, example in this regard was the screening of Gerald Green's/Marvin J. Chomsky's television mini-series *Holocaust* (1978), which sent a shudder through the German public consciousness, in turn impacting upon domestic TV production in a variety of ways, most famously provoking Edgar Reitz to produce his own television epic, *Heimat* (1984), as a corrective to what he saw as Chomsky and Green's Americanisation of German history.[5]

Since the 1990s, however, the dominant mode in the relationship of the German industry to the US has been one of emulation rather than correction. There has been a further wave of emigration by German and Austrian filmmakers, actors and technicians,

a number of whom are now major figures in Hollywood. Wolf-gang Petersen and Roland Emmerich, for example, are currently amongst an elite of Hollywood directors who have gained the right to the final cut of their films. Uli Edel, Florian Henckel von Donnersmarck, Tom Tykwer and Mennan Yappo have also directed big-budget Hollywood features, although so far generally with rather less commercial success than Petersen and Emmerich. Michael Ballhaus, Fassbinder's cinematographer, has worked regularly with Martin Scorsese. The German stars Til Schweiger (*Inglourious Basterds*, Quentin Tarantino, 2009), Daniel Brühl (*The Bourne Ultimatum*, Paul Greengrass, 2007; *Inglourious Basterds*) and Franka Potente (*Blow*, Ted Demme, 2001; *The Bourne Identity*, Doug Liman, 2002) have all played supporting roles in major Holly-wood films, and of course one cannot forget the most commercially successful of them all, the Austrian *Terminator* turned Governor of California, Arnold Schwarzenegger. At home, Hollywood provides the model for many German production companies. The most obvious name to mention in this regard is Bernd Eichinger, a producer in the Pommer-mode, whose Constantin is the closest the German industry has to a US-style major studio, producing films in both Germany and Hollywood, or Nico Hofmann, whose teamWorx, as the name suggests, is self-consciously styled on Steven Spielberg's US production company DreamWorks, Hofmann having similarly ambitious international aspirations.

In terms of the business economics in Germany, there has been a clear trend towards emulating successful Hollywood models on a smaller scale. This has, at times, also been reflected in the types of films that have been made. The romantic comedies from the 1980s onwards were noted for their aping of Hollywood aesthetics. However, unlike the Hollywood films they seemed intent upon copying, they largely failed to attract an international audience. Eichinger even brought Doris Dörrie to the United States at the time on what the filmmaker describes as a 'schmooze tour' (Beier 2008), but to no avail, leading only to the production of the commercial flop *Me and Him* (1988). While emulation might offer a useful busi-ness model – however aspirational this remains within a German context still heavily reliant on public subsidy – when it comes to the types of films produced, the best way for German product to be successful abroad is clearly to tell stories that foreground its national specificity, and nothing does that better, it would seem,

than films which present images of the nation's problematic past. This is, for example, staple content of the teamWorx's 'amphibian' productions that have been sold the world over (*Dresden*, Roland Suso Richter 2006; *Die Flucht*/March of Millions, Kai Wessel, 2007). It is a key element in many of the highest grossing German films internationally (*Good Bye, Lenin!*, Wolfgang Becker 2003; *Der Untergang*/Downfall, Oliver Hirschbiegel 2004). It is more or less obligatory if you are looking to be nominated for an Oscar (*Das schreckliche Mädchen*/The Nasty Girl, Michael Verhoeven, 1990; *Sophie Scholl – Die letzten Tage*/Sophie Scholl – the Last Days, Marc Rothemund, 2005; *Der Baader Meinhof Komplex*/The Baader Meinhof Complex, Uli Edel, 2008; *Das weiße Band – Eine deutsche Kindergeschichte/* The White Ribbon, Michael Haneke, 2009), and absolutely essential if you want to win (*Nirgendwo in Afrika/* Nowhere in Africa, Caroline Link 2001; *Das Leben der Anderen*/The Lives of Others, Florian Henckel von Donnersmarck, 2006; *Die Fälscher*/The Counterfeiters, Stefan Ruzowitzky, 2007). Nonetheless – and echoing the policy adopted by Pommer post-First World War – the use of specifically German content must never be so overt as to make such films difficult for international audiences to understand. Henckel von Donnersmarck's film is seen by some as the perfect 'Oscar movie' in this regard, his Stasi melodrama offering the academy judges a perfect blend of 'exoticism' and 'universalism', which the director and his US distributor subsequently capitalised upon by running a very slick campaign that did everything possible to position the film well for a win. Henckel von Donnersmarck travelled the length and breadth of the country in the run-up to the awards, speaking at screenings and giving multiple interviews every day, his confidence with the English language making him an easy guest for US talk-show hosts (Seeßlen 2007; Vahabzadeh and Göttler 2007). Finally, it is also clear that Germany's problematic history remains central, more broadly, to the place of the nation in Hollywood's own imagination. It is not only German-language productions that do well with films about Germany's past, as the five Oscar nominations for Stephen Daldry's *The Reader* (2008) show. Peter Zanders puts it bluntly: 'Nazi topics work best at the Oscars' – Henckel von Donnersmarck's GDR film notwithstanding (Zander 2009b). Indeed, it is this moment in the nation's history that has been a key driver in attracting certain large-scale Hollywood projects to the country's

studios since the mid-2000s – along with, of course, the still very generous and recently reconfigured subsidy system. Here we might recall, along with Stephen Daldry's *The Reader* (2008), Bryan Singer's Tom Cruise vehicle *Valkyrie* (2008) and Tarantino's *Inglourious Basterds*, all of which, in their own very different ways, utilise the Berlin Babelsberg context of their production to endow their projects with a degree of German 'authenticity'.

As Gerd Gemünden notes, while the relationship between the US and German industries can be traced to the beginning of the medium, the broader cultural engagement between the two nations goes back even further. Focusing in particular on the place of the United States within German culture, he writes: 'America has always claimed a privileged space in the German imagination [...] From Goethe to Kafka and beyond' (Gemünden 1998: 18). Throughout the twentieth century, the United States has functioned variously as a symbol of democratic modernisation or of the corruption of an authentic sense of Germanness. On the one hand, 'Americanisation' has been viewed as synonymous with the growth of mass popular culture, embraced by the nation's youth since the days of Weimar, while their parents, on the other, looked on with concern. Thus, as the young Billy Wilder would both experience and describe during his time as a cub reporter in 1920s Berlin, *Amerikanismus* was already a 'buzzword that implied both peril and promise' (Gemünden 2008: 7). During the Cold War, Americanisation continued to be a concept contested by the authorities on either side of the Berlin Wall, both politically and culturally, constructed as a symbol of aspiration and stability in the West, of fascistic cosmopolitanism in the East. Elements of the population of the two states, conversely, seemed at times to reflect more directly the views of the opposing regime.[6] For many ordinary people in the GDR, American popular culture – only available to them in much sought-after *Westpakete* (Western packages) sent by family and friends in the Federal Republic, in the high-priced 'hard currency' *Intershops*, on the black market or on the Western television that could be received in most parts of the country – was a symbol of Western freedom. In the FRG, while American popular culture became increasingly influential over time, for the 68ers Americanisation was also inextricably interlinked with a new version of neo-colonial fascism. 'USA – SA – SS' rang the chants of the anti-Vietnam War demonstrators in front of Amerika Haus in

Berlin (Kraushaar 1998: 244–8). Since unification, a relationship between Americanisation and neo-liberal 'neo-colonialism' has continued to be posited by the Left, now connected to financial and cultural globalisation, the world ostensibly homogenising, so its critics suggest, under the sign of the McDonalds' golden arches and other US-global brands (Belk 1996). Indeed, in the 2000s the kind of anti-Americanism to which a neo-colonial view of Americanisation can give rise spilled over into mainstream political discourse, as the Schröder government voiced its vehement opposition to the US-led invasion of Iraq. Nonetheless, American popular culture in general, and Hollywood specifically, continues to dominate consumer taste. This is a state of affairs that, on one level, might be explained by the ability of American popular culture to control the means of its distribution, ensuring that the world drinks Coke and its cinema screens largely show the latest Hollywood event movie. But, to some degree at least, this must also surely be due to the fact that people simply want to consume these cultural products. Here one might recall the 1994 Oscar ceremony when the host Whoopi Goldberg began proceedings provocatively by declaring the event to be a celebration of 'the best of Hollywood cinema, which is the best of world cinema', a self-conscious declaration of Hollywood's status as an internationally understood art form which, for Goldberg, unlike other types of film often defined as 'world cinema', is a truly global cultural product that can attract audiences and talent from around the world.[7]

In this chapter, I explore how America is conceptualised as an imagined space in the work of a range of contemporary filmmakers. From the thumbnail sketch offered above, it is clear that the place of America in the German social consciousness works in complex and often competing ways that have long exercised the nation's artists, operating variously, as Rentschler identified in the 1980s, as 'a fantasy, a daydream, a nightmare [...] as a playground for the imagination, as a mirror that reflects and intensifies the preoccupations and imported conflicts of its visitors' (Rentschler 1984: 604–6). In productions since 2000 America's role as a 'playground for the imagination' continues. For some older filmmakers, not least some of the established figures of the New German Cinema who are still making films, such as Wenders, Schlöndorff and Herzog, America is used as a space in which they continue to reveal their ambiguous relationship with the global dominance

of US popular culture. Conversely, for others such as Emmerich, Petersen and – albeit with an emphasis at times more reminiscent of the New German Cinema – Tykwer, Hollywood becomes a realm of imagination and spectacle that allows them to escape the angst that often still pervades the 68ers' love–hate relationship with US culture. Elsewhere we see American culture continue to be configured as a symbol of utopian freedom. In the process, and again echoing Rentschler's description, the US functions as a mirror used to critique not the state of the American union, but rather the German one. Finally, recalling the discussion in Chapter 4, we also see a growing engagement with US popular culture not simply as an *inter*national brand but as part of a *trans*national encounter with the United States as a physical space, inhabited by real people. Here America is again used to reflect a spectrum of concerns that range from that of foil for political critique to a utopian space of aspiration. However, we also begin to see a representation of the United States that suggests a far stronger feeling of comfortable coexistence between the two nations than can be identified in the work of earlier generations, further evidence, perhaps, of a broader process of 'normalisation' taking place within contemporary society.

The New German Cinema today: the problems of the 'long march through the institutions'

As already suggested, some of the filmmakers of the New German Cinema had a deeply ambivalent relationship with the United States. While their parents had ostensibly willingly accepted US domination in the West in exchange for post-war stability and a way out of having to deal too profoundly with the Nazi past, by the late 1960s the situation was starting to change. Those who were born with no experience or knowledge of the war years were now students and, guided by the Marxist writings of the Frankfurt School, were beginning to attack what they saw as American cultural imperialism and the hypocrisy of their parents' acceptance of it. 'The Yanks have colonised our subconscious', the protagonists of Wenders' *Im Lauf der Zeit* (Kings of the Road, 1976) famously agree. At the same time, and seeming to challenge this relationship to Americanisation, Wenders himself has also equally famously suggested that his 'life was saved by Rock 'n' Roll' (Dawson 1976:

28). His generation was itself also deeply attracted to American culture, having been brought up on what many felt to be an intoxicating diet of Coca Cola, Anglo-American pop music and Hollywood. When some of those who would later enjoy particular success abroad came to make films, it was America that provided them with a cinematic model. However, rather than wishing simply to emulate the styles of the American movies they had themselves watched, the likes of Fassbinder and Wenders set about trying to deploy and simultaneously examine the visual and aural grammar of American film as a means of achieving a more authentic sense of their own identity by highlighting the incongruity of this ill-fitting template.[8]

As the energy of the student movement of the late 1960s began to dissipate and its protagonists got older, new approaches were adopted. The student leader Rudi Dutschke called for the protestors to get involved in mainstream politics, to take the 'long march through the institutions' in order to change the country from within (Koenen 2001: 58). For filmmakers echoes of the 'long march' – however tangentially they might be linked to the politics of Dutschke's call – can be felt in a variety of ways. It is suggested, for example, in the move of Wenders, Schlöndorff, Herzog and others to Hollywood, a move that has often been fraught with difficulty. This is most obviously exemplified in Wenders' experience of working with Francis Ford Coppola's Zoetrope. In 1977, hearing that Wenders wanted to make his first American movie, Coppola invited the director, who was riding high on the success of *Der amerikanische Freund* (The American Friend, 1977), to work on *Hammett* (1982), a noirish homage to the author of *The Maltese Falcon* (1930). The partnership was doomed from the start. Coppola was dissatisfied with Wenders' work, from his rewrite of the screenplay to the first rushes, ordering the film to be completely reworked and prompting Wenders finally to disown the project almost entirely (Phillips and Murch 2004: 198–201). Less fraught, but rather more quirky perhaps than Wenders' encounter with Hollywood has been that of Werner Herzog. He moved to the United States in 1995 and has now lived for over a decade in Los Angeles. Although he has spent years in the vicinity of Hollywood, he has assiduously avoided becoming part of the mainstream industry, in the process offering instead a deliberately sideways glance at American culture. High points of this period in his career include his critically

acclaimed documentary work, most notably his account of the life and death of US grizzly bear enthusiast Timothy Treadwell, *Grizzly Man* (2005), as well as his subtle deconstruction of Hollywood genre films – the Vietnam War Movie in *Rescue Dawn* (2007) and the Police Thriller in *Bad Lieutenant: Port of Call – New Orleans* (2009). Yet although Herzog self-consciously positions himself as existing on the periphery of the mainstream film industry in the US, it would appear that he is gradually becoming part of its establishment. *Rescue Dawn*, for example, was bankrolled by MGM. His growing stature within the industry is also signalled in his ability to attract major actors such as Nicolas Cage to star in his decidedly low-budget movies and in 2006 in an invitation to become a member of the Academy of Motion Picture Arts and Sciences.

But the New German Cinema's 'long march' has not just been about trying to infiltrate Hollywood. By now elder statesmen of the industry, in the 1990s Wenders and Schlöndorff took on important roles as President of the European Film Academy and head of the UFA Studio at Babelsberg respectively, both wishing to revitalise the post-Cold War European film industry. In both cases this ended in failure, leading to little more than political frustration on their part and some very mediocre movies. Yet, to whatever extent and on whatever terms the *enfants terribles* of the New German Cinema have become part of the establishment, their love–hate relationship with the United States has often continued. This is clearly evident, for example, in Herzog's approach to the genre films mentioned above. Similarly, Schlöndorff, who never achieved the success many expected in the wake of his Oscar win for *Die Blechtrommel* (The Tin Drum, 1979), also briefly returned to America and Hollywood genre filmmaking after his sojourn as a would-be movie mogul to direct the neo-noir *Palmetto* (1998). The film was universally panned by the critics, once more renewing his cynicism towards the US industry. Nonetheless, it remains an industry within which he wants to work – at least on occasion. Wenders also crossed the Atlantic once more in the 1990s, where he enjoyed a far more successful phase in his career with films such as *The End of Violence* (1997), *The Buena Vista Social Club* (1999), *The Million Dollar Hotel* (2000) and *Don't Come Knocking* (2005). Most of these films exhibit a continued engagement with the perennial themes of Wenders' oeuvre. On the one hand, one senses his profound attraction to American popular culture and to the United States as what

might be termed an aesthetic phenomenon, as well as the power of cinema to capture the beauty of this phenomenon on screen. Here one finds a particularly clear example of what Gemünden describes in the work of Wenders and others of his generation as a celebration of 'the surface of things and the imagistic and iconographic quality of life', in turn promoting the indulgence – through the affective potential of the visual image – of 'sensuality over sense' (Gemünden 1998: 14). On the other, one also apprehends Wenders' distrust of this same culture, and the corrupting potential of visual images, manifest most explicitly in what commentators have long identified as his rejection of narrative (Cook and Gemünden 1996; Graf 2002). 'In story', Wenders sees 'a kind of vampire, trying to suck all the blood from an image' (Wenders 1992: 1). Narrative for Wenders looks to limit and undermine the visual, providing him with a metaphor for his broader critique of the culture industry, which confines the aesthetic realm to the logic of an American-sponsored form of global capitalism, a logic that can misuse and manipulate art and, with it, individuals for its own corrupt ends.[9]

In *The Million Dollar Hotel*, for example, FBI Agent Skinner (Mel Gibson) is sent to a rundown hotel in LA for dropouts and social misfits to investigate the death of Izzy (Tim Roth), the junkie son of a media tycoon (Harris Yulin) who has had Skinner sent in to wrap up the investigation quickly in order to avoid a media frenzy and to establish that his son did not commit suicide. This is a disgrace the man could not bear. Skinner is a hard-talking, incorruptible agent whose goal is to find the truth about the events that led to Izzy's death. Izzy's father, however, sees this as a naive aim, the 'truth' only existing in terms of its packaging in the media: 'Truth?' he asks Skinner, somewhat confused. 'My people decide the truth in over sixty countries every morning, and in each one it's different. The truth is the explanation that most people want to buy [...] This is Hollywood, my boy.' The small screen, in particular, is seen as a highly manipulative medium driven by a corrupting search for narrative – for stories with beginnings, middles, and most importantly ends. Skinner fails to keep a lid on the news and the much-feared media frenzy engulfs the hotel, a frenzy that helps to construct a completely false image of Izzy as a frustrated artist whose work, actually painted by another of the residents, now has a market value due to his posthumous celebrity. Meanwhile, beyond the media circus, the real 'truth' at least partially unfolds

to the spectator. We learn of the love of the simple-minded Tom Tom (Jeremy Davies) for the hooker Eloise (Milla Jovovich) and of Tom Tom's implication in Izzy's death. In a flashback, we watch Tom Tom let the junkie fall from the hotel roof after Izzy admits raping the woman, in turn helping to explain the film's opening and closing sequences, in which Tom Tom leaps off the roof to his death. The story of Tom Tom and Eloise is told in a very different style to the rest of the film. Here one finds what might be described as a more 'European' aesthetic, reminiscent of the French New Wave or Wenders' own earlier work from the 1970s. During Tom Tom's first approach to Eloise, the camera moves around the couple as Tom Tom moves around Eloise, employing a mixture of long takes, variable slow motion and jump cuts, a style that continues into their subsequent encounters until it mutates in the film's closing credits into a shadowy sequence in extreme slow motion, now almost better described as a series of stills, in which one can just make out Eloise gently caressing Tom Tom's face. These are images far removed from the frenetic world of the Channel Six News that fill the televisions screens in the hotel lobby, with their prioritisation of story – whatever story – over the opened-ended affective potential of the image. Neither does it sit comfortably with the world as it is perceived by Agent Skinner who, for all his dedication to 'the truth', attempts to strong-arm the hotel's largely insane guests into conforming to the hunches he has about what has happened. This is a world encapsulated in a series of stills that Skinner seems to take in his mind's eye, stills that, unlike the Tom Tom and Eloise sequences, do not slow down the narrative flow in order to disrupt it, but rather crystallise the film's narrative expectations, underlining Skinner's prejudicial view of the hotel and its inhabitants.

Through the juxtaposition of differing visual and narrative modes, Wenders highlights the conflicting possibilities of film as a representational medium. In terms of the Deleuzian dichotomy discussed in Chapter 2, Tom Tom and Eloise exist in a world of the time-image. The visual mode of their representation highlights the ways in which film can reveal the open-ended nature of duration rather than allowing itself to be subjected to the constraints of the movement-image and its inexorable drive towards narrative resolution. This is what John E. Davidson describes in his analysis of the film – recalling Kracauer – as Wenders' characters'

ability to avoid 'rushing through places that ought to be dwelt in' (Davidson 2004: 91). The capacity that Tom Tom and Eloise have to 'dwell' rather than 'rush' is then further emphasised in the ways in which the camera presents them as both within but also separate from the rest of their environment, the hotel's labyrinthine structure providing a refuge that protects them from the events which bombard the hotel from outside. They are repeatedly shot in one of a number of rooms, set against a window that shows them to be high up in the hotel, cut off from the world on the ground, the camera focusing tightly on their bodies, locked together, on an interchangeable hotel bed.

Ironically, neither Skinner's decidedly 'hard boiled' detective narrative, nor the Channel Six News, for all their obsession with the quest for a story, ultimately find out what actually happened to Izzy. Instead, the closest one comes to a sense of narrative closure in the film, to the fulfilment of the movement-image logic that dominates these sections of the movie aesthetically, comes at the moment of Tom Tom's suicide, during which the film offers one of its most explicit evocations of the time-image's celebration of duration. In both its presentation at the beginning and end of the film, Tom Tom's suicide scene opens with a lingering panoramic sequence highlighting the majestic splendour of the LA cityscape at dusk. This then cuts to Tom Tom walking to one edge of the roof. He pauses, turns and runs the length of the hotel, shot in slow motion and – in its first presentation – shown several times from a variety of angles in the signature style of the Tom Tom/Eloise thread in the film. He smiles at someone off camera (whom we learn in the scene's reprise is Eloise), before finally leaping off into the skyline. The suicide scene suggests how a screen can be used to present a very different type of reality than that to be found in the film's other modes of representation. Moreover, it also extends the frame of reference of this aesthetic strand beyond the story of Tom Tom and Eloise to point to the broader affective potential of the world outside the hotel. This is a vision of America that we would never see on television, or in more mainstream Hollywood fare. Nonetheless, it is a world that shares their geography, which also exists, and which Tom Tom embraces as a liberation both from his guilt for Izzy's death and from the TV frenzy he has experienced inside.

Wenders thus reinforces a straightforward hierarchy between

41 The LA cityscape at dusk from the roof of the hotel, *The Million Dollar Hotel* (2000).

European 'high art', as reflected in the cinema of the time-image – as well as in the decidedly modernist take on Rock 'n' Roll conveyed in the film's soundtrack, the result of a collaboration between the Irish band U2 and that most avant-garde of producers Brian Eno – and the corrupt world of contemporary globalised US popular culture. This would also seem to be suggested in the spacial construction of the LA vista we see at the beginning and end of the film. Tom Tom and Eloise belong to the 'old world' of the hotel, which is dwarfed by the 'new world' of corporate America's skyscrapers that surround it. Yet this value dichotomy is ultimately rejected. In the suicide sequence which bookends the main narrative, it is the beauty rather than size or, most importantly, the function of these skyscrapers that is emphasised. The architecture of globalisation is evacuated of its content and the spectator is allowed to indulge in the aesthetic beauty of its surface. All narrative remains inside the hotel. Tellingly, it is at this point too that Tom Tom considers life to be 'perfect' as he becomes one with the vista. He leaps to his death and, as the credits roll, we are left with a final echo of his life, a moment of perfect sensuous intimacy which similarly foregrounds the surface of the image rather than its narrative backstory. The image of the two lovers caressing is so shadowy as to be almost unrecognisable, giving it a haptic rather than straightforwardly visual quality, having been stripped back to a series of pixels that reveal its affective core. All we are left with is the emotion that exudes from the motion of these shadows, now seemingly stretched out forever in super slow motion.[10]

Celebrating Hollywood as an international brand

The films of Wenders and other figures from the New German Cinema continue to highlight the ambivalence many of these artists feel towards Hollywood. However, this is not the only position evident amongst the 1960s' generation of filmmakers. Wolfgang Petersen, for example, also used international success, in his case with the submarine drama *Das Boot* (The Boat, 1981), to make the move to America. But unlike Wenders or Schlöndorff, Petersen both embraced and was embraced by the Hollywood system and its entertainment ethos. Petersen has thrived in this environment, making films with ever-bigger budgets, the likes of which his European colleagues could only dream of, from *In the Line of Fire* (1993, estimated budget $40 million), and *Air Force One* (1997, estimated budget $85 million) to *The Perfect Storm* (2000, estimated budget $120 million) and *Poseidon* (2006, estimated budget $150 million). And he is not alone. The 1990s also saw the entrance of the younger Roland Emmerich onto the Hollywood A-list, achieving his breakthrough with the blockbuster *Independence Day* (1996, estimated budget $70 million). This has been followed up with a string of hits, including *The Patriot* (2000), *The Day After Tomorrow* (2004), *10,000 BC* (2008) and *2012* (2009), films that latterly also command large, Spielberg-sized funding. The budget for *2012*, for example is estimated at $200 million.

In the 2000s, among the younger generation of filmmakers who enjoyed particular success both at home and abroad, Tom Tykwer is the best known to have made the move to Hollywood. Initially it seemed that Tykwer's relationship with the US industry might go the way of Wenders'. Peter Biskind describes Tykwer's initial encounter with the bullying tactics of Harvey Weinstein's Miramax as it attempted to buy the US rights to *Lola rennt*, an encounter that ended in a screaming match between the company's boss and the filmmaker (Biskind 2004: 359). Indeed, it might have appeared to some that Tykwer had simply not learnt his lesson about the nature of the industry on the other side of the Atlantic when he subsequently agreed to work with the company on the production of *Heaven* (2002). After offering Tykwer the job of filming a screenplay written by the Polish *auteur* Krzysztof Kieślowski, Weinstein asserted far more artistic control than Tykwer was used to, casting the lead, choosing locations and bringing in Anthony Minghella

and Sydney Pollack to keep an eye on the finances during this, Tykwer's first big-budget international movie.[11] Nonetheless, the filmmaker insists that the experience of working with Miramax was ultimately very good: 'After the first impression of [Weinstein] that was kind of horrifying, during that production I was completely free to do the movie I wanted to do, including even final cut. And it is exactly the movie I was hoping for' (quoted in Biskind 2004: 462). Since *Heaven*, Tykwer has continued to make films that have at least one foot in the Hollywood industry, most recently his German-British-US co-production *The International* which, with a budget of $50 million, is still smaller than those commanded by the likes of Emmerich and Petersen, but nonetheless is within the range of mainstream Hollywood productions. That said, it only made around $60 million on its theatrical release. To this can be added revenues from DVD, television and other outlets to come. Nonetheless, the cinema box office does not suggest that the film will necessarily amortise the costs of not only producing but also marketing and exhibiting the film. Consequently, it remains an open question as to whether Tykwer will be given further opportunities to make big-budget movies.

Tykwer, Petersen and Emmerich all engage with Hollywood in a far less critical fashion than the likes of Wenders or Schlöndorff. All three play to and exploit in different ways Hollywood as the quintessential brand of international filmmaking. Indeed, neither Petersen nor Emmerich actually see themselves in any way as German filmmakers. When asked what it is like to be a German filmmaker in Hollywood, Emmerich immediately refutes the question: 'I wouldn't see Wolfgang Petersen or me or Bernd Eichinger as Germans. The Americans have always known that there are people all over the world who produce films, and they've always seen it as an international field' (Blum 2001: 73). Emmerich, instead, views himself as part of a global phenomenon that transcends the barriers of national specificity. And, to a degree, this is reflected in the numerous blockbusters he has made. As Christine Haase puts it, Emmerich's movies 'are largely articulated in the transnationally intelligible cinematic language of high-concept Hollywood movies, so as not to demand too much of spectators by including references too complex and nation-specific to be readily globally decipherable' (Haase 2007: 128–9). Consequently, while such films might be 'transnationally intelligible', they are straightforwardly

'universal' in their outlook, seemingly divorced from any notion of an identifiable 'transnational' encounter such as those discussed in Chapter 4. If some New German Cinema filmmakers were intent upon exploring the 'Yanks' colonisation of the German subconscious, Emmerich and Petersen see Hollywood, rather, as the natural home of entertainment cinema, providing a universally understandable language in which they are both extraordinarily well versed. Moreover, as they are both also at pains to point out in interviews, their experience of working within the tighter budgets available to European filmmakers domestically has helped make them particularly attractive to Hollywood majors worried about expensive star directors overspending and thus eroding profits. Emmerich, in particular, earned his spurs as a director in the US by creating high-concept spectacular narratives on what was, in Hollywood terms at least, a very limited budget (Blum 2001: 74). Although he now commands far larger funding, he nonetheless continues to pride himself on offering value for money, while nonetheless providing the spectator with a contemporary form of the 'Cinema of Attractions' that makes great use of the potential for digital technology to create a spectacle on the screen, allowing him to blow up the White House (*Independence Day*), to float a Russian cargo ship along the flooded streets of New York (*The Day After Tomorrow*, 2004) or to have his hero attacked by a woolly mammoth (*10,000 BC*).

The films of Emmerich and Petersen have been very successful around the world. Yet how far does their representational universe self-consciously 'transcend' national boundaries and what is their specific relationship to the American domestic context? Is it mere coincidence, for example, that the two filmmakers went head to head in the battle for ticket sales on 4 July 2000 when Petersen released *The Perfect Storm* and Emmerich *The Patriot*, in Emmerich's case repeating the tactic of his 1996 hit *Independence Day*? A more specifically *American* release date is surely not possible. And then, of course, there are the obviously nationalistic connotations of his choice of titles. That said, in most of his films, there is little engagement with the nature of life in a 'real' America. Instead the US works almost like another international 'star' within the film, heightening the power of a universally understandable spectacle. With regard to *Independence Day*, for example, in a pre-9/11 world, it was breathtaking to see such a realistic portrayal of the White

House being blown up. This is one of a few globally recognisable buildings and this might well justify its inclusion in his film, allowing the spectator to enjoy the macabre spectacle of this apparently indestructible icon's destruction. However, the choice of film to be released on 4 July 2000, *The Patriot* – which like Wender's film coincidentally also starred Mel Gibson – surely troubles such a non-nationalist view of Emmerich's oeuvre?

The film tells the story of Benjamin Martin (Gibson) who is compelled to join the South Carolina Militia during the American War of Independence, after one of his sons is murdered by a cold-blooded British Dragoon commander, Colonel Tavington (Jason Isaacs). Initially Martin is vociferously against military conflict, due to his experiences during the French-Indian War. Through his encounter with Tavington he learns to embrace violence again for noble ends, in this case the protection of the rest of his family and the liberation of his country from British oppression, thereby putting in place the foundation stone for the democratic, multicultural society that, the film suggests, is to come. This is implied symbolically in its closing moments, when Martin returns with his family to his pre-war farm. We see the family home being rebuilt by the multiethnic troop he has led through the war, the freed slave and the former bigot who has learnt to respect the black soldier now coming together in a gesture that points towards the potential for a future of multicultural harmony, while also setting the seal on the established class structure, the former soldiers re-establishing Martin's position as the property-owning master of the land.

The Patriot is slightly anomalous in Emmerich's oeuvre in that it is one of the few films for which he did not at least partially write the screen play. The moral universe the film presents, however, is typical. Be it a world under attack from foreign invaders (*Independence Day*), or one man's heroic struggle to free his prehistoric tribe from slavery (*10,000 BC*), Emmerich provides a superficially politically correct world where the values of tolerant multiculturalism triumph in the face of oppression, while at the same time confirming the dominant status of the heterosexual white male, conservative in outlook, and the value of violence to defend a righteous cause. Consequently, although the films might not engage with the specificities of American life, they do conform to a worldview that is typical of much mainstream Hollywood production, from Frank Capra to James Cameron, and their idealised

presentation of American values. In *The Patriot*, the implicit link to the idealised American context of much of Emmerich's other work is made explicit. He seems to revel in the film's national specificity, as is made clear in the featurette that accompanied its DVD release where he explains how his whole team worked with relish to produce an authentic image of the American Revolution.[12] Indeed, counter to the filmmaker's own universalist claims, and echoing comments by a number of critics, Emmerich, along with Petersen, often produces films that, within a US context, are 'unusually patriotic, more so than one might expect from most American directors' (Krämer 2008: 248).

That said, while Emmerich denies that it is his intention to make specifically *American* films, neither he nor Petersen refutes the claim that that they wish to tell *patriotic* stories (Blum 2001: 78). Here one detects the sense that it was perhaps not only the bigger budgets that attracted Emmerich and Petersen to Hollywood, but also the ability to tell stories in a way that is not available to filmmakers in Germany. This is thrown into relief if *The Patriot* is read along side Green and Chomsky's television mini-series *Holocaust* (1978) which, somewhat surprisingly perhaps, it seems to echo at various moments throughout its narrative. *Holocaust* is recalled most clearly in the sequence where Tavington orders the colonial inhabitants of a village to be locked inside a church and the church set on fire. This is very reminiscent of a similar sequence in Green and Chomsky's series where Jewish victims are burnt alive inside a synagogue, the image of a burning Star of David from the synagogue subsequently forming the backdrop to the opening credits of each episode of the mini-series. Within the narrative other similarities also appear. *Holocaust* tells the story of a respectable Jewish family in Berlin. As the Nazis take over, Josef, the father (Fritz Weaver), refuses to act decisively to save himself and the rest of his family, believing that the situation will improve, until it is too late. Similarly, Martin initially will not fight back, wishing instead to plead with the British for fair representation, long after the majority of his countrymen have given up all hope of a peaceful resolution to the conflict. However, Martin's attitude changes with the entrance of *The Patriot*'s version of the Nazis, the British Dragoons led by the evil Tavington, who, like many of his Nazi equivalents in *Holocaust*, is shown to be a nouveau riche thug with no 'breeding'. Martin's son is unjustly killed, and as a consequence this American father

42 Emmerich recalls *Holocaust* (1978), in his depiction of a congregation locked inside a burning church, *The Patriot* (2000).

decides he must take up arms to protect the rest of his family. At this point the plots of the two narratives diverge. While the Jewish victims in *Holocaust* largely accept their fate, in *The Patriot* the American victims fight back, a battle that finally ends, as we have seen, with the promise of a multicultural future for the nation in which black and white unite in the service of capital.

From the other films discussed in this volume, it is clear that this is a very different type of movie to those produced within the German domestic industry. As we have also seen, there has been a great deal of discussion in recent years about the representation of Germans as victims within historical films that explore events such as the bombing of Dresden or the mass rape of German women by the Red Army. While such films at times follow narrative patterns familiar from Hollywood, they must invariably qualify the status of Germans as victims by reminding the spectator of the nation's culpability for the Holocaust and the Second World War. Moreover, such qualification notwithstanding, these films are also invariably received with a good deal of opprobrium. In the US, Emmerich can present his story with no need for the type of more nuanced engagement with historical debates required within a German context. Instead, a story can be told in which good and evil are unproblematically differentiated and where the Americans can be constructed straightforwardly as victims. Elements that recall the *Holocaust* mini-series can be marshalled to increase the emotional engagement of the spectator and re-written to provide an even happier ending than that conceived of by Green and Chomsky.

43 Traces of the mountain film in Petersen's depiction of the sea, *The Perfect Storm* (2000).

In *The Patriot* one potentially finds a reference to a German context, albeit one mediated through a US version of events, the echoes of *Holocaust* heightening the power of the melodrama. Aesthetically, however, there is very little that appears to be specifically 'German' – however that might be defined – in Emmerich's films, even in his early German productions. This is a filmmaker, it seems, who always saw himself as destined for Hollywood. In Petersen's work, on the other hand, Haase identifies a degree of irony in his engagement with Hollywood conventions which, she suggests, can be seen as an oblique legacy of the New German Cinema. She cites his portrayal of a US President (Harrison Ford) who overcomes hijackers to save himself and his family in *Air Force One*. This she reads as overcoded, too drenched in Hollywood clichés to be taken at face value (Haase 2007: 91–4). Might one identify here the faintest legacy of a Fassbinder-type reworking of dominant Hollywood codes, such as we see in his engagement with Sirkian melodrama? In terms of aesthetics, one might also mention *The Perfect Storm*, the film that went up against *The Patriot* at box offices in 2000 and its story of a fishing boat caught up in a torrential hurricane. Curiously, given its setting, at times this film seems to recall visually that most German of film genres, the mountain film, in its CGI construction of gargantuan tidal waves that buffet the ship, along with its representation of the crew battling the elements in their vain attempt to find their way home. Nonetheless, as with Emmerich, if there are echoes of a German tradition in Petersen's work, their overall effect is simply to add flavour to

films that are fundamentally Hollywood presentations of a spectacle that will be attractive, their creators hope, to audiences the world over.

By contrast Tykwer's films balance their engagement with the spectacular world of the Hollywood event movie with elements that seek to preserve his credentials as a European *auteur*. In so doing, his work at times seems to have more in common with Wenders than Emmerich, gesturing towards the kind of critique of global capitalism's media culture one sees in *The Million Dollar Hotel*. Ultimately, however, in Tykwer, a passionate lifelong cinephile, there is far less cynicism than is to be found in Wenders. While, as Ian Garwood suggests, Wenders is fundamentally sceptical of the contemporary visual media industry, ever since *Lola rennt*, Tykwer has exploited the visual iconography of this world (Garwood 2002: 207–8). At the same time, he also attempts to infuse it with a European sensibility which, unlike Wenders, is intent upon enhancing rather than critiquing its central values.

According to Godard's disparaging critique of classical Hollywood films, 'all you need to make a movie is a girl and a gun'. Tykwer turns this into a virtue and indeed, with *Lola rennt*, suggested that in post-unification Germany, all you needed was 'a girl', his film being built around the image of Lola racing through the streets of Berlin. More recently, in *The International* (2009), a global conspiracy thriller set in a corrupt world of international banking and high finance, he completes the equation, revelling now in the image of the gun and the mechanics of assassination, all framed against the spectacular glass and steel architecture of corporate capitalism. The film was a commercial flop and received mixed reviews. However, its subject matter was seen to be extraordinarily prescient given the banking crisis much of the world had just gone through. An Interpol agent (Clive Owen) and US District Attorney (Naomi Watts) attempt to uncover the corruption at the heart of an international merchant bank, an investigation that sees them zip around Europe and across the Atlantic, from Berlin and Luxembourg to New York, the pair gradually coming to understand the depth and spread of corruption and, most importantly, the unwillingness of the world's 'legitimate' governments to allow this corruption to be exposed for fear the bank might collapse – an event they could never allow. Clearly, as can be seen even more explicitly from his contribution to the omnibus film *Deutschland*

09 (2009), *Feierlich reist* (Feierlich Travels), Tykwer is as cynical as Wenders about the forces of global capitalism. However, this cynicism has far less impact upon his approach to US popular culture.

As Dietmar Kammerer notes, unlike the ephemeral, decidedly postmodern, concepts of 'credit-default swaps', 'toxic assets' and 'subprime loans' that fuelled the real near collapse of the banking system, Tykwer's film is rooted in the seemingly far more concrete and now somewhat old-fashioned sounding world of arms deals, power politics and third world coups (Kammerer 2009). Indeed, although ostensibly reflecting present-day fears of globalisation, the narrative has a decidedly Cold War feel to it, emphasised in its inclusion of an ex-Stasi officer spy master, played by the German veteran actor Armin Mueller-Stahl, who enforces the bank's will as once he did the will of the East German Communist Party, the ease with which he has slipped from one role to another suggesting the corrupt equivalence of Eastern Bloc communism and Western capitalism. The retro-feel to the narrative is also reflected in the film's aesthetic, which recalls Alan J. Pakula's 1970s 'Paranoia Trilogy' *Klute* (1971), *The Parallax View* (1974) and *All the President's Men* (1976). In a similar fashion to these and other movies produced during the 'New Hollywood' period of the 1960s and 1970s by the likes of Coppola, Scorsese and De Palma, filmmakers strongly influenced by the French and other European New Waves, Tykwer's film has a decidedly European tone, also noted in Suchsland's review discussed in Chapter 2 (Suchsland 2009b), its grainy film stock seeming further to underline the illusion that it is a film from an earlier period.[13] This is not the first film in the 2000s to look to the 1970s for its inspiration. The same grainy quality that gestures towards the European-inspired aesthetic of the 1970s can also be found in the *Bourne* trilogy (*The Bourne Identity*, Doug Liman, 2002; *The Bourne Supremacy*, Paul Greengrass, 2004; *The Bourne Ultimatum*, 2007), as well as the decade's reinterpretation of the Bond franchise (*Casino Royale*, Martin Campbell, 2006; *Quantum of Solace*, Marc Forster, 2008). However, *The International* has a much slower pace than these other films, their frenetic editing replaced here with an aesthetic that focuses to a far greater extent upon the actors' performances. Indeed, as Lars-Olav Beier suggests, the film seems deliberately to 'fight against the Bournification' of recent action cinema (Beier 2009). In doing so, it at times also resonates with the aesthetic landscape of Wenders' work. Like *The Million*

Dollar Hotel, Tykwer's camera enjoys the visual splendour of the skyscrapers which fill the wide shots of the cities that punctuate his protagonists' journey between Europe and the US. Moreover, to return to Gemünden's analysis of Wenders' generation, Tykwer, too, seems to celebrate the 'surface of things'. In a similar fashion to many of his previous films, most noticeable in the opulence of his tableaux in *Heaven* or his adaptation of Patrick Süskind's bestselling novel *Das Parfüm – Die Geschichte eines Mörders* (Perfume – The Story of a Murderer, 2006), Tykwer's camera frames the world with geometric precision, transfiguring its 'natural' beauty into a self-consciously aesthetic phenomenon.

In *The International*, Tykwer's celebration of the surface extends to his engagement with plot. For Rodek, the film is 'an (almost) perfect genre movie' (Rodek 2009a). The 'almost' here is telling, however, opening up a space that gestures towards the type of US media industry critique found in Wenders. While its main plotline follows the classic pattern of a conspiracy theory/police procedural, as the forces of evil, on the one hand, and law and order, on the other, negotiate their way through the narrative, we are offered no romantic subplot between Watts and Owen. Thus, the film challenges the genre's gender-role expectations. This leads at times to a rather stilted performance between the couple, the film's refusal to develop the stereotypical role for 'the girl' in its exclusive focus on 'the gun' resulting in a number of deliberately awkward moments between them that seem to point to the film's own generic omissions. Nonetheless, any potential critique of the mainstream thriller as a cultural form, and with it the dominant place of US-driven popular culture is at best only hinted at. Overwhelmingly, one senses Tykwer's wish to offer a pastiche, rather than subversive critique, of Hollywood genre cinema. This is suggested most clearly in the film's set pieces, such as the extended, highly stylised sequence in which the hands of an assassin carefully construct and practise shooting a rifle, or in the much-discussed spectacular moment during which a CGI-created image of the Guggenheim Museum is destroyed in a hail of bullets. Here Tykwer revisits the celebration of popular cultural images that dominate *Lola rennt*, the Guggenheim sequence enacting 'in reality' the kind of scenario one finds in contemporary 'first person shooter' video games, just as *Lola rennt* could be read as the performance of a computer-based adventure game. As in the work of Emmerich or

44 The assassin's hands construct and load his rifle, *The International* (2009).

Petersen, elements of Tykwer's German background can be iden-
tified in the film, here somewhat less obliquely than in the work
of these other filmmakers. Tykwer explicitly evokes the legacy of
the East German secret police in his inclusion of the Mueller-Stahl
character. Also, much of the film is set in Berlin. However, again
as one sees in the work of other German Hollywood directors, this
German element is largely present in order to give a dimension to
this straightforward genre piece not generally seen in such films.
Tykwer was keen to exploit his insider knowledge of Berlin as a city
that has enjoyed an architectural boom since unification, funded
by global corporations, but which is largely unknown to much of
the outside world (Billington 2009). Consequently, the city allowed
him to present a universally recognisable world from a different
perspective. That said, the Berlin setting can also be viewed simply
as a pragmatic financial decision on behalf of the director rather
than as being due to any intrinsic requirement of the plot. A good
part of the film's funding came from the DFFF, a German funding
pot which, as discussed in Chapter 1, ties production to a 'local
spend'.

Transnational America and newer filmmakers

If the work of Tykwer, Emmerich and Petersen highlights the ways
in which German filmmakers engage with Hollywood as a univer-
sally understood film brand, elsewhere America is constructed
in a manner more reminiscent of the kinds of transnational

encounters discussed in Chapter 4, that is, as a specifically locatable, real place, populated by real people. This is the America, for example, of Percy Adlon (*Bagdad Café*, 1987; *Salmonberries*, 1991) and Monika Treut (*Die Jungfrauenmaschine*/The Virgin Machine, 1988; *My Father Is Coming*, 1991), artists who began to achieve critical acclaim in the 1980s. Here America is constructed as a hugely diverse space of possibility where, through an exploration of life on the periphery of the type of metropolitan society often depicted in Hollywood blockbusters, these films' German protagonists come to a better understanding of their sense of self, be that in terms of their gender, sexuality or national identity.[14] In the work of those filmmakers who began to gain an audience in the new millennium, America often similarly functions as an imagined space configured in transnational, rather than international terms. At times, as was the case for Wenders' generation, it offers a space for political critique. However, for the younger generation, the target of attack is frequently not the sensibilities of those who grew up under National Socialism, but of the 68ers themselves. In Oliver Rihs' *Brombeerchen* (Blackberry, 2002), for example, the 60s-inspired anti-American stance of the young, would-be radical Andre (Robert Stadlober), who is squatting in the Spanish villa of an American businessman, is presented as just plain silly. The American owner is shown to be not the greedy capitalist the boy assumes he will be, but the victim of a financial downturn. Indeed, the spectator cannot help but feel for the man who, rather touchingly, fears losing his wife's love if he can no longer provide for her. Or the promise of America is held up to be an impossible dream for the population of present-day Germany, particularly for those former GDR citizens suffering economic hardship as they come to terms with life under a capitalist system that produces pressures they never imagined when their consumption of Western culture was filtered through their pre-unification television screens. One thinks, for example, of the failed American car dealership deep in the eastern German provinces in Vanessa Jopp's *Vergiss Amerika* (Forget America, 2000), or the ridiculous incongruity of the obsession of Marcel (Milan Peschel) with a GDR version of US country and western music and his experience of life in post-unification Berlin in Robert Thalheim's *Netto* (2005). In both films, American culture highlights the frustration of the ex-GDR population whose pre-unification hopes and expectations for a better life, symbolised

in their love of American popular culture, have never been met. While such films might seem to offer continued evidence of a US colonisation of the German social psyche, ultimately this is not their point. Instead, American culture becomes a symbol of the continuing economic and cultural inequalities facing the population in the east. Particularly noticeable is the far more relaxed, self-confident engagement with US culture such films at times also suggest, for all their exploration of contemporary social frustrations, a further reflection of the much vaunted 'normalisation' that the Schröder government hoped would come to characterise the Berlin Republic of the 1990s and beyond.

A good example of such cinematic normalisation is Michael Schorr's surprise 2004 debut hit, *Schultze Gets the Blues*, the story of its eponymous accordion-playing hero's journey of musical discovery from the potash mines of Saxony to the Bayou of Louisiana. A life-long fan of the polka, which, like his father before him, he plays as a member of his local music society, one night Schultze discovers and becomes obsessed with the zydeco music of Louisiana, a discovery that initially sends him to the doctor in the belief that he must be sick, so disorienting are the feelings evoked by this unfamiliar musical form. Most of the rest of Schultze's village refuses to accept his new passion, the young in particular dismissing the zydeco tune he plays repeatedly as 'Scheiss Negermusik' (shitty nigger music). Depressed by his treatment, Schultze tries to save enough money to visit Louisiana, only to be thwarted by price hikes in the wake of the introduction of the euro in 2002. However, his friends in the music society club together to send him as their representative to a 'Wurstfest' in their twin town of New Braunfels, Texas. From this sausage and music festival, which is more 'German' than anything Schultze has ever experienced at home, he finds a boat and travels down the Bayou, where he discovers the source of his new music, inner peace and ultimately death.

On the face of it, the film seems to offer a continuation of the type of 68er 'colonisation' narrative expressed in Wenders' films, or, as we shall see, perhaps more obviously in Herzog, updated to reflect the use of American culture to critique the state of post-unification Germany from an east German perspective. Schultze and his friends are victims of the post-unification deindustrialisation of the east. Teutschenthal is a town located in the shadow

45 Jürgen (Harald Warmbrunn) and Manfred (Karl-Fred Müller) contemplate their friend's life in America, *Schultze Gets the Blues* (2003).

of a potash mine that is living on borrowed time. Dust from the mine's imposing slag heap blows over Schultze's allotment garden, forcing him regularly to clean the gnomes with which he fills his rather pitiful attempt to create a rural idyll. Meanwhile, as we have seen, elsewhere in the town a younger generation with no future greets Schultze's attempt to play something new with racist indignation, while a disregarded petit-bourgeois older generation waits out its remaining days on society's scrapheap, engaging in pointless squabbles about such life and death issues as when one should be allowed to mow the lawn. Schultze travels to America, where his friends assume he will discover the gold-paved streets of the American dream and thereby escape his east German life of drudgery. He sends pictures back to Teutschenthal where we see his former colleagues drinking in their regular bar, the Stars and Stripes behind them on the wall: 'He'll be in a recording studio now,' Manfred suggests, to which his friend Jürgen replies, 'He'll become a millionaire and won't speak to us any more.' However cynical they might be of the results, Manfred and Jürgen assume that Schultze will experience a rags-to-riches transformation in the US. But the spectator already knows that there is, in fact, very little that is actually different about America. Schultze meets similar people in New Braunfels to those he knows from Teutschenthal.

The shots of the men playing Skat in his local bar are reprised in a series of similar shots of bars in New Braunfels, an equally post-industrial wasteland that now makes a living from its annual hyper-real version of a German *Volksfest*.

It would seem that New Braunfels is to be Schorr's version of Railroad Flats from Herzog's *Stroszek* (1978), the story of another German misfit's journey to the States, which in this case ends in his failure to achieve a non-existent American dream. However, unlike the eponymous hero of Herzog's film, Schultze is offered a way out of the mirror image of Germany with which he is confronted, his geographical journey working alongside an increasingly surreal journey of musical discovery. This musical journey first begins in Teutschenthal. Jürgen and Manfred have a row over a chess match, one of their regular retirement activities. They storm off, and Schultze is left alone in the frame, confirming the emptiness of his life. The film then cuts to a long take of Schultze's slag heap. However, the dusty monstrosity to which the spectator has been previously introduced has now been transfigured by the night sky into a beautiful landscape, reminiscent of the type of bucolic vista one might find in a 1950s' Heimat film. The physical transformation of the east German landscape then sets the scene for Schultze's existential transformation. We are taken into the man's home, where we find him unable to sleep, his daytime troubles having caught up with him. Until this point, Schultze has generally been filmed in mid-shot in his house, the point of view that is duly appropriated by the spectator being sourced to the other side of a door frame looking into the man's living room from outside. Now Schultze comes into the spectator's room and we are given a close up of his face as he hears a zydeco tune playing on the radio. The daily grind of the man's life gives way to a moment of the sublime, the physical landscape working in harmony with the film's diegetic soundtrack to highlight the epiphanic nature of his discovery. This is further highlighted by the way in which, through this discovery, Schultze seems to come closer to the spectator and into sharper relief. The sense of increasing proximity between our hero and the spectator then continues as we journey to America and Schultze takes his boat to Louisiana. Now the image of the sublime slag heap is replaced by a similarly lingering shot of the Bayou, placing the spectator in the wheel house of Schultze's boat as he nears his journey's end, ultimately finding the source of his zydeco tune in the

46 Schultze's (Horst Krause) moment of epiphany, *Schultze Gets the Blues* (2003).

'Rock 'n' Bowl' dance hall, to which he is taken by a local African-American family he has befriended. The transcendent moment he experienced in his German home town is reprised and intensified in Louisiana. It would seem that Schultze has found his true home in the Bayou, a home that allows him to embrace the multicultural potential of the music he discovers along the way, be it Cajun, American-Czech or zydeco. And, in a self-conscious visual echo of Bergman's *Det sjunde inseglet* (Seventh Seal, 1957), having reached the music's source, he is allowed to die in peace, having his new multicultural idyll posthumously transported back to Teutschenthal as the main participants in the narrative from both sides of the Atlantic come together at his funeral to the sound of his old music society playing his favourite zydeco tune.

In this reading, the film alternates between the poles of critique and emulation set by the work of Wenders and Emmerich respectively. On the one hand, the film seems to critique the possibilities of the American Dream in Schultze's encounter with the people he meets in the United States, thereby appearing to recall some of the work of the New German Cinema, reconfigured, as we see in films such as *Vergiss Amerika*, to reflect the contemporary dissatisfaction of an ex-GDR population confined to the post-unification scrapheap. On the other, Schultze finds the kind of multicultural idyll Emmerich presents, albeit in a far less glossy, more explicitly

transnational fashion than one sees in *The Patriot*. However, both these possible interpretations are troubled by Horst Krause's presence in the film. Any story of political critique or personal fulfilment is challenged by his extraordinarily understated performance of Schultze as a man who ultimately just accepts life as it comes. Schultze's journey takes place in a version of America, and clearly this brings with it certain cultural expectations, as one can see from the critical commentary in this chapter. Yet in a sense this journey could take place anywhere. For this man, America is neither idealised 'other' nor oppressive coloniser. It is simply a space where he can express his sense of yearning and within which he can continue to develop. The hyper-real version of Germany he finds in the 'Wurstfest', where the trachten-wearing revellers can celebrate the German national anthem in a way that would be anathema in Europe, might offer him a more relaxed version of German national identity. However, Schultze is not interested in staying at the festival, not because he wishes to reject its values, as the West German students of the 1960s might have done, but because he is fundamentally not interested in it. Schultze's final journey through the Bayou swampland reminds us again of Herzog, in this case of his South American stories of megalomaniacal Europeans attempting to impose their will on nature. Yet, as Davidson notes, 'the aesthetic drive to difference that marked, say, *Aguirre, der Zorn Gottes* (Aguirre, The Wrath of God, 1972), is alternatively figured in *Schultze gets the Blues*: there is no positing of depth or mystery in the swamp forest; Schultze does not go native and is not more "other" than the others he meets; he certainly is not the Wrath of God' (Davidson 2007: 202). This is an image of German normalisation in action. It is the music, not the politics, that matters. Schultze has no axe to grind with his new environment. While the title of the film might, on one level, highlight a sense of dissatisfaction with his lot, it also expresses his quiet acceptance of it. Schultze just 'gets' it. Of course, the music that he finally finds is not 'the blues' at all, but zydeco. However, the blues to which the title of the film refers is less a musical form than a state of mind, an inner acceptance of the contradictory rhythms of the everyday world, be they life-affirming or mournful, rhythms that are equally present in all the popular folk traditions he encounters, from the polka to zydeco.

The United States, and its culture, continues to enjoy a special place in the imagination of German filmmakers, be it as a source

of creative inspiration, a crucial market to be cracked or as a place to work. With regard to the cultural representation of the US in Germany, at times this continues to reflect long-standing anxieties, often configured in hierarchical terms, where European 'high' culture is seen as a counterweight to the worryingly manipulative banality of American popular culture. Increasingly, however, we find this dichotomy troubled by some newer filmmakers who have a more relaxed relationship to US popular culture than the previous generation. In the work of a number of artists who came to the fore in the 2000s, at times a straightforward celebration of US cultural forms is offered, or a traditional image of the United States as an 'other' against which its protagonist must react is reconfigured to reflect inner German anxieties. All these competing tendencies are at work in Schorr's film. At the same time, through Horst Krause's performance, the very notion of America as 'other' to Germany is undermined, any antagonism between these two national cultures giving way to a sense of mutual respect. This is just one example of many of this tendency amongst younger filmmakers. It can also be found, for example, in Markus Goller's *Friendship!* (2010), a road movie set just after the Berlin Wall is opened, two young east German men travelling across America to see the Golden Gate Bridge. Or one might mention several recent revisitations of West German appropriations of US cultural forms from the 1950s and 1960s. These include Michael 'Bully' Herbig's *Der Schuh des Manitu* (Manitou's Shoe, 2001), a parody of a series of films based on the German Westerns of Karl May, or Cyrill Boss and Philipp Stennert's *Jerry Cotton*, a comic reinterpretation of Delfried Kaufmann's fictional FBI agent who appeared in numerous novels and films during the 1960s.[15] Such films simultaneously satirise and celebrate the post-war generation's love affair with American culture, attacked by the 68ers in their rejection of 'Papas Kino'. Throughout these recent films German and American culture comfortably co-exist. The butt of the joke – always affectionately expressed – is invariably the Germans themselves, rather than any sense of anti-Americanism. And, as I shall discuss in more detail in my concluding chapter, the rediscovery, indeed rehabilitation, of certain motifs from the world of 'Papas Kino' suggests that the ease this new generation of filmmakers exhibits in its relationship with its American neighbours at times now also extends to its relationship with the nation's past.

Notes

1 For a good overview of Lubin's career see Eckhardt 1997.

2 Jennifer Fay's *Theaters of Occupation: Hollywood and the Reeducation of Postwar Germany* offers a fascinating account of cultural policy in the post-war US zone of occupation. Hollywood films were a key driver of this policy and its aim to educate the population in the ways of democracy. Particularly illuminating in her study is the discussion of how the US post-war occupation was evoked during the country's more recent occupation of Iraq. The parallels are indeed striking, not least the authorities' apparent failure to learn from the mistakes of the past and the fact that cultural artifacts created in one context do not necessarily transfer straightforwardly to another (Fay 2008: 184).

3 For a detailed account of the reception of the New German Cinema in the United States see Rentschler 1981.

4 See Chapter 1 of this volume.

5 For a good overview of the debates surrounding the screening of *Holocaust* in Germany see Bathrick 2005.

6 For a detailed comparative analysis of the competing ways America functioned as a mirror that reflected the critical concerns of the population on either side of the Cold War divide in the first two decades after the war see Poiger 2000.

7 The concept of 'World Cinema' is a fraught one, often used to describe films produced from beyond Hollywood and Europe, a definition that has been challenged in a number of ways, not least by those who share Goldberg's perspective, but also by those who identify neo-colonial tendencies in a definition of 'World Cinema' as synonymous with cinema from the global periphery. For further discussion of the concept see Nagib 2006; Cooke 2007.

8 It should be noted, of course, that America was not the only influence on the diverse field of filmmaking practice that made up the New German Cinema. Schlöndorff and von Trotta, for example, were initially drawn to French film, Hans-Jürgen Syberberg looked to France and Italy and numerous documentary makers at the time found their role models in the British documentary tradition (Elsaesser 1989).

9 That said, one can see Wenders attitude towards narrative soften over the course of his career, even if he remains highly cynical

towards its appropriation in mainsteam Hollywood. See Brady and Leal 2011.

10 For a discussion of the ways in which filmmakers have attempted to use a visual medium to capture the human senses beyond sight and sound see Laura U. Marks's study, and in particular her examination of 'haptic visuality' (Marks 2000: 127–93).

11 *Heaven* had a budget of $12 million, far more than the $1.75 million of *Lola rennt* or even the $6 million of his subsequent German feature *Der Krieger und die Kaiserin* (The Princess & the Warrior, 2000) (Tykwer, Kieslowski and Piesiewicz 2002: 105–12).

12 See 'The True Patriots Featurette', included on the 2006 Sony Pictures Home Entertainment DVD release of the film.

13 Interestingly, as Tykwer notes in interview, the original treatment of the story he received was, in fact, set in the 1970s (Billington 2009).

14 It might be noted that this is also a common trope in a number of US 'indie' films that enjoyed popularity around the same time, such as *Me and You and Everyone We Know* (Miranda July 2005), *Little Miss Sunshine* (Jonathan Dayton, Valerie Faris 2006) and *Juno* (Jason Reitman, 2007), along with the 'regional' cinema of figures such as Richard Linklater (*Slacker*, 1990; *Waking Life*, 2001). Increasingly, of course, the major studios are also funding the 'independent' film sector, seeing this as another business opportunity. Although limited, there is clearly a market for 'art house' films in the US. In earlier years this was a space that was often filled by the latest Fassbinder or Tarkovsky. The problem for non-English language filmmakers attempting to gain distribution today is that Hollywood has begun to corner this niche too, most of the major Hollywood studios now maintaining subsidiaries that release 'indie', niche pictures, from Fox Searchlight Pictures (owned by Twentieth Century Fox) to Paramount Classics. For further discussion see Biskind 2004; Cooke 2007.

15 For a detailed discussion of both these cycles of films see Bergfelder 2005: 171–235.

7 The Heimat film: reconfiguring 'Papas Kino'

Point of view shot: an aerial camera flying through the clouds towards what looks like a large mountain-top observatory, accompanied by a blues rock soundtrack. Cut to the inside of the building, where the camera pans across a series of iconic images of dead pop stars, from Elvis Presley and Otis Redding to Janis Joplin and Kurt Cobain. Cut to a clothing rack filled with rock-inspired costumes, behind which we glimpse a man swapping an 'Uncle Sam' topper for a black cowboy hat. Cut to an extreme close-up of the same man lighting a cigarette, fading down the music on a mixing desk and opening his mouth to speak. So begins Marcus H. Rosenmüller's surprise hit of 2006 *Wer früher stirbt ist länger tot* (Grave Decisions), an opening sequence awash with intertextual references that encapsulate many of the tensions present in the contemporary films discussed throughout this volume. The first shot from a camera descending onto the mountain recalls the famous opening of Leni Riefenstahl's *Triumph des Willens* (Triumph of the Will, 1935), and its depiction of Hitler's approach to the 1934 Nuremburg Rally (Ludewig 2011: 372). This echo of Germany's problematic cinematic legacy is then juxtaposed with the presentation of the inside of the building which, it transpires, is a radio station that has far more in common with George Lucas's classic nostalgia film, *American Graffiti* (1973). The man we see on the screen before us seems to recall that archetypal American DJ Wolfman Jack, who acts as mythical seer to the teenagers of Lucas's film. However, the echoes of Lucas' Americana are immediately shattered as Rosenmüller's DJ utters his first words in a thick Bavarian dialect. The camera pulls back to reveal a vista of the Bavarian Alps and sets off again on its airborne course, through the station window into

the clouds, before beginning its descent to the verdant countryside below. This shift of focus from American rock to Bavarian country-side in turn signals to the spectator the key generic affiliation of Rosenmüller's movie. This is to be a Heimat film, a genre most famous in its 1950s incarnation, when West German audi-ences flocked to cinemas to watch films such as Hans Deppe's *Grün ist die Heide* (The Heath Is Green, 1951) or Hans Wolff's *Am Brunnen vor dem Tore* (At the Spring Before the Gate, 1952). These were films that provided escapist, brightly coloured images of Germany and Austria as provincial rural idyll, where dirndl-clad women and lederhosen-wearing men fell in love to a soundtrack of German *Volksmusik*, providing a cinematic embodiment of ideal-ised German family values. As Elsaesser suggests, the Heimat film is 'Germany's only indigenous and historically most enduring genre' (Elsaesser 1989: 141). However, it has also, until recently, received scant critical attention. It is a genre that has had very little impact beyond the German-speaking world. Moreover, it reached its zenith during a decade that remains, in Johannes von Moltke's words, 'the quintessential "bad object" of West German film histo-riography' (von Moltke 2005: 21). And, as Anton Kaes notes, the Heimat film itself has generally received particular opprobrium, its 'cliché-ridden, Agfa-coloured images' being dismissed by its critics, most notably the 68er protest generation, as the worst form of 'Papas Kino', a cinema they viewed as both aesthetically and ideo-logically defunct (Kaes 1989: 15). Instead, in 'anti-Heimat' films such as Peter Fleischmann's *Jagdszenen aus Niederbayern* (Hunting Scenes from Lower Bavaria, 1969) or Schlöndorff's *Der plötzliche Reichtum der armen Leute von Kombach* (The Sudden Wealth of the Poor People of Kombach, 1971), the image of a timeless rural idyll that populated the 1950s cycle of Heimat films is replaced with a world of bigotry and violence. The seamless presentation of a time-less Heimat space that is central to these earlier films is fractured, often using a quasi-documentary mode to present a historically locatable province in all its raw filth.

Critical interest in the Heimat film, as well as German popular cinema more generally, has been growing since the late 1990s (Trimborn 1998; Halle and McCarthy 2003; Bergfelder 2005; von Moltke 2005; Davidson and Hake 2007). *Wer früher stirbt* has a complex relationship with the Heimat tradition. Nonetheless, its

success has led Rosenmüller to be styled by the German media as the 'Poster boy' of a new Heimat film movement, popular with critics and audiences alike (von Festenberg 2007). What is particularly noteworthy about Rosenmüller's work is its national appeal beyond the Bavarian province of its setting, selling 1.8 million tickets during its theatrical release across Germany (FFA 2010b). However, *Wer früher stirbt* is only the tip of a very large iceberg of films that have been linked in a variety of ways to the Heimat film tradition in recent years, some of which are now contributing to the growing international reputation of the nation's cinema. To see the diverse list of titles which have been defined as Heimat films as part of a unified corpus begs numerous questions, not least the definition of the word Heimat itself, a term that is notoriously difficult to translate into English. Loosely equivalent to the English 'home' or 'homeland', Heimat is an heterogeneous concept which, as Elizabeth Boa and Rachel Palferyman outline in their examination of the historical trajectory of the term, has been used to reflect a wide range of positions in discussions over the years around the role of place, belonging and identity in the German-speaking world (Boa and Palfreyman 2000: 1–29). Moreover, it is invariably emotion-laden, thus always escaping the words used to define it.[1] Coming into widespread use in the nineteenth century, as Germany began to negotiate the challenges of modernity and nationhood, in the literature and art of the time Heimat came to denote society's unindustrialised margins, the Bavarian Alps, the Black Forest, the Lüneburger Heath. It stood for tradition and family, for cultural roots that seemed to resist urban cosmopolitanism, foreignness and progress (Boa and Palfreyman 2000: 2). Heimat was a place beyond time, and certainly beyond critique. It was, as Peter Blickle puts it, 'a space free from irony', a utopia shrouded in nostalgia and thus also always elsewhere, always already lost, but nonetheless longed for, often framed as a return to the childhood home and in particular to the love of a mother (Blickle 2002: 40). That said, and in order to prove the impossible heterogeneity of the concept, when we come to the history of the Heimat film, it is clear that this is, at best, only a partial explanation of a term that is as much about negotiating and incorporating the process of modernity into tradition, of the national and ultimately the global within the local, as it is about protecting the inhabitants of the mythical Heimat from such forces. Rather than seeing Heimat, as it is presented in film,

simply as a refuge from modernity, and following von Moltke in his study of the genre, Heimat must be understood dialectically. Drawing on Freud's reading of the uncanny, von Moltke highlights the ways Heimat implicitly references, indeed is defined by and thus inextricably linked to, its 'others'. Consequently, the type of binaries described above (modernity versus tradition, the local versus the national and so on) should not ultimately be seen to be in opposition within the term, but rather 'mutually contingent on one another' (von Moltke 2005: 13).

In this concluding chapter, I wish to extend previous explorations of the genre by examining the competing ways the term circulates in contemporary German film culture. The explosion of interest in the genre highlights many of the wider cultural challenges and political uncertainties the county faces as it attempts to reconfigure its place in the world post-unification, from global warming to globalisation. Contemporary interest in Heimat motifs highlights particularly clearly the destabilisation of the population's sense of space/place these same concerns often provoke. How does the iconography of the Heimat genre that has built and developed over time, its affective language, or what Rick Altman terms the 'semantic' elements of a genre, currently play against its 'syntactic' elements, that is the ideas this language seeks to convey (Altman 1999: 216–226)? How does the interplay of syntax and semantics impact upon the aesthetics of contemporary German film as well as the stories and issues it seeks to present? Specifically, I am interested in the way much of this new wave of filmmaking engages the dialectical relationship between modernity and tradition discussed by von Moltke that has always existed within the term, the present moment in the genre's development pointing to a widespread recuperation of the Heimat province, such as we find in the 1950s cycle, in the face of the New German Cinema's critique of the following decades. Thus, I focus on how contemporary popular films in particular often reconfigure the genre's semantic iconography, at times evoking the critical tradition of the New German Cinema, only ultimately to find a way back to the far more affirmative syntactic world of the 1950s and the construction of the nation as a timeless, yet modern, idyll; negotiating the legacy of the New German Cinema to return to the mores of 'Papas Kino', updated for the twenty-first century Berlin Republic. At the same time, we also see a number of productions

self-consciously challenging this trend, be it Michael Haneke's multi-award-winning period drama *Das weiße Band – Eine deutsche Kindergeschichte* (The White Ribbon, 2009), or various, often small-scale, projects that focus on the real and perceived economic and social asymmetries between the eastern and western regions of the country, all of which reconfigure the genre's iconography into a syntactic landscape of anti-Heimat despair. Finally, and somewhat counter-intuitively, we find elements of the Heimat tradition – a tradition that has, for better or worse, always been linked to specific aspects of the German-speaking world as a physical space – engage contemporary issues of transnationalism and multiculturalism, offering new 'deterritorialised' versions of Heimat that seem to challenge its very foundational parameters, while at the same time continuing to highlight the resilience of both the term and the various types of films to which it has given rise.

Rehabilitating the Heimat film

From its roots in Peter Ostermayr's hugely successful cinematic adaptations of Ludwig Ganghofer's nineteenth-century Alpine Heimat novels (e.g., *Der Edelweißkönig*/The Edelweiss King, 1920, remade 1939 and 1957) and the mountain films of the 1920s and 1930s (Arnold Franck, *Die weiße Hölle vom Piz Palü*/The White Hell of Pitz Palu, 1929; Leni Riefenstahl, *Das blaue Licht*/The Blue Light, 1932), the rural landscape has been present as a 'semantic' space, to return to Altman's terminology, configured 'syntactically' to exist, seemingly paradoxically, both beyond and yet subject to the forces of modernity. This is reflected, for example, in the easy integration of the aspirational accoutrements of 1950s consumerism into the timeless, nostalgic kitsch of the all-singing, all-dancing provincial landscape found in Deppe and Wolff's films, where BP petrol pumps and motor cars can comfortably co-exist with horse-drawn carts and *Volksmusik* groups, tradition and modernity working comfortably together in a productive dialectic. Indeed, the very existence of these films reflects this same dialectic. The vividness of the rural idyll was, after all, only made possible by the use of the latest colour film technology, the films' very presentation of the rural seeming to advertise the potential of the modern.[2] Within the films themselves, the promise of progress within a fundamentally unchanging rural world is often reflected in the long

lingering shots of the countryside found throughout the genre. As Rentschler notes in his discussion of the mountain film, the images of billowing clouds set against the immutable mountains, caught using time-lapse photography, owe a great deal to the romantic iconography of Caspar David Friedrich and his depictions of the sublime power of nature beyond civilization, updated to take account of the visual innovations of Weimar Expressionism and most obviously the poetic realism of F.W. Murnau (Rentschler 1996: 32–8). Thus, these films highlight the ever-changing nature of the apparently permanent and with it the dialectical quality of the Heimat as a place that might be both a haven from, and yet also subject to, the progression of time and with it the concomitant processes of modernity.

Although losing some of its popularity in the wake of its 1950s West German heyday, the Heimat tradition continued to develop, incorporated variously into the nation's media landscape as a staple of television's light entertainment programming – a trend which culminated in 2002 in the creation of the digital *Heimatkanal* (Sandy 2008: 38–63) – or into a number of popular film genres, not least during the soft-core pornography boom of the 1970s in the form of the erotic *Lederhosenfilm*.[3] Titles such as *Liebesgrüße aus der Lederhose* (Love Greetings from his Lederhosen, 1973) and *Unterm Dirndl wird gejodelt* (How Sweet Is Her Valley, 1974) perhaps give a clear enough flavour of how this particular trend sought to commodify the Heimat film. At the same time, in the work of Fleischmann and Schlöndorff mentioned above, we also begin to find a more critical engagement with the tradition. In the anti-Heimat films of the New German Cinema, the notion of a timeless Heimat is directly challenged, forcing audiences to reflect upon the historical specificity of the provincial the traditional films attempted to elide. In particular, this generation attacked the ways in which the 1950s boom appeared to ignore how the Heimat tradition had been compromised by its incorporation into the Nazis' *Blut und Boden* (Blood and Soil) understanding of German identity, when films such as Carl Froelich's *Heimat* (1938) or Veit Harlan's *Die goldene Stadt* (The Golden City, 1942) supported an industrially based, exclusionary ideology and the need to create a visceral link between the land and Germanness. The 'Papas Kino' manifestation of the genre, seemingly intent upon drawing a line under the past and creating the illusion of an integrated West German

nation embracing an Allied-driven 'Economic Miracle', did little or nothing, its critics argued, to address the tradition's corruption.[4]

The new wave of Heimat films produced for the cinema since the turn of the millennium continues a more positive understanding of the tradition than that found in the New German Cinema. In doing so, they can be seen as part of a broader trend in the cultural production of Heimat that is particularly evident on the nation's television screens.[5] Yet unlike the types of shows broadcast on the *Heimatkanal* – be they *Volksmusik* shows, Heimat soaps such as *Die Schwarzwaldklinik* (The Black Forest Clinic, 1984–88), or re-runs of the 1950s films – rather than simply ignoring the place of anti-Heimat within the genre's history we find films that self-consciously attempt to recuperate the tradition in the face of anti-Heimat critique. This is evident in the work of Hans Steinbichler (*Hierankl*, 2003, *Winterreise*/Winter Journey, 2006), Thomas Kronthaler, (*Die Scheinheiligen*/The Hypocrites, 2001) and Rosenmüller as well as in the work of their North German colleagues Detlev Buck (*Liebes Luder*/Bundle of Joy, 2000) Sven Taddicken (*Emmas Glück*/Emma's Bliss, 2006) and many others. Rather than the ironic evocation of a rural province being used to challenge the very existence of Heimat values in the present, as it had been in the work of many 68ers, irony is often now used to reinvest Heimat with meaning for the contemporary spectator. Returning to Rosenmüller, for the most part he would seem to be working in a very traditional Heimat mould. His coming-of-age romantic comedies *Beste Zeit* (Good Times, 2007) and *Beste Gegend* (The Best of Regions, 2008), for example, engage straightforwardly with the tradition's celebration of the regional and the function of the rural world as a sanctuary, where its inhabitants can learn to negotiate the pressures of modernity. However, his first feature and to date his greatest commercial success, *Wer früher stirbt ist länger tot* (Grave Decisions, 2006), offers a more complex engagement with the Heimat tradition than the rest of his oeuvre.

Rosenmüller's film tells the story of 11-year-old Sebastian (Fritz Karl) who believes himself responsible for the death of his mother. Fearing the fires of purgatory, this young Catholic boy spends the duration of the narrative looking for a way to redeem himself of this 'crime', as well as other grievous sins, such as the accidental killing of his brother's rabbits, or spitting in the soup of a guest in his father's hostelry when he failed to give the boy a tip. Or if

salvation is impossible, he seeks a way to become immortal and so similarly to avoid the pains of the afterlife. *Wer früher stirbt* is a Heimat comedy. However, as can be seen from its opening described above, it engages with a network of allusions through which the film reflects upon its own generic status. Once we move beyond Riefenstahl and Lucas and are introduced to the world on the ground, the idyllic innocence of the Heimat vista is almost immediately challenged by the attitude of the drayman, Sepp (Johann Schuler), whom we see ogling the local primary school teacher, Veronika (Jule Ronstedt), from the inside of his truck. Sepp is a figure who could have appeared in a Heimat sex film, if it were thirty years earlier and he were thirty years younger. However, it is a role to which he clings throughout the film, as he explains to Sebastian how best to approach a woman ('nibble her earlobe and ask her "Do you want to screw me?"'). Our first encounter with Sebastian follows that of the drayman. Here the film shifts from the softest of porn into a children's film in the tradition of Gerhard Lamprecht's *Emil und die Detektive* (Emil and the Detectives, 1931) – a precocious boy drives his father to distraction, cycling his bicycle through the bar, only to be knocked down by the drayman's truck. The audience is stunned by this event, and the genre seems to shift again, as we are presented with an overhead shot of the motionless child, whom we assume to be dead, lying on the ground. The camera pauses for the first time and the title appears, one with all the cadence of a Fritz Lang film noir (the German translates literally as 'The Earlier You Die, the Longer You're Dead'). Fortunately the boy survives. 'That was lucky', says an off-screen voice, either the boy's or that of a spiritual guide. This could be his mother who, we will shortly learn, died bringing him into the world, an event for which he is, of course, blameless. Back in the hostelry the regulars are preparing a tradi-tional *Volkstück*, a morality play about the Day of Judgement. The play's nightly rehearsals invade Sebastian's sleep, attempting, in vain, to turn the film into a grotesque horror movie reminiscent, as Palfreyman notes, of the gothic Heimat film *Rosen blühen auf dem Heidegrab* (Hans Heinz König, Roses Bloom on the Grave in the Meadow, 1952) – a particularly dark film within the 1950s cycle – in its evocation of a spirit world returning to haunt the living (Palfer-yman 2010: 157–8). Finally, against this whirlwind of allusions to a range of cinematic fantasy worlds, Rosenmüller sets up a realist

47 Anti-Heimat 'reality' inside a Heimat fantasy, *Wer früher stirbt ist länger tot* (2006).

mise-en-scène that has more in common with anti-Heimat film than it does with the lurid world found in *Grün ist die Heide*. This is a real village, where we see the mud of the farmyards, the blood of slaughtered pigs, where we know that rabbits are food not pets, and even if Sebastian had not killed them by accident, they were destined to be eaten. It is a world where life is defined by death and where all the characters are acutely aware of their own mortality.

Despite its self-conscious allusion to the entire history of the Heimat genre, unified into a single cinematic moment, the kind of nostalgic innocence often to be found in the 1950s Heimat cycle dominates, communicated to the spectator through our identification with Sebastian. While the mise-en-scène evokes semantic elements of the anti-Heimat world, there is none of its cynicism. The fracturing of time and place, introduced through anti-Heimat's use of realism, is papered over. Life might be defined by dirt and death; but we also know that life will go on in this little upper-Bavarian community. The regulars at the village hostelry might eventually pass on, but the pub itself will remain forever. Consequently, the evocation of anti-Heimat merely allows the 1950s Heimat fantasy to be updated slightly and given more credibility. The rural idyll is challenged by Sebastian's attempt to redeem himself. He decides that he must find a new wife for his father and, apparently following his mother's signals from the spirit world, is led to the primary school teacher Veronika. Unfortunately she is already married to the DJ Alfred (Jürgen Tonkel). Despite this barrier, the romantic subplot of the film is eventually resolved with

Veronika and Sebastian's father falling in love. Yet this resolution is far from comfortable, leaving Alfred out in the cold contemplating suicide. In the final sequence of the film, Alfred seems to have got over his former wife. We see him playing air-guitar in his radio station as he broadcasts Sebastian's musical debut, the boy at last appearing to be on the way to finding immortality, having learnt the guitar, thereby following in the footsteps of the rock heroes that adorn the walls of the radio station, all of whom, he is assured by Alfred, live on forever in their music.

As Alfred and Sebastian disappear into their fantasy world of rock, we are given an inkling, perhaps, of the reasons why Veronika left her husband, preferring the domestic stability of life with Sebastian's family to Alfred's permanent adolescence. Nonetheless, we are not wholly convinced by her insistence to Sebastian that Alfred is now fine. The neat resolution generally demanded of the traditional Heimat film is withheld, although the power of the Heimat idyll is maintained. As with the use of a realist mise-en-scène, the evocation of real world problems, such as marriages that do not necessarily end 'happily ever after', merely seeks to enhance the 'authenticity' of the fantasy. This is a postmodern Heimat that assumes a cine-literate audience who will have an inbuilt 'ironic distance' from this tradition. At the same time, it exploits the knowingness of its audience to overcome any cynicism for the Heimat genre and to indulge their perhaps unavowed desires for the nostalgic innocence the Heimat space always represents.

Heritage, Heimat and the historical backstory

The self-conscious deconstruction of the Heimat genre in order to enact its recuperation is found in numerous contemporary films, both in the type of explicit engagement discussed above and in other more indirect manifestations, such as Til Schweiger's romantic comedy *Keinohrhasen* (Rabbit Without Ears, 2007). Schweiger mixes backstage comedy with Heimat schmaltz in this mainstream, highly successful, romantic comedy. Of particular interest to the present discussion is his depiction of the backstory to an outwardly happy couple who present a *Volksmusik* show, but who are barely able to refrain from screaming at each other off camera long enough to film their links between songs. While the staging of the Heimat backstory seems to deconstruct the Heimat

illusion, ultimately this simply provides an authenticating contrast to the 'true' Heimat fantasy encapsulated in the film's central romantic narrative.

A similar use of the Heimat backstory can be found in a number of recent heritage films. The affinities between the Heimat genre and the heritage film have been discussed by several commentators, with the Heimat film appearing 'ready made', as von Moltke puts it, for the 'postwall revisionist impulses' German heritage cinema often seems to encapsulate (von Moltke 2005: 233). As was discussed in Chapter 3, such films need not always be constructed as wholly revisionist in their ability to open up a public space for debate. However, the overlaps between some recent heritage films and elements of a Heimat aesthetic are less debatable. This connection becomes particularly clear in films such as Sönke Wortmann's story set around West Germany's Football World Cup win in 1954, *Das Wunder von Bern* (The Miracle of Bern, 2003), or Philipp Stölzl's account of the race to be the first to climb the north face of the Eiger, *Nordwand* (North Face, 2008). Here we find films exploring specific moments that have found their way into German national history as they intersect with important moments in the development of the Heimat genre. Through a sustained engagement with the historical backstory to the worldview seen in the 1920–30s mountain film and the 1950s Heimat cycle respectively, these films seem to deconstruct the cinematic images of the time, showing the historical reality behind the celluloid. This is a strategy already discussed in connection with Uli Edel's *Der Baader Meinhof Komplex*, which restages 'for real' iconic photographs taken during the 1970s terrorist wave. However, in the case of Stölzl's and Wortmann's films, this deconstruction is used, once again, to recuperate Heimat nostalgia and its fantastic image of life.

Das Wunder von Bern, for example, tells the story of the former Wehrmacht soldier Richard Lubanski (Peter Lohmeyer), who returns to his home and family in the Ruhr in 1954 after having spent twelve years in a Soviet POW camp. Adopting a standard Heimat film trope of the lost family member returning to the fold, we see the difficulties Richard faces trying to find a place in a family that has learnt to manage without him and a society that he does not recognise. The story of the family trying to readjust to post-war reality is then mirrored in the story of the German national football team winning the World Cup in 1954. The fraught

relationship between Richard and his children, in particular his football-obsessed son Matthias (Louis Klamroth), gradually eases, as do the tensions between the German national coach, Sepp Herberger (Peter Franke), and his high-spirited striker Helmut Rahn (Sascha Göpel). Both father and coach learn that the authoritarian ways of the German past are out of step with the present and that discipline must be tempered with love and compassion. At the same time, their respective 'children' begin to understand the world from their fathers' point of view, and, most importantly, that it is not their elders' fault that they act in the way they do.

This journey of intergenerational reconciliation is further reflected in the film's mise-en-scène. Richard returns to a bombed-out grey world of rubble, reminiscent of the early post-war *Trümmerfilme* (rubble films). These films, shot amid the destruction of the German cities, tended to be highly introspective in tone, their setting offering an external projection of the protagonists' inner turmoil (Shandley 2001: 2). Richard could be a figure from such a film, his alienation from the world around him recalling, for example, the traumatised protagonist of Wolfgang Staudte's *Die Mörder sind unter uns* (The Murderers are Among Us, 1945). The muted tones of the Ruhr sequences are subsequently contrasted with the vibrant colours of the football training camp in Switzerland. Here we are presented with the chocolate-box semantics of the 1950s Heimat film, full of beautiful mountainscapes bathed in sunlight overlooking the lush green fields where the team trains. This is a world unsustainable in the Germany of the time. However, as both team and family learn to trust each other, and Germany progresses to World Cup victory, the Heimat semantic begins to spread. Green shoots appear on the mud-filled field where the children play their own football matches. And finally, as the German team returns home victorious, the transformation from *Trümmer* to Heimat film is completed. We join the train which is taking the team to Germany, along with Robert and Matthias who have also managed to sneak on, as it travels off into the sunset through a picturesque rural landscape that could be straight out of the 1950s genre cycle, populated by country folk, driving hay-carts and waving their team on its way.

As in *Wer früher stirbt*, there are brief moments where the world of anti-Heimat is recalled. However, unlike Rosenmüller's film, here the syntactic configuration of this moment in the genre's

48 The German team ride their train into the sunset through the Heimat landscape, *Das Wunder von Bern* (2003).

history is only evoked to be rejected. Coincidentally, once again, rabbits are used to communicate the tension between Heimat fantasy and anti-Heimat reality. Richard slaughters his son's pets in order to provide a meal for his wife's birthday, a meal Matthias thoroughly enjoys until he realises that he is eating his beloved 'Karnickel' (bunnies). While we understand Richard's motives, we sympathise most strongly with Matthias. The shot of the bloody rabbit carcasses covered in flies is out of step with the film's dominant Heimat/heritage aesthetic, thereby highlighting the inappropriate nature of the father's actions. These were Heimat 'Karnickel', not anti-Heimat food. The intrusion of this anti-Heimat moment in turn reflects the relationship of the film to the critical agenda of this period in the genre's history. As already discussed, anti-Heimat was part of a broader attack by the youth of the 1960s on their parents, whom their children accused of not only having been complicit with National Socialism but of subsequently not having accepted their guilt for this compliance. This is a view reflected most obviously by Richard's eldest son Bruno (Mirko Lang), a character who prefigures the confrontational attitudes that would dominate in the late 1960s. Eventually, Bruno leaves the family for the GDR, where he believes he will find a better, more open society. Of course, the spectator knows that this is a deeply naive and ultimately self-destructive view. Bruno will eventually

be walled in, cut off for decades from his family. The potentially real 68er in the film is Matthias. He would be old enough to be a student at the time and able to take to the streets. But Matthias will not be amongst the protestors. The tensions that will come to the fore a decade or so later have already been resolved in the film. History is telescoped and we can move directly from post-war trauma and questions of guilt to contemporary declarations of German 'normality', and the nation's right to move on from its past and be treated like any other Western democracy. It would seem that the famous newspaper headline of 1954 celebrating football victory, 'Wir sind wieder wer' (We are someone again), is in 2003 at last allowed to come to fruition. Crucially, however, this is not to be understood as a statement of a problematic version of German nationalism. The film does not, for example, show the crowd singing the outlawed first verse of the national anthem, as the actual crowd in Bern famously did, an omission that sparked a strong reaction amongst some of the film's reviewers (Kuhlbrodt 2003). Instead, this is an image of a harmonious, mature post-unification German nation that has already confronted its authoritarian ways and put them behind it, where the generational conflicts that would dominate the 1960s and 1970s have already been overcome. The tensions of history are resolved and a timeless Heimat idyll is put in their place, where the past can re-circulate in the present as consumable heritage culture, signalled most obviously in the boom in sales of replica football shirts from the 1954 team the film helped to promote.

East Germany as Heimat space

Beyond offering an escape from the legacy of National Socialism and the question of German guilt, football would also seem to offer a resolution to German division, as we see Bruno and his new friends in the East also enjoying the West German World Cup win. As Jutta Braun and René Wiese discuss, football was indeed important to the population across Germany at the time, allowing a unified point of identification for Germans in both the East and West (Braun and Wiese 2005). And, in the event of the fall of the Berlin Wall and German unification, it once again played a role as the West German team raised the World Cup in the summer of 1990 for the third time in the country's history. The timing could

not have been better, the win seeming to confirm the status of the population as 'the happiest people in the world', as the mayor of Berlin Walter Momper famously declared them at the time. This is a motif that plays a key role in a number of films that examine the question of German unification, films that often also offer a further engagement with the notion of German Heimat.

An obvious example of this trend can be found in the third instalment of Edgar Reitz' epic chronicle of German history *Heimat 3*. *Heimat*, which Reitz made in response to NBC's television mini-series *Holocaust* and first screened in Germany in 1984, depicts life in the fictional village of Schabbach near the German-French border from 1919 to the early 1980s. In similar vein to Fleischmann's or Schlöndorff's films, Reitz engages critically and self-consciously with the Heimat tradition as visual spectacle, using a mixture of film styles to challenge the notion of the Heimat as timeless idyllic space, in particular forcing the spectator to reflect on the use of the concept in Nazi visual culture. That said, Reitz offers a far less abrasive image of rural life than is to be found in the earlier anti-Heimat films, a development for which he was heavily criticised at the time, in particular for his lack of explicit engagement with questions of German culpability for the Holocaust.[6] In *Heimat 3*, Reitz returns to the village, focusing on the decade following the fall of the Berlin Wall; his television film, which like his previous instalments also received a limited cinema release, marked a notable exception amongst the otherwise generally affirmative reproduction of the Heimat tradition on the small screen. Furthermore, although less popular with viewers than the first series, it too was bought by television companies around the world. Thus Reitz continued to buck the general trend of Heimat culture only being of interest to the German-speaking world, the recent international success of some Heimat-infused heritage films notwithstanding. *Heimat 3* presents the 1990 World Cup win as an early staging post in the construction of a new national community, as Reitz reconfigures the provincial West German Heimat of his earlier series into a unified German space where easterners and westerners meet. In so doing, he ironises the celebration of German unity under the sign of the West German team. The provincial Heimat is a locus fraught with tensions, pointing to broader fissures within the young nation. This is made clear in the decision of Hermann (Henry Arnold) and Clarissa (Salome Kammer) – the film's central

couple – to employ cheap East German labour to renovate their country house. The celebration of the football victory is only able briefly to elide the view of unification as a neo-colonial takeover of the East by the West, in which citizens of the former GDR exchange Soviet domination for capitalist exploitation.

Reitz's film is one of many that have reconfigured semantic elements of the genre into a syntax that can explore the changing relationship between east and west since unification.[7] This can be seen, for example, in a series of road movies by west German production companies produced soon after unification, including the so-called 'Trabi Comedies' (Peter Timm's *Go Trabi Go*, 1991 and Wolfgang Büld and Reinhard Klooss's *Das war der wilde Osten/ That was the Wild East*, 1992), which tell of the humorous adventures of the plucky but naive Struutz family, or Detlev Buck's *Wir können auch anders* (No More Mr Nice Guy, 1993), the comic story of two brothers who travel to the former GDR to claim their family inheritance. Such films, Leonie Naughton reads as a revisitation of the 1950s Heimat cycle, the former GDR now reconfigured nostalgically as a rural fantasy world, at times even evocative of the frontier space in the American Western, with the power of integration to be found throughout the earlier West German films (Naughton 2002: 125–38). Here, the east is 'discovered' by the west, presenting the so-called *neue Länder* (new states), as they are popularly described, as a narcissistic, orientalist vision that helps to define Germanness in the unified nation on western terms.[8]

In the early twenty-first century, as we can see from Reitz's film, the construction of the east as a proto-western Heimat space has been challenged in a variety of ways. Probably the best-known film that has sought to question orientalist constructions of the ex-GDR is Wolfgang Becker's bittersweet comedy *Good Bye, Lenin!* (2003), one of the biggest national and international hits of the decade (FFA 2010b). Unlike the earlier comedies, Becker's film focused on the demise of the GDR as the loss of an *east* German Heimat. But this is not a Heimat film in the traditional sense. It is, for example, largely set in Berlin, and not the provinces. It does, however, evoke a syntactical world that draws strongly on Heimat motifs, not least in its nostalgic construction of a sense of belonging rooted in the love the main protagonist, Alex (Daniel Brühl), feels for his mother. Indeed, the connection between the type of nostalgia the film explores and the Heimat tradition is suggested explicitly

in the opening credits, in which Super 8 footage shows Alex and his sister as children enjoying a happy moment playing in the garden of their family's country dacha nearly two decades before the events we are about to witness. This is also the location for a key moment in the film's denouement, when the children learn the truth about their father, which begins to rebuild their faith in their familial ties with him. Moreover, although the film's connection to the Heimat genre is somewhat oblique, it does nonetheless recall a similarly oblique engagement with Heimat culture within GDR filmmaking.

The GDR produced a number of Heimat films, incorporating the tradition into its socialist worldview, at times negotiating contemporary Cold War fears, at times raising specific issues facing the East German countryside such as the collectivisation of farms (Konrad Wolf, *Einmal ist Keinmal*/Once is Not Enough, 1955; Kurt Maetzig, *Schlösser und Katen*/Castles and Cottages, 1957).[9] *Good Bye, Lenin!*, however, can be related more directly to a GDR Heimat trend identified by Boa and Palfreyman in the DEFA 'Berlin films' of the 1960s, banned by the SED until unification in 1990 (Gerhard Klein, *Berlin um die Ecke*/Berlin Around the Corner, 1965; Frank Vogel, *Denk bloß nicht, ich heule*/Just Don't Think I'm Crying, 1965) (Boa and Palfreyman 2000: 130–43). These films are not straightforwardly generic Heimat films. Neither are they 'feelgood' comedies as Becker's film is. Nonetheless, like *Good Bye, Lenin!*, they are 'films about Heimat [...] providing a sense of security and belonging at times of stressful historical change' (Boa and Palfreyman 2000: 132). In the 'Berlin films', like the West German cycle from the previous decade, the notion of Heimat is evoked in the compulsion to build a new sense of a local community in the years following the turmoil of war. However, here this is based on a socialist rereading of what are constructed as traditional German humanist values, where, once again, the trappings of modern life can be negotiated and integrated. Of course, this was a far more complicated affair for filmmakers in the East, where the population had little prospect of acquiring the consumer goods that helped to drive the Federal Republic's 'Economic Miracle' of the 1950s and with it the population's enthusiasm for modernity.

Although Becker is a west German filmmaker, the relationship between Heimat, an 'East German' version of humanism and consumer goods is similarly central. Christiane Kerner (Katrin

Sass) is a fiercely devout citizen of the GDR with two children, Alex and Ariane (Maria Simon), whom she is forced to bring up on her own after her husband escapes to the West. Shocked by seeing her son arrested at a demonstration just before the fall of the Wall, Christiane suffers a heart attack, and as a result falls into a coma. She remains unconscious for eight months, during which time we witness the end of the GDR and the rush of its population to embrace the West. When she does awaken, the doctor tells her children that their mother's heart remains very weak. She is to be confined to bed, and above all must not be upset in any way. Since the news of the end of socialism would be devastating to her, Alex decides that he will have to keep this from her by recreating the GDR in her bedroom. He brings back the drab old East German furniture that Ariane has already disregarded in favour of new western fittings. He plays her videos of old editions of *Aktuelle Kamera*, the GDR's news programme, and, to complete the illusion, he feeds her GDR groceries such as Spreewald gherkins and Moccafix Gold coffee. These are products he is forced to hunt down with increasing desperation, since they are now almost impossible to find due to the population's rapid turn towards western consumer culture, his searches providing the film with a good deal of its humour. Alex's sentimental attempts to protect his mother from the truth of German unification are punctuated throughout with comic fast motion sequences of the young man speeding around the streets of East Berlin on his moped, seeking out the necessary artefacts to populate the illusory world he constructs for his mother.

The film's re-creation of the GDR self-consciously played to the then much discussed phenomenon of *Ostalgie*, the widespread nostalgia for aspects of life during the GDR made manifest most obviously in the rediscovery of the types of consumer items Alex looks for in the film. For its critics, *Ostalgie* was seen as a worrisome development, evidence of the failure of unification and revisionist tendencies amongst the ex-GDR population that, at best, were attempting to downplay the crimes of the communist regime and, at worst, seemed to want to return to the old days of national division. *Good Bye, Lenin!* engages critically with *Ostalgie*. However, rather than simply dismissing it as a revisionist tendency amongst the population, the film explores the underlying reasons for its existence. Specifically, it examines the ways in

49 'Unser Heimat': the community collects around the mother's bed to
re-enact the GDR, *Good Bye, Lenin!* (2003).

which *Ostalgie* arose from the sense of dislocation many easterners
felt in the wake of unification. With the dismantling of the GDR,
the population had to adjust rapidly to an entirely new political,
economic and cultural system. As Paul Betts suggests, consumer
culture became a key locus for east Germans wishing to recon-
nect with their lost past in order to redefine their sense of identity
within the unified state (Betts 2000: 742–3). In *Good Bye, Lenin!*
this process of reconnection is configured as the re-creation of
a lost Heimat, constructed via these same consumer goods and
centred around the world of Alex's mother. Christiane's bedroom
becomes an emotional haven for the whole family and their friends
as this ex-GDR community looks to come to terms with the world
changing rapidly around them, encapsulated in the moment when
members of her former communist youth group also join this
community during her birthday celebration to sing the GDR song
'Unser Heimat' (Our Heimat).

The film's configuration of Heimat suggests the normality of
Ostalgie in the face of the challenges the population is forced to
deal with. At the same time, the film does not allow the spec-
tator to forget that it was the GDR population itself which sought
these changes, or the fundamental inhumanity of the GDR system,
thereby separating the phenomenon of *Ostalgie* as it is presented
in the film from any revisionist impulses. We learn during a trip to

the family dacha towards the end of the film that Alex's father was forced to leave the country because of the intolerable pressures put on him at work, in the words of Alex, 'just because he wasn't in the party'. We see Alex's mother being interrogated by the Stasi, an event which causes her to have a nervous breakdown, and which in turn has a profoundly damaging effect on the rest of the family, particularly on her young son. Finally, as the GDR comes to an end, we witness the unbridled violence of the state's repressive institutions against the people as the regime tried, increasingly in vain, to maintain its grip on power. Yet while the film might be unambiguous in its condemnation of the GDR state, it is similarly unambiguous in its recuperation of the utopian impulse behind the GDR's socialist project, an impulse that recalls the exploration of Heimat to be found in DEFA's Berlin films. But if in *Denk bloß nicht, ich heule* a socialist Heimat is posited as a future ideal, here it is created nostalgically as a lost opportunity. As Alex's project of reconstructing the GDR for his mother becomes more complicated, and an ever-increasing number of the family's neighbours are brought in on the deception, he begins to realise that 'the GDR that I built for my mother was becoming more and more the GDR that I would have liked to have had'.

The importance of this utopian version of the state's ideology is symbolised throughout in the motif of space travel, embodied in the figure of Sigmund Jähn, a GDR cosmonaut, the first German in space and Alex's childhood hero. After the fall of the Wall, Alex actually meets his hero in the flesh (or at least a man he takes for Jähn), who is now working as a taxi driver in Berlin. As his mother grows weaker, Alex decides to complete his imagined GDR by making Jähn its new president. In so doing, he sets the seal on the philosophy of his fantasy socialist state. In his inaugural speech, filmed by Alex and his friend for one of their faked *Aktuelle Kamera* reports, Jähn declares, 'Socialism is not about building walls. Socialism is about approaching the other person and living with the other person. It's not about dreaming of a different world. It's about making it happen.' In the words of Jähn we have Alex's conception of what the GDR should have been about: socialism with a human face, which could urge the population on to new heights of achievement. Alex's idealised, broadly humanist version of the GDR's ideology is then used to critique contemporary post-unification society. The continued relevance of utopian socialist

views as a corrective to Germany's present-day value system is most obviously communicated during one of Alex's final editions of *Aktuelle Kamera*. Unable to keep the evidence of western influence on their community from his mother, he rewrites history to present the end of the Cold War as a moment when Westerners want to join the East. The reasons the news report gives for the West taking this step – mass unemployment and concomitant social instability – have been major concerns for the whole of German society since unification, as the country undertakes the painful process of social restructuring driven by the imperatives of globalisation. Thus, on the face of it at least, the presentation of an inverted version of unification would seem perfectly plausible.

On the one hand *Good Bye, Lenin!* presents an overwhelmingly negative picture of life in the GDR, in which the population lived in fear of the Stasi. On the other, it recuperates the state's utopian project, constructing it as a version of Heimat expressed through Alex's emotional connection with the world of his mother. Nonetheless, the film finally accepts the loss of this GDR Heimat, as well as the changes that Germany is currently undergoing. In so doing, the film ultimately points to the need for easterners and westerners to come together to build a *new* German community. In line with traditional conceptualisations of Heimat, the ideas of the past cannot be ignored in the present. The inhabitants must, rather, engage productively with it. This is highlighted in the film's closing moments. Alex's mother has died, having learnt that the GDR has gone but also of her son's efforts to protect her from this news. At her funeral, her entire family is united, including their long-lost father who now lives in the west, everyone coming together to mourn her passing. Alex fires his mother's ashes into the sky using a rocket he built at school, a gesture which makes clear that Christiane's worldview, like the utopian vision of Alex's cosmonaut-led GDR, no longer has a place in the real world. And then, before the final credits roll, the film returns to the Super 8 footage with which it began, and its direct evocation of the Heimat tradition, of Alex's lost GDR roots which will always be embodied for him in the memory of his mother. With their mother's time past, the family must move on, accepting the challenges this new society will bring all Germans, easterners and westerners. Thus, the film is ultimately a eulogy to Germany's divided past. It is an enactment of mourning, and like all acts of mourning it involves fondly

remembering this past time, allowing the mourners to indulge in the nostalgic recollection of their lost Heimat. But it also involves drawing a line under the past, forcing these same mourners to realise that the past can also never be regained. The memory of the mother, and the value system for which she stood, cannot be kept alive artificially. It must instead be incorporated into this reunified German family's identity, into a new understanding of Heimat, as the family attempts, along with the rest of the nation, to negotiate its future.

Reconfiguring anti-Heimat

Good Bye, Lenin! is the best known of a number of nostalgia films to examine pre-unification German society, often in a similarly comic fashion. These include Leander Haußmann's *Sonnenallee* (Sun Alley, 1999) and *Herr Lehmann* (2003), Benjamin Quabeck's *Verschwende deine Jugend* (Play it Loud, 2003), Carsten Fiebeler's *Kleinruppin forever* (2004) and Hans Weingartner's more laconic *Die fetten Jahre sind vorbei* (The Edukators, 2004) which explicitly evokes the rural Heimat as a space to explore the lessons that contemporary Germany might learn from the West German 68ers. Indeed, as many of these films now explore popular nostalgia for the old West German state as they do for the GDR. Such contemporary manifestations of what has come to be understood as *Westalgie* consequently highlight the growing understanding amongst the population as a whole that unification brought about a genuinely new Germany which has meant the end of both the GDR *and* the old Federal Republic. As Alexander Ludewig suggests, this has, in turn, engendered broader nostalgic recollections, for better or worse, of both, as a lost Heimat (Ludewig 2011: 9). Nonetheless, for all their sense of nostalgic loss, many of these films offer a positive assessment of the nation's future. In similar fashion to *Good Bye, Lenin!*, the nostalgic recollection of a pre-unification Heimat can more often than not be incorporated into a new unified German community.

However, if we remain with the place of the east within contemporary German society, in films such as Vanessa Jopp's *Vergiss Amerika* (Forget America, 2000), Susanne Irina Zacharias's *Hallesche Kometen* (Halle Comets, 2005), Valeska Grisebach's *Sehnsucht* (Longing, 2006), Ann-Kristin Reyels's *Jagdhunde* (Hounds,

2007) and Christian Klandt's *Weltstadt* (Cosmopolitan City, 2008) we find a far bleaker prognosis. Here we return to the world of provincial Germany and with it a more direct evocation of the Heimat tradition than is to be found in Becker's film. It is, however, the syntax of anti-Heimat upon which these films draw most explicitly in their critique of life in the ex-GDR. Christian Klandt's debut feature *Weltstadt* (2008), styled in its tagline a 'Heimatfilm', for example, depicts the events that lead up to a violent attack on a homeless beggar (Jürgen A. Verch) by two teenagers in the provincial Brandenburg town of Beeskow. Based on a true event, this ex-GDR, anti-Heimat film also draws on a tradition of social realist filmmaking, from Ken Loach (*Raining Stones*, 1993) and Mathieu Kassovitz (*La haine*, 1995) to Larry Clark (*Kids*, 1995) and Gus Van Sant (*Elephant*, 2003) in order to contextualise an extraordinarily brutal and unprovoked attack. In so doing, Klandt presents us with a decaying, post-industrial landscape, where the population has lost everything, where the town's older inhabitants live in fear of a youth they cannot understand, and where the young have little chance of escape. Karsten (Gerdy Zint) and Till (Florian Bartholmäi) spend their days drinking and smoking dope, their anger with the world erupting into violence on themselves, each other and ultimately the homeless tramp.

Weltstadt explodes the clichés of the Heimat film. In a similar fashion to earlier moments in the genre's development, the narrative is punctuated by long takes of the local countryside. Set during a crisp winter's day, the spectator is offered shots of the Spree River in all its tranquil splendour, or of the bright winter sky, its light breaking through the dilapidated estates of pre-fabricated housing which fill the town's suburbs. While in the 1950s such landscapes would have offered a space which the rural community could come together and find a common point of identification, here the population of the town is entirely dislocated from the natural world around it. Echoes of Caspar David Friedrich re-emerge as the film's protagonists stare into the landscape that surrounds them. However, their brief moments of contemplation simply underline their dislocation, as well as the lack of any real sense of community in the town, above that which can be mustered when a few people come together temporarily to drown their sorrows in alcohol or drugs. Heinrich (Hendrik Arnst), a failed businessman who is being forced to close his snack bar to make way for a car park,

stares at the Spree in one such moment. Rather than finding peace in the sublime beauty of the river, we see that his focus is his own reflection. He is unable to find a way beyond his own misery. This sequence is then immediately followed by shots of the other main characters in the film, caught in similarly self-reflexive moments of isolation. If this provincial town has the timeless quality associated with earlier visions of Heimat, then it is a dystopian timelessness rooted in the certainty that its population has no prospect of a better future.

If we move away from the ex-GDR and return to films that explore earlier moments in the nation's history, anti-Heimat is also the dominant mode of Michael Haneke's *Das weiße Band – Eine deutsche Kindergeschichte* (The White Ribbon, 2009), a film set in a fictional north-German village on the eve of the First World War. Although a decidedly transnational project in terms of its production context – the film is a German, Austrian, Italian and French co-production – it was received internationally as a German film, aided by its all-German cast and its producer Stefan Arndt. This was a view subsequently cemented by its place as a German film on the shortlist for the 2010 Oscar for best foreign-language film, much to the annoyance of Martin Schweighofer, head of the Austrian Film Commission which failed to get its own intended nomination in to the Academy quickly enough. Although born in Munich, Haneke grew up in Austria and is the country's most internationally renowned filmmaker (Hudson 2009). Haneke, for his part, sees any debate about his film's national affiliation as irrelevant, suggesting that it in fact engages with questions that are of universal applicability. For Haneke, the film is to be read as an examination of fundamentalism, whatever form this might take, be it religious or political (Köhler 2009). Indeed, he claims it was originally inspired not by life at the start of the twentieth century, but by the experience of several members of the 1970s German terrorist group the Red Army Faction who were brought up within rigidly religious households.[10] Moreover, like much of his oeuvre, the film explores the violence upon which Haneke suggests bourgeois society is built. This is a violence that drives and defines the whole of his filmic world, from the media images the public readily consumes on its television and cinema screens (*Funny Games*, 1997) and the macro-political relationships between the developed and developing world (*Caché*/Hidden, 2005) to the internal

domestic realm of the early twentieth-century family he explores in *Das weiße Band* (Wheatley 2009).

For all its transnational production context, however, and the broad applicability of the topic it examines, the subtitle of the film, 'eine deutsche Kindergeschichte' (a German children's story), locates the narrative within a specific national context, the purpose of which is made explicit at the film's outset as its elderly narrator recollects events from much earlier in his life when he was a young village teacher. This is to be a story, he suggests, that might explain what happened next in this country. The small village of Eichwald is suffering a series of violent, sadistic crimes: the doctor is brought off his horse by a tripwire, the local Baron's son is beaten up, the Down's syndrome child of the midwife is almost blinded. All the attacks are carried out by unknown assailants, although the whole community assumes the culprits to be amongst the village's inhabitants. It soon becomes clear to the audience that these crimes are simply the public manifestation of a deeply disturbed society, gripped by patriarchal violence, where women are psychologically and physically abused and children are subjected to a similarly abusive educational philosophy, grounded in a draconian version of protestant Christianity which forcibly represses all natural urges. This is symbolised in the white ribbon that the local pastor forces some of his children to wear as an outward sign of their failure to live up to his impossible ideal of childhood innocence. As the film progresses, the fabric of this society starts to unravel at an ever greater pace. We follow the young teacher, one of very few men in the village who seems to have a more humane understanding of the needs of the children in his care, as he begins to suspect that it is these same children who are the perpetrators of the crimes. Their actions, if it is indeed the children who are guilty, would seem simply to be the logical fulfilment of their education, the children punishing the hypocrisy of their parents who fail to live according to the rules they force upon their offspring. Finally, however, we learn of the death of Archduke Franz Ferdinand of Austria and events in the village are overtaken by events in the outside world. The future will unfold as we expect. The children's guilt or otherwise is forgotten and, we can assume, they will grow up to play their inevitable part in the Germany that will come in the decades to follow.

As a history film, *Das weiße Band* differs starkly from other recent

productions that explore this period. As we have already discussed, much heritage fare that looks at the Nazi period and its aftermath still tends to be guarded in its portrayal of German society, for all the recent declarations of German 'normalisation' and the 'discovery' of German wartime suffering. In such films, the question of German culpability for the crimes of the past must always be at least addressed. In films that look at the pre-Nazi period there would appear to be less need to deal with such troubling issues. For example, in the German-French-British-Belgian-Romanian co-production *Joyeux Noël* (Christian Carion, Happy Christmas, 2005) – which, unlike Haneke's transnational co-production, is something of a europudding – or Nikolai Müllerschön's *Der rote Baron* (The Red Baron, 2008), both of which depict famous moments from the First World War, the German combatants are presented straightforwardly as honourable soldiers, no different from their British or French counterparts. In *Das weiße Band*, Haneke troubles the notion that pre-Nazi Germany can be depicted in a similar fashion to other European nations, suggesting that the violent authoritarianism that would grip the country in the 1930s had deep roots and can be found at work within society long before anyone had ever heard of Hitler. In so doing, Haneke's film echoes the explanation adopted by many on the left in the 1960s as to the roots of National Socialism, encapsulated in Theodor W. Adorno, Else Frenkel-Brunswik and Daniel J. Levinson's seminal 1950 study *The Authoritarian Personality*. More specifically, Haneke also seems here to be influenced by Alice Miller's analysis of German society, *For Your Own Good: Hidden Cruelty in Child-Rearing and the Roots of Violence* (1983), in his presentation of a society in the grip of so-called *Schwarze Pädagogik* (black pedagogy). This is a volume that we might note also provided the starting point for Levy's controversial Hitler satire, the film presenting the Führer himself as a victim of such educational methods (*Mein Führer – Die wirklich wahrste Wahrheit über Adolf Hitler*) (Levy 2007: 215–17).

With regard to the broader discussion of this chapter, aesthetically, Haneke's film also recalls the sensibility of the 1960s, using the Heimat genre against itself to challenge a cosy understanding of German identity based on timeless rural traditions. Like Fleischmann's or Schlöndorff's anti-Heimat films, the violent brutality of country life is made clear. The rural world is similarly defined by death and dirt and by an exploitative class system, the entire

50 The rural landscape drained of colour, *Das weiße Band—Eine deutsche Kindergeschichte* (2009).

village being in thrall to the whims of the local Baron and his family. The film's apparently authentic portrayal of life at the start of the twentieth century is emphasised in Haneke's self-conscious recollection of the German documentary photographer August Sander in the framing of many of his shots. Sander, best known for his social-realist portraits, was committed to capturing the everyday lives of people from all levels of society, his photographs offering Haneke an invaluable resource in his recreation of rural life at the time. However, for all the film's ostensible commitment to a realist aesthetic and the authentic reconstruction of the past, *Das weiße Band* is very different from earlier anti-Heimat films, engaging much more explicitly in a dialectical relationship with a positive Heimat tradition. James S. Williams points to the importance of Christian Berger's cinematography in this regard and, in particular, his meticulous process of post-production during which the original 35mm colour footage was digitally enhanced before being transferred to black and white. While the mise-en-scène, like its anti-Heimat precursors, is 'punctiliously realistic in design, the film's ultimate effect is strangely synthetic', the original shots of the rural landscape that punctuate the film, having been drained of colour and digitally treated, create a collage of images that 'becomes progressively more grey and matt, monotonous and uniform' (Williams 2010: 50). The beautiful cornfields

51 The children move around the village 'in unwholesome intimacy', *Das weiße Band—Eine deutsche Kindergeschichte* (2009).

that surround the village, their crop bending gently against the rustle of the wind, the clouds billowing across the sky above, are images that we might find in earlier manifestations of the Heimat genre. However, here they have become strangely sanitised. In the process they form part the film's overall strategy of *Verfremdung* (distanciation), a deliberately modernist gesture preventing identification with the characters, forcing the audience to reflect upon the story as it unfolds. This is then further supported by Haneke's use of elliptical editing, where much of the action within the narrative has to be inferred, the use of closely cropped shot/reverse-shot sequences, which seem to dislocate conversations from their setting, and the understated performances of the children at the centre of the violence. These are children who, as Peter Bradshaw suggests, could have been taken from *The Village of the Damned* (1960), moving around their rural world as one 'in unwholesome intimacy' like the unnerving monsters of Wolf Rilla's film (Bradshaw 2009). Even the narrator's commentary seems to highlight this sense of distanciation and dislocation. At times, his words block out the diegetic dialogue, preventing us from hearing what is actually being said and forcing us to rely on his version of events. Yet how reliable is this version? He too is a product of this society. He too will live through the Nazi period. From what moment in history is he retelling this story? From the 1950s, by

which time the 31-year-old teacher we see in the film would have become the elderly narrator we hear in the commentary? Does his perspective now enact the broader sense of revisionism that, the 68ers argued, gripped the whole of society during that decade, the Heimat film being a particularly good example of this tendency?

Reterritorialising/Deterritorialising Heimat

The films discussed in this chapter highlight some of the ways that contemporary filmmakers are engaging with and developing the Heimat film. At times we see a re-appropriation of the New German Cinema's anti-Heimat tradition. In a number of low-budget, socially critical films that examine the state of unification, for example, anti-Heimat motifs emphasise the difficulties faced by the population in the ex-GDR. Similarly Haneke's far larger-scale movie, *Das weiße Band*, recalls earlier anti-Heimat films as it reminds the spectator of the corruption of the Heimat tradition in the face of the nation's National Socialist history. In many of the best-known German films internationally, however, we find a more affirmative engagement with the concept of Heimat. Here film-makers mine the history of the genre to recuperate the projected/longed for idyllic innocence of the 1950s, using the tradition of Heimat to validate the modern nation, in this case reworking aspects of 'Papas Kino' to set the seal on the Berlin Republic as not only having overcome the traumas of the Nazi past but also the critical legacy of the 68ers and the New German Cinema.

Yet these are not the only ways in which the Heimat genre impacts upon contemporary German film, as might be gathered from the echoes of Heimat we find in films discussed across this volume. There is, for example, also a wide range of productions that use the idea of Heimat syntactically to explore the inter-national boundaries of the new Germany, in both physical and existential terms. Many of these films have been discussed here as evidence of a broader transnational turn in contemporary film-making. However, for some critics, such as Ludewig, they can also be seen as part of a trend that would appear to be working in the opposite direction, namely highlighting a continuation of a specifically German mode of Heimat filmmaking (Ludewig 2011: 385–417). There are films that transpose the 'other' of the former GDR to be found in the comedies of the early 1990s to the country's

eastern borders. As discussed in Chapter 4, in Henner Winck-
ler's *Klassenfahrt* (2002), Jan Krüger's *Unterwegs* (2004), or, most
explicitly, in Stefan Betz's comedy *Grenzverkehr* (2005) the repre-
sentation of Poland or the Czech Republic becomes a self-reflexive
device, at times enabling a critique of Germany's changing role in
the new Europe, at times providing new spaces to define the limits
of the German Heimat.[11]

This is also explored in a number of films that take this transpo-
sition further still. Here we might recall Doris Dörrie's *Kirschblüten*,
and the filmmaker's use of Japan as a backdrop for her examina-
tion of death, identity and mourning, discussed in Chapter 5,
or films that place their German protagonists within an African
'other', such as Caroline Link's Heimat/heritage film *Nirgendwo in
Afrika* (Nowhere In Africa, 2001), Hermine Huntgeburth's *Die weiße
Massai* (The White Masai, 2005) and Hans Steinbichler's *Winterre-
isse* (Winter Journey, 2006). In all three cases, the sub-Saharan
landscape provides a beautiful yet disorienting world against
which their protagonists are forced to redefine their sense of self.
For Link and Huntgeburth this ultimately leads their protagonists
back to their German Heimat, changed by their experience but
ready to reintegrate. In the case of Steinbichler's *Winterreise*, the
most direct reworking of the Heimat genre of the three, this leads
to the protagonist's death. A Bavarian businessman (Josef Bier-
bichler) travels to the country to retrieve his money after investing
thousands of euros in a corrupt business deal. The journey he
undertakes, which has both physical and existential dimensions,
is constructed as a reworking of Schubert's song cycle *Winterreise*,
updated for the age of globalisation. Schubert's story of depression
and isolation ends in uncertainty. We do not know if its hero will
resolve to kill himself or attempt to hold on to life. In the Kenyan
savannah of Steinbichler's film, however, the story finds its reso-
lution. After having ensured that his family will be secure in his
Bavarian provincial home, Bierbichler's character commits suicide
– a final acceptance of his failed life and the impossibility of his
finding peace. Thus, while their German protagonists can come to
a better understanding of who they are in the Kenya of all these
films, it can never be their home.

Ludewig also uses the concept of Heimat to inform her exami-
nation of Fatih Akın's *Gegen die Wand* and Angelina Maccarone's
Fremde Haut, both discussed in Chapters 4 and 5 of my study. In

52 Franz (Josef Bierbichler) surveys the Kenyan savannah that will never be his Heimat, *Winterreise* (2006).

the case of these films the concept of Heimat operates syntactically to examine dynamic, hybrid conceptualisations of contemporary identity construction, 'rethinking Heimat as a transnational and transcultural space'. At the same time, in the films of Akın, Maccarone and others we also sense the need for 'small spaces, local places, and familiar settings and dialects' intent upon delimiting the concept of Heimat, focusing on the mirco in the face of the apparently every-expanding transnational macro perspective available in a globalising world (Ludewig 2011: 385). Heimat, it would seem, operates simultaneously in competing directions, opening itself up to an understanding of identity that escapes definition as a specific place, and yet also continues to hang on to a notion of the local.

Akın's 2009 film *Soul Kitchen* examines both these tendencies. However, here the ideas of Heimat and identity construction are not only engaged syntactically but also semantically in a film that explicitly reworks the genre conventions of the Heimat film (Rodek 2009a). In the process, Akın goes beyond the kind of territorial redefinition we see in films that move discussions of Heimat to the German-Polish border or to Africa. Like *Good Bye, Lenin!*, Heimat is located in the city, not the countryside, specifically Akın's home town of Hamburg. However, *Soul Kitchen* is also different from Becker's film. Now the urban landscape is directly expressed semantically as Heimat for the multicultural group of misfits who come together to build the reputation of the rundown café that gives the film its title. Moreover, although there is a

great deal of affection for the city in the film, it loses any sense of being a specifically German Heimat. On the one hand, the city as a whole is a Heimat space. However, unlike the Heimat of the Bavarian province or the Lüneburg Heath of earlier films, which offer comfort to their inhabitants in their unchanging permanence, these inhabitants of Hamburg are actively implicated in the creation and preservation of their environment. This is highlighted for example in a drunken outing the café's owner Zinos (Adam Bousdoukos) and his head waitress (Anna Bederke) undertake one night. Their journey through the city's dives takes on the dimension of a psychogeographical *dérive* (drift), the comfortable randomness of their movement, through which they inscribe their ownership of the city at night, highlighting a sense of union with their environment. The sequence's explicit connection to the Heimat tradition is then subsequently suggested in the shot of the city skyline that signals the end of their trip, the giant cranes which cut across the horizon replacing the alpine landscapes of earlier times, underlining the sense that this urban Heimat is under constant construction. On the other hand, the concept of Heimat is reduced to the micro level. Heimat is the Soul Kitchen restaurant itself. Indeed, in the film's closing moments it is even reduced to a single table within the restaurant when Zinos, having rebuilt against all the odds not only his business but also his love life, finds contentment in a romantic dinner for two. But ultimately, even this moment of idyllic perfection cannot capture a complete sense of what Heimat means in the film. Here we return to our opening discussion of a term that always brings with it an emotional dimension which escapes definition. As much as it is located in the physical space of the restaurant that Zinos and his staff have built, it also finds expression in the classical European cuisine prepared by the Spanish chef (played by the Turkish-German actor Birol Ünel), a man driven by an exuberant, sometimes violent, passion for his craft. It exists in an individual's relationship to music, particularly in this case to the funk-rock sound of the band that entertains the restaurant diners each evening. And equally, of course, it exists in the emotion of a couple's love for one another suggested in the film's final shot, but already made clear in the song by 1960s US band The Doors that gives the film its title, the *Soul Kitchen* of Jim Morrison's vocals promising not food but a night of passionate lovemaking.

53 Zinos (Adam Bousdoukos) and Lucia (Anna Bederke) take in their Heimat vista, still under construction, *Soul Kitchen* (2009).

For all the emphasis on the physical dimension of Heimat as a German rural idyll, even in its 1950s manifestation Heimat was often as much a cultural as it was a geographically defined space. Films such as Deppe's *Grün ist die Heide* or Wolff's *Am Brunnen vor dem Tore* created escapist fantasies where the 12 million Germans who had been expelled from their homes east of the Oder-Neisse line could find a new sense of belonging. Indeed in Wolff's film – along with many others of the period – like *Soul Kitchen*, the centre of the Heimat space is a tavern that unites the community in food, beer and song. That said, in the 1950s films, there remained a geographical specificity, a German dimension rooted in a romantic longing for lost territory. In *Soul Kitchen* this has disappeared. Instead, the film creates an idealised multicultural community that offers its inhabitants a sense of belonging to counter a non-nationally defined version of modernity embodied in the forces of globalisation and symbolised in the threat posed to the restaurant by an evil property developer intent upon profiting from the city's decidedly international-looking 'gentrification'. Such gentrification destroys tradition. But this is not a specifically German sense of tradition. What it seeks to destroy are the random nooks and crannies within which the city's inhabitants locate and *create* their Heimat, however this might be understood, be it through enjoying Spanish Gazpacho, Greek techno music, or in the love

Zinos discovers for his Hungarian physiotherapist (Dorka Gryllus) during his treatment for backache by a backstreet alternative chiropractor, the Turkish 'bone breaker' Kemal (Ugur Yücel).

Soul Kitchen is defined by Akın as a 'dirty Heimat film' (Zander 2009a). In so doing, it would seem that he wishes to distance himself from the Agfa-colour brilliance of the 1950s. As we have seen throughout this chapter, this is a common tendency in contemporary films that engage the Heimat tradition. Akın, like Rosenmüller, is intent upon giving his version of 'Papas Kino' some of the grit of anti-Heimat in order to be able to have his Heimat 'cake', as it were, and eat it too. The important place that US-inspired rock music plays within the film also recalls the Americana of Rosenmüller, as well as the world of Michael Schorr's *Schultze Gets the Blues*, discussed in Chapter 6, which similarly moves the notion of Heimat beyond a physical place to an individual's identification with popular music. This is a relationship that ultimately returns us to the New German Cinema, while also highlighting how German society has moved on and developed. Although rock 'n' roll might have saved Wim Wenders' life as much as it forced him to question his relationship to American culture, Akın's life does not appear to be in need of salvation. Nonetheless, he has a similarly passionate relationship with American popular culture, specifically in his case with the sounds of African-American hip-hop, often given a transnational twist in the soundtracks of his movies.

If we explore contemporary German film solely in syntactic terms, an extraordinarily broad range of films can be defined as part of a Heimat corpus. Indeed, it is a motif that runs throughout my discussion of German cinema in the 2000s, linked as it is inextricably to broader questions of Germanness, identification and community. These are issues that the nation as a whole, and filmmakers in particular, continue to address as they examine the cultural and political legacies of the past, along with the tension produced as traditional conceptions of Germanness rub up against the imperatives of a society facing the pressures of globalisation and the continuing challenges of post-unification integration. These are, in turn, issues that are shaped by numerous other factors including the film-funding system, contemporary use of realist aesthetics and the representational potential of film as a cultural form, the legacies of the *Frauenfilm*, the changing demographics of

society and the continuing demands of those who have long been marginalised to be given a voice.

How long the present wave of Heimat cinema will continue to flourish remains to be seen, as does the broader success of the country's films both at home and abroad. For the moment, neither seems to be waning. Film production continues to increase year on year – an increase celebrated by some as evidence of the industry's creative vibrancy, while for others highlighting the inability of the industry to focus its resources on the 'best' films. Of course, as we have also seen, what might be defined as 'the best' depends on one's point of view. It is, however, an issue that provokes particularly fierce debate in Germany, as commentators argue over not only the cultural value of a particular film text, but also the normative question of what *should* constitute German cinema. Like the Heimat genre, this is, perhaps, a peculiarly German phenomenon, a result of the nation's continuing need to face the specific challenges raised by its problematic past, for all the contemporary discussion of 'normalisation'. Indeed, the very existence of a 'normalisation' debate seems to highlight a specific sense of national particularism. There is surely nothing more *ab*normal than self-consciously to declare oneself 'normal'.

This tension was revealed once again in a recent intervention by the 68er philosopher Jürgen Habermas on the normalisation debate. He recognises that the country has at last become a 'normal' nation, having reached 'the end of a "long path to the west"'. However, this is ultimately a worrying development for Habermas, since, in the process

> What has disappeared is the anxiousness of a people, who were also defeated morally and compelled to engage in self-criticism, to find their bearings in the postnational constellation. The solipsistic mindset of this self-absorbed colossus in the middle of Europe can no longer even guarantee that the unstable status quo in the EU will be preserved. (Habermas 2010)

For Habermas, writing in response to the currency crisis in the Eurozone which provoked the need for huge bailouts of some member states, it is deeply worrying that Germany is now behaving like any other European state. Habermas laments the fact that the country is openly expressing concerns in terms of its own national self-interests – for the cost of the bailout just as the German

economy seems to be getting on the right track after two decades dealing with the economic ramifications of unification – rather than focusing on the 'postnational' project of European integration, to which the Federal Republic committed itself in the wake of the Second World War, and again in 1990 as the Kohl government attempted to allay the fears of Britain and France that a powerful unified German state might once again pose a threat to European peace. There are not many that still hold these fears. However, in Habermas's discussion we find the continuing sense that Germany must be held to a different standard than other nations, that it must find its way 'back' to a form of 'postnationalism' in order to renew the project of European integration.

Within the context of my discussion of German cinema in this volume, the notion of 'postnationalism' might seem to recall that of the 'europudding', a transnational cultural product that ultimately never satisfies. The tone of Habermas's intervention can also be found throughout discussions of German cinema, as critics challenge contemporary films for failing to live up to the agenda of the past, criticisms that are particularly prevalent in the debates that tend to follow the release of major heritage films. While many of these films are praised unproblematically in the international press, in Germany as well as in the numerous academic articles and books they also provoke, there is generally a good deal of scepticism towards the easy answers such films often seem to offer. This is certainly a tendency I recognise in my own feelings towards these films. As I watch *Das Wunder von Bern* or *Das Leben der Anderen*, I might instinctively long for the more explicitly critical stance of a Fassbinder movie, or the aesthetic experimentation of Angela Schanelec that seems to recall the sensibility of this earlier age. That said, I am more likely to go to the cinema to see the films of Worthmann or Henckel von Donnersmarck, not only because these are the films that are most likely to receive a theatrical release in the UK, but also because they are more likely to exploit the spectacular qualities of the big screen. Moreover, as I discussed in Chapter 3, while one might be able to identify conservative impulses within the diegesis of many of these films, they might also offer an experience to the contemporary spectator that the films of the previous generation could not, or perhaps did not need to. Time has moved on; living memory of the Second World War is fading. Consequently, has the moment arrived for the

type of film that can offer a more immediate, emotional connection to this history for generations with no experience of the past other than through the images they see in history books or in the documentary footage that continues to circulate on television screens, images that appear far removed from their own reality? How realistic, or desirable, it is for Germany ever to turn its back on its problematic past – another fear often expressed by the critics of 'normalisation' – remains to be seen. But perhaps the time has come for its films about the past to be judged on their own terms, and not against the politics of another age, or the 'normality' of others. At the same time, for the moment at least, it is clear that filmmakers themselves will continue to engage with both these agendas, while also increasingly looking beyond the nation's borders for answers to these questions and for the funding to turn these answers into movies.

Many of the issues raised in this volume are, of course, not unique to Germany, nor to German cinema. German filmmakers work within a globalising world, where many of the most important questions that society must address are not limited by national borders. However, the national perspective still often flavours an individual filmmaker's response to these questions in a variety of ways. As Stephen Brockmann notes in his history of German film, 'the process of globalisation is not simply a uni-directional move towards Americanisation or uniformity; it is, rather, a complex process of interpenetration and encounter that also engenders the resistance of, and affection for, particular and distinct local, regional, and national identities' (Brockmann 2010: 435). This is particularly clear in our discussion of the Heimat genre. This is a German form which often works in conjunction with a variety of other, more international, traditions, its ongoing presence on German screens highlighting just one of the ways in which the nation's filmmakers continue to make a unique contribution to discussion of the challenges facing the world today, as well as to global film culture.

Notes

1 For a good discussion of this aspect of Heimat see Applegate 1990: 4–8.

2 The 'modernity' of the images is also reflected in the ways in which

such Heimat films played to the growing domestic tourist industry at the time. Tim Bergfelder points out that the Austrian Tourist Board was keen to fund Heimat films during the 1950s boom in the hope of fuelling a thoroughly modern domestic holiday market (Bergfelder 2005: 41–4). That said, the relationship between Heimat films and the tourist industry, however nascent, has long existed, as Rentschler identifies in his discussion of the mountain film (Rentschler 1996: 32–8).

3 This is a period of history that is also revisited humorously in Marc Rothemund's romantic comedy *Pornorama* (2007).

4 In the recent work that has been undertaken on the genre, however, there has been much discussion of the ways in which the 1950s cycle in fact actually points, however obliquely, to darker aspects of Germany's history that, on the face of it, it seems to ignore. See, for example, Boa and Palfreyman 2000: 86–129; King 2003; von Moltke 2005.

5 For a discussion of the place of Heimat culture in contemporary German television see Virchow 2009.

6 For an overview of the reception of Reitz's *Heimat* see Hansen *et al.* 1985. Reitz's *Die zweite Heimat – Chronik einer Jugend* (The Second Heimat – Chronicle of a Youth) followed in 1993 and focused on the experience of Hermann (Henry Arnold), the youngest member of the Simon family from the first series, as a student in 1960s Munich.

7 For discussion of the way in which *Heimat 3* reconfigures the question of Heimat in the light of the media reception of the earlier series see King 2011.

8 For further discussion see Cooke 2005: 27–59.

9 For a more detailed examination of such GDR Heimat films see von Moltke 2005: 170–200.

10 The influence of their strict protestant upbringing on some members of the RAF has been previously explored more directly in Margarethe von Trotta's *Die bleierne Zeit* (The German Sisters, 1981). For further discussion see Silberman 1995: 198–213.

11 For a detailed examination of the use of Eastern Europe, and in particular the Baltic region, as a space to explore a German Heimat, as well as the uncomfortable questions this raises with regard to Germany's past – specifically the legacy of the German occupation of the region – see also Ludewig 2006.

Bibliography

Abel, Marco (2008a), 'Intensifying Life: The Cinema of the "Berlin School"', *Cineaste*, 33/4: www.cineaste.com/articles/the-berlin-school.htm.

——(2008b), 'The Cinema of Identification Gets on my Nerves: An Interview with Christian Petzold', *Cineaste*, 33/4: www.cineaste.com/articles/the-cinema-of-identification-gets-on-my-nerves-an-interview-with-christian-petzold.

——(2009), '"There is no Authenticity in the Cinema!": An Interview with Andreas Dresen', *Senses of Cinema*, 50: archive.sensesofcinema.com/contents/09/50/andreas-dresen-interview.html.

——(2010), 'Imaging Germany: The (Political) Cinema of Christian Petzold', in *The Collapse of the Conventional German Film and Its Politics at the Turn of the Twenty-First Century*, ed. by Jaimey Fisher and Brad Prager, Detroit: Wayne State University Press, pp. 258–84.

Adelson, Leslie A. (2000), 'Touching Tales of Turks, Germans, and Jews: Cultural Alterity, Historical Narrative, and Literary Riddles for the 1990s', *New German Critique*, 80: 93–124.

Adorno, Theodor W., Else Frenkel-Brunswik and Daniel J. Levinson (1950), *The Authoritarian Personality*, New York: Harper.

Albrecht, Nicolai *et al.* (2005), 'Ludwigshafener Position': www.iffmh.de/de/Festival_des_deutschen_Films/Ludwigshafener_Position, 10 July.

Allan, Seán (2007), '"Seit der Wende hat der Mann nur Pech gehabt. Jetzt soll er auch noch Jude sein": Theatricality, Memory and Identity in Dani Levy's Alles auf Zucker! (2004)', *Debatte*, 14/1: 25–42.

Altenloh, Emilie (2001), 'A Sociology of the Cinema', *Screen*, 42/3: 249–93.

Altman, Rick (1999), *Film/Genre*, London: BFI.

Anon (2009), 'Am Rad gedreht; Acht Berliner reisen mit einem mobilen Kino und zeigen in Polen und Deutschland Kurzfilme', *Der Tagesspiegel*, 15 July.

Ansen, David (2007), 'A Waking Nightmare, Sex: Spies und Audiotape in Corrupt East Germany', *Newsweek*, 12 February.

Applegate, Celia (1990), *A Nation of Provincials: The German Idea of Heimat*, Berkeley: University of California Press.

Arndt, Stefan (2009), 'Marken aus der Manufaktur: Filme für das 21. Jahrhundert', in *Guru Talk: Die Deutsche Filmindustrie im 21. Jahrhundert*, ed. by Thorsten Hennig-Thurau and Victor Henning, Marburg: Schüren, pp. 45–57.

Arnold, Ingrid (2007), 'Frauen und Film: Hast du heute schon einen Film von einer Frau gesehen?', *fluter*: http://film.fluter.de/de/238/thema/6448/, 28 November.

Baer, Hester (2009), *Dismantling the Dream Factory: Gender, German Cinema and the Postwar Quest for a New Film Language*, New York: Berghahn.

Bathrick, David (2005), 'Cinematic Americanization of the Holocaust in Germany: Whose Memory Is It?', in *Americanization and Anti-Americanism: The German Encounter With American Culture After 1945*, ed. by Alexander Stephen, New York: Berghahn, pp. 129–47.

——(2007), 'Whose Hi/story Is It? The US Reception of *Downfall*', *New German Critique*, 34/3: 1–16.

Bax, Daniel (2003), 'Vom Leben in Grenzsituationen; Handel und Wandel auf beiden Seiten der Oder', *Die Tageszeitung*, 12 February.

Becker Katharina (2006), 'Filmförderung: Wohin mit dem dummen Geld?', *Spiegel Online*, www.spiegel.de/kultur/kino/0,1518,400008,00.html, 9 February.

Beier, Lars-Olav (2007), 'On the Oscar Campaign Trail', *Spiegel Online International*: www.spiegel.de/international/spiegel/0,1518,466450,00.html, 23 February.

——(2008), 'Death Can Make People Feel Very Alive', *Spiegel Online*: www.spiegel.de/international/germany/0,1518,533538,00.html, 2 June.

——(2009), 'Lauter Leichen auf dem Konto', *Spiegel Online*: www.spiegel.de/kultur/kino/0,1518,605720,00.html, 5 February.

——(2010), 'Filmgroßprojekt "Henri 4": Riesig, stressing, babylonisch', *Spiegel Online*: www.spiegel.de/kultur/kino/0,1518,681528,00.html, 5 March.

——and Matthias Matussek (2007), 'Ich mag offene Enden', *Der Spiegel*, 24 September.

Belk, Russell W. (1996), 'Hyper-reality and Globalization: Culture in the Age of Ronald McDonald', in *Global Perspectives in Cross-Cultural and Cross-National Consumer Research*, ed. by Lalita A. Manrai and Ajay K. Manrai, London: Routledge, pp. 23–38.

Bender, Peter (2005), 'Normalisierung wäre schon viel', *Deutschland und Polen: Aus Politik und Zeitgeschichte*, 5–6: 3–9.

Berg, Sibylle (2008), 'Herr Wepper ist gut', *Die Zeit*, 20 March.

Berger, Stefan (2002), *The Search for Normality: National Identity and Historical Consciousness in Germany since 1800*, 2nd Edition, New York: Berghahn.

Bergfelder, Tim (2005), *International Adventures: Popular German Cinema and European Co-Productions in the 1960s*, Oxford and New York: Berghahn.

Berghahn, Daniela (2005), *Hollywood Behind the Wall: The Cinema of East Germany*, Manchester: Manchester University Press.

——(2006), 'Post-1990 Screen Memories: How East and West German Cinema Remembers the Third Reich and the Holocaust', *German Life and Letters*, 59: 294–308.

——(2010), 'Resistance of the Heart: Female Suffering and Victimhood in DEFA's Antifascist Films', in *Screening War: New Perspectives on German Suffering*, ed. by Paul Cooke and Marc Silberman, Rochester: Camden House, pp. 165–86.

——(2011), '"Seeing Everything with Different Eyes": The Diasporic Optic in the Films of Fatih Akın', *New Directions in German Cinema*, ed. by Paul Cooke and Chris Homewood, London: I.B. Tauris, pp. 235–52.

Betts, Paul (2000), 'The Twilight of the Idols: East German Memory and Material Culture', *Journal of Modern History*, 72/3: 731–65.

Billington, Alex (2009), 'Interview: The International Director Tom Tykwer', *firstshowing.net*: www.firstshowing.net/2009/02/12/interview-the-international-director-tom-tykwer/, 12 February.

Biskind, Peter (2004), *Down and Dirty Pictures*, London: Bloomsbury.

Bisky, Jens (2003), 'Wenn Jungen Weltgeschichte spielen, habed Mädchen stumme Rollen/Wer war die Anonyma in Berlin? Frauen, Fakten und Fiklionen/Anmerkungen zu einen grossen Bucherfolg dieses Sommers', *Süddeutsche Zeitung*, 24 September.

BKM (2009), 'Kulturstaatsminister Bernd Neumann fördert Film- und Drehbuchprojekte mit 1,742 Millionen Euro': www.bundesregierung.de/nn_25226/Content/DE/Pressemitteilungen/BPA/2009/05/2009-05-18-bkm-film-drehbuchfoerderung.html, 15 March.

Black, Joel (2002), *The Reality Effect: Film Culture and the Graphic Imperative*, London: Routledge.

Blickle, Peter (2002), *Heimat: A Critical Theory of the German Idea of Homeland*, Camden House: Rochester.

Blickpunkt: Film (2004), 'Arthouse-Filme erobern Multiplexe', 29 November, p. 12.

——(2005), 'Erfolgreiche Bilanz für GFP-GF David Groenenwold', 31 January, p. 14.

——(2006), 'WIFT Germany setzt Aufbauarbeit fort', 24 July, p. 26.

——(2009a) 'Filmstandort Nummer eins', 9 February, p. 38.

——(2009b), 'Förderstabilität im 13. Jahr', 9 February, p. 38.

——(2009c), 'Von 1001 Nacht bis Salome', 1 June, p. 26.

——(2009d), 'Von Deutschland in die Welt', 23 February, p. 18.

——(2009e), 'Vorbereitung auf die Krise', 2 Feb, p. 30.

——(2010), 'Fünf vor Zwölf für die FFA?': www.mediabiz.de/film/news/fuenf-vor-zwoelf-fuer-die-ffa/284620, 18 January.

Blum, Heiko R. (2001), *Meine Zweite Heimat Hollywood: Deutschsprachige Filmkunstler in Den USA*, Berlin: Henschel.

Boa, Elizabeth and Rachel Palfreyman (2000), *Heimat—A German Dream: Regional Loyalties and National Identity in German Culture 1890–1990*, Oxford: Oxford University Press.

Boberski, Heiner (2004), *Adieu Spaßgesellschaft*, Vienna: Edition va bene.

Borcholte Andreas (2007), 'Fatih Fassbinder', *Der Spiegel*, 23 May.

Bowcott, Owen (2010), 'For you, YouTube, the spoofs are over ...', *The Guardian*, 21 April.

Bracher, Karl Dietrich (2001), *Die totalitäre Erfahrung. Geschichte als Erfahrung. Betrachtungen zum 20. Jahrhundert*, Stuttgart: DVA.

Bradshaw, Peter (2003), '*Good Bye, Lenin!*', *The Guardian*, 25 July.

——(2007), '*The Lives of Others*', *The Guardian*, 13 April.

——(2009), '*The White Ribbon*', *The Guardian*, 12 November.

Brady, Martin and Joanne Leal (2011), *Wim Wenders and Peter Handke: Collaboration, Adaptation, Recomposition*, Amsterdam: Rodopi.

Braun, Jutta and René Wiese (2005), 'DDR-Fußball und gesamtdeutsche Identität im Kalten Krieg', *Historical Social Research*, 30: 191–210.

Breinersdorfer, Fred and Marc Rothemund (2006), 'Inspiration durch Fakten: Bemerkungen zum Konzept des Films', in *Sophie Scholl: Die letzten Tage*, ed. by Fred Breinersdorfer, Frankfurt am Main: Fischer, pp. 316–30.

Brockmann, Stephen (2010), *A Critical History of German Film*, Rochester: Camden House.

Broder, Henryk M. (2007), 'Dani Levy's Failed Hitler Comedy', *Spiegel International*: www.spiegel.de/international/spiegel/0,1518,458499,00.html, 1 September.

Burbidge, James (2009), 'Piracy and the Future of the Film Industry', *raindancetv*:http://raindance.tv/blog/jamesburbidge/09–11–2009/piracy-and-future-film-industry, 9 November.

Burns, Rob (2009), 'On the Streets and on the Road: Identity in Transit in Turkish-German Travelogues on Screen', *New Cinemas*, 7/1: 11–26.

Buß, Christian (2009), 'Dann lieber Mario Barth', *Spiegel Online*, www.spiegel.de/kultur/kino/0,1518,615349,00.html, 23 March.

Butler, Judith (1990), *Gender Trouble*, London: Routledge.

Caprio, Temby (1997), 'Women's Cinema in the Nineties: *Abgeschminkt!* And Happy Ends?', *Seminar* 33/4: 374–87.

Castendyk, Oliver (2006), 'Der Filmfonds is tot – es lebe der Filmfonds!' *Blickpunkt: Film*, 7 June, pp. 44–5.

——(2008), *Die deutsche Filmförderung: eine Evaluation*, Potsdam: Eric Pommer Institute.

CDU, CSU und SPD (2005), *Gemeinsam für Deutschland. Mit Mut und Menschlichkeit. Koalitionsvertrag*, Berlin: Bundesregierung.

Clarke, David (2006), 'Introduction: German Cinema Since Unification', in *German Cinema Since Unification*, ed. by David Clarke, London: Continuum, pp. 1–9.

——(2011), '"Capitalism Has No More Natural Enemies": The Berlin School', in *The Blackwell Companion to German Cinema*, ed. by Terri Ginsberg and Kirsten Moana Thompson, Oxford: Blackwell, pp. 134–54.

Clewell, Tammy (2004), 'Mourning Beyond Melancholia: Freud's Psychoanalysis of Loss', *Journal of the American Psychoanalytic Association*, 52/1: 43–67.

Cook, Pam (1991), 'Melodrama and the Woman's Picture', in *Imitations of Life: A Reader on Film and Television Melodrama*, ed. by Marcia Landy, Detroit: Wayne State University Press, pp. 248–62.

Cook, Roger F. and Gerd Gemünden, eds (1996), *The Cinema of Wim Wenders: Image, Narrative, and the Postmodern Condition*, Detroit: Wayne State University Press.

Cooke, Paul (2004), 'Whatever happened to Veronica Voss? Rehabilitating the "68ers" and the problem of *Westalgie* in Oskar Roehler's *Die Unberührbare* (2000)', *German Studies Review*, 27: 33–44.

——(2005), *Representing East Germany Since Unification: From Colonization to Nostalgia*, Oxford: Berg.

——(2006), 'Abnormal Consensus: The New Internationalism of German Cinema', in *German Culture, Politics, and Literature into the Twenty-First Century*, ed. by Stuart Taberner and Paul Cooke, Rochester: Camden House, pp. 223–37.

——(2007), 'Introduction: World Cinema's "Dialogues" with Hollywood', in *World Cinema's 'Dialogues' with Hollywood*, ed. by Paul Cooke, Basingstoke: Palgrave, pp. 1–16.

——(2008a), '*Der Untergang* (2004): Victims, Perpetrators and the Continuing Fascination of Fascism', in *A Nation of Victims? Representations of German Wartime Suffering from 1945 to the Present: German Monitor*, 67, ed. by Helmut Schmitz, Rodopi: Amsterdam, pp. 247–61.

——(2008b), '*Dresden* (2006), teamWorx and *Titanic* (1997): German Wartime Suffering as Hollywood Disaster Movie', *German Life and Letters*, 61: 279–94.

——(2009), 'The Limits of Consensual Film-Making? Representing National Socialism on the Screen and German "Normalisation"', in *Aesthetics and Politics in Modern German Culture*, ed. by Brigid Haines, Stephen Parker and Colin Riordan, Oxford: Peter Lang, pp. 65–77.

——(2010), 'Recent Trends in German Film Studies', *Monatshefte*, 101/3: 384–99.

——and Marc Silberman, eds (2010), *Screening War: Perspectives on German Suffering*, Rochester, Camden House.

——and Chris Homewood, eds (2011), *New Directions in German Cinema*, London: I.B. Tauris.

Copsey, Dickon (2006), 'Women Amongst Women: The New German Comedy and the Failed Romance', in *German Cinema Since Unification*, ed. by David Clarke, London: Continuum, pp. 181–206.

Corrigan, Tim (1983), *New German Film: The Displaced Image*, Austin: University of Texas Press.

Corsten, Volker (2006), 'Fest des deutschen Autorenkinos', *Welt am Sonntag*, 19 February.

Coury, David N. (1997), 'From Aesthetics to Commercialism: Narration and the New German Comedy', *Seminar: A Journal of Germanic Studies*, 33/4: 356–73.

Davidson, John E. (1999), *Deterritorializing the New German Cinema*, Minneapolis: University of Minnesota Press.

——(2004), '"Against Rushing through Places that Out To Be Dwelt In": Kracauer, Wenders, and the Post-Turnerian impulse', *Studies in European Cinema*, 1/2: 91–104.

——(2007), 'Gnome is Where the Heart is: The New Europe in German-Language Cinema', in *Zoom in, Zoom out: Crossing Borders in Contemporary European Cinema*, ed. by Sandra Barriales-Bouche and Marjorie Attignol Salvodon, Newcastle: Cambridge Scholars Press, pp. 186–207.

——and Sabine Hake, eds (2007), *Framing the Fifties: Cinema in a Divided Germany*, New York: Berghahn.

Dawson, Jan (1976), *Wim Wenders*, trans. by Carla Wartenberg, Toronto: Festival of Festivals.

ddp (2006), 'Lust auf Kino machen', *ddp Basisdienst*, 30 March.

de Luca, Tiago (2011), *Realism of the Senses: A Tendency in Contemporary World Cinema*, unpublished PhD Thesis, University of Leeds.

Decker, Kerstin (2000), 'Immer wieder: das Leben. Ein Defa-Regisseur in einer Anti-Defa-Wirklichkeit', *Tagesspiegel*, 10 May.

——(2002), 'Die Wüste lebt', *Tagesspiegel*, 13 October.

Deleuze, Gille (1986), *Cinema 1: The Movement-Image*, trans. by Hugh Tomlinson and Barbara Habberham, London: Continuum.

——(1989), *Cinema 2: The Time-Image*, trans. by Hugh Tomlinson and Robert Galeta, London: Continuum.

Dell, Matthias (2009), '*Männerherzen*', *epd Film*, October: 40.

Demmerle, Denis (2008), 'Ich bin ein gestörter Teenager', *Spiegel Online*: www. spiegel.de/schulspiegel/leben/0,1518,594020,00.html, 20 December.

Dettweiler, Marco (2009), 'Fragwürdige Werbung: Ein Selbstmordanschlag, der keiner war', *FAZ.net*: www.faz.net/s/RubCD175863466D41B-B9A6A93D460B81174/Doc~EBDF6257F06E64F8BB86776CCC0DF8D09~ATpl~Ecommon~Scontent.html, 10 September.

Doane, Mary Ann (1981), '*Caught* and *Rebecca*: the Inscription of Feminity as Absence', *Enclitic* 5/2: 75–89.

——(1990), 'Information, Crisis, Catastrophe', in *Logics of Television: Essays in Cultural Criticism*, ed. by Patricia Mellencamp, London: BFI, pp. 222–39.

dpa (2005), 'medieninitiative! Deutschland als Aktionsbündnis gegründet': www.presseportal.de/story.htx?nr=699812&firmaid=53859, 8 July.

Dress, Peter (2002), *Vor Drehbeginn: Effektive Planung von Film- und Fernsehproduktion*, Bergisch Gladbach: Bastei Lubbe.

Eckhardt, Joseph P. (1997), *The King of the Movies: Film Pioneer Siegmund Lubin*, Cranbury: Associated University Presses.

Eichinger, Bernd (2004), 'Hitlers letzte Tage als Kinofilm', www.ard.de/kultur/film-kino/-/id=8328/nid=8328/did=188420/zclncd/, 16 September.

Elsaesser, Thomas (1989), *New German Cinema: A History*, Basingstoke: Macmillan.

——(1999), 'Introduction: German Cinema in the 1990s', in *The BFI Companion to German Cinema*, ed. by Thomas Elsaesser with Michael Wedel, London: BFI, pp. 3–16.

——(2002), 'New German Cinema and History: The Case of Alexander Kluge', in *The German Cinema Book*, ed. by Tim Bergfelder, Erica Carter and Deniz Göktürk, London: BFI, pp. 182–91.

——(2005), *European Cinema Face to Face with Hollywood*, Amsterdam: Amsterdam University Press.

Epstein, Edward Jay (2005), 'How To Finance a Hollywood Blockbuster', *The Hollywood Economist*: www.slate.com/id/2117309/, 25 April.

Erbe, Günter (1993), *Die verfemte Moderne: die Auseinandersetzung mit dem ‚Modernismus‘ in Kulturpolitik, Literaturwissenschaft und Literatur der DDR*, Opladen: Westdeutscher.

Erdoğan, Nezih (2009), 'Star Director As Symptom: Reflections on the Reception of Fatih Akın in the Turkish Media', *New Cinemas*, 7/1: 27–38.

Eurimages (2009), 'Co-Production Facts and Figures since 1989': www.coe.int/t/e/cultural_co-operation/eurimages/funding_history/coproduction/2009_coproductions.asp#TopOfPage, accessed 30 August.

Evans, Owen (2010), 'Redeeming the Demon? The Legacy of the Stasi in *Das Leben der Andersen*', *Memory Studies*, 3: 164–77.

——(2011), 'Wonderfully Courageous? The Human Face of a Legend in *Sophie Scholl: The Final Days* (2005)', in *New Directions in German Cinema*, ed. by Paul Cooke and Chris Homewood, London: I.B. Tauris, pp. 57–75.

Ezra, Elizabeth and Terry Rowden, eds (2006), *Transnational Cinema: The Film Reader*, London: Routledge.

Fainaru, Dan (2005), '*Unveiled (Fremde Haut)*', *Screen International*, 12 July.

Fay, Jennifer (2008), *Theaters of Occupation: Hollywood and the Reeducation of Postwar Germany*, Minneapolis: University of Minnesota Press.

FAZ (2007), 'Deutsche Frauen machen, was sie wollen', *Frankfurter Allgemeine Zeitung*, 19 October.

FFA (2001), 'Kino-Ergebnisse – 1996 bis 2001 auf einen Blick': www.ffa.de/downloads/marktdaten/1_Fuenf_Jahre_Blick/96bis01_jahresabschluss.pdf, accessed 28 February.

——(2004), 'Kino-Ergebnisse - 1999 bis 2004 auf einen Blick': www.ffa.de/downloads/marktdaten/1_Fuenf_Jahre_Blick/99bis04_jahresabschluss.pdf, accessed 28 February.

——(2009), 'Das Kinoergebnis 2009': www.ffa.de/downloads/marktdaten/1_
Fuenf_Jahre_Blick/04bis09_jahresabschluss.pdf, accessed 28 February.

——(2010a), 'DFFF Figures 2007–2009: www.ffa.de/downloads/dfff/dfffin-
zahlen/2010–02–10%20DFF%20Flyer%20Evaluation_engl.pdf, accessed
18 February.

——(2010b), 'Filmhitliste', www.ffa.de, accessed 18 February.

——(2010c), 'Haushalt', www.ffa.de, accessed 18 February.

——(2010d), 'Kinobesucher 2009 Strukturen und Entwicklungen auf Basis
des GfK Panels', http://www.ffa.de/downloads/publikationen/kinobe-
sucher_2009.pdf, accessed 23 January.

Fiedler, Matthias (2006), 'German Crossroads: Visions of the Past in German
Cinema after Reunification', in Memory Contests: the Quest for Identity
in Literature, Film, and Discourse since 1990, ed. by Anna Fuches, Mary
Cosgrove, and Georg Grote, Rochester: Camden House, pp. 127–45.

Filmmaker (2009), 'Doris Dörrie, Cherry Blossoms', Filmmaker Magazine,
http://filmmakermagazine.com/directorinterviews/2009/01/doris-
drrie-cherry-blossoms.html, 16 January.

Fischer, Leo (2006), 'Geschäft mit Filmfonds völlig zusammengebrochen', Die
Welt, 12 August.

Fisher, Jaimey (2011), 'German Autoren Dialogue with Hollywood? Refunc-
tioning the Horror Genre in Christian Petzold's Yella (2007)', in New
Directions in German Cinema, ed. by Paul Cooke and Chris Homewood,
London: I.B. Tauris, pp. 182–99.

——and Brad Prager (2010), 'Introduction', in The Collapse of the Conventional:
German Film and its Politics at the Turn of the Twenty-first Century, ed. by
Jaimey Fisher and Brad Prager, Detroit: Wayne State Press, pp. 1–38.

Flynn, John L. (2005), War of the Worlds: From Wells to Spielberg, Owings
Mills: Galactic Books.

Forrest, Tara and Anna Teresa Scheer, eds (2010), Christoph Schlingensief: Art
Without Borders, Bristol: Intellect.

Freydag, Nina (2001), 'Quälend und wahr', Die Woche, 23 May.

Frickel, Thomas (2010), German Documentaries 2010, Munich: German Films
Service + Marketing.

Frieden, Sandra, Richard W. McCormick, Vibeke Rutzou Peterson and aurie
Melissa Vogelslang, eds (1993), Gender and German Cinema: Gender and
Representation in New German Cinema, vol. 1, Providence: Berg.

Fuhr, Eckhard (2004), 'Auf Augenhöhe', Die Welt, 25 August.

Funck, Gisa (2003), 'Im Auge des Sturms: Wird ein Autor entdeckt: Bernd
Lichtenbergs Good Bye, Lenin!', Frankfurter Allgemeine Zeitung, 15
February.

Funke, Thorsten (2005), Fremde Haut, critic.de: www.critic.de/film/fremde-
haut-327/, 2 October.

Gaines, Jane (1995), 'Feminist Heterosexuality and Its Politically Incorrect
Pleasures', Critical Inquiry, 21: 382–410.

Gaitanides, Michael (2001), *Ökonomie des Spielfilms*, Munich: Reinhard Fischer.

Gansera, Rainer (2009), 'Deutschland, einig Förderland', *epd Film*, December: 32–3.

Garncarz, Joseph (1994), 'Hollywood in Germany: The Role of American Films in Germany, 1925–1990', in *Hollywood in Europe: Experiences of a Cultural Hegemony*, ed. by David W. Ellwood and Rob Kroes, Amsterdam: VU University Press, pp. 94–135.

Garwood, Ian (2002), 'The Autorenfilm in Contemporary German Cinema', in *The German Cinema Book*, ed. by Tim Bergfelder, Erica Carter and Deniz Göktürk, London: BFI, pp. 202–10.

Gemünden, Gerd (1998), *Framed Vision: Popular Culture and the Contemporary German and Austrian Imagination*, Ann Arbor: University of Michigan Press.

—— (2008), *A Foreign Affair: Billy Wilder's American Films*, New York: Berghahn.

German Film Quarterly (2002), 'Regional Film Funding In Germany – the "Big Six"', *German Film Quarterly*, 1: 8–15.

Ginsberg, Terri and Kirten Moana Thompson, eds (1996), *Perspectives on German Cinema*, New York: G.K. Hall & Co.

Gledhill, Christine (1987), *Home is Where the Heart is: Studies in Melodrama and the Woman's Film*, London: BFI.

Göktürk, Deniz (2002), 'Beyond Paternalism: Turkish German Traffic in Cinema', in *The German Cinema Book*, ed. by Tim Bergfelder, Erica Carter and Deniz Göktürk, London: BFI, pp. 248–56.

Golz, Hans-Georg, ed. (2005), *Deutschland und Polen APuZ*, 5–6.

Graf, Alexander (2002), *The Cinema of Wim Wenders: The Celluloid Highway*, London: Wallflower.

Graf, Dominik, Christian Petzold and Christoph Hochhäusler (2006), *Ein Gespräch via e-mail über die 'Neue Berliner Schule'*, Berlin: Deutsche Film- und Fernsehakademie.

Graton, Elise (2006), 'Den Kinobesuch als Ereignis vermarkten Deutsche Filmwirtschaft', *Berliner Zeitung*, 31 March.

Haase, Christine (2006), 'Ready for His Close-up? On the Success and Failure of Representing Hitler in *Der Untergang*', *Studies in European Cinema*, 3/3: 189–99.

——(2007), *When Heimat Meets Hollywood: German Filmmakers and America, 1985–2005*, Rochester: Camden House.

Habermas, Jürgen (2010), 'Germany and the Euro Crisis', trans. by Ciaran Cronin, *The Nation*, 28 June.

Hagen, Brad (1996), 'Women Control Pic Picks', *Variety*, 19 August.

Hake, Sabine (2002), *German National Cinema*, London: Routledge.

——(2008), *German National Cinema*, 2nd Edition, London: Routledge.

——(2010), 'Political Affects: Antifascism and the Second World War in

Frank Beyer and Konrad Wolf', in *Screening War: Perspectives in German Suffering*, Rochester: Camden House, pp. 102–22.

Hallam, Julia with Margaret Marshment (2000), *Realism and Popular Cinema*, Manchester: Manchester University Press.

Halle, Randall (2000), '"Happy Ends" to Crises of Heterosexual Desire: Towards a Social Psychology of Recent German Comedies', *Camera Obscura*, 15/2: iv–39.

——(2002), 'German Film, Aufgehoben: Ensembles of Transnational Cinema', *New German Critique*, 87: 1–48.

——(2007), 'Views from the German-Polish Border: The Exploration of International Space in *Halbe Treppe* and *Lichter*', *The German Quarterly*, 80/1: 77–96.

——(2008), *German Film After Germany: Towards a Transnational Aesthetic*, Urbana: University of Illinois Press.

——and Margaret McCarthy, eds (2003), *Light Motives: German Popular Film in Perspective*, Detroit: Wayne State University Press.

Hanich, Julian (2007), 'Ein Recht auf Liebe gibt es nicht', *Tagesspiegel*, 13 February.

Hansen, Miriam (1981), 'Cooperative Auteur Cinema and Oppositional Public Sphere: Alexander Kluge's Contribution to Germany in Autumn', *New German Critique*, 24/25: 36–56.

——, Karsten Witte, J. Hoberman, Thomas Elsaesser, Gertrud Koch, Friedrich P. Kahlenberg, Klaus Kreimeier and Heide Schlüpmann (1985), 'Dossier on Heimat', *New German Critique*, 36: 3–24.

Hardt, Ursula (1996), *From Caligari to California: Eric Pommer's Life in the International Film Wars*, Providence: Berghahn.

Harmsen, Torsten (2006), 'Irgendwie geht's um Stasi: 700 Schüler sehen auf Einladung Klaus Bögers *Das Leben der Anderen*', *Berliner Zeitung*, 4 April.

Hauser, Dorothea and Andreas Schroth (2002) 'Das Thema ist erledigt. Romuald Karmakar, Christian Petzold und Andres Veiel zum Politischen im deutschen Film', *Ästhetik & Kommunikation*, 117: 44–60.

Heisenberg, Benjamin, Jens Börner, Christopher Hochhäuster and Nicolas Wackerbarth (2006), 'Selbstgespräch', in *Revolver: Kino muss gefährlich sein*, ed. by Marchus Seibert, Frankfurt am Main: Verlag der Autoren, pp. 9–30.

Henckel von Donnersmarck, Florian (2006), 'Im Ausland wird man immer zuerst auf Nazis angesprochen. Das nervt', *Die Welt*, 21 March.

Hennig-Thurau, Thorsten and Victor Henning, eds (2009), *Guru Talk: Die Deutsche Filmindustrie im 21. Jahrhundert*, Marburg: Schüren.

Herminghouse, Patricia and Magda Mueller (1997), 'Introduction: Looking for Germania', in *Gender and Germanness: Cultural Productions of the Nation*, ed. by Patricia Herminghouse and Magda Mueller, Providence: Berghahn, pp. 1–18.

Higson, Andrew (2000), 'The Limiting Imagination of National Cinema', in *Cinema and Nation*, ed. by Mette Hjort and Scott Mackenzie, London: Routledge, pp. 63–74

——(2003), *English Heritage, English Cinema: Costume Drama Since 1980*, Oxford: Oxford University Press.

Hochhäusler, Christoph *et al.* (2006), 'Neue realistische Schule', in *Revolver: Kino muss gefährlich sein*, ed. by Marchus Seibert, Frankfurt am Main, Verlag der Autoren, pp. 343–63.

Hodgin, Nick (2011), *Screening the East: Heimat, Memory and Nostalgia in German Film Since 1989*, New York: Berghahn.

Homewood, Chris (2006), 'The Return of "Undead" History: The West German Terrorist as Vampire and the Problem of "Normalizing" the Past in Margarethe von Trotta's *Die bleierne Zeit* (1981) and Christian Petzold's *Die innere Sicherheit* (2001)', in *German Culture, Politics, and Literature into the Twenty-First Century: Beyond Normalization*, ed. by Stuart Taberner and Paul Cooke, Rochester: Camden House, pp. 121–35.

——(2007), 'Challenging the Taboo: The Memory of West Germany's Terrorist Past in Andres Veiel's Black Box BRD (2001)', *New Cinemas*, 5/2: 115–26.

——(2011), 'From Baader to Prada: Memory and Myth in Uli Edel's *The Baader Meinhof Complex* (2008)', in *New Directions in German Cinema*, ed. by Paul Cooke and Chris Homewood, London: I.B. Tauris, pp. 128–46.

Hubert, Eva (2009), '"Anspruch vor Kommerz" – Filmförderung Hamburg Schleswig-Hostein', *Blickpunkt: Film*, 16 February, p. 17.

Hudson, David (2009), '*The White Ribbon*: How German is it?', *MUBI*: http://mubi.com/notebook/posts/953, 28 August.

Hughes-Warrington, Marnie (2007), *History Goes to the Movies: Studying History on Film*, London: Routledge.

Iljine, Diana and Klaus Keil (2000), *Film Produkion: Der Produzent*, Munich: TR-Verlagswesen.

Jäckel, Anne (2003), *European Film Industries*, London: BFI.

Jacobsen, Wolfgang, Anton Kaes and Hans Helmut Prinzler, eds (2004), *Geschichte des deutschen Films*, Stuttgart: Metzler.

Jäger, Manfred, (1994), *Kultur und Politik in der DDR 1945–1990*, Cologne: Verlag Wissenschaft und Politik Claus-Peter von Nottbeck.

James, Nick (2006), 'German Cinema: All Together Now', *Sight and Sound*, 12: 26–32.

——(2008) 'New Crowned Despair', *Sight and Sound*, 18: 5.

Jancovich, Mark, Lucy Faire and Sarah Stubbings (2003), *The Place of the Audience: Cultural Geographies of Film Consumption*, London: BFI.

Jekubzik, Günter H. (2005), 'Wenders Interview', FILMtabs: www2.arena.de/FILMtabs/archiv/Personen/Wenders%20in%20Aachen.html, accessed 17 May.

John, Erhard (1964), *Einführung in die Ästhetik*, Leipzig: VEB Verlag Enzyklopädie.

Jones, Amelia (1994), 'Postfeminism, Feminist Pleasures, and Embodied Theories of Art', in *New Feminist Criticism: Art, Identity, Action*, ed. by Joana Frueh, Cassandra L. Langer and Arlene Raven, New York: Harper Collins, pp. 16–41.

Jung, Irene (2009), 'Über 70—da geht doch noch was', *Hamburger Abendblatt*, 19 December.

Kaes, Anton (1989), *From Hitler to Heimat: The Return of History as Film*, Cambridge, Harvard University Press.

Kammerer, Dietmar (2009), 'Kontrolle ist alles', *taz*, 6 February.

Keil, Klaus, Felicitas Milke, Dagmar Hoffmann, Martina Schuegraf and Marcus Zoll (2006), *Demografie und Filmwirtschaft: Studie zum demografischen Wandel und seinen Auswirkungen auf Kinopublikum und Filminhalte in Deutschland*, Potsdam: Erich Pommer Institut.

Kelly, Richard (2000), *The Name of This Book is Dogme 95*, London: Faber and Faber.

Kershaw, Ian (2004), 'The Human Hitler,' *The Guardian*, 17 September.

King, Alasdair (2003), 'Placing Grün ist die Heide (1951): Spatial politics and emergent West German identity' in *Light Motives: German Popular Cinema*, ed. by Randall Halle and Margaret McCarthy, Detroit: Wayne State University Press, pp. 130–47.

——(2011), 'No Place Like Heimat: Mediaspaces and Moving Landscapes in Edgar Reitz's *Heimat 3*', in *New Directions in German Cinema*, ed. by Paul Cooke and Chris Homewood, London: I.B. Tauris, pp. 252–73.

Kirschner, Stefan (2002), 'Es war nicht klar, ob wir je zum Ende kommen', *Berliner Morgenpost*, 12 February 2002.

Kleiner, Felicitas (2008), '*Krabat*', *film-dienst*, 21: 22.

Knight, Julia (1992), *Women and the New German Cinema*, New York: Verso.

——(2004), *New German Cinema: Images of a Generation*, London: Wallflower.

Koebner, Sascha (2006), 'Oldtimer: Alte Menschen im Film', *Film-dienst* 16: 38–40.

Koenen, Gerd (2001), *Das rote Jahrzehnt: Unsere kleine deutsche Kulturrevolution 1967–1977*, Cologne: Kiepenheuer & Witsch.

Koepnick, Lutz (2000), 'Consuming the Other: Identity, Alterity, and Contemporary German Cinema', *Camera Obscura*, 44: 41–72.

——(2002a), 'Reframing the Past: Heritage Cinema and Holocaust in the 1990s', *New German Critique*, 87: 47–82.

——(2002b), *The Dark Mirror: German Cinema between Hitler and Hollywood*, Berkeley: University of California Press.

Köhler, Marget (2002), '"Dogmen sind Schwachsin" Die größte Freiheit beim Drehen: Andreas Dresen über sein Filmexperiement *Halbe Treppe*', *Berliner Morgenpost*, 2 October.

——(2009), 'Im Bürgerkrieg: Michael Haneke und *Das weisse Band*', *Filmdienst*: http://film-dienst.kim-info.de/artikel.php?nr=154758, 11 October.

Kopp, Kristin (2002), 'Exterritorialized Heritage in Caroline Link's "Nirgendwo in Afrika"', *New German Critique*, 87: 106–32.

——(2007), 'Reconfiguring the Border of Fortress Europe in Hans-Christian Schmid's Lichter', *Germanic Review*, 82/1: 31–53.

Kracauer, Siegfried (1960), *Theory of Film: Redemption of Physical Reality*, New York, Oxford: Oxford University Press.

Krämer, Peter (2002), 'Hollywood in Germany/Germany in Hollywood', in *The German Cinema Book*, ed. by Tim Bergfelder, Erica Carter and Deniz Göktürk, London: BFI, pp. 227–37.

——(2008), 'German Hollywood and the Germans—A Very Special Relationship', in *The Contemporary Hollywood Film Industry*, ed. by Paul McDonald and Janet Wasko, Oxford: Blackwell, pp. 240–50.

Kraushaar Wolfgang, ed. (1998), *Frankfurter Schule und Studentenbewegung: Von der Flaschenpost zum Molotowcocktail 1946–1995*, vol. 1, Frankfurt am Main: Rogner & Bernhard.

Kreimeier, Klaus (1973), *Kino und Filmindustrie in der BRD*, Kronberg: Scriptor.

Kreye, Adrian (2009), 'Männer, von Natur aus feige', *Süddeutsche Zeitung*, 22 October.

Kriest, Ulrich (2007), 'Reue und Vergebung: Hanna Schygulla ist die Galionsfigur des neuen Films von Fatih Akın *Auf der anderen Seite*', *Die Welt*, 26 September.

Kroner, Marion (1973), *Film: Spiegel der Gesellchaft?Inhaltsanalyse des jungen deutschen Films von 1962 bis 1969*, Heidelberg: Quelle & Meyer.

Krüger, Thomas (2005) 'Kulturwirtschaft: Wirtschaftspolitik oder Kulturpolitik?' *Bundeszentrale für politische Bildung*: www.bpb.de/presse/KSMLYF.html, 1 December.

Kuhlbrodt, Dietrich (2003), 'Papa ist der Größte', *taz*, 15 October.

——(2006), *Deutsches Filmwunder: Nazis immer besser*, Hamburg: Konkret.

Kulaoğlu, Tunçay (1999), 'Der neue "deutsche" Film ist "türkisch"? Eine neue Generation bringt Leben in die Filmlandschaft', *Filmforum*, 16: 8–11.

Kuratorium (2010), *Kuratorium junger deutschen Film: Informationen 49*: www.kuratorium-junger-film.de/pdf/kurinf49.pdf, January.

Kurp, Matthias (2004) 'Filmförderung erreicht Rekord-Niveau', *Medienmaerkte*: www.medienmaerkte.de/artikel/kino/040502_film_foerderung.html, 2 February.

Kuzniar, Alice A. (2000), *The Queer German Cinema*, Stanford: Stanford University Press.

Landsberg, Alison (2004), *Prosthetic Memory. The Transformation of American Remembrance in the Age of Mass Culture*, New York: Columbia University Press.

Landy, Marcia (1997), *Cinematic Uses of the Past*, Minneapolis: University of Minnesota Press.

Lee, Nathan (2005), 'In Brief', *The New York Sun*, 18 November.

Lenssen, Claudia (2001), 'Departure from the "Women's Corner": Women Filmmakers in Germany Today', *Kino* 4: 6–13.

Lequeret, Elisabeth (2006), 'Printemps allemands', *Cahiers du Cinema*, 609, February: 45–8.

Levy, Dani (2004), 'Interview': www.zucker-derfilm.de/interviewdanilevy.php, accessed 28 December.

——(2007), *Das Buch zum Film: Mein Führer: Die wirklich wahrste Wahrheit über Adolf Hitler*, Reinbek: RoRoRo.

Lewis, Alison (2003), 'Reading and Writing the Stasi File: On the Uses and Abuses of the File as (Auto)biography', *German Life and Letters*, 61: 377–97.

Lim, Dennis (2009), 'A German Wave, Focused on Today', *The New York Times*, 10 May.

Lindenberger, Thomas (2008), 'Stasiploitation – Why Not? The Scriptwriter's Historical Creativity,' *German Studies Review* 31: 557–66.

Lode, David (2009), *Abenteuer Wirklichkeit: die Filme von Andreas Dresen*, Marburg: Schüren.

Loutte, Bertand (2005), 'Allemagne année 05', *Les Inrockuptibles*, 9 February.

Lowry, Stephen and Helmut Korte (2000), *Der Filmstar*, Stuttgart: J.B. Metzler.

Ludewig, Alexander (2006), 'A German "Heimat" Further East and in the Baltic Region? Contemporary German Film as a Provocation', *Journal of European Studies*, 36: 157–79.

——(2011), *Screening Nostalgia: 100 Years of Heimat Film*, Bielefeld: transcript.

Lukács, Georg (1969) '"Größe und Verfall" des Expressionismus', in *Marxismus und Literatur. Eine Dokumentation in drei Bänden* II, ed. by Fritz J. Raddatz, Reinbek: Rowohlt, 1969, pp. 7–42.

Maccarone, Angelina (2006), 'Interview': www.ventura-film.de/fh/interv.htm, 10 July.

Malik, Sarita (1996), 'Beyond "The Cinema of Duty"? The Pleasures of Hybridity: Black British Film of the 1980s and 1990s', in *Dissolving Views: Key Writings on British Cinema*, ed. by Andrew Higson, London: Cassell, pp. 202–15.

Manovich, Lev (2000), 'What is Digital Cinema?', in *The Digital Dialectic: New Essays on New Media*, ed. by Peter Lunenfeld, Cambridge: MIT Press, pp. 174–92.

Marks, Laura U. (2000), *The Skin of the Film: Intercultural Cinema, Embodiment, and the Senses*, Durham: Duke University Press.

Martenstein, Harald (2007), 'Adolf auf der Couch', *Die Zeit*, 4 January.

Martin, Francesca (2008), 'Fans demand end to Boll's movies', *The Guardian*, 9 April.

Martin-Jones (2006), *Deleuze, Cinema and National Identity: Narrative Time in National Contexts*, Edinburgh: Edinburgh University Press.

Matschenz, Jacob (2010), 'Berlinale 2010: Der deutsche Film ist weiblich', *Zitty*, 8 February, p. 22.

McCarthy, Margaret (2003), 'Angst Takes a Holiday in Doris Dörrie's *Am I Beautiful?* (1998)', in *Light Motives: German Popular Film in Perspective*, ed. by Randall Halle and Margaret McCarthy, Detroit: Wayne State, pp. 376–94.

McGee, Laura G. (2003), 'Revolution in the Studio? The DEFA's Fourth Generation of Film Directors and Their Reform Efforts in the Last Decade of the GDR', *Film History*, 15/4: 444–64.

——(2011), 'Too Late for Love? The Cinema of Andreas Dresen on *Cloud 9* (2008)', in *New Directions in German Cinema*, ed. by Paul Cooke and Chris Homewood, London: I.B. Tauris, pp. 219–34.

McRobbie, Angela (2004), 'Post-Feminism and Popular Culture', *Feminist Media Studies*, 4/3: 255–64.

MEDIA (2007), http://ec.europa.eu/information_society/media/overview/2007/index_en.htm, 15 November.

Metz, Christian (2000), 'The Imaginary Signifier', in *Film and Theory: An Anthology*, ed. by Robert Stam and Toby Miller, Oxford: Blackwell Publishing, pp. 408–36.

Meza, Ed (2005), 'New Government Not as Kind to Hollywood', *Daily Variety*, 15 November.

Mildenberger, Katja (2000), 'Filme von Frauen: "Die feministische Frage ist heute eher sekundär"', *Die Welt Online*: www.welt.de/print-welt/article539079/Filme_von_Frauen_Die_feministische_Frage_ist_heute_eher_sekundaer.html, 18 October.

Millar, Alice (1983), *For Your Own Good: Hidden Cruelty in Child-Rearing and the Roots of Violence*, New York: Farrar, Straus & Giroux.

Miller, Toby, Nitin Govil, John McMurria and Richard Maxwell (2001), *Global Hollywood*, London: BFI.

Miller, Toby, Nitin Govil, John McMurria, Richard Maxwell and Ting Wang (2005), *Global Hollywood: No. 2*, London: BFI.

Moorti, Sujata (2003), 'Desperately Seeking an Identity: Diasporic Cinema and the Articulation of Transnational Kinship', *International Journal of Cultural Studies*, 6/3: 355–76.

Mueller, Gabriele and James Skidmore, eds (2012), *Cinema and Social Change in Germany and Austria*, Waterloo: Wilfried Laurier University Press.

Mulvey, Laura (1975), 'Visual Pleasure and Narrative Cinema', *Screen* 16/3: 6–18.

——(2006), *Death 24x a Second: Stillness and the Moving Image*, London: Reaktion.

Muntean, Nick and Anne Helen Petersen (2009), 'Celebrity Twitter: Strategies of Intrusion and Disclosure in the Age of Technoculture', *M/C Journal*, 5/12: www.journal.media-culture.org.au/index.php/mcjournal/article/viewArticle/194/0.

Nagib, Lúcia (2006), 'Towards a Positive Defeinition of World Cinema', in *Remapping World Cinema: Identity, Culture and Politics in Film*, ed. by

Song Hwee Lim and Stephanie Dennison, London: Wallflower Press, pp. 30–7.

——(2009),'Introduction', in *Realism and Audiovisual Media*, ed. by Lúcia Nagib and Cecilia Mello, Basingstoke: Palgrave, pp. xiv–xxvi.

Naughton, Leonie (2002), *That Was the Wild East*, Ann Arbor: University of Michigan Press.

Neckermann, Gerhard (2000), *Die Kinobesucher 1999: Strukturen und Entwicklungen auf Basis des GfK-Panels*, Berlin: FFA.

Negele, Thomas (2009), '"Schnelle Lösung angestrebt", interview with HDF-Vorstandsvortizender Thomas Negele', *Blickpunkt: Film*, 30 March.

Neumann, Bernd (2009), 'Der deutsche Film ist weiter auf Kurs', *Blickpunkt Film*, 1 June, p. 21.

Newman, David (2006), 'The Lines That Continue to Separate Us: Borders in Our "Borderless" World', *Progress in Human Geography*, 30/2: 143–61.

Niven, Bill (2001), *Facing the Nazi Past: United Germany and the Legacy of the Third Reich*, London: Routledge.

Noh, David (2008), 'Cherry Blossom Time: Germany's Doris Dörrie Ventures to Japan for Drama of Aging and Rebirth', *Film Journal International*: www.filmjournal.com/filmjournal/content_display/news-and-features/features/movies/e3ic8de2356a5754927491aefe2b76a8f1a, 30 December.

Nord, Christina (2008), 'Die neue Naivität', *taz*, 20 October.

Nörenberg, Britta (2010), *Auswertung der Top 50-Filmtitel des Jahres 2009 nach soziodemografischen Sowie kino- u. filmspezifischen Informationen auf Basis des GfK Panels*, Berlin: FFA.

Palfreyman, Rachel (2006), 'The Fourth Generation: Legacies of Violence as Quest for Identity in Post-Unificatin Terrorism Films', in *German Cinema Since Unification*, ed. by David Clarke, London: Continuum, pp. 11–42.

——(2010), 'Links and Chains: Trauma Between the Generations in the Heimat Mode', in *Screening War: Perspectives on German Suffering*, ed. by Paul Cooke and Marc Silberman, Rochester: Camden House, pp. 145–65.

Paoli, Paul-François (2009), 'Une histoire qui ne cesse d'évoluer', *Le Figaro*, 21 November.

Petrie, Graham (1985), *Hollywood Destinies: European Directors in America, 1922–1931*, London: Routledge.

Petro, Patrice (1989), *Joyless Streets: Women and Melodramatic Representation in Weimar Germany*, Princeton: Princeton University Press.

Petzold, Christian (2009), 'Uns Fehlt eine Filmwirtschaft', *epd Film*, December: 30–1.

Phillips, Gene D. and Walter Murch (2004), *Godfather: The Intimate Francis Ford Coppola*, Lexington: University Press of Kentucky.

Phillips, Klaus (1998), 'Interview with Doris Dörrie: Filmmaker, Writer, Teacher', in *Triangulated Visions: Women in Recent German Cinema*, ed. by Ingebord Majer O'Sickey and Ingeborg von Zadow, Albany: State University of New York, pp. 173–82.

Pierson, Michele (2005), 'A Production Designer's Cinema: Historical Authenticity in Popular Films Set in the Past', in *The Spectacle of the Real: From Hollywood to Reality TV and Beyond*, ed. by Geoff King, Bristol: Intellect, pp. 139–49.

Pinkert, Anke (2008), *Film and Memory in East Germany*, Bloomington: Indiana University Press.

Pirro, Robert (2008), 'Tragedy, Surrogation and the Significance of African-American Culture in Postunification Germany: An Interpretation of *Schultze Gets the Blues*', *German Politics and Society* 26/3: 69–92.

Plowman, Andrew (2010), 'Defending Germany in the Hindukush: The "Out-of-Area" Deployments of the Bundeswehr in Somalia, Kosovo and Afghanistan in Literature and Film', *German Life and Letters*, 63: 212–28.

Poiger, Uta (2000), *Jazz, Rock and Rebels: Cold War Politics and American Culture in a Divided Germany*, Berkeley: University of California Press.

Prager, Brad (2007), *The Cinema of Werner Herzog: Aesthetic Ecstacy and Truth*, London: Wallflower Press.

——(2010), 'Suffering and Sympathy in Volker Schlöndorff's *Der neunte Tag* and Dennis Gansel's *NaPolA*', in *Screening War: Perspectives on German Suffering*, ed. by Paul Cooke and Marc Silberman, Rochester: Camden House, pp. 187–206.

Presseheft (2009a), *Deutschland 09: 13 Filme zur Lage der Nation*, Berlin: Piffl Medien.

——(2009b), *Short Cut to Hollywood*, Berlin: Senator Film Verleih.

Probst, Lothar (2006), '"Normalization" Through Europeanization: The Role of the Holocaust', in *German Culture, Politics and Literature into the Twenty-First Century: Beyond Normalization*, ed. by Stuart Taberner and Paul Cooke, Rochester: Camden House, pp. 61–74.

Rahayel, Oliver (2006) 'Funding Film in Germany', *Goethe Institute*: www.goethe.de/kue/flm/en1394196.htm, 26 August.

Rasch, William (2008), 'Introduction: Looking Again at the Rubble', in *German Postwar Films: Life and Love in the Ruins*, ed. by Wilfried Wilms and William Rasch, Basingstoke: Palgrave, pp. 1–5.

Rentschler, Eric (1981), 'American Friends and New German Cinema: Patterns of Reception', *New German Critique*, 24/25: 7–35.

——(1984), 'How American Is It? The U.S. as Image and Imaginary in German Film', *German Quarterly*, 57: 603–20.

——(1996), *The Ministry of Illusion*, Cambridge: University of Harvard Press.

——(2000), 'From New German Cinema to the Post-Wall Cinema of Consensus', in *Cinema and Nation*, ed. by Mette Hjort and Scott Mackenzie, London: Routledge, pp. 260–77.

——(2002), 'Postwall Prospects: An Introduction', *New German Critique*, 87: 3–5.

RESPE©T COPYRIGHTS (2009), '40 Prozent der Kinofilme online: Aktuelle

AfD-Studie': www.respectcopyrights.de/uploads/media/091029_PM_
RC_AfD-Studie_2009.pdf, 29 October.

Revolver (2006), 'Selbstgespräch', in *Revolver: Kino muss gefährlich sein*,
Frankfurt/Main: Verlag der Autoren, pp. 10–30.

Rodek, Hanns-Georg (2005a), 'Das Richtige tun; Premiere auf der Berlinale:
Marc Rothemunds Film über die Wider-standskämpferin *Sophie Scholl*',
Die Welt, 12 February.

—— (2005), 'Die Stars als Schnäppschen', *Die Welt*, 24 February.

—— (2006), 'Reality ping-pong', *Sign and Sight*: www.signandsight.com/
features/1074.html.

—— (2007), 'Schuld und Vergebung: Fatih Akıns Auf der anderen Seite',
Berliner Morgenpost, 27 September.

—— (2009a), 'Fatih Akıns letzte Party vor der Yuppie-Invasion', *Die Welt*, 22
December.

—— (2009b), 'Wie eine "Bad Bank" von der Stasi profitiert', *Die Welt*, 5
February

Rodowick, David N. (1998), *Gilles Deleuze's Time Machine*, Durham: Duke
University Press.

Rohrbach, Günter (2007), 'Das Schmollen der Autisten', *Der Spiegel*, 22
January.

Rombes, Nicholas (2009), *Cinema in the Digital Age*, London: Wallflower.

Romney, Jonathan (2010), 'In Search of Lost Time', *Sight and Sound*, 20: 43–4.

Rosenstone, Robert (2006), *History on Film/Film on History*, New York:
Longman.

Rössling, Ingo (2006), 'Film und Diskussion: Enkel von Stasi-Opfer zeigt
Flagge', *Die Welt*, 29 March.

Rothman, William (2004), *The 'I' of the Camera: Essays in Film Criticism,
History, and Aesthetics*, 2nd Edition, Cambridge: Cambridge University
Press.

Rupprecht, Annette Maria (2006), 'Florian Henckel von Donnersmarck – X X
L', *German Films Quarterly*: www.german-films.de/en/germanfilmsqua-
terly/seriesgermandirectors/florianhenckelvondonnersmarck/index.
html.

Rutschky, Michael (2006), 'Wir Deutschenhasser', *taz*, 15 February.

Said, Edward (1979), *Orientalism*, Vintage Books: New York.

Sander, Daniel (2007), Fassbinders Erben: die Welle, *Spiegel Online*: www.
spiegel.de/kultur/kulturspiegel/0,1518,463372,00.html, 29 January.

Sandy, Pletz (2008), *Die Phänomene Heimatfilme und Volksmusiksendungenin
Deutschland*, Saarbrücken: VDM.

Schäfer, Ulrike (2010), 'Fördert das Internet den Ideenklau?', *Stern*, 10
February.

Schanelec (2006), 'Revolver Live! Angela Schanelec and Reinhold Vorsch-
neider', in *Revolver: Kino Muß gefährlich sein*, ed. by Marcus Seibert,
Frankfurt am Main: Verlag der Autoren, pp. 404–21.

Schlipphacke, Heidi (2006), 'Melodrama's Other: Entrapment and Escape in the Films of Tom Tykwer', *Camera Obscura*, 62: 108–43.

Schmeide, Gabriela Maria (2003), 'Schauspielerischer Luxus', in *Werkgespräche zur 'Halben Treppe'*, ed. by Nikolaj Nikitin and Oliver Baumgarten, pdf provided with the DVD release of the film, pp. 36–8.

Schroth, Patrick (2010), 'Kinovergnügen zum Anfassen', *Börse Online*: www.boerse-online.de/aktie/nachrichten/516955.html?nv=nv-suche, 18 February.

Schulz-Ojala, Jan (2004), 'Der Übersterbensgroße – von Monstern und Menschen: Bernd Eichinger und sein Team stellen in Berlin ihren Hitler-Film *Der Untergang* vor', *Tagespiegel*, 23 August.

Seeßlen, Georg (1999), 'Außen. Nacht. Andreas Dresens *Nachtgestalten* machen Hoffnung auf ein anderes detusches Kino', *Die Zeit*, 19 August.

——(2007), 'So gewinnt man einen Auslands-Oscar', *Die Zeit*, 22 February.

——(2008), 'Neue Heimat, alte Helden', *epd Film*, April: 22–7.

Shandley, Robert R. (2001), *Rubble Films: German Cinema in the Shadow of the Third Reich*, Philadelphia: Temple University Press.

Sicinski, Michael (2009), 'Once the Wall Has Tumbled: Christian Petzold's *Jerichow*', *Cinema Scope*, 38: 6–9.

Sieglohr, Ulrike (2002), 'Women Film-Makers, the Avant Garde and the Case of Ulrike Ottinger', in *The German Cinema Book*, ed. by Tim Bergfelder, Erica Carter and Deniz Götürk, London: BFI, pp. 192–201.

Silberman, Marc (1995), *German Cinema: Texts in Context*, Detroit: Wayne State University Press.

——ed. (1982), 'Film and Feminism in Germany Today', *Jump Cut*, 27: 41–53.

Silverstein, Melissa (2010), '2009 Was No Year of the Woman in Hollywood', *Women in Hollywood*: http://womenandhollywood.com/2010/02/24/2009-was-no-year-of-the-woman-in-hollywood/, 24 February.

Spiegel (1996), 'Das Lachen macht's', 16 September.

——(2000), 'Marlene', 19 June.

Spitzenorganisation der Filmwirtschaft e. V. (2009), *Filmstatistisches Jahrbuch 2009*, Nomos Verlag: Berlin.

Stacey, Jackie (1991), 'Feminine Fascinations: Forms of Identification in Star-Audience Relations', in *Stardom: Industry of Desire*, ed. by Christine Gledhill, London: Routledge, pp. 141–63.

Staiger, Janet (1993), 'Taboos and Totems: Cultural Meaning of *The Silence of the Lambs*', in *Film Theory Goes to the Movies*, ed. by Jim Collins, Hilary Radner and Ava Collins, London: Routledge, pp. 142–54.

Stone, Rob (2012), *Walk, Don't Run: The Cinema of Richard Linklater*, New York: Columbia University Press.

Storm, Sebastian (2000), *Stukturen der Filmfinanzierung in Deutschland*, Potsdam: Verlag für Berlin-Brandenburg.

Stuart, Jan (2009), 'Seeking the Essence of Japan? Look to Germany', *New York Times*, 9 January.

Stumpf, Rainer (2009), 'Starke Frauen: Das aktuelle deutsche Kino ist weiblich', *Deutschland Magazine*: www.magazine-deutschland.de/de/artikel/ artikelansicht/article/starke-frauen.html, 19 October.

Suchsland, Rüdiger (2005), 'Langsames Leben, schöne Tage kino Annäherungen an die "Berliner Schule"', *film-dienst*, 13: 7–9.

——(2006), 'Mundger konsumierbare Vergangenheit', *Teleopolis*, 23 March.

——(2009a), 'Das Superweib des Mittelalters', *Teleopolis*: http://www.heise. de/tp/blogs/6/146406, 22 October.

——(2009), 'The International', *film-dienst*, 4: 20–1.

Sylvester, Regine (2005), 'Wir drehen hier nur einen Film: der Regisseur Andreas Dresen erzählt vim Glück des Wanderers', *Berliner Zeitung*, 12 November.

Taberner, Stuart (2005), 'Philo-Semitism in Recent German Film: *Aimee und Jaguar, Rosenstrasse* and *Das Wunder von Bern*', *German Life and Letters*, 58: 357–72.

——and Paul Cooke (2006), 'Introduction', in *German Culture, Politics and Literature into the Twenty-First Century*, ed. by Stuart Taberner and Paul Cooke, Rochester: Camden House, pp. 1–17.

Tagespiegel (2009), 'Warum unser Land so toll ist: Eine Antwort auf Deutschland 09', 26 March.

Thomsen, Christian Braad (1997), *Fassbinder: The Life and Work of a Provocative Genius*, trans. by Martin Chalmers, London: Faber and Faber.

Tillson, Tamsen (2006), 'Boll K.O.'s Crix in the Ring', *Daily Variety*, 25 September.

Tilmann, Christina (2007), 'Wer ist Florian Henckel von Donnersmarck', *Tagesspeigel*, 25 February.

Tittelbach, Rainer (2001), 'Wenn Schauspieler plötzlich Pommes verkaufen', *Die Welt*, 28 May.

Toplin, Robert Brent (2002), *Reel History. In Defense of Hollywood*, Lawrence: University of Kansas Press.

Trimborn, Jürgen (1998), *Der Deutsche Heimatfilm der fünfziger Jahre: Motive, Symbole und Handlungsmuster*, Cologne: Teiresias Verlag.

Tudor, Andrew (1974), *Theories of Film*, London: BFI.

Tunç, Ayça (2011), 'Diasporic Cinema: Turkish-German Filmmakers With Particular Emphasis On Generational Differences', unpublished PhD thesis, Royal Holloway College University of London.

Tuttle, Harry (2007) 'Minimum Profile' in *Unspoken Cinema*: http://unspokencinema.blogspot.com/2007/01/minimum-profile.html, 18 January.

Tykwer, Tom, Krzysztof Kieslowski and Krzysztof Piesiewicz (2002), *Tom Tykwer: Heaven. Drehbuch, Storybord-Zeichnungen, Interviews*, Belleville: Munich.

Uhlmann, Steffen (2005), 'Affenliebe: Mit King Kong wollen die deutschen Kinos ihre Krise überwinden', *Süddeutsche Zeitung*, 14 December.

Vahabzadeh, Susan and Fritz Göttler (2007), 'Dabei sein ist längst nicht alles', *Süddeutsche Zeitung*, 23 February.

Vermögen & Steuern (2006), 'Medienfonds-Resümee: Die erwarteten Traumrenditen hat es für die Anleger nie gegeben', 1 August.

Virchow, Eckart Voigts (2009), 'Heritage and Literature on Screen: Heimat and Heritage', in *The Cambridge Companion to Literature on Screen*, ed. by Deborah Cartmell and Imelda Whelehan, Cambridge: Cambridge University Press, pp. 123–37.

von Festenberg, Nikolaus (2007), 'Die neue Alm', *Spiegel*, 30 July.

von Moltke, Johannes (2005), *No Place Like Home: Locations of Heimat in German Cinema*, Berkeley: University of California Press.

——(2007), 'Sympathy for the Devil: Cinema, History, and the Politics of Emotion', *New German Critique*, 34/3: 17–43.

Warner, Marina (1981), *Joan of Arc: The Image of Female Heroism*, New York: Knopf.

Weaver, Matthew (2010), 'Angela Merkel: German Multiculturalism has "Utterly Failed"', *The Guardian*, 17 October.

Weingarten, Susanne (2005), 'Wunders Never Cease', *Special Spiegel International Edition*, 4: 198–201.

Wenders, Wim (1992), *The Logic of Images: Essays and Conversations*, London: Faber and Faber.

——(2004), 'Tja, dann wollen wir mal,' *Die Zeit*, 21 October.

Wengierek, Reinhard (2002), 'Ein Quantum Angst bleibt immer', *Die Welt*, 26 February.

Wheatley, Catherine (2009), *Michael Haneke's Cinema: The Ethics of the Image*, New York: Berghahn.

Wilke, Manfred (2008), 'Fiktion oder erlebte Geschichte? Zur Frage der Glaubwürdigkeit des Films *Das Leben der Anderen*', *German Studies Review*, 31: 589–98.

Williams, James S. (2010), 'Aberrations of Beauty: Violence and Cinematic Resistance in Haneke's *The White Ribbon*', *Film Quarterly*, 63/4: 48–55.

Worthmann, Mertin (2001), 'Mit Vorsicht Genießen', *Die Zeit*, 27 September.

X-Filme (2010), 'X-Filme sind keine x-beliebigen Filme, sondern das genaue Gegenteil': www.x-filme.de/html/philosophie.html, accessed 17 March.

Zander, Peter (2007), 'Wenn geschludert wird; Constantin-Film feuert Volker Schlöndorff als 'Päpstin'-Regisseur. Der Grund: Kritik an der Multiverwertung von Filmen', *Die Welt*, 24 July.

——(2009a), 'Genuss mit Ironie – Fatih Akıns *Soul Kitchen*', *Die Welt*, 10 September.

——(2009b), 'Nazi-Stoffe gehen bei den Oscars am besten', *Die Welt*, 23 February.

Index

Note: 'n.' after a page reference indicates the number of a note on that page.
Page numbers in *italic* refer to illustrations.
Literary, film and television works can be found under authors' or directors' names. A separate list of film and television titles is also provided at the end of the main index.

1968 2, 95, 186
 See also student movement
'68er' 3, 6, 15, 16, 73, 104, 110, 145,
 147, 186, 187
 as contemporary elite 73
 feminism 169
 Heimat film 231, 236, 243, 251,
 258
 relationship with America 198,
 201–3, 221–7
9/11 13, 53, 115, 127, 138, 212
'99 Euro films' 32

Abrahams, Jim
 works by: *Airplane* 42; *Hot Shots!*
 42
Academy of Motion Picture Arts and
 Sciences
 German success 7, 13, 20n.6, 28,
 90, 200
 Goldberg, Whoopi 202
 Herzog, Werner 205
Ade, Maren 71, 72, 73, 164
 works by: *Alle Anderen* 34, 35, 72,
 73, 87n.5
Adlon, Percy 12, 221

works by: *Bagdad Café* 12, 221;
 Fünf letzte Tage 174;
 Rosalie Goes Shopping 12;
 Salmonberries 221
Adorno, Theodor
 works by: *Authoritarian
 Personality, The* 255
affect, affective 79–80, 105, 107,
 206–9
Afghanistan 60, 82
ageing 19, 185, 194
 representation on screen 19,
 185–95
 sexual relations amongst the
 elderly 65, 186
 See also cinema audience/
 demographics
'Agenda 2010' 2
Akın, Fatih 15, 19, 129, 138, 140–3,
 148, 183
 melodrama 5, 15, 140–6
 works by: *Alle Anderen* 34, 35, 72,
 73, 87n.5; *Auf der anderen
 Seite* 6, 34, 140, 142, 147,
 187; *Garbage in the Garden
 of Eden* 50; *Gegen die Wand*

6, 13, 140–7, *145*, 259;
Im Juli 140; *Kurz und
schmerzlos* 140; *Solino* 140;
Soul Kitchen 260–3, 262
Aladag, Feo
works by: *Fremde, Die* 137
Aladag, Züli
works by: *Elefantenherz* 139
Allied bombing 91, 108, 121n.11, 205
See also Dresden/bombing
Altman, Robert
works by: *Short Cuts* 135
America
American and German film
industry 197–203
anti-Americanism 202, 221, 227
New German Cinema 203–10,
212, 335, 228n.3, 228n.8
representation in German
culture 201–3
transnationalism 220–7
See also '68er'/relationship with
America
Americanisation 123–4, 128, 188,
198, 201–6, 222, 266
'amphibian film' 40–1
Anderson, Michael
works by: *Pope Joan* 171
Anderson, Paul
works by: *Resident Evil* 88
Annaud, Jean-Jacques
works by: *Enemy at the Gates* 126
anti-Semitism 108, 153, 154, 157
Antonioni, Michelangelo 74
Apollo Media 45
Arndt, Stefan 34, 52n.2, 253
Arslan, Thomas 71–2, 138, 139
works by: *Dealer* 139; *Ferien* 139
art house cinema 28, 43, 51, 56, 139,
198
asylum seeker 138, 180–1, 183
Ataman, Kutluğ
works by: *Lola + Bilidikid* 137
Auschwitz 126–7, 150, 158–60
auteur cinema See Autorenkino

Autorenfilm See Autorenkino
Autorenkino 12, 29–30, 43–5, 49, 51,
72, 74
auteurist 5, 12, 49
avant-garde 5, 28, 79

Baader, Andreas 2, 99, 100
Babelsberg Studio 36, 38–9, 71, 201,
205
Bademsoy, Aysum 71
Baier, Jo
works by: *Henri IV* 33
Ballhaus, Michael 13, 155, 199
Baltic region, occupation of 267n.11
banking crisis 186, 217, 218
Barth, Mario
works by: *Männersache* 40
Başer, Tevik
works by: *Vierzig Quadratmeter
Deutschland* 137
Baumann, Tobi
works by: *Wixxer, Der* 47
Bazin, André 18, 61, 75, 80
*Beauftragte der Bundesregierung für
Kultur und Medien* 34
Becker, Lars 139
Becker, Wolfgang 5, 13, 39, 43, 44,
95, 157, 200, 245, 246, 252,
260
works by: *Good Bye, Lenin!* 5,
13, 20n.5, 44, 95, 157, 200,
245–51
Berben, Iris 164, 186–7
Berger, Christian 256
Bergmann, Gretel 173
Bergman, Ingmar
works by: *sjunde inseglet, Det*
186, 225
Berlin 135, 220, 245
Berlin School 5, 15, 18, 24, 45, 61,
71–86, 88, 98, 103, 130, 131
Berlin Wall
fall of 2, 8, 118, 119, 163n.6, 227,
243, 244, 247
life with 155, 157, 163n.6, 242–3

Berliner Schule See Berlin School
Bertele, Brigitte
works by: *Nacht vor Augen* 60
Betz, Stefan
works by: *Grenzverkehr* 131, 259
Beyer, Frank 8
works by: *Jakob, der Lügner* 90;
Nackt unter Wölfen 90
Biermann, Wolf 111
Bigelow, Kathyrn
works by: *Hurt Locker, The* 166
BitTorrent 23
Bleibtreu, Mortiz 5, 7, 13, 99, 101,
139
'Bluewater Attack' 53–7, 86
Bogdanski, Hagen 97
Boll, Uwe 47–9
works by: *Blackout* 48;
BloodRayne 47; *House
of the Dead* 47; *Max
Schmeling* 48, 49; *Postal* 48
Börner, Jens 72
Borscht, Mirko
works by: *Kombat Sechzehn* 59
Braun, Eva 109
Braun, Harald
works by: *Träumerei* 171
Breloer, Heinrich
works by: *Buddenbrooks* 96
Bresson, Robert 74
Brooks, Mel
works by: *Producers, The* 109
Brown, Clarence
works by: *Song of Love* 171
Brückner, Jutta
works by: *Hungerjahre* 166
Brühl, Daniel 7, 9, 13, 33, 97, 139,
199, 245, 248
Büchel, Lars
works by: *Erbsen auf halb 6* 131;
Jetzt oder nie – Zeit ist Geld
186
Buck, Detlev 58–9, 236
works by: *Hände Weg von
Mississippi* 59; *Knallhart*
58; *Liebes Luder* 236;
Same But Different 58; *Wir
können auch anders* 245
Büld, Wolfgang
works by: *Das war der wilde
Osten* 245
Butler, Judith 179, 182
performativity 130, 156, 157, 170,
179, 182, 187, 191, 193

Cain, James M.
works by: *Postman Always Rings
Twice, The* 82–3, 86
Cameron, James 213
works by: *Avatar* 23
Campbell, Martin
works by: *Casino Royale* 218
capitalism, capitalist 12, 115, 186
global 58, 135, 206, 217, 218
late 81, 82, 84
Capra, Frank 213
works by: *It Happened One Night*
131
CGI *See* computer generated images
Chadha, Gurinder
works by: *Bend it like Beckham* 36
Chaplin, Charlie
works by: *Great Dictator, The*
90, 109
children's film 34
Cho, Sung Hyung
works by: *Full Metal Village* 35
Chomsky, Marvin
works by: *Holocaust* 198, 214–16,
215, 228n.5, 244
cinema audience 24, 125, 128
demographics 50–1, 51n.1, 52n.4,
169–70, 185, 195n.6
female 165–6, 167–8, 169
'Cinema of Attractions' 212
'cinema of consensus' 12–13, 26–8,
57–9, 91, 92, 98, 105, 110,
114, 119
See also Rentschler, Eric
'Cinema of Duty' 137–8

Cinema Owners Trade Association
36
cinéma vérité 58
Clark, Larry
works by: *Kids* 252
Cold War 160, 201, 218, 228n.6, 246
film during 90, 201
filmic discourse since end of 2,
12, 92, 124, 125, 179, 250
'coming to terms with the past' *See*
Vergangenheitsbewältigung
computer generated images 57, 216,
219
Constantin Films 42, 43, 52n.2, 88,
121, 199
Coppola, Francis Ford 118, 218
Wenders, Wim 204
Zoetrope 204
works by: *Conversation, The* 115
Council of Europe 126
See also 'Eurimages'
Cruise, Tom 48, 201
Czech Republic 33, 131, 225, 259

Daldry, Stephen
works by: *Reader, The* 48–9,
200–1
Dance, Charles
works by: *Ladies in Lavender* 186
Danquart, Didi
works by: *Offset* 131
Dardenne, Jean-Pierre, Luc 74
Davaa, Byambasuren
works by: *Geschichte vom*
weinenden Kamel, Die
21n.6
Davies, Andrew
works by: *Pride and Prejudice* 96
Dayton, Jonathan
works by: *Little Miss Sunshine*
229n.13
DEFA *See Deutsche Film-*
Aktiengesellschaft
Deleuze, Gilles 18, 84, 87n.7
'duration' 87n.8, 208

'movement-image' 79, 87n.7,
207–8
'time-image' 18, 75, 79, 80, 87n.7,
87n.8, 207–9
de Maizière, Lothar 119
Demme, Ted
works by: *Blow* 199
De Palma, Brian 218
Deppe, Hans 234
works by: *Grün ist die Heide* 231,
262
Deutsche Film-Aktiengesellschaft 8,
8, 18, 61–5, 90, 246, 249
Deutscher Filmförderfonds 48–9, 220
DFFF *See Deutscher Filmförderfonds*
'dieSeher.de' 106–7
Dietrich, Marlene 197
digital
age 17, 37
technology 31, 57, 58, 65, 67, 97,
212, 256
division of Germany 95, 152, 157,
163n.6, 243, 247, 250
documentary filmmaking 55, 64
documentary realism 18, 74, 131,
188, 194
Dogme 95 58, 61, 65, 72, 87n.4
Dörrie, Doris 19, 164, 167, 169, 194,
196n.12, 199
Japanese culture 188
works by: *Erleuchtung garantiert*
188; *Kirschblüten – Hanami*
19, 170, 185, 187–95, 190,
192, 259; *Männer* 40, 167;
Me and Him 199
DreamWorks 199
Dresden
bombing 89, 91, 108, 174, 215
Dresen, Andreas
works by: *Halbe Treppe* 61–86,
68, 70, 131; *Nachtgestalten*
62, 66; *Sommer vorm*
Balkon 64–5; *Whisky mit*
Wodka 38, 39, 50, 64;
Wolke 9 65, 186

Dreyer, Carl Theodor 196n.10
 works by: passion de Jeanne
 d'Arc, La 177, 196n.10
Dutschke, Rudi 204
Dwyer, Alice 134, 164, 193, 194

'Economic Miracle' 236, 246
Edel, Uli 199
 works by: Baader Meinhof
 Komplex, Der 42, 95,
 98–100, 100, 200, 240
Eichinger, Bernd 18, 42–3, 52n.2,
 72, 88, 97–102, 171, 195,
 199, 211
 Päpstin, Die 171–5, 172, 178,
 182, 195n.6; unendliche
 Geschichte, Die 88
Elsner, Hannelore 155, 156, 164, 178,
 180, 186–7, 192, 193, 193
Emmerich, Roland 7, 139, 199,
 210–20, 225
 works by: 10,000 BC 210, 212, 213;
 Day After Tomorrow, The
 210; Independence Day 57,
 210, 212, 213; Patriot, The
 210, 212–16, 215, 226
Endemann, Till
 works by: Lächeln der
 Tiefseefische, Das 132
Enders, Sylke 8, 63
 works by: Kroko 8, 63; Mondkalb
 8, 63; Schieflage 8
Engelmann, Juliane
 works by: Narben im Beton 164
Ensslin, Christiane 170
Ensslin, Gudrun 2, 150, 170
Enzensberger, Hans Magnus 173,
 196n.9
ethnicity 120, 127, 178, 182–5
EU See European Union
Eurimages 31–3, 140, 149, 158
Europa Cinemas 158
Europe 32
 cultural identity 126–7, 152
 See also 'europudding'

eastern Europe in contemporary
 German film 130–7 passim,
 267n.11
'German-Jewish symbiosis'
 147–58, 162
 integration 32, 33, 126, 130,
 158–62
European Film Academy 205
European film industry 31–6, 124,
 126, 132, 133, 136, 158, 205,
 212
European Union 69, 123, 127, 133,
 142, 148, 264–5
 film funding 31, 37, 126
 See also Kinomobilny;
 MEDIA
 See also Holocaust/
 'Europeanization'
'europudding' 33, 38, 44, 98, 126,
 128, 140, 154, 255, 265
Eurozone currency crisis 264
expellees 89, 91, 123, 262

Falorin, Luigi
 works by: Geschichte vom
 weinenden Kamel, Die
 21n.6
Färberbock, Max
 works by: Aimée & Jaguar 89, 98,
 121n.11, 172; Anonyma –
 Eine Frau in Berlin 89, 173,
 174, 175, 177; September
 138
Faris, Valerie
 works by: Little Miss Sunshine
 229n.13
Farocki, Harun 71
Fassbinder, Rainer Werner 2,
 13–15, 26, 56, 74, 82, 125,
 142, 187, 198, 199, 204,
 229n.13, 265
 'FRG Trilogy' 14, 90, 142, 177
 legacy 14–17, 216
 melodrama 141
 works by: amerikanische Soldat,

Der 83–4; *Angst essen Seele auf* 124; *Ehe der Maria Braun, Die* 90, 141; *Götter der Pest* 83–4; *In einem Jahr mit 13 Monden* 15, 178; *Katzelmacher* 124; *Liebe – kälter als der Tod* 83–4; *Lola* 90; *Sehnsucht der Veronika Voß, Die* 10, 90, 178; *Tod der Maria Malibran, Der* 182
 See also New German Cinema
Federal Enquete Commissions 111, 112
feminism 167, 176, 188, 194
 See also Frauenfilm/feminism; 'post-feminism'
Ferres, Veronica 164
FFA *See Filmförderungsanstalt*
FFG *See Filmförderungsgesetz*
Fiebeler, Carsten
 works by: *Kleinruppin forever* 94, 251
Filmförderung Hamburg 36–7
Filmförderungsanstalt 25, 195n.6
Filmförderungsgesetz 25, 35–6
film noir 82–6, 153, 205, 137
Filmverlag der Autoren 15, 43
First World War 200, 253, 255
Fischer, Elmar
 works by: *Fremder Freund* 138
Fleischmann, Peter 235, 244
 works by: *Jagdszenen aus Niederbayern* 231
football 32, 36, 241, 245
 1954 World Cup 89, 240, 243
 1990 World Cup 244–5
Forster, Marc
 works by: *Quantum of Solace* 218
Foth, Jörg 63
Franck, Arnold
 works by: *weiße Hölle vom Piz Palu, Die* 234
Frankfurt School 203

Frauenfilm 120, 164, 167–9, 176, 195
 contemporary gender relations 178–95
 ethnicity 178, 182–5
 feminism 168–9, 194
 'heritage film' 169, 170–8, 195n.6
 'New German Comedy' 168, 169, 170, 175
 queer cinema 178–85
 See also ageing/representation on screen; cinema audience/demographics/female; New German Cinema/*Frauenfilm*
Frauen und Film 168
French New Wave 74, 79, 207, 218
Frenkel-Brunswik, Else
 works by: *Authoritarian Personality, The* 255
Freud, Sigmund 104, 191, 233
Freund, Karl 197
Freydank, Jochen Alexander
 works by: *Spielzeugland* 21n.6
Froelich, Carl
 works by: *Heimat* 235

Gansel, Dennis
 works by: *NaPolA: Elite für den Führer* 90, 92, 94, *94*, 103, 106–7
Ganz, Bruno 99, 103, *103*
Garnett, Tay
 works by: *Postman Always Rings Twice, The* 82
Garton Ash, Timothy 114
GDR
 See German Democratic Republic
Gedeck, Martina 111, 171
gender 221
 See also Frauenfilm/contemporary gender relations
generations
 intergenerational relations 187
 shift 104, 186
 See also '68er'

genre cinema 4, 10–12, 15, 17, 29, 56, 82, 205, 219
genre film *See* genre cinema
Gerhard, Tom 41
 works by: *7 Zwerge – Männer allein im Wald* 41
German Autumn, 2
German Democratic Republic 2, 44, 61, 84, 90, 110–20, 174
 contemporary German film 84–98 *passim*, 131, 132, 155–7, 186, 242–58
 See also Stasi
 film culture 8, 60, 61–5 *passim*, 72, 195n.2
 See also Heimat film/GDR
 orientalist representation 135, 162n.3, 245
 See also Said, Edward
 See also Ostalgie
German Film Academy 27
'German-Jewish symbiosis' 129, 147–58, 162
'Germanness' 43, 52n.3, 93, 106, 209, 147, 148, 150, 152, 156, 162, 182, 201, 235, 245, 263
Geschonneck, Matti
 works by: *Boxhagener Platz* 95
Gförer, Jörg
 works by: *Ganz unten* 124
Ginsberg, Mathias 43
Glasner, Mathias
 works by: *freie Wille, Der* 59, 60
global warming 233
globalisation 3, 4, 20, 72, 81, 123–62 *passim*, 202, 209, 218, 233, 250, 259, 262, 266
Godard, Jean-Luc 1, 6
 works by: *Allemagne 90 neuf zero* 1
Godfrejow, Bogumil 136
Goebbels, Joseph 87n.3, 107, 150
Goldbrunner, Evi
 works by: *WAGS*

Goller, Markus
 works by: *Friendship!* 227
Graf, Dominik 6
 works by: *Felsen, Der* 59; *Rote Kakadu, Der* 94
'Grand Coalition' 29, 47
Green, Gerald
 works by: *Holocaust* 198, 214–16, 215, 228n.5, 244
Greengrass, Paul
 works by: *Bourne Ultimatum, The* 199, 218
Grisebach, Valeska 71, 64
 works by: *Sehnsucht* 27, 27, 74, 251
Gronenborn, Esther
 works by: *Adil geht* 138
Groenenwold, David 47
Grünen Partei, Die 46
Günar, Sülbiye 138

Habermas, Jürgen 264–5
Hamburg, John
 works by: *I Love You, Man* 40
Haneke, Michael 28, 74, 253
 works by: *weiße Band: Eine deutsche Kindergeschichte, Das* 21n.6, 32, 34, 200, 234, 253–8, 256, 257
'Hannerbersch' series 106
 See also 'mashup'
Harfouch, Corinna 164
Harlan, Viet
 works by: *goldene Stadt, Die* 235
Harvey, Herk
 works by: *Carnival of Souls* 82
Hauptverband Deutscher Filmtheater 23
Haußmann, Leander 95
 works by: *Dinosaurier* 186; *Herr Lehmann* 251; *Sonnenallee* 251
Hegemann, Helen 196n.13
 works by: *Axolotl Roadkill* 196n.13; *Torpedo* 193, 194, 196n.13

Heidelbach, Kaspar
 works by: *Berlin 36* 173, 178;
 Wunder von Lengede, Das
 47
Heimat, concept of 85, 232–6
 passim
 Eastern Europe 267n.11
Heimat film 6, 10, 20, 27, 34, 59, 95,
 131, 186, 224, 230–68
 anti-Heimat 234, 235–6, 238,
 241–2, 244, 251–8, 263
 East Germany 21n.9, 243–51
 GDR 246, 267n.9
 New German Cinema 233, 235,
 236, 258
 television 235, 267n.5
 tourism 267n.2
 See also '68er'/Heimat film;
 'heritage film'/Heimat
 film; mountain film
Heimatkanal 235, 236
Heisenberg, Benjamin 71–2
 works by: *Schläfer* 138
Heller, André
 works by: *Im totem Winkel –
 Hitlers Sekretärin* 101
Henckel von Donnersmarck 7, 28,
 97, 98, 199, 265
 works by: *Leben der Anderen, Das*
 7, 18, 20n.6, 28, 39, 92, 94,
 95, 97, 98, 110–20, *113*, *117*,
 200, 265
Herbig, Michael 7, 41–2
 works by: *Schuh des Manitu, Der*
 41, 42, 88, 227, 229n.13;
 *(T)Raumschiff Surprise –
 Periode 1* 41–2, 42
'heritage film' 7, 18, 19, 26, 86,
 88–123, 126, 265
 authenticity 97–122 *passim*
 British 93, 96
 European 120, 126, 128, 130,
 148
 GDR historiography 110–20
 Heimat film 239–43, 259

normalisation 147–58, 158–62
 passim
 web technology 105–10
 See also Frauenfilm/'heritage
 film'
Herzog, Werner 10, 19, 56, 74, 124–5,
 198, 202–5, 222, 226
 works by: *Aguirre, der Zorn
 Gottes* 124, 226; *Bad
 Lieutenant: Port of
 Call – New Orleans* 205;
 Fitzcarraldo 10, 14; *Grizzly
 Man* 205; *Rescue Dawn*
 205; *Stroszek* 224
Hillers, Marta 196n.9
Hirschbiegel, Oliver
 works by: *Untergang, Der* 9, 13,
 20n.5, 42, 88 90, 98–108,
 103, 113, 121n.3, 121n.4,
 200
Hitchcock, Alfred 118
 works by: *Rear Window* 115
Hitler, Adolf 9, 60, 90, 98–113
 passim, 121n.4, 122n.7, 154,
 230, 255
'Hitler-Kunst' 106, 108
Hochhäusler, Christoph 5, 6, 15, 71,
 72, 73
 works by: *Falscher Bekenner* 73;
 Milchwald 5, 130
*Hochschule für Film und Fernsehen
 'Konrad Wolf'* 62, 67, 71
Hoffmann, Anna
 works by: *Haushaltshilfe, Die*
Hoffmann, Nico 41, 199
Hollywood 31, 33, 42
 genre cinema 4, 5, 12, 14, 40, 56,
 198, 202, 219
 German finance and 18, 46, 221
 international brand 210–20
 relationship with German
 cinema aesthetic 9, 13–14,
 29, 40
 See also America/American and
 German film industry

Holocaust 2, 21n.6, 49, 90, 98, 147,
 148, 157, 161, 198, 214–16,
 244
 'Europeanization' 126, 148–62
 passim
 memorial 91
 memory 160–1
 See also German-Jewish
 symbiosis; Poland/
 German-Polish relations
home entertainment market 23,
 51n.1
Hooper, Tobe
 works by: Texas Chainsaw
 Massacre, The 14
Hosenrolle films 182
Hoss, Nina 83, 84, 173
Howard, Ron
 works by: EDtv 55
Huntgeburth, Hermine 164
 works by: Effi Briest 96; weiße
 Massai, Die 259

identity 127, 129, 167, 221, 232,
 259–60
 female 169, 176, 178–85
 German 20, 108, 129, 152, 158,
 162, 163n.6, 170, 226, 232,
 235, 248
 'hyphenated' 127, 137, 140, 146,
 148, 158
 Jewish 121n.11, 149
 Turkish-German 129, 137–47, 149,
 162
 See also Butler, Judith; Europe/
 cultural identity; 'German-
 Jewish symbiosis'; Jewish/
 non-Jewish relations;
 multiculturalism
illegal downloading See piracy
immigration, immigrant 127, 182
'indie' films 229n.13
International Movie Database
 107–8
Iraq 202, 228n.2

Ivory, James
 works by: Maurice 93, 96; Room
 with a View, A 93

Jackson, Peter
 works by: Lord of the Rings:
 The Return of the King,
 The 45
Jähn, Sigmund 249
Jannings, Emil 197
Jarmusch, Jim
 works by: Night On Earth 32, 62
Jentsch, Julia 7, 13, 97, 164, 174, 176,
 177
Jewish/non-Jewish relations 5, 89,
 98, 172–3
 See also 'German-Jewish
 symbiosis'
Jopp, Vanessa 164
 works by: Vergiss Amerika 221,
 225, 251
July, Miranda
 works by: Me and You and
 Everyone We Know 229n.13
Junge, Traudl 101–2

Kanievska, Marek
 works by: Another Country 90,
 92, 93
Karmakar, Romuald 6
 works by: Himmler Projekt, Das 6
Kartoffel-Affäre 123
Kassovitz, Mathieu
 works by: Haine, La 252
Kaufmann, Delfried 227
Kaufmann, Lloyd 14
Kaufmann, Rainer
 works by: Stadtgespräch 168
Kelemen, Fred
 works by: Abendland 131
Ketteler, Maria 173
Kiarostami, Abbas 74
Kieślowski, Krzysztof 210
Kinomobilny 123–4
'Kinotauglichkeit' 23, 40–1

Klandt, Christian
 works by: *Weltstadt* 252
Klein, Gerhard
 works by: *Berlin um die Ecke*
 246
kleine Fernsehspiel, Das 45, 55
Kleinert, Andreas 8, 63
 works by: *Neben der Zeit* 63;
 Wege in die Nacht 63
Klier, Michael
 works by: *Überall ist es besser,*
 wo wir nicht sind 130
Klooss, Reinhard
 works by: *Das war der wilde*
 Osten 245
Kluge, Alexander 2, 24, 25, 56, 74
 works by:, *Abschied von Gestern*
 24; 'essay films' 4, 10
Köhler, Ulrich 44, 71
 works by: *Bungalow* 44, 73;
 Montag kommen die
 Fenster 44, 73, 74
Kohlhaase, Wolfgang 64
 works by: *Berlin – Ecke*
 Schönhauser 64; *Solo*
 Sunny 64; *Sommer vorm*
 Balkon 64–5; *Whisky mit*
 Wodka 38, 39, 50, 64
König Hans, Heinz
 works by: *Rosen blühen auf dem*
 Heidegrab 237
Kracauer, Siegfried 56, 207
Krause, Horst 225, 226, 227
Kreuzpainter, Marco
 works by: *Krabat* 57
Kristallnacht 127
Kronthaler, Thomas
 works by: *Scheinheiligen, Die*
 236
Kross, David 49
Krüger, Jan
 works by: *Unterwegs* 73, 131, 259
Krüger, Thomas 29
Kubrick, Stanley
 works by: *Spartacus* 97

Kulaoğlu, Tunçay 138, 142, 164
Kümel, Harry
 works by: *Europe* 32
Kuratorium junger deutscher Film
 24, 25, 34

Laemmle, Carl 197
Lamprecht, Gerhard
 works by: *Emil und die Detektive*
 237
Landsberg, Alison 103–4
 See also 'prosthetic memory'
Lang, Fritz 197, 237
Langton, Simon
 works by: *Pride and Prejudice* 96
Lederhosenfilm 235
Leigh, Mike 65
Levinson, Daniel
 works by: *Authoritarian*
 Personality, The 255
Levy, Dani 5, 43, 108, 109, 110,
 122n.12, 153, 154, 156, 157,
 158, 162, 179, 255
 works by: *Alles Auf Zucker*, 5, 130,
 154–7, *156*; *Mein Führer*
 – Die wirklich wahrste
 Wahrheit über Adolf Hitler
 108–10, *109*, 154, 255;
 Meschugge 153
Lilienthal, Peter 26
Liman, Doug
 works by: *Bourne Identity, The*
 199, 218
Link, Caroline 7, 164, 167
 works by: *Nirgendwo in Afrika*
 7, 20n.6, 27, 148, 195n.6,
 200, 259
Linklater, Richard 73–4
 works by: *Before Sunrise* 73;
 Before Sunset 73; *Slacker*
 73, 229n.13; *Waking Life*
 229n.13
Loach, Ken 65, 252
 works by: *Raining Stones* 135–6,
 252

Lorre, Peter 197
Lubin, Sigmund 197, 228n.1
Lubitsch, Ernst 154
 works by: *To Be or Not To Be* 109
Lucas, George 57, 230, 237
 works by: *American Graffiti*
 230–1; *Star Wars* 42
'Ludwigshafener Position' 26
Lumière, Auguste, Louis
 works by: *L'arrivée d'un train à*
 La Ciotat 56
Luthardt, Matthias 71

McCarey, Leo
 works by: *Make Way for*
 Tomorrow 189
Maccarone, Angelina 178–83, 195
 works by: *Alles wird gut* 180;
 Fremde Haut 19, 138,
 169, 180–3, *184*, *185*, 259;
 Kommt Mausi raus?! 180
McTeigue, James
 works by: *V for Vendetta* 36
Maetzig, Kurt
 works by: *Schlösser und Katen*
 246
'magic realism' 66, 69, 70
Marx Brothers 154
'mashup' 9, 106, 108, 121n.4, 196n.13
May, Karl 41, 227
MEDIA 31–3
media funds 45–50
Medienboard Berlin-Brandenburg 36
medieninitiative! Deutschland 47
Meinhof, Ulrike 196n.13
Méliès, Georges 56–7
 works by: *Voyage dans la lune,*
 Le 56
melodrama, melodramatic 28, 104,
 112–14, 146, 165, 171–2, *172*,
 177, 216
 See also Akın, Fatih/melodrama;
 Fassbinder, Rainer
 Werner/melodrama; Sirk,
 Douglas

Melville, Jean-Pierre 58
memory 104, 105
 See also Holocaust/memory;
 'prosthetic memory'
Merchant Ivory 93, 96
Merkel, Angela 29, 45, 47, 127, 141
Metro-Goldwyn-Mayer Studios 205
Metz, Christan 115
 See also spectatorship
Meyers, Nancy
 works by: *Something's Gotta Give*
 186
MGM *See* Metro-Goldwyn-Mayer
 Studios
migration, migrant 9, 60, 84, 124,
 27, 131, 133, 137–40, 161,
 163
Miller, Alice
 works by: *For Your Own Good:*
 Hidden Cruelty in Child-
 Rearing and the Roots of
 Violence 255
Minghella, Anthony 210
Miramax 210–11
Mittermeier, Marcus 53–8, 86
 works by: *Muxmäuschenstill* 54;
 Short Cut to Hollywood
 53–5
Moers, Walter 121n.6
Mostow, Jonathan
 works by: *Terminator 3: Rise of*
 the Machines 45
mountain film 216, 234–5, 240
Mucha, Stanislaw
 works by: *Mitte, Die* 32, 132
Mueller-Stahl, Armin 218, 220
Mühe, Ulrich 108, 111, *113*, 117, *117*
Müllerschön, Nikolai
 works by: *rote Baron, Der* 96,
 255
multiculturalism, multicultural,
 127–9, 161, 162, 213, 215,
 225, 260, 262
 See also transnationalism
Murnau, Friedrich Wilhelm 197, 235

national cinema, German 4–20, 44,
 128, 129, 142, 162
National Socialism 2, 198, 200, 203,
 214, 221, 243, 255–8
 German complicity 101–2, 106,
 174, 242
 Germans as 'victims' 89, 91, 215
 heritage film 88–97, 101–13
 passim, 121n.11, 171–7
 passim, 200, 255
 See also 'German-Jewish
 symbiosis'
Nationale Volksarmee, Die 95
Nazism, Nazi See National Socialism
Negele, Thomas 23–4
neo-colonialism, neo-colonial 124,
 128, 130, 158–62, 201–2,
 228n.7, 245
neo-Nazi 59
neo-noir 153, 205
neo-realism, neo-realist 1, 63, 72, 79,
 82, 84
'neue Länder' 59, 97, 221
 economic asymmetry with west
 8, 59, 234
 life in 63–71, 155, 248
Neul, Nana
 works by: Mein Freund aus Faro
 182
Neumann, Bernd 22, 48, 49
'New German Comedy' 12, 19, 40,
 167, 169, 175, 199, 258
 See also Frauenfilm/'New
 German Comedy'
New German Cinema 2–4, 24–9, 39,
 43–5, 56, 62, 74, 91, 96, 98,
 101, 104, 105
 Frauenfilm 164, 165, 182, 194
 historical context 10–20
 transnationalism 124–32 passim
 See also America/New German
 Cinema; Heimat film/New
 German Cinema
'New Hollywood' period 218
'New New German Cinema' 13

Nolan, Christopher
 works by: Inception 28; Memento
 28
'normalisation' 12, 18, 20, 91, 96,
 110, 162, 203, 222, 255, 242,
 264, 166
'Nouvelle Vague allemande' 13, 44,
 71–2
NVA See Nationale Volksarmee, Die

'Oberhausen Manifesto',
 Oberhausener 10, 20, 24,
 26
Oberli, Bettina
 works by: Herbstzeitlosen, Die 186
Ohnesorg, Benno 99, 100
'ordinary Germans' 89, 106, 173
Orientalism See Said, Edward
Oscar See Academy of Motion
 Picture Arts and Sciences
Ostalgie 5, 95, 111, 112, 114, 120,
 247–8
Ostermayr, Peter
 works by: Edelweißkönig, Der 234
Ottinger, Ulrike
 works by: Bildnis einer Trinkerin
 166
Ozu, Yasujirô
 works by: Tokyo Story 189

Pakula, Alan
 works by: All the President's Men
 218; Klute 218; Parallax
 View, The 218
Pamuk, Kerim 139
'Papas Kino' 10–11, 15, 27, 120, 227,
 230, 231, 235, 258, 263
Paramount 46, 229n.13
Park, Jin-pyo
 works by: Jukeodo joha 186
Pasolini, Pier 61
Payne, Alexander
 works by: About Schmidt 186
Peirce, Kimberley
 works by: Boys Don't Cry 182

Petersen, Wolfgang 7, 28, 199, 203,
 210–16
 works by: *Air Force One* 210, 216;
 Boot, Das 210; *In the Line
 of Fire* 210; *Perfect Storm,
 The* 210, 212, *216*; *Poseidon*
 210; *unendliche Geschichte,
 Die* 88
Petzold, Christian 15, 24, 44, 60–1,
 71–5, 80–6, 98, 103
 works by: *Gespenster* 44; *innere
 Sicherheit, Die* 15, 44, 60,
 72, 81, 87n.5; *Jerichow* 15,
 44, 82–5, *84*, *85*, 137; *Yella*
 81, 82
piracy 9, 23, 50, 51n.1
poetic realism 235
Pohland, Hansjürgen 10, 24
Poland 158, 160
 in contemporary German film
 130–7
 German-Polish border 66–9, 124,
 129–37, 158, 259
 German-Polish relations 123, 130,
 158–62, 162n.1
political correctness 109–10, 130,
 147, 154
Pollack, Sydney 211
 works by: *Out of Africa* 148
Polt, Gerhard 7
'pool-hall movie' 5, 155
Pommer, Erich 197, 199, 200
pornography 25, 235, 237
'post-feminism' 168–9, 176, 195n.5
'postnationalism' 264–5
Potente, Franke 5, 7, *14*, 164, 199
Potsdamer Platz 82, 152
Pro-Sieben 39
'prosthetic memory' 103, 107–8, 114,
 175

Quabeck, Benjamin
 works by: *Europe* 32;
 Verschwende deine Jugend
 96, 251

queer cinema 40, 137, 180–1
 See also *Frauenfilm*/queer
 cinema

RAF *see* Red Army Faction
Rafelson, Bob
 works by: *Postman Always Rings
 Twice, The* 82–3, 86
Raspe, Jan-Carl 2
realism 5, 18, 53–87, 87n.1, 87n.4,
 91, 99, 101, 111, 238
 See also documentary realism;
 'magic realism';
 Neo-realism; poetic
 realism; social realism;
 Socialist Realism
'reality TV' 53–5, 57
Red Army 89, 173, 215
Red Army Faction 2, 95, 101, 150,
 170, 196n.13, 253, 267n.10
Reitman, Jason
 works by: *Juno* 229n.13
Reitz, Edgar 10
 works by: *Heimat* 198, 244–5,
 267n.6; (*Heimat 3*) 244–5
Rentschler, Eric 12, 26, 57, 91, 105,
 202–3, 235, 267n.2
 See also 'cinema of
 consensus'
Revolver 72, 74
Reyel, Ann-Kristin
 works by: *Jagdhunde* 251
Reygadas, Carlos 74
Richter, Roland Suso
 works by: *Dresden* 89, 174, 200
Riefenstahl, Leni 237
 works by: *blaue Licht, Das* 234;
 Triumph des Willens 230
Riemann, Katja 12, 109, 150, 164,
 168, 195n.4
Rihs, Oliver
 works by: *Brombeerchen* 221
Rilla, Wolf
 works by: *Village of the Damned,
 The* 257

Roehler, Oskar 15
 works by: *Agnes und seine
 Brüder* 178; *Suck My Dick*
 15; *Unberührbare, Die* 15,
 178–9, *180*, 186
Rohmer, Eric 74
Rohrbach, Günter 27, 40–1
Roll, Gernot
 works by: *Männersache* 40
romantic comedies *See* 'New
 German Comedy'
Rosenmüller Marcus 232, 236, 241,
 263
 works by: *Beste Gegend* 236; *Beste
 Zeit* 236; *Wer früher stirbt
 ist länger tod* 34, 230–2,
 236–8, *238*, 241, 263
Rosi, Francesco 58
Rossellini, Roberto 1, 6
 works by: *Germania, anno zero* 1
Rossen, Robert 5, 155
 works by: *Hustler, The* 5, 155
Roth, Christoph
 works by: *Baader* 95
Rothemund, Marc
 works by: *Pornorama* 267n.3;
 *Sophie Scholl – Die letzten
 Tage* 89, 174–7, *176*,
 196n.10, 200
Ruzowitzky, Stefan
 works by: *Fälscher, Die* 121n.11,
 200

Said, Edward 132
Sander, August 256
Sander, Helke 165–6, 170
 works by: *allseitig reduzierte
 Persönlichkeit-Redupers,
 Die* 166
Sanders-Brahms, Helma 45, 170, 172
 works by: *Deutschland bleiche
 Mutter* 90, 166, 171, 177;
 Geliebte Clara 171; *Shirins
 Hochzeit* 124
Sass, Katrin 164, 247

Saul, Anno
 works by: *Kebab Connection* 139
Schanelec, Angela 5, 15, 61, 72,
 75–86, 164, 265
 works by: *Marseille* 5, 44, 76–81,
 78, 81; *Mein langsames
 Leben* 44, 71; *Nachmittag*, 5
Scheffner, Philip
 works by: *Tag des Spatzen, Der* 60
Scherer, Alexander
 works by: *Kommt Mausi raus?!*
 180
Schleyer, Hanns-Martin 2, 3
Schlingensief, Christoph 14, 15
 works by: *120 Tage von
 Bottrop, Die* 14; *Deutsche
 Kettensägenmassaker, Das*
 14
Schlink, Bernhard
 works by: *Vorleser, Der* 49
Schlöndorff, Volker 2, 40–1, 195n.8
 works by: *Blechtrommel, Die* 10,
 90, 205; *neunte Tag, Der*
 89, 103; *Palmetto* 205;
 *plötzliche Reichtum der
 armen Leute von Kombach,
 Der* 231
Schmid, Hans-Christian 19, 49, 136,
 140, 158
 works by: *Lichter* 133–7, *134,
 135*, 141, 158; *Storm* 133;
 *wundersame Welt der
 Waschkraft, Die* 49, 133
Schmiderer, Othmar
 works by: *Im totem Winke –
 Hitlers Sekretärin* 101
Schmidt, Evelyn 63
Schneider, Helge 108, *109*, 110
Schneider, Romy 11, *11*
Schneider, Susanne
 works by: *Es Kommt der Tag* 60,
 186
Schnitzler, Gregor
 works by: *Was tun, wenn's
 brennt?* 96

Scholl, Sophie 102, 174, 175
Schorr, Michael
 works by: *Schultze Gets the Blues*
 186, 222–6, 223, 225, 263
Schrader, Maria 150, 154, 172
Schragenheim, Felice 172
Schröder, Gerhard 202, 222
Schroeter, Werner 4
 works by: *Poussières d'amour
 – Abfallprodukte der
 Liebe* 182; *Tod der Maria
 Malibran, Der* 182
Schüfftan, Eugen 155, 197
Schünzel, Reinhold
 works by: *Viktor und Viktoria* 182
Schütte, Jan
 Auf Wiedersehen Amerika 130
Schwarzenberg, Xaver
 works by: *Otto – Der Film* 42
Schwarzenegger, Arnold 199
Schwarze Pädagogik 255
Schweiger, Rudolf
 works by: *Mörderischer Frieden*
 60
Schweiger, Til 12, 199
 works by: *Keinohrhasen* 40, 239
Schygulla, Hanna 15, 26, 164, 187
Scorsese, Martin 139, 140, 199, 218
 works by: *Color of Money, The* 5,
 155; *Raging Bull* 139
Scott, Tony
 works by: *Enemy of the State* 115
Screen 115
Second World War 2, 79, 197, 215,
 265
Senft, Haro 24, 25
Shuksin, Vasili 62
Siebler, Harald
 works by: *GG19: Eine Reise durch
 Deutschland in 19 Artikeln*
 1
Singer, Bryan
 works by: *Valkyrie* 48, 201
Sinkel, Bernhard
 works by: *Lina Braake* 186

Sirk, Douglas 82, 216
'Sissi' trilogy 11, *11*
social realism, realist 63, 72, 252, 256
Socialist Realism, Socialist Realist
 60–5
Sontag, Susan 196n.13
*Sozialdemokratische Partei
 Deutschlands* 29, 46
Soziale Marktwirtschaft 3
Spaßgesellschaft 12–13, 59, 101
SPD *See Sozialdemokratische
 Partei Deutschlands*
spectatorship, 115–18
Speer, Albert 101, *103*
Speth, Maria 71, 164
 works by: *In den Tag hinein* 73
Spielberg, Steven 159, 199, 210
 works by: *Jurassic Park* 57;
 Minority Report 42;
 Schindler's List 89, 149
Stahlberg, Jan Henrik
 works by: *Muxmäuschenstill* 54;
 Short Cut to Hollywood
 53–5
Stanley, Richard
 works by: *Europe* 32
Stark, Christoph
 works by: *Julietta* 59
star system 99, 139
Stasi 92, 97, 98, 112–20 *passim*, 200,
 218, 249, 250
 file 119–20
Staudte, Wolfgang
 works by: *Mörder sind unter uns,
 Die* 241
Steinbichler, Hans 6, 15, 236
 works by: *Hierankl* 6, 187, 236;
 Winterreise 6, 236, 259,
 260, *260*
Stennert, Phillip
 works by: *Jerry Cotton* 25, 227,
 229n.13
Stöhr, Hannes
 works by: *Berlin Calling* 59; *One
 Day in Europe* 32, *32*

Stölzl, Philipp
 works by: *Baby* 134; *Nordwand*
 240
Story, Tim
 works by: *Fantastic Four* 43
Struck, Andreas
 works by: *Chill Out* 59
student movement 2, 3, 179, 204, 226
subjectivity 229n.13
subsidy system 16, 18, 21n.8, 24, 25,
 29–45, 48–50, 63, 66, 199,
 201
 co-production treaties 37, 124,
 130
 Länder 25, 36–7
 and private investment 45–9
 television 24, 39- 42, 45
Sukowa, Barbara 164, 171, 187
surveillance film 118
Süskind, Patrick
 works by: *Parfüm – Die
 Geschichte eines Mörders,
 Das* 5, 219
Swift, David
 works by: *Parent Trap, The* 95
Syberberg, Hans-Jürgen 74, 228n.8

Taddicken, Sven
 works by: *Emmas Glück* 236
Tarantino, Quentin 139
 works by: *Inglourious Basterds*
 49, 199, 201
Tarkovsky, Andrei 63, 229n.13
Tarr, Béla 74
taxation 45–8, 125
teamWorx 41, 95, 199, 200
television 17, 24, 24–6, 35–9, 96, 198,
 211, 253, 266
 realism and 54–6, 61–2
 See also Heimat film/television;
 subsidy system/television
terrorism
 1970s Germany 2, 6, 60, 81, 82,
 92, 95, 163n.6
 global 13

Thalheim, Robert 63
 works by: *Netto* 63, 221; *Am Ende
 kommen Touristen* 63,
 158–62, *159*
Third Reich, the 87n.3, 90, 100, 148,
 149, 170
Timm, Peter
 works by: *Go Trabi Go* 245
'Trabi Comedies' 245
transnationalism 19, 20, 30, 125, 126,
 129, 130, 132, 140, 162, 183,
 196n.11, 234, 258
 multiculturalism 127–30
 See also America/
 transnationalism;
 'German-Jewish
 symbiosis'; Poland/
 in contemporary
 German film; Poland/
 German-Polish relations;
 Turkish-German film
Treut, Monika 12, 164, 180, 196n.11
 works by: *Ghosted* 196n.11;
 *Jungfrauenmaschine,
 Die* 196n.11, 221; *Made in
 Taiwan* 196n.11; *My Father
 Is Coming* 221; *Verführung:
 Die grausame Frau* 12,
 196n.11
Trümmerfilme 1, 241
'true realism' *See* Bazin, André
Turkish-German
 film, filmmakers 6, 129, 137–47,
 164
 representation in contemporary
 German film 83–5, 163n.4
 See also identity/Turkish-
 German
Turner, Lana 82–3
Twentieth Century Fox 229n.13
Twitter 9, 53, 57
Tykwer, Tom 1
 works by: *Deutschland 09: 13
 Kurze Filme zur Lage der
 Nation* 1–20, 4, 196n.13;

Feierlich reist 4, 218;
Heaven 210–11, 229n.10;
International, The 5, 49, 57,
 211, 217–19, 220, 229n.12;
 Krieger und die Kaiserin,
 Der 229n.10; *Lola rennt*
 5, 13, *14*, 210, 217, 219,
 229n.10; *Perfume: The*
 Story of a Murderer 27,
 42–3, 219

UFA *See* Universum Film AG
unification 1, 2, 10, 14, 21n.9, 44, 90,
 132, 155, 157, 178, 179, 220,
 245–51, 258, 265
United Artists 43
Universal 197
Universum Film AG 197, 205

vampire movie 82
Van Sant, Gus 74
 works by: *Elephant* 252
Verband der Filmarbeiterinnen
 165–6
Verfremdung 257
Vergangenheitsbewältigung 104–5,
 148, 161, 264
Verhoeven, Michael
 works by: *Männerherzen* 40, *41*;
 schreckliche Mädchen, Das,
 200; *Weiße Rose, Die* 174
Vilsmaier, Joseph
 works by: *Gustloff, Die* 89–90;
 Marlene 38
Vinterberg, Thomas 65
VIP Medienfonds 45
Visconti, Luchino
 works by: *Ossessione* 82
Vogel, Frank
 works by: *Denk bloß nicht, ich*
 heule 246, 249
Vogel, Jürgen 59, *60*, 152
Volksmusik shows 236, 239
von Bingen, Hildegard 171, 175
von Borries, Achim

works by: *Was nützt die Liebe in*
 Gedanken 96
von Donnersmarck, Henckel 7, 28,
 97, 199, 265
 works by: *Leben der Anderen,*
 Das 7, 18, 20n.6, 28, 39,
 92, 94, 95, 97–8, 110–20,
 200
von Garnier, Katja 168, 169
 works by: *Abgeschminkt!* 168
von Stroheim, Erich 197
von Trier, Lars 65, 87n.4
 works by: *Antichrist* 33
von Trotta, Margarethe 12, 89,
 129–30 149, 164, 172, 187,
 198, 228n.8
 works by: *bleierne Zeit, Die* 150,
 163n.6, 166, 170, 195n.7,
 267n.10; *Rosenstraße* 89,
 129, 149–158, *151*, 170–1,
 172, 182; *Versprechen, Das*
 163n.6; *Vision – Aus dem*
 Leben der Hildegard von
 Bingen 171 187; *zweite*
 Erwachen der Christa
 Klages, Das 166
von Vietinghoff, Joachim 40

Waalkes, Otto
 works by: *Otto – Der Film* 42
Wacker, Torsten
 works by: *Süperseks* 139
Wackerbarth, Nicolas 72
Wallraff, Günter
 works by: *Ganz unten* 124
Walser, Martin 104
Walter, Connie
 works by: *Schattenwelt* 60; *Wie*
 Feuer und Flamme 94
Waltz, Christoph 49
'War on Terror' 127
Web 2.0 9, 57, 106
Weerasethakul, Apichatpong 74
'Wehrmacht Exhibition' 91
Weiller, Wilhelm 28

Weimar 182, 201
 cinema 17, 197
 Expressionism 235
 filmic representation of 96, 151,
 152, 153
Weingartner, Hans 6
 works by: *fetten Jahren sind
 vorbei, Die* 6, 7, 13,
 251; *Free Rainer – Dein
 Fernseher lügt* 6, 55
Weinstein, Harvey 210–11
Weir, Peter
 works by: *The Truman Show* 55
Weiße Rose 174
Wenders, Wim 12, 19, 26, 43, 49, 56,
 102, 103, 109, 125, 203–11,
 217–25, 264
 works by: *amerikanische Freund,
 Der* 204; *Buena Vista
 Social Club* 21n.6, 205;
 Don't Come Knocking 205;
 End of Violence, The 205;
 Hammett 204; *Im Lauf der
 Zeit* 123–4, 203–4; *Million
 Dollar Hotel, The* 205, 206,
 209, 217, 218–19; *Palermo
 Shooting, The* 49; *Stand
 der Dinge, Der* 10
Wessel, Kai
 works by: *Flucht, Die* 89, 200
West, Simon
 works by: *Lara Croft: Tomb
 Raider* 46
Westalgie 16, 95–6, 251
Western 88, 227, 245
White House 57, 212, 213
Wikipedia 53, 57
Wilder, Billy 154, 197, 201
Winckler, Henner 71
 works by: *Klassenfahrt* 131
Wokalek, Johanna 164, 172, *172*
Wolf, Christa 119

Wolf, Konrad 8
 works by: *Einmal ist Keinmal*
 246; *Ich War Neunzehn* 8,
 90; *Solo Sunny* 64
Wolff, Hans 234
 works by: *Am Brunnen vor dem
 Tore* 231, 262
Women in Television and Film 167
Woolfolk Cross, Donna
 works by: *Pope Joan* 40
'World Cinema' 162, 228n.7
Wortmann, Sönke 171–2, 175–6, 240
 works by: *Allein unter Frauen*
 168, 189; *Bewegte Mann,
 Der* 40; *Päpstin, Die* 171–5,
 172, 178, 182, 195n.6,
 195n.8; *Superweib, Das*
 168, 175–6; *Wunder von
 Bern, Das* 26–7, 89, 240–2,
 242, 265
Wyler, William
 works by: *Ben-Hur* 97

X Filme Creative Pool 4, 15, 34, 43–4,
 52n.2, 72, 153

Yapo, Mennan
 works by: *Lautlos* 139;
 Premonition 139
Yavuz, Yüksel 138
Yeşilçam 142
Yildirim, Özgür
 works by: *Chiko* 139
Young German Cinema 26, 45, 56
YouTube 9, 53, 108, 121n.4, 121n.6

Zacharias, Susanne Irina
 works by: *Hallesche Kometen* 251
Zaimoglu, Feridun
 works by: *Kanak Attack* 139
Zemeckis, Robert
 works by: *Back to the Future* 42

Index of film and television titles:

7 Zwerge – Männer allein im Wald
41
'99 Euro films' 32
120 Tage von Bottrop, Die 14
10,000 BC 210, 212, 213

Abendland 131
Abgeschminkt! 168
About Schmidt 186
Abschied von Gestern 24
Adil geht 138
Agnes und seine Brüder 178
Aguirre, der Zorn Gottes 124, 226
Aimée & Jaguar 89, 98, 121n.11, 17
Air Force One 210, 216
Airplane 42
Alle Anderen 34, 35, 72, 73, 87n.5
Allein unter Frauen 168, 189
Allemagne 90 neuf zero 1
Alles Auf Zucker, 5, 130, 154–7, 156
Alles wird gut 180
'Allo 'Allo 109
*allseitig reduzierte Persönlichkeit-
Redupers, Die* 166
All the President's Men 218
Am Brunnen vor dem Tore 231, 262
Am Ende kommen Touristen 63,
158–62, 159
American Graffiti 230–1
amerikanische Freund, Der 204
amerikanische Soldat, Der 83
Angst essen Seele auf 124
Anonyma – Eine Frau in Berlin 89,
173, 174, 175, 177
Another Country 90, 92, 93
Antichrist 33
L'arrivée d'un train à La Ciotat 56
Auf der anderen Seite 6, 34, 140, 142,
147, 187
Auf Wiedersehen Amerika 130
Avatar 23

Baader 95

Baader Meinhof Komplex, Der 42,
95, 98–100, 100, 200,
240
Baby 134
Back to the Future 42
*Bad Lieutenant: Port of Call – New
Orleans* 205
Bagdad Café 12, 221
Before Sunrise 73
Before Sunset 73
Bend it like Beckham 36
Ben-Hur 97
Berlin 36 173, 178
Berlin Calling 59
Berlin – Ecke Schönhauser 64
Berlin um die Ecke 246
Beste Gegend 236
Beste Zeit 236
Bewegte Mann, Der 40
Bildnis einer Trinkerin 166
Blackout 48
blaue Licht, Das 234
Blechtrommel, Die 10, 90, 205
bleierne Zeit, Die 163n.6, 166, 170,
195n.7, 267n.10
BloodRayne 47
Blow 199
Boot, Das 210
Bourne Identity, The 199, 218
Bourne Ultimatum, The 199, 218
Boxhagener Platz 95
Boys Don't Cry 182
Brombeerchen 221
Buddenbrooks 96
Bungalow 44, 73

Carnival of Souls 82
Casablanca 28
Casino Royale 218
Chiko 139
Chill Out 59
Color of Money 5, 155
Conversation, The 115

Das war der wilde Osten 245
Day After Tomorrow, The 210
Dealer 139
Denk bloß nicht, ich heule 246, 249
Deutsche Kettensägenmassaker, Das 14
Deutschland 09: 13 Kurze Filme zur Lage der Nation 1–20, 196n.13
Deutschland bleiche Mutter 90, 166, 171, 177
Deutschland im Herbst 2, 3, 3, 4, 6, 8, 10, 16, 21n.8
Dinosaurier 186
Dresden 89, 174, 200

Edelweißkönig, Der 234
EDtv 55
Effi Briest 96
Ehe der Maria Braun, Die 90, 141
Einmal ist Keinmal 246
Elefantenherz 139
Elephant 252
Emmas Glück 236
Emil und die Detektive 237
Enemy at the Gates 126
Enemy of the State 115
Erbsen auf halb 6 131
Erleuchtung garantiert 188
Es Kommt der Tag 60, 186
Europe 32

Fälscher, Die 121n.11, 200
Falscher Bekenner 73
Feierlich reist 4, 218
Felsen, Der 59
Ferien 139
fetten Jahren sind vorbei, Die 6, 7, 13, 251
Fitzcarraldo 10, 14
freie Wille, Der 59, 60
Flucht, Die 89, 200
Free Rainer – Dein Fernseher lügt 6, 55
Fremde, Die 137

Fremder Freund 138
Fremde Haut 19, 138, 169, 180–3, 184, 185, 259
Friendship! 227
Full Metal Village 35
Fu Manchu 25
Fünf letzte Tage 174

Ganz unten 124
Garbage in the Garden of Eden 50
Gegen die Wand 6, 13, 140–7, 145, 259
Geliebte Clara 171
Germania, anno zero 1
Geschichte vom weinenden Kamel, Die 21n.6
Gespenster 44
GG19: Eine Reise durch Deutschland in 19 Artikeln 1
Ghosted 196n.11
Godfather Part II 28
goldene Stadt, Die 235
Good Bye, Lenin! 5, 13, 20n.5, 44, 95, 157, 200, 245–51
Go Trabi Go 245
Götter der Pest 83
Great Dictator, The 90, 109
Grenzverkehr 131, 259
Grizzly Man 205
Grün ist die Heide 231, 262
Gustloff, Die 89–90

Haine, La 252
Halbe Treppe 61–86, 68, 70, 131
Hallesche Kometen 251
Hammett 204
Hände Weg von Mississippi 59
Heaven 210–11
Heimat (Froelich, Carl) 235
Heimat (Reitz, Edgar) 198, 244–5, 267n.6
Heimat 3 244–5
Henri IV 33
Herbstzeitlosen, Die 186
Herr Lehmann 251

Hierankl 6, 187, 236
Himmler Projekt, Das 6
Holocaust 198, 214–16, 215, 228n.5, 244
Hot Shots! 42
House of the Dead 47
Hungerjahre 166
Hurt Locker, The 166
Hustler, The 5, 155

Ich War Neunzehn 8, 90
I Love You, Man 40
Im Juli 140
Im totem Winke – Hitlers Sekretärin 101
Inception 28
In den Tag hinein 73
Independence Day 57, 210, 212, 213
In einem Jahr mit 13 Monden 15, 178
Inglourious Basterds 49, 199, 201
innere Sicherheit, Die 15, 44, 60, 72, 81, 87n.5
International, The 5, 49, 57, 211, 217–19, 220, 229n.12
In the Line of Fire 210
It Happened One Night 131

Jagdhunde 251
Jagdszenen aus Niederbayern 231
Jakob, der Lügner 90
Jerichow 15, 44, 82–5, 84, 85, 137
Jerry Cotton 25, 227, 229n.13
Jetzt oder nie – Zeit ist Geld 186
Jukeodo joha 186
Julietta 59
Jungfrauenmaschine, Die 196n.11, 221
Juno 229n.13
Jurassic Park 57

Katzelmacher 124
Keinohrhasen 40, 239
Kids 252
Kirschblüten – Hanami 19, 170, 185, 187–95, 190, 192, 259

Klassenfahrt 131, 259
Kleinruppin forever 94, 251
Klute 218
Knallhart 58
Kombat Sechzehn 59
Kommt Mausi raus?! 180
Krabat 57
Krieger und die Kaiserin, Der 229n.10
Kroko 8, 63
Kurz und schmerzlos 140

Lächeln der Tiefseefische, Das 132
Ladies in Lavender 186
Lara Croft: Tomb Raider 46
Lautlos 139
Leben der Anderen, Das 7, 18, 20n.6, 28, 39, 92, 94, 95, 97, 98, 110–20, 113, 117, 200, 265
Lichter 133–7, 134, 135, 141, 158
Liebe – kälter als der Tod 83
Liebesgrüße aus der Lederhose 235
Liebes Luder 236
Lina Braake 186
Little Miss Sunshine 229n.13
Lola 90
Lola + Bilidikid 137
Lola rennt 5, 13, 14, 210, 217, 219, 229n.10
Lord of the Rings: The Return of the King, The 45

Made in Taiwan 196n.11
Make Way for Tomorrow 189
Männer 40, 167
Männerherzen 40, 41
Männersache 40
Marlene 38
Marseille 5, 44, 76–81, 78, 81
Maurice 93, 96
Max Schmeling 48, 49
Me and Him 199
Me and You and Everyone We Know 229n.13
Mein Freund aus Faro 182

Mein Führer – Die wirklich wahrste
 Wahrheit über Adolf Hitler
 108–10, *109*, 154, 255
Mein langsames Leben 44, 71
Memento 28
Meschugge 153
Milchwald 5, 130
Million Dollar Hotel, The 205, 206,
 209, 217, 218–19
Minority Report 42
Mitte, Die 32, 132
Mondkalb 8, 63
Montag kommen die Fenster 44, 73, 74
Mörderischer Frieden 60
Mörder sind unter uns, Die 241
Muxmäuschenstill 54
My Father Is Coming 221

Nachmittag, 5
Nachtgestalten 62, 66
Nacht vor Augen 60
Nackt unter Wölfen 90
NaPolA: Elite für den Führer 90, 92,
 94, *94*, 103, 106–7
Neben der Zeit 63
Netto 63, 221
neunte Tag, Der 89, 103
Night On Earth 32, 62
Nirgendwo in Afrika 7, 20n.6, 27, 148,
 195n.6, 200, 259
Nordwand 240

Offset 131
One Day in Europe 32
Ossessione 82
Otto – Der Film 42
Out of Africa 148

Palmetto 205
Päpstin, Die 171–5, *172*, 178, 182,
 195n.6, 195n.8
Parallax View, The 218
Parent Trap, The 95
passion de Jeanne d'Arc, La 177,
 196n.10

Patriot, The 210, 212–16, *215*, 226
Perfect Storm, The 210, 212, 216
plötzliche Reichtum der armen
 Leute von Kombach, Der
 231
Pope Joan 171
Pornorama 267n.3
Poseidon 210
Postal 48
Postman Always Rings Twice, The
 82–3, 86
Poussières d'amour – Abfallprodukte
 der Liebe 182
Premonition 139
Pride and Prejudice 96
Producers, The 109
Putain du Roi, La 33

Quantum of Solace 218

Raging Bull 139
Raining Stones 135–6, 252
Reader, The 48–9, 200–1
Rear Window 115
Rescue Dawn 205
Room with a View, A 93
Rosalie Goes Shopping 12
Rosen blühen auf dem Heidegrab
 237
Rosenstraße 89, 129, 149–58, *151*,
 170–1, *172*, 182
rote Baron, Der 96, 255
Rote Kakadu, Der 94

Salmonberries 221
Same But Different 58
Schattenwelt 60
Scheinheiligen, Die 236
Schläfer 138
Schlindler's List 89, 149
Schlösser und Katen 246
schreckliche Mädchen, Das, 200
Schuh des Manitu, Der 41, 42, 88,
 227, 229n.13
Schulmädchen Report 25

Schultze Gets the Blues 186, 222–6,
 223, 225, 263
Schwarzwaldklinik, Die 236
Sehnsucht 27, *27*, 74, 251
Sehnsucht der Veronika Voß, Die 10,
 90, 178
September 138
Shirins Hochzeit 124
Short Cuts 135
Short Cut to Hollywood 53–5
Sissi 11, *11*
sjunde inseglet, Det 186, 225
Slackers 73, 229n.13
Solino 140
Solo Sunny 64
Something's Gotta Give 186
Sommer vorm Balkon 64–5
Song of Love 171
Sonnenallee 251
Sophie Scholl – Die letzten Tage 89,
 174–7, *176*, 196n.10, 200
Soul Kitchen 260–3, *262*
Spartacus 97
Spielzeugland 21n.6
Stadtgespräch 168
Star Trek 42
Star Wars 42
Storm 133
Stroszek 224
Suck My Dick 15
Süperseks 139
Superweib, Das 168, 175–6

Tag des Spatzen, Der 60
Terminator 3: Rise of the Machines 45
Texas Chainsaw Massacre, The 14
To Be or Not To Be 109
Tod der Maria Malibran, Der 182
Tokyo Story 189
Torpedo *193*, 194, 196n.13
Träumerei 171
(T)Raumschiff Surprise – Periode 1
 41–2, *42*
Triumph des Willens 230
Truman Show, The 55

*Überall ist es besser, wo wir nicht
 sind* 130
Unberührbare, Die 15, 178–9, *180*,
 186
unendliche Geschichte, Die 88
Untergang, Der 9, 13, 20n.5, 42, 88
 90, 98–108, *103*, 113, 121n.3,
 121n.4, 200
Unterm Dirndl wird gejodelt 235
Unterwegs 73, 131, 259

Valkyrie 48, 201
Verführung: Die grausame Frau 12,
 196n.11
Vergiss Amerika 221, 225, 251
Verschwende deine Jugend 96, 251
Versprechen, Das 163n.6
V for Vendetta 36
Vierzig Quadratmeter Deutschland
 137
Viktor und Viktoria 182
Village of the Damned, The 257
*Vision – Aus dem Leben der Hildegard
 von Bingen* 171, 187
Voyage dans la lune, Le 56

Waking Life 229n.13
Was nützt die Liebe in Gedanken 96
Was tun, wenn's brennt? 96
Wege in die Nacht 63
*weiße Band: Eine deutsche
 Kindergeschichte, Das*
 21n.6, 32, 34, 200, 234,
 253–8, *256*, 257
weiße Hölle vom Piz Palu, Die 234
weiße Massai, Die 259
Weiße Rose, Die 174
Weltstadt 252
Wer früher stirbt ist länger tod 34,
 230–2, 236–8, *238*, 241,
 263
Whisky mit Wodka 38, *39*, 50, 64
Wie Feuer und Flamme 94
Winterreise 6, 236, 259, 260, *260*
Wir können auch anders 245

Wixxer, Der 47
Wolke 9 65, 186
wundersame Welt der Waschkraft,
 Die 49, 133
Wunder von Bern, Das 26–7, 89,
 240–2, 242, 265

Wunder von Lengede, Das 47

Yella 81, 82

zweite Erwachen der Christa Klages,
 Das 166